THE
ENCYCLOPEDIA OF
NEW PHOTOGRAPHY

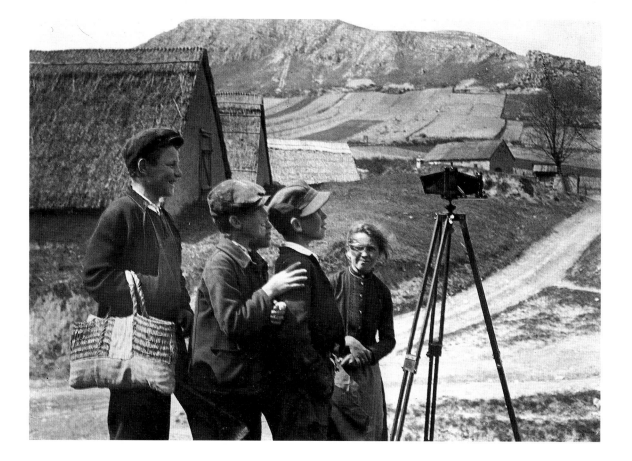

THE ENCYCLOPEDIA OF NEW PHOTOGRAPHY

GUS WYLIE

MALLARD PRESS

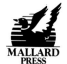

MALLARD
PRESS

An Imprint of BDD Promotional Book Company, Inc.
666 Fifth Avenue
New York, N.Y. 10103

"Mallard Press and its accompanying design and logo are trademarks
of BDD Promotional Book Company, Inc."

Copyright © 1989

First published in the United States of America in
1989 by The Mallard Press

ISBN 0792-45006-X

Note: Definitions of the technical terms shown in bold type
in the text may be found in the Glossary on pp. 250–1.

Produced by Mandarin Offset
Printed and bound in Hong Kong

CONTENTS

INTRODUCTION

If I were pressed to name a picture that sums up the thrill, the pleasure and the glory of the photographic process I am bound to say that I would not automatically pick one of the most famous photographs in the world. Instead, I would choose a wonderful, but lesser known, photograph taken by André Kertész in the early half of this century; 1919, in fact. It shows a gaggle of children on a dusty road in rural Hungary peering into the rear of the photographer's tripod-based camera. A little girl watches, somewhat defensively, as the boys smirk at the upside-down image in the rear of the focusing screen. That photograph, as much as any other that I have seen, conjures up the quintessence of the process, with its mechanical contrivance to produce fleeting and evocative images of life in its passing; the joys, the sorrows, the elation, the despair – all condensed into that bright little viewfinder that can be held in the palm of one hand.

The thrill of photography exists both at the taking stage, as the lens is racked in and out of focus and, particularly, at the printing stage, when the mystical qualities of the latent image, the negative and its inverse values, are ultimately revealed in the photographic print. This thrill is difficult to define or explain but, without it, no amount of expenditure on the latest and most sophisticated photographic apparatus will bring the magic of the medium any nearer. It is true of all the creative arts: Stanley Kubrick was once asked why he made films – was it for the glory, the money, the fame? 'None of these', he explained – 'it is the same thrill that the painter gets when he first opens the lid of the sketchbox, that indefinable pleasure of smelling the aroma of turpentine and linseed oil. For me, it is that irresistible pleasure, when I say "Action", of hearing the whirring of the camera's motors.'

Photography, regrettably, has no evocative aromas in its process, but it does have that wonderful sound of the shutter being tripped, especially the older mechanical types, and the singular thrill of an image coming slowly into focus on either the ground-glass viewfinder or the darkroom easel; these phenomena form the entire basis of my involvement with photography. The medium heightens one's awareness, too. Joel Meyerowitz has written: 'When I walk with the camera I am ready for anything; as in the motto of the Zen swordsman – "expect nothing, be prepared for everything".' This awareness is further heightened by encounters with people one would not usually meet were it not for photography.

I once had the pleasure of quite unexpectedly running into one of my heroes at the Photographers' Gallery in London. A friend of mine, the English photographer Margaret Murray, was chatting to an anonymous man in a 'bomber jacket' by the bookstall and called me over for an introduction – "Gus, this is Bruce Davidson. . . ." Slightly taken aback, I gathered my thoughts, and, in the light of my affection for his work, confessed that if there was ever one photograph above all others that had turned me away from my first love, fine art, and towards photography in the late 1950s, then it was the image of the girl combing her hair in the mirror of a cigarette machine on the Coney Island boardwalk (see p. 230). He nodded and I thanked him for changing my life. "Well, I have to tell you", he smiled, "that photograph just about changed my life too." We laughed, shook hands and realized that a shared experience had founded our mutual affection for photography. Even today I always think of Bruce Davidson's 'Teenage Gang' series when I think of my own tentative beginnings in photography.

Of course, it also came from other inputs – such as the wonderful Fred Astaire darkroom sequence in the film *Funny Face*. Sitting in the darkened cinema, I longed, one day, to have a darkroom like that. (Although the film was a musical, Richard Avedon had been its photographic adviser, and, in turn, it was loosely based on his own early days in Paris.) It was part of my upbringing, as

Southern Belle, Harlow, Essex
I have always been drawn to those people who are on the fringes of society. Latterly I have been working on the theme of rockers and bikers in the United Kingdom. I find the individualism of these devotees of rock 'n' roll music and Harley-Davidsons fascinating. Roll film colour negative, exposed by daylight.

were the attendant images of the 1950s; Robert Frank and 'The Americans', William Klein's photographs of Rome and New York, and the continuing affinity with the imagery of that generation.

These experiences came to influence my own aspirations in photography, as did the childhood days in Scotland during World War Two and their seminal link with the essays of Paul Strand. I met Strand briefly in the early 1970s and valued his advice to base my Hebridean work with the help of a local and kindred soul – a minister of the church, or a teacher – to act as a go-between in the pursuit of images within a remote rural context. So began my first essays on the Western Isles of Scotland.

Other influences were the American music of the 1950s, the jukebox culture and the lyrics of the freeway, teenage protest and all that went with that. In addition to Bruce Davidson and Robert Frank, I discovered the compassionate Walker Evans, Irving Penn and his phototent, and developed a compulsive affection for the 'American Dream' as expressed in popular song. On to the Sixties and the disaffection, the riots and the opting out of the middle-class mainstream – more Bruce Davidson on East 100th Street, the 'Freedom' marches, Black identity and the biker gangs of Danny Lyon; Avedon's haunted faces in *In the American West*, and latterly a renewed interest in the potential of large-format colour negatives – through the work of Stephen Shore, Joel Sternfeld and Richard Misrach. I ended up on a Greyhound bus in the early 1980s, with a songbook and a small rangefinder camera, taking photographs of the American heartland for the sheer love of it.

The concept of 'for the sheer love of it' governs much of what I do and, in my opinion, lays the ghost of the idea that to be an amateur is somehow an inferior way

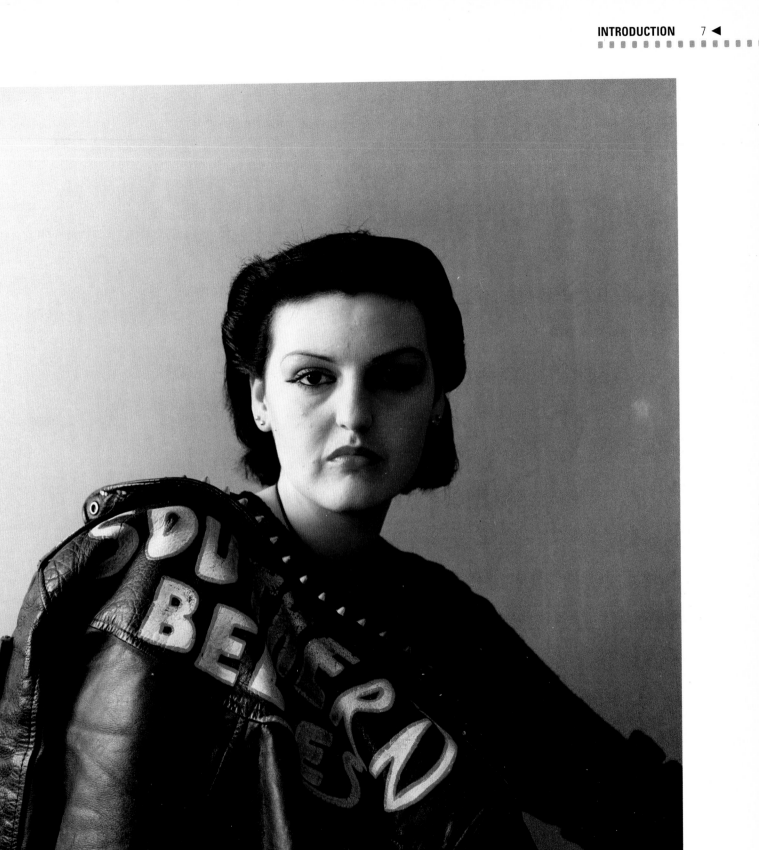

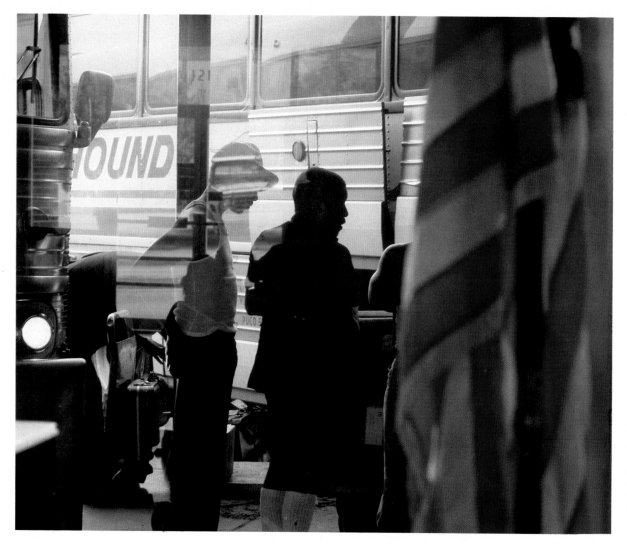

Left: Baggage Halt in the Deep South from the essay *Promised Land*, an affectionate tribute to the lyrics of Chuck Berry's songs of American aspirations in the 1950s. The work was carried out on a small rangefinder camera for ease of use and portability, with three lenses (28 mm, 40 mm and 90 mm).

Right: Evening Twilight, Staffin, Isle of Skye The end of the day on a croft in the Western Isles of Scotland; 24 mm wide angle lens, exposed for 1 second, on a gatepost, with a time delay. This shot was taken during my second major document in the Hebrides.

to work. All of us have stories to tell and pictures to take — we just tell ourselves that they are not sufficiently important and so never begin the first step on the long road of enquiry. Yet they are important, and this book is directed in part towards helping you to realize this reality. Technique is, of course, important but only as far as it is essential for your work. For some photographers, however, it can get in the way. They are convinced that the only way ahead is via the latest and most expensive equipment coupled to the latest technology. It is a delusion to believe that all that is new is, by its nature, of value.

As a primer to beginning work on this book, I in fact used some equipment that was infinitely more expensive and modern than those cameras that I normally use. One such camera had extremely sophisticated circuitry and boasted the latest in selective spot metering and, as I had no experience of this in an SLR system, I was anxious to set this deficiency to rest. I was dismayed to realize that, despite the sophistication of the metering system, with its potential for cumulative averaging of several readings, it still had no ability to work on the basis of 'point-and-shoot', with automatic settings that are the preserve of almost any cheap camera system. Further, it did not even have the benefit of a time delay in its circuitry. Offering every other development, it had nevertheless failed to provide the most basic working requirements for me.

Therefore, this book is not directed exclusively towards the ever more complex search for ever more complex equipment — it is directed much more to matters of visual language, rather than pure technology and its attendant methods of working. The acquisition of the latest synthesizer will not, alas, make you write music like Mozart. You are much better advised to *listen* more and come to it by association; the latest word processor will not help the content of your writing — it may well make it easier, but not necessarily better. Instead, you should read as much good literature as you can lay your hands on. So it is with photography. Look at pictures, styles, attitudes and approaches and do not beset yourself with artificial barriers of tech-

nique. Above all, creativity is to do with imagination, not limitations. As Bill Brandt has said: 'Photography has no rules – It is not a sport. It is the result which counts, no matter how it is achieved.'

Photography is, however, a vast subject, immensely rewarding and wholly absorbing. Each and any section of this book could, in itself, be the basis for another book. There are only introductory essays on the complexities of colour printing or, indeed, good quality monochrome printing; little is said about the many differing developing agents that are currently available to the experienced user – better by far to employ a simple formula to begin with and concentrate instead on what is in front of the camera; more obscure solutions can

come later. When a student of mine once enquired of a leading Magnum photojournalist which developer he chose for his films, the reply was 'the one that is sold by the nearest chemist'.

I have no difficulty in considering myself an amateur for I believe that the true definition of that word is applicable to the finest work in photography, which derives not from a concern for payment or assignment or gain, but from the simple love of its creation. After thirty years in fulltime education, I still gain enormously from the influence of students and their enthusiasm and energy for the photographic process. Similarly, I know of few pleasures to compare with looking back to the imagery of the great photographers of

this century, or indeed the last. In fact, my respect for P.H. Emerson and his work on the Norfolk Broads (see p. 210), coupled to a renaissance of interest in large-scale colour negative work on traditional cameras, leads me to think that my next major series of pictures will involve my tramping the moist grass of Norfolk. I have always longed to stand where Emerson once stood, and revisit those earlier icons through modern materials; the bridge at Potter Heigham, the Church at Irstead, the Eels Foot at Ormesby – all, surely, still there. I have never exposed 10×8 in film in my life and, frankly, I simply cannot wait to begin.

Gus Wylie, St. Albans, 1988

CAMERAS
AND
THEIR
CONTROLS

'The poetry of photography will always be more important than the mechanics of the camera . . . you see the picture is taken with the eye, the heart. The most sophisticated camera in the world can never replace this.'

JACQUES-HENRI LARTIGUE

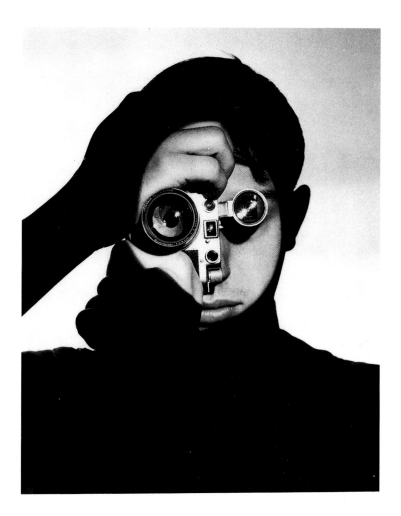

ANDREAS FEININGER
THE PHOTOJOURNALIST
1955

THE CAMERA

Photography is a relatively young visual discipline, no more than 150 years old, but the principle upon which the camera itself is based goes back much farther in time. In the eleventh century an apparatus known as the **camera obscura** (literally 'dark chamber') was used to observe solar eclipses. A camera obscura in its most basic form consists of a room with a small hole in one outside wall. Rays of light passing through the hole produce an image on a screen of the scene outside the room. The first published illustration of such an instrument appeared in 1545. Within another five years the first mention was made of an early lens and even, in 1568, of a lens and **diaphragm**. These early image-forming devices were in effect room-sized pinhole cameras and indeed the 17th century examples that were employed by artists in their studies of perspective and nature bear a remarkable family likeness to the present-day **single lens reflex** camera. This was due to the introduction of a 45-degree reflecting mirror that would produce an image on a viewing screen from which the draughtsman could work.

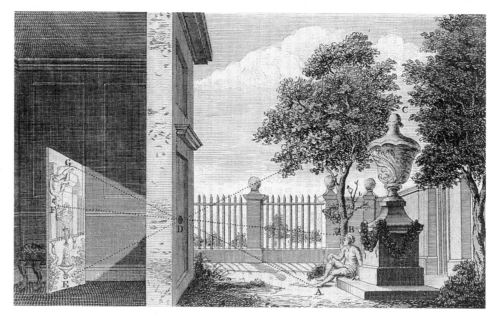

It seems extraordinary therefore that it should take so long for a phenomenon that had been previously described by Leonardo Da Vinci in the late 15th century to crystallize into photography, but the reality was, of course, that, although it was wholly feasible to *see* the image there was no known means of arresting and, above all, preserving it. The absence of a meaningful working knowledge of the basic properties of photographic chemicals meant that it was not until 1826 that the missing link fell into place. This was when the French lithographer and inventor Nicéphore Niépce discovered that by coating a pewter plate with asphaltum he could retain a permanent image. In England William Henry Fox Talbot made similar experiments with paper treated with nitrate of silver, and later with silver chloride, and produced his first negative of the window of his home at Lacock Abbey in 1835.

Essentially, the basic criteria for the production of the photograph have changed little since. Despite the enormous changes in the size, shape, and portability of cameras that have recently taken place, the principles remain the same: the camera is a light-tight box equipped with a film-holding device at one end and an image-forming lens at the other. This being so, it seems incongruous that there should be such a variety of camera systems currently available to the photographer, but the reality is that the search for the 'perfect' camera is as tantalizing as that for the Holy Grail. Put simply, there is no such thing. Everything in photography is subject to the 'swings and roundabouts' dilemma – what is good in one respect is frequently bad in another. In respect to cameras it is usually a question of quality against expediency. For example, it is undoubtedly true that the larger the negative, the finer the image quality. But a large image requires a large camera and a large camera can only be operated effectively on a tripod. Take away the tripod and you have a negative that is no better than one produced by a small-format camera.

This perennial question of choice therefore has had a lasting influence on the design of cameras and it is no surprise that the current large-format field camera has

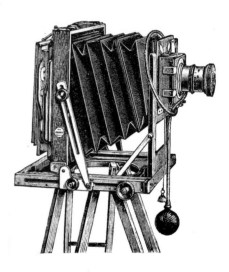

changed so little over the past 150 years for, frankly, there is little in its design to improve upon. The large negative remains, as do the **bellows**, the **viewing screen** and the film sheath, and, of course, the tripod. It is cumbersome, slow and painstaking to use, yet offers total control of the negative as in no other system and is the unsurpassed instrument when image quality is of paramount importance. On the other hand, it could be argued that the increased potential of faster and more refined films in present-day photography has opened up an area of representation that was unknown to the pioneers of photography.

Indeed, the refinement of the miniature camera over the past half century into its modern electronic equivalent is responsible, more than any other factor, for bringing photography to a wider public.

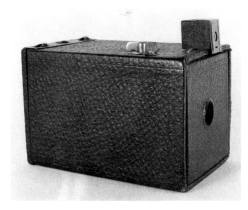

Above left: This engraving clearly shows the principle upon which the camera obscura was based, with the small opening in the window shutter producing an inverted image on the opposite wall.

Left: The camera obscura's light path and image formation are directly related to the configuration of the early plate cameras. This layout was so effective that the design has hardly changed.

Above and right: The introduction of the small portable hand-held camera, the Kodak (later to be known as the Brownie), was to change the role of photography forever. Its ease of operation, and mass production and marketing meant that, by the turn of the century, photography was to leave the studio and the scientific bench and be the image-maker for millions of people. No specialist knowledge was required for the camera's use and roll film meant that the glass plate was no longer necessary, and that you could take more than one view of any situation.

However, photography does not exist merely in terms of technique and the limitations and potentials of materials and equipment – it is a powerful visual language with a unique quality of its own and this is greatly influenced by the selection of the camera and the approach to the subject. Large cameras use individual sheets of film which, in turn, can be processed and printed individually, according to the conditions in which they were exposed; modern medium- and small-format (miniature) cameras do not offer this facility: they employ rolls or cassettes of film that allow for a greater number of sequential exposures and a greater ease of portability. This can be a critical consideration when selecting cameras for specific purposes.

Miniature cameras

The potential for the evolution of the smaller camera was first realized by George Eastman in 1888 with the introduction of 'The Kodak' and the slogan "You press the button, we do the rest". It had been Eastman's conviction that, once freed from the constraints of the tripod, the chemist's bench and the artist's studio, the camera would open up new frontiers of experience for millions of ordinary people and that the Box Brownie would enable him to achieve this goal. Knowledge of optics and chemistry was unnecessary – the camera was pre-loaded by the manufacturers and then returned to them after exposure of the film for development and the insertion of new film. No fumbling with plates, no need for a darkened room – a new era had arrived, and with it the universal recording of domestic everyday life.

The development of smaller cameras took an important step forward in the early 1920s with the introduction of the Ermanox (see photographs on p.15, a camera made famous because of its use by Erich Salomon in many candid photographs. Miniaturized sufficiently to allow it to be carried in the palm of one hand, it took small glass plates and was coupled to the first really innovative small-format lens – an f2 objective that allowed photography to take place under previously impossible conditions. Another important small camera of this period was the first Leica, introduced by Oskar Barnack in 1924 for Leitz of Germany. The Leica combined the advantages of the small portable camera with a potential for using standard 35 mm cinematographic film – the format that is used to this day – and pioneered the concepts of both the **coupled rangefinder** and the **focal plane shutter**.

Therefore, when considering the potential of any given camera system, the photographer should be fully informed of the respective advantages and disadvantages of its format, and particularly to consider the type of photography that is likely to be undertaken. No system is perfect.

THE MINIATURE 35 MM CAMERA

The modern 35 mm miniature camera has developed logically from the early Leica models, which were small and had a rangefinding system that obviated the need for a groundglass viewing screen. This rangefinder, coupled to a very high performance lens, enabled the photographer to work in very restricted light, while the operation of the focal plane shutter was sufficiently quiet to render the photographer unobtrusive. These qualities are so important to many photographers that the modern Leica remains an unsurpassed standard for this type of equipment. Other rangefinder cameras have fallen by the wayside but the precision engineering of the German original and its very durable performance under adverse conditions still renders it the first choice for many professional photojournalists. On location, it is almost silent, its longbased rangefinder allows it to focus in very poor light and the absence of a mirror and reflex housing means that the body remains light and small. However, this strength is also the camera's greatest weakness for the simple reason that the viewing position of the rangefinder differs from that of the taking lens and therefore the question of **parallax** arises. This is a perennial source of dissatisfaction for many would-be users and poses a particular problem when working close to the subject in still life or portraiture. But the rangefinder principle is still the basis of many compact cameras. It will be discussed more fully when dealing with this particular system of camera design (see 'The Modern Compact', p.18).

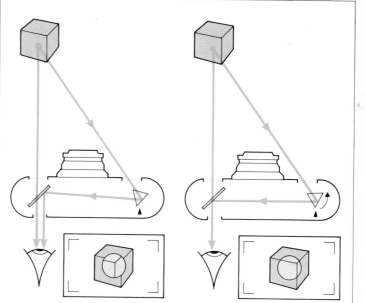

Left: The rangefinder principle of the Leica allows precise focusing. Looking through the viewfinder, you see an overall sharp image, together with a small rectangular secondary image, formed by a revolving prism. As the camera is focused the prism moves, and when the two images are precisely superimposed the lens is in exact focus.

Below: It is not unusual for a Leica to be working forty years after its manufacture. Later models have built-in electronic circuitry so that the camera has a form of spot metering from a circular area on the focal-plane blind.

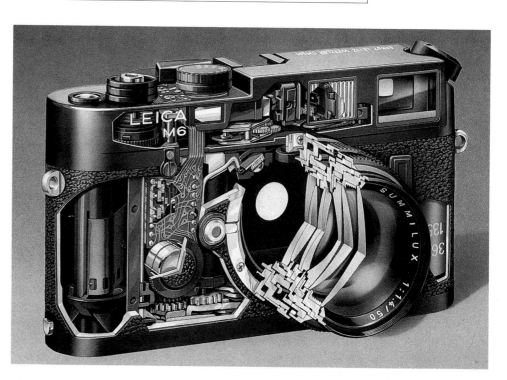

The Single Lens Reflex

The fundamental need to see precisely what was being viewed through the taking lens led to the development of the single lens reflex camera (SLR). The logical means of achieving this was to introduce a 45° mirror into the lightpath of the lens. The reflex focusing system allows the photographer to evaluate the content of the photograph in terms of depth, focus, field of view and composition right to the moment of exposure. The advantages are numerous but, in the simplest sense, they derive from the elementary principle of 'what you see is what you get'. Similarly, these rules of application apply to *all* auxiliary lenses that will attach to the throat of the camera body and accommodate the action of the moving mirror, from the widest **wide-angle** to the narrowest **telephoto** as well as to the highly specialist lenses used for macrophotography, microscopy and astronomy.

Yet all systems have their limitations

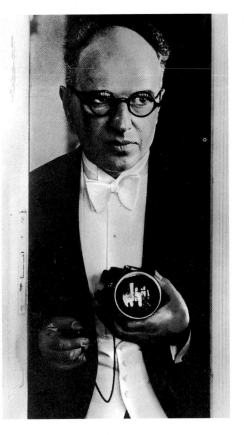

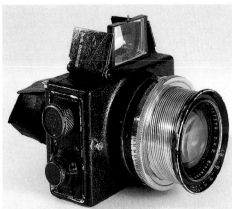

direct the nature of the image so formed, it was a logical step to take this principle further and apply it to the measurement of light itself. This meant that the camera could offer greater control in not only the content of the viewfinder but also in monitoring the amount of light entering that viewfinder and, thus, exposing the film. Modern SLRs incorporate sophisticated metering devices in the lens throat assembly that enable the photographer to make comprehensive decisions on composition, exposure and **angle of view** without taking the eye from the viewfinder.

Left and above: It was Dr Eric Salomon (left) who pioneered the widespread use of the Ermanox camera (above) for gathering pictures in available light. He used it at the Assemblies of the League of Nations in the 1930s to produce a remarkable record of diplomats 'behind the scenes'. Strictly speaking, the Ermanox is not the predecessor of the modern SLR, yet it does have similarities, such as the large aperture lens. This allowed Salomon exciting possibilities, and certainly compares to the type of lens that is taken for granted today. Also, it was very portable and thus Salomon was able to merge into the assembled political negotiators without much difficulty.

Below: The appearance of the modern Single Lens Reflex camera has not changed greatly; certainly, the basic layout is the same as the early cameras such as the German Exakta, of the 1930s. However, whereas the layout of the modern SLR may appear similar to that found in earlier models, the camera's character is wholly different. Microchip technology has done much to change the SLR, making possible features like high-speed focal plane shutters that are far more accurate than their mechanical equivalents. Also, behind the facia of the camera are packed printed circuits that carry information to the viewfinder display and greatly assist in the monitoring and control of exposure.

and the SLR is no exception. The introduction of the mirror into the lightpath of the taking lens means that, obviously, it must be removed at the instant of exposure, so that the light can reach the film, and return again if the viewfinder is not to remain blacked out. The resulting camera is therefore heavy and bulky. Not only must the camera body be large enough and deep enough to allow the mirror to swing upwards, but the image has to be laterally reversed and re-oriented by a viewfinder prism that is in itself quite heavy. Finally, there is the question of noise – no mirror system can be sufficiently dampened to eliminate this crucial factor and for many areas of intimate photography it remains an unwarranted intrusion and hindrance.

Despite these limitations the configuration of the SLR represents a near-perfect solution to the question of camera design and allows for further sophistication in its layout. Having successfully solved the question of utilizing the lightpath entering the taking lens of the camera to view and

THE ELECTRONIC SLR

The unquestioned supremacy of the SLR has led naturally to the question of how this type of camera can be further updated and improved. In the last decade the advent of microchip technology has revolutionized the internal design of the SLR. The principle remains the same but the internal circuitry and information technology heralds a whole new chapter in camera design and application. For the photographer, this can be a seductive and dangerous misconception for, however ingenious and remarkable the various systems and devices are, they do not lessen the need for a working understanding of the principles that govern photography itself – quite the contrary, in fact. The electronic SLR can afford, in one compact body, at least four differing modes of exposure, immediate electronic read-outs of aperture or shutter prioritization, selective and variable exposure automation, multispot averaging, continually variable and self-monitoring shutter speeds – to say nothing of speeds up to 1/4000th sec – manual override for abnormal lighting, automatic winding, and self-timing. Electronics also provide rapid communication between one part of the camera and another. Yet all this sophistication is worthless if it is not employed in the context of well founded knowledge and experience, without which the photographer will quickly find himself becoming disenchanted. Photography is not about microchips but about *seeing*, and the expression of ideas and attitudes. The technology is nothing without a firm comprehension of the principles that govern photographic practice and enable one to express this in terms of pictures. To this end, succeeding chapters of this book will consider in detail those very elements that make up the repertoire of the experienced photographer – successful pictures do not happen merely by the acquisition of a more expensive and sophisticated system of taking photographs.

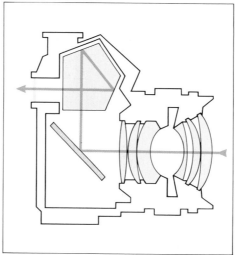

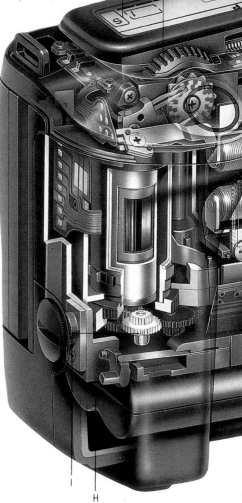

Left: The basic viewing principle of the SLR camera remains the same in the electronic model shown below as it was in the earliest SLRs. A mirror and pentaprism direct the light passing through the lens to the viewfinder so that you see the same image as the camera. At the moment of exposure, the mirror swings up, allowing the light to pass to the film plane.

Features of the Canon EOS 650

A: The panel on the top of the camera gives a readout of all functions – such as the exposure mode, aperture and shutter settings, and the number of exposures made on the film. On some models the panel can be illuminated in low light.

B: The accessory shoe is provided with electronic contacts that connect a compatible flash gun to the camera's main microprocessor. This enables the camera to perform accurate through-the-lens flash metering and to adjust the power output of the flash gun to the lighting requirements of the subject.

C: At the heart of an electronic SLR is its main microprocessor, the on-board computer that co-ordinates signals from the lens and the manual controls and sends the correct instructions to the parts of the camera that are to be adjusted automatically. As soon as a lens is fitted, information about its focal length and maximum aperture is sent to the main microprocessor so that the camera is prepared for photography. The camera's computing power is particularly useful

when depth of field is important in a photograph, since the microprocessor can carry out all the complex calculations that determine depth of field with a particular lens very quickly indeed. The microprocessor can also control accessories fitted to the camera, such as data backs and electronic flash units.

D: Traditional lens mounts use a series of pins to couple lens and camera body and permit the aperture to be linked to the camera by means of a mechanical lever. These pins allow only a limited range of adjustments and must be produced to very high tolerances in order to work reliably. In the newer type of SLR, the pins are replaced by electronic contacts, which allow a greater range of instructions to be sent from the microprocessor to the lens and vice versa, making possible very fast adjustment not only of the aperture but also of the focus setting. The electronic mount also gives the microprocessor vital data about the lens in use, such as its focal length, maximum aperture, and whether it is set for autofocus or manual operation; this helps the camera to respond instantly to any shooting

situation. In addition, electronic contacts mean that the transfer of data between the camera and any future accessories will be possible with ease.

E: In this system, the motors that move the lens elements during autofocus

are placed inside the lens itself, rather than within the camera body; this means that the different power requirements required for driving lenses of different sizes and focal lengths can easily be met. Some of the lenses in this range use ultrasonic

B

C

Canon

EOS
650

J D

50mm

1:1.8

E

F

G

CANON

LENS MADE IN JAPAN

assures long life for the part of the camera that has to withstand maximum wear and tear because the motor's only metal-to-metal contact is at one bearing. Control is also much more precise than with conventional manual apertures.

G: With the camera in manual mode, this ring is turned to focus the lens, as on a traditional camera.

H: Power for the camera's motors is provided by batteries carried in the base. A battery-check button at the back of the camera allows you to keep an eye on battery power. Some cameras also give an audible low-power warning.

I: There is a built-in motor for film advance and rewind; this allows both

single-shot operation, self-timing, and continuous shooting at up to 3 fps. The motor drive is controlled by the shutter button on top of the handgrip. Adjacent to this control is a multi-function thumbwheel that provides manual adjustment of shooting, AF and film-winding modes, as well as lens aperture and exposure compensation.

J: The camera's ranging sensor is designed to provide accurate and rapid focusing even at low light levels. The ranging system works by splitting in two the light rays that pass through the camera lens. Two images are therefore formed on the surface of the ranging sensors and the camera can detect the direction of defocus by the distance between these images – too far forward,

and the images are spaced narrowly; too far back, and they are spaced widely; when the subject is in sharp focus, the images are spaced correctly. Each element of the sensor has its own amplifier, so that even poorly illuminated subjects can be focused accurately and quickly; this is a marked improvement on previous autofocus systems, in which a single amplifier was used for all the elements, making distortion possible and leading to a reduction in the accuracy of the signal.

K: The metering system used by a traditional SLR generally takes an average of the light measured from the whole scene, giving special weight to the illumination of the centre of the frame. The main problem with this system is its inability to cope with backlit subjects. The solution employed on this camera is a design that measures light from six separate areas of the frame. The camera's microprocessor compares the resulting pattern with its own memory-bank of typical patterns, so that the camera can determine the size of the main subject, whether it is backlit, whether there are shadows that might need filling and so on. The automatic exposure will then be adjusted to suit the situation.

L: Modern electronic SLRs offer a number of different exposure modes. You can choose whether you want to control either the aperture or shutter manually, or have full manual control. The fully automatic (or 'program') mode can be adjusted (for example, if you want to use a faster-than-normal shutter speed or a larger aperture), to allow you some creative control over exposure.

motors – their ring shape and high torque make them ideal for lenses such as the large 300 mm f2.8. In standard lenses, such as the one shown here, more conventional arc-form motors are employed. Even though such motors use electromagnets, these are

miniaturized and fit neatly into the lens barrel.

F: Iris diaphragm
The aperture unit is combined with its own stepping motor, which allows quiet and precise control of the iris diaphragm. The design

THE MODERN COMPACT

As a counterpoint to the ever more sophisticated specification and performance of the present-day SLR camera, there is an increasing awareness of the potential of the small, lightweight non-reflex camera that is considerably smaller than even the smallest SLR – the compact. Although it appears to revert to the earlier Leica models (and indeed Leica were one of the first manufacturers to bring out a compact version of their leading camera) the modern compact is based on a different philosophy. It is characterized by a shorter-than-usual **focal length**, usually around 35 mm or 40 mm, and this makes for greater depth of field and ease of focusing, even if there is no rangefinder system. The lack of a return-mirror in the body allows the lens to be nearer the filmplane and thus the overall dimensions of the body to be that much smaller. Interchangeability of lenses is not a feature, and the emphasis is placed on ease of operation and compactness of size. More recent models have now included both infrared focusing devices that fully accommodate the question of definition, and automatic programmed shutter mechanisms. These, together with a built-in flash, equip the photographer for a very wide range of spontaneous picture-taking opportunities. The most attractive feature of these cameras is their size, and most have no need for separate carrying cases to protect them – they can simply be placed in the pocket for use at any time.

But the compact camera is no mere toy – it is a wholly viable instrument. Its uniqueness lies in its diminutive scale and ease of operation and this, coupled to the latest technology in automatic focusing, affords its user universal picture-making, almost without thinking. It performs admirably in informal situations like wedding receptions and parties, but it is also useful for picture-taking under difficult conditions when the shutter will offer solutions to landscape photography at dusk or in large buildings like cathedrals. It goes without saying, however, that some form of camera rest is vital for this and additionally a **self-timer** setting is useful, so that the shutter can be fired without the risk of jarring the camera and causing blur.

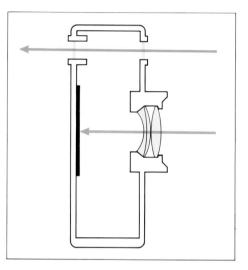

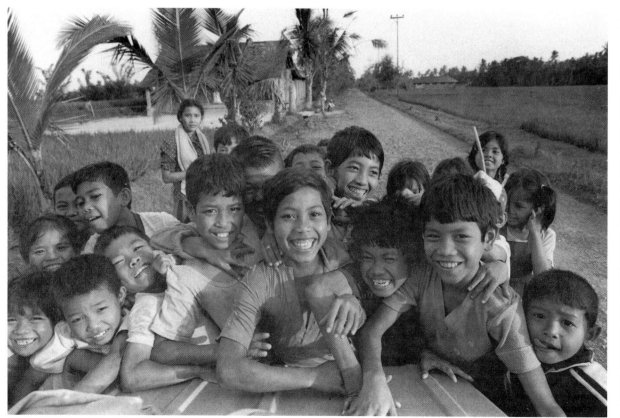

Above: On most compacts the viewfinder is positioned to one side of the main lens. Framing errors can occur, especially with close subjects.

Left: This photograph shows the potential of the compact camera for candid photography. Small, light and portable, the compact allows for picture-taking under all manner of conditions. Although most models are based on the principle of 'point-and-shoot' and require no setting of either aperture or shutter speed, the optics are first class and many of the latest models have autofocus. One handy feature of the camera's miniaturized circuitry is that it allows for use in difficult lighting conditions. You can use the camera's internal metering system to allow photography in poor light by means of improvised tripods; this is useful in landscape work after dusk, for example.

Left: The compact camera has brought about a mini-revolution in photography: fast, easy to use and incorporating many of the features found on its 'big brother', the SLR, it has taken much of the anguish out of picture-taking for those people who have not been bitten by the camera bug.

Above: The compact camera with a built-in zoom offers the choice of either a medium wide angle (35 mm) or a short telephoto (70 mm) within the same body. Whereas this innovation may well be convenient for the user at one level, its incorporation together with additional features such as autofocus, flash and the automatic setting of the film ISO/ASA index has meant that the cameras are now becoming larger, almost to the size of a standard SLR. The whole novelty of the original compact concept lay in the fact that the camera was, quite literally, a pocket camera and not a great deal larger than a packet of cigarettes.

The two illustrations, left and right, show the comparative angle of view between the choice offered by the opposite ends of the zoom range, taken within a few seconds of each other.

LARGER FORMAT CAMERAS

Despite the universal popularity and applications of the 35 mm SLR, there is still a major need for camera systems using larger negatives and transparencies, especially when big enlargements are required or when images are intended for reproduction. Without doubt the modern miniature camera is a legitimate tool of the practising professional, but there is a resurgence of interest in the new medium-format camera systems that use 120 roll film. Professionals do not look on medium-format cameras as a replacement for the miniature camera, rather as a substitute for the large studio cameras that previously dominated professional output. The reason for this centres not so much on the camera but on the recent advances in film technology that have taken place over the past decade or so. The increased definition, higher manufacturing tolerances, and finer **grain** structure in both monochrome and colour emulsions now mean that the former gap in image quality between sheet film and medium format is closing. Similarly, there is a move away from the square 6 × 6 cm format of earlier roll-film cameras to that of a slightly longer format placed across the film in a 6 × 7 cm **aspect ratio**. This has always been known as the 'ideal' format because its proportions relate directly to 10 × 8 in printing paper so that the whole of the working negative is utilized when printing. In addition to this there is a slightly larger format, 6 × 9 cm (which is too large for the camera to use a reflex mirror), and a smaller one that places the format across the film in a 6 × 4.5 cm configuration (commonly known as the 645 format). There are others, like the new technical camera that employs a curious mixture of the systems on a 6 × 8 cm format. This uses reflex focusing, which renders the camera almost as large as the studio cameras already in use for sheet film; then there are the unique formats like the 617 for panoramic work which, as its

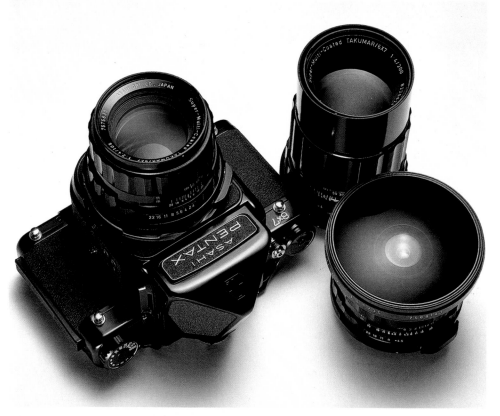

Above: Some 6 × 7 cm cameras are designed like a scaled-up 35 mm SLR, with handling ability and ease of lens changing. The pentaprism arrangement for such a large format means that it cannot really be compared to the 35 mm miniature. The large mirror is noisy and liable to vibration but later models have a lock-up device.

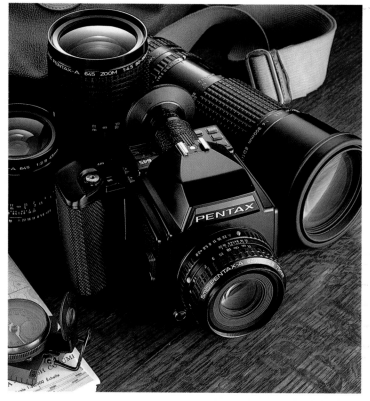

Left: The 645 format is a diminutive of the 6 × 6 and allows 15 exposures on one roll of 120 film. Its handling ability, almost rivals that of the 35 mm miniature, while affording a larger negative. It incorporates the latest in microchip technology.

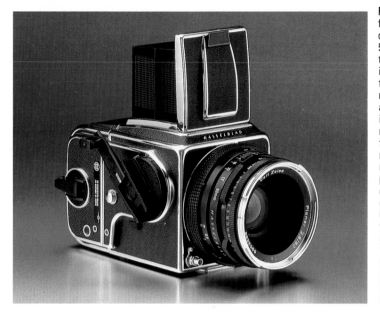

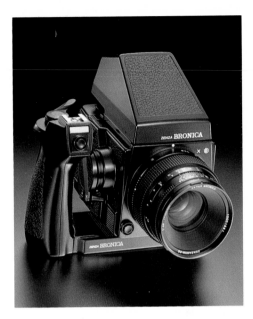

Right: The 6 × 7 cm format most readily challenges the role of the 5 × 4 in studio camera in two ways. First, the recent improvements of the film technology mean that the roll film medium format is able to offer an image that is very nearly as good in resolution as the sheet film. Secondly, its aspect ratio nearly perfectly matches that of 10 × 8 in printing paper and thus overcomes the disadvantage of the 6 × 6 cm square format of the traditional roll film camera. The format allows 10 exposures on a 120 roll film. This 6 × 7 cm Bronica resembles the Hasselblad layout but relies on electronic circuitry.

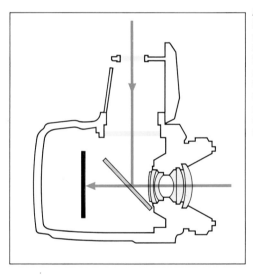

Above: Although the Hasselblad has an unrivalled position as the quintessential medium format SLR, modern film emulsions and coating technology have led to a revival of interest in the roll-film format as an alternative to sheet-film studio cameras.

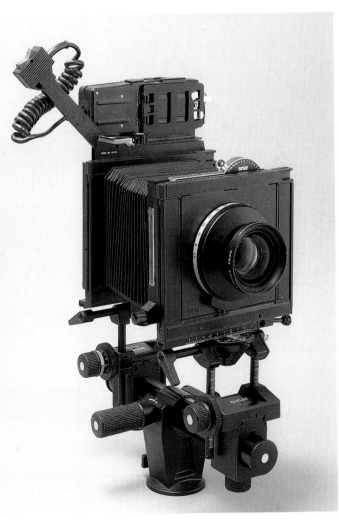

designation implies, uses an aspect ratio of almost 3:1 and is a very large camera to work with (see pp. 170–77).

Essentially two main types predominate: the time-honoured 6 × 6 cm solution, with both interchangeable backs and lenses, and its larger derivitive, 6 × 7 cm. There are three different camera designs for the latter format: the enlarged version of the earlier design for the 6 × 6 camera; a design that owes its priorities to typical studio practice, and incorporates bellows; and an entirely different approach that takes the form of a scaled-up version of a 35 mm SLR.

Right: Even the monorail camera can be provided with electronic equipment, as with the special meter probe fitted to this Sinar. In this instance the probe is placed into the film plane and effectively affords a form of spot metering for the image on the screen. This allows for precise estimation of not only the exposure but also the contrast range.

FOCUSING

One of the simplest ways to demonstrate the principles of image formation is to consider the pinhole camera. This early method of forming an image predates photography itself and yet does not use a lens. The pinhole camera forms the image by restricting the rays of light that are reflected from the subject so that only the smallest number are able to pass through the tiny hole at the front of the camera.

To make a pinhole camera it is probably better not to use a rectangular box at all, but something like a biscuit tin or tea caddy. This will enable the film to be held in a curved plane, maximizing the use of light passing through the pinhole and minimizing fall-off. In use take the apparatus to a subject that has a good range of tonal values and make a test exposure. An adequate exposure is usually in the region of 5 seconds in good sunlight on medium-speed film. It is better to use something like 5 × 4 in sheet film so that each can be handled and developed separately.

On examining the photograph, you may be agreeably surprised that such a simple device can afford such a readable result, but on closer examination the pinhole offers something that is unique in image-forming systems – it has universal **depth of field** and no selective **focus**. This is because the rays of light in the foreground are subject to the same laws as those in the background and therefore they do not 'focus' the subject at all; everything has the same degree of definition.

This early system of image-forming is intolerably slow and suffers from low resolution throughout. Its logical improvement is the addition of a lens system, however simple. If you photograph the same subject with even a basic convex lens it is immediately apparent that an improvement in definition takes place and that the phenomenon of focus comes into effect, with some areas of the image appearing sharp while others, at different distances from the lens, are less well defined. This ability to focus is the natural

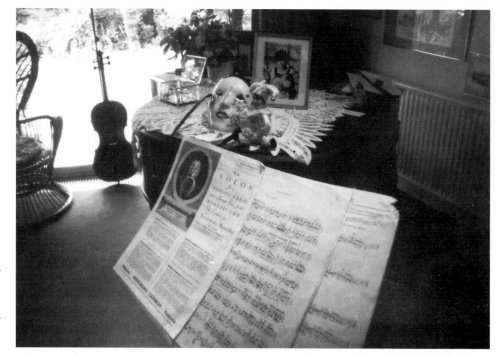

Above: The unique properties of the pinhole photograph are shown in this image, for there is no selective focus; the whole picture retains the same degree of sharpness throughout. From the small notes on the manuscript in the foreground, through the doll and mask on the lace covering to the piano, out to the cello leaning against the window, there is no fall-off. The 'camera' was, in fact, a tea caddy.

Right: Use of selective focus enables you to change the emphasis within a picture. In these examples, the viewpoint has not altered at all, yet in each photograph the emphasis is different. The first could, for example, be an advertising picture for a particular make of cycling equipment, the second a portrait of two young sportsmen, while the third could be the cover of a book on the social anthropology of architecture. The only thing that differentiates the three photographs is the point of focus.

constituent of all lens systems and is the primary method of selection and emphasis of different parts of a photographic subject. The ability of the lens therefore, when coupled to other control devices such as the **aperture** and the shutter, to select, emphasize and de-select elements of an observed scene is one of the fundamental aspects of photographic language that differentiates it from painting and drawing.

This is a critical consideration and stems from the reality that the human eye

is, after all, a continually variable lens system that is linked to the brain via the retina and optical nerve. As we take in visual experiences, the lens adjusts automatically for light and subject distance, even within the same angle of view. This phenomenon is directly related to the way in which we perceive the world around us and even the most complex and sophisticated arrangements of autofocus and **exposure compensations** are merely mechanical devices that are trying to mimic the

FOCUSING 23

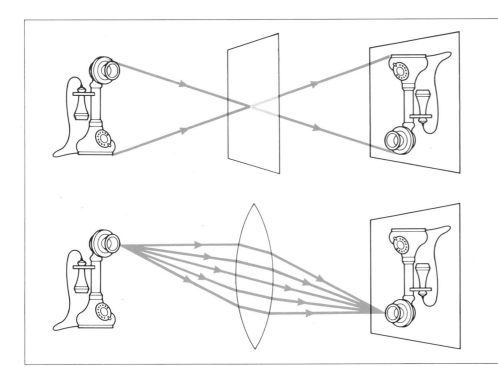

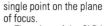

Left and above: The quality that characterizes the pinhole results from the path that light has to follow in producing the image (left). The smaller the hole the sharper the image but the longer the exposure. All points throughout the subtended image are equally sharp. In a lens the elements bend the rays of light into a single point on the plane of focus.

The prism of the SLR is fitted with one of several types of focusing screen: a central split image surrounded by a refracting ring (above); or the fresnel type with its circular configuration; or the same again but with the addition of a linear grid; or a plain ground glass device.

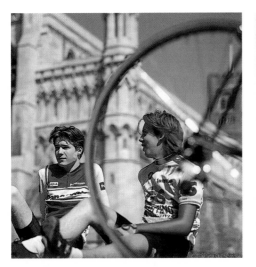

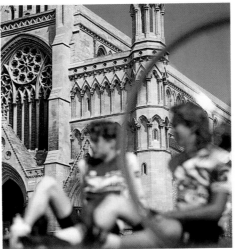

everyday performance of the human eye.

The importance of focusing means that it is vital that photographic lenses can be accurately focused. Judging whether the image is correctly focused is usually achieved in one of two ways, either by the coupled rangefinder or by the ground-glass screen. (A third method is by the numerical distance setting in either feet or metres, engraved on the barrel to facilitate focusing by means of estimating distance to the subject.) These methods will be considered in greater detail later when dealing with aperture control and depth of field (see p. 35). Additionally, there is the bonus of autofocus in present-day photographic applications (see p. 24). The most foolproof method of focusing is by the use of a ground-glass screen and this is the basis for viewing in the large-format studio camera. In this type of camera the apparatus allows for not only critical focusing on the screen but also the observation of the plane of focus once the vertical alignment of the lens is altered. This ability to tilt the axis and verticality of the lens panel enables the emphasis to be shifted from a vertical to an angled or even horizontal plane.

When focusing, the lens should be set at its widest aperture. This is normally achieved automatically on most modern cameras, with the lens being instantly 'stopped down' to the required setting as the shutter is pressed. Focusing at maximum aperture has two functions. First, it allows the maximum amount of light, and hence the brightest image, to pass through the lens. Secondly, it provides the shallowest depth of field and thus the narrowest band of focus to facilitate the critical alignment of definition. When there is a ground-glass screen it is preferable to employ additionally a magnifying viewer, as in the case of the SLR camera with its integral viewing system. In such a system there are additional viewing screens to make easier not only the focusing of the lens but also to indicate the vertical lines or the precise alignment of rectangles. Different viewing screens often suit different types of photography and for this reason the best systems allow the respective viewing screens to be interchanged.

AUTOFOCUS

Many purist photographers find it tempting to dismiss autofocus. It is surely not hard to view and focus a lens with the aid of **microprisms**. But the advent of microchip technology has revolutionized the design and performance of cameras to such an extent that almost all of the leading manufacturers are now offering an autofocus camera as part of their top model range. The reason for this is because the former limitations of camera design no longer apply and the internal circuitry is so rapid and responsive that camera functions can operate not only right up until the moment of exposure but even *during* exposure. Therefore, it is wholly feasible to set the internal metering system so that the fluctuations and variations of exposure during a panned sequence (which may well be to follow the action of, say, a sportsman in motion) can be wholly accommodated by the camera's metering system. It is obviously useful if this same technology can be offered in the service of lens focusing. The critical difference between modern electronic cameras and earlier models is their operational times. In a recent comparative test of the eight leading professional level 35 mm cameras offering autofocus, none of the lenses took as long as 1 second to achieve focus. This is a level of performance that manual focusing could not better. Also, autofocus really comes into its own when operated in very low light levels – the very time when the SLR has always been faulted for its limitations in critical focusing.

How autofocus works

Autofocus SLRs work by means of a phase-matching system. Light coming through the lens of the camera is focused on a mirror just below the main mirror and enters the autofocus (AF) sensor. It passes through an infrared filter and a condenser lens and is divided yet again by two further lenses into two image-forming rays. These are then projected onto a **charge coupled device** (CCD) which has lines of image

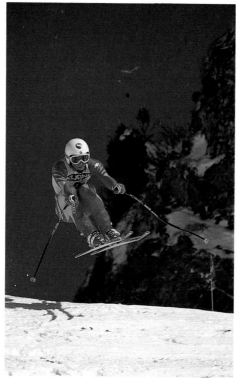

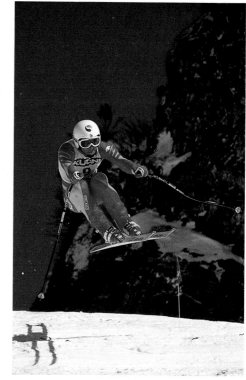

sensors called arrays, which can number as many as 200. For as long as the subject is unsharp the rays fall on different positions, causing a phase difference in the output signals. The camera can translate this information and send corresponding signals to change the extension of the lens's focusing ring. Immediately the two rays fall on the same relative position of the sensors the lens is in focus and the signals cease.

A further consideration is the fact that whereas at one time the use of motordrives and automatic winders meant the addition of bulky peripherals, the miniaturization of modern camera technology has allowed such refinements to be used as standard equipment built into the camera's circuitry. Such sophistication means therefore that new attitudes to the use of autofocus are necessary – to follow-focus, wind on, expose three frames per second, and continually monitor exposure in the process of photographing a moving object coming towards the camera, *without* taking the eye from the viewfinder, is no mean feat, yet it is wholly possible with an autofocus SLR.

This means that an autofocus camera of such specification is unchallenged in certain applications, such as sport and scientific technology. This is particularly so when the camera is used in conjunction with other specialist peripherals like infrared remote control and when cameras are sited in positions that physically prevent the photographer's manual control. This potential is clearly an obvious advantage of the autofocus system but it can be equally useful in another area that may at first appear surprising – portraiture.

Remote control of the camera, coupled to autofocus on the lens, means that the former strictures on continually viewing the image in the camera and adjusting the focus no longer apply. If a motordrive is also at hand then this means that there is no longer the need for continuous checking of the viewfinder image during a portrait sitting. In this way, therefore, it is possible to put the sitter at ease by merely engaging in conversation with him or her as you work, and allowing the camera functions to advance and monitor the images as they are being made.

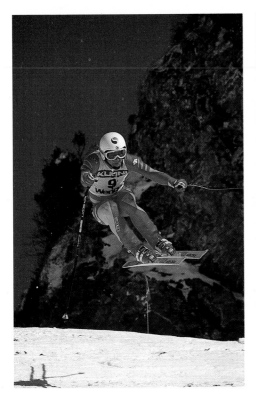

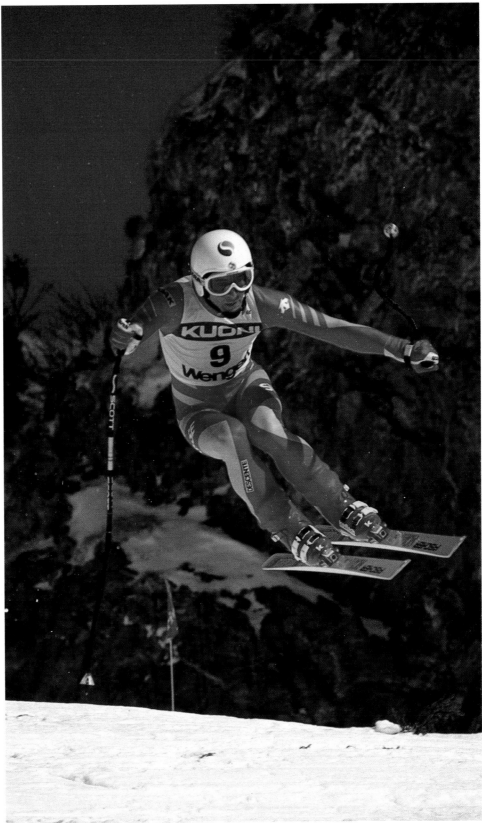

Above and right: This sequence recording a downhill skier would have been quite out of the question a few years ago. The sheer physical speed of the subject, together with the limits of earlier mechanical focal-plane shutters would have ruled out any hope of recording such an action. Autofocus, integral film advance and high-speed focal plane shutters have all helped in the process of catching hitherto impossible images from sporting events.

Modern fast films also play a vital part, allowing correspondingly fast shutter speeds to arrest the action. Colour films in particular have now outstripped their monochrome counterparts. Film speed indices (ISO ratings) of 1000 are now readily available, in reversal colour films, as are focal-plane shutters offering speeds of anything up to 1/4000th sec, and there is a great deal to be gained from exploiting this potential.

CREATIVE FOCUS

Consideration has already been given to selective focus, wherein the intelligent use of the lens allows the photographer to emphasize certain parts of the picture in preference to others, and this can be logically extended into the area of creative focus. In this case, pictures can be made in which normal logic and precedence may be seen in reverse and the attention is directed 'through' the prime subject and on to the background area. This type of experiment is particularly valuable when applied to lenses of longer than normal focal length for, with these objectives, the depth of field gets progressively shallower as the focal length increases.

Similarly, the longer the lens, the greater the potential for extracting small interesting details from the general scene, and lifting out one object against another by virtue of colour, form, shape and pattern. When working with such lenses, it is often useful to allow the mind's eye to 'fill in' some of the details of a soft image with imagination, rather than to express everything as too sharply defined and naturalis-

tic. A great deal of this is as much to do with human perception and psychology as it is to do with photography but is an interesting area to explore.

By the same token, it is worthwhile considering the purely psychological effect of colour, of hue and 'warmth' or 'coolness' on our emotional responses. The playing off of a red, suffused against an expanse of water, slightly cooled by the evening sun, can afford a memorable impression of a particular event at a given time.

At the height of a tense exchange in a sporting event, it is useful to 'shoot through' the attendant paraphernalia of the court or pitch and its surroundings, and concentrate on the singular determination of the player in question; the sinews on the forearm, the perspiration on the brow or the steely fixed stare of the eye. It is from this type of selective view that many great sporting photographs are made.

Of course, the question of emphasis can extend beyond matters of focusing and into the whole question of definition, or lack of it, by other means. 'Panning', for example, is a useful method of creating a sense of movement or distilling one piece of action from its background detail. In

Left: In this photograph the primary image has been deliberately thrown out of focus so that the eye naturally rests on the water in the rear. There is enough information to allow the viewer to presume that there is a figure in the foreground, whereas, had the process been reversed, the background might not have conveyed the quality of water. This type of subjective illustration leaves much more to the imagination and can often be more descriptive than a purely literal approach.

Above: The reverse is true in this photograph of a moment of tension in an important tennis match. There is sufficient information to show that there is a person in the foreground, but the essential drama stems from the expression of anxiety on the face of the player. The message is entirely conveyed in this one gestural image – a point of issue is being made.

this technique, the camera is moved in unison with the principle action and, coupled to a relatively slow shutter speed, enables the subject to be separated from its background; see picture of Carl Lewis on p. 195. This is because the relative differential between the camera and the subject movement, when moving in unison, is reduced, whereas the opposite is true for the background.

Further, this technique can be accentuated a great deal when it is possible to employ a wide-angle lens in close proximity to a very dramatic action – like racing cyclists, or cars, turning at speed past the position of the camera. The dynamic of the action, coupled to the wide-angle properties of the lens, results in the image being 'stretched' across the focal plane.

In matters of landscape, there are other means at the photographer's disposal. Much attention is drawn towards the idea that all landscapes should be critically sharp and in total focus, but it is well to remember that landscapes, by their nature, are organic and living spaces, played on by the elements, which in turn are rarely static. By the same token, there is a tendency only to photograph the land when there is sufficient light for a reasonably short exposure time. It is well therefore to challenge these assumptions by employing a heavy-duty tripod and exposing the landscape under conditions that could well result in exposure times of anything up to one minute in length.

There are other techniques also: for example, if the question of organic influence of the elements is a critical part of the landscape then this feeling of the contrast between static form and moving can be the basis for experimentation with multiple exposures. It is wholly feasible to replace the given shutter speed with four successive exposures at a quarter of the original reading, and build up the exposure by recocking the shutter but not winding the film on. The resultant imagery stems from the contrast of the moving elements (grass, trees, water, etc) against the rocks, buildings, walls, etc, which will not be affected.

Right: In this image, a great deal is left to the imagination and requires little qualification. However, the particular quality of the lens in use has a direct bearing on the nature of the image obtained. The waterway and bridge are softly rendered through the long-distance selectivity of the mirror lens. This lens has also produced the large areas of doughnut-shaped circular suffusion and faint double-images around uprights; this is a feature of the mirror lens, the aperture of which is fixed.

EXPOSURE

Exposure is the single most important technical factor in determining the nature of a photograph. For this reason this introduction to the principles of exposure precedes the two functions of the camera that directly influence exposure: the shutter and the aperture. It follows the question of camera selection because it is the next logical step to getting the best from any camera.

Expressed simply, Exposure = l × t, where l = Intensity, or strength of light, and t = time. Light intensity is normally controlled by adjusting the lens aperture, while exposure time is regulated by changing the camera shutter speed. It follows from the formula that if one factor is halved while the other is doubled then the exposure effectually remains the same. However, the result of altering either the aperture or the shutter speed means that although the amount of light that is reaching the film (and thus the *density* of the negative) remains the same, additional variations are introduced into the photograph (see p. 35).

The importance of exposure stems from the practical need to place the right amount of light on the surface of the film for just enough time to get the best possible negative. Failure to do so means that the film simply does not perform as well as it should in reproducing the subject's tonal values. This is because all films have a limited ability to render the tonal range from darkest black to absolute white. The function of exposure, therefore, is to 'place' the negative between the two extremes. If this is achieved then it allows the film to give of its best in matters of tonal scale, definition and density. (The development of the negative is also vitally important, but the first step in the direction of the final print or transparency is accurate exposure.)

With black and white film, underexposure gives negatives in which the shadow area is almost clear film, with little light reaching its surface. Therefore there is

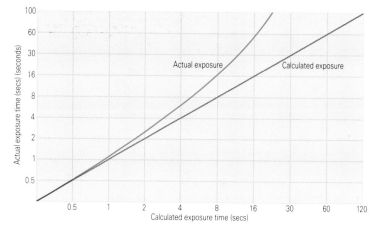

Left: The graph shows how the relationship between the actual and the calculated exposure alters when the times become lengthy. The film does not build up the same amount of density as would be expected and additional exposure has to be given so that it will catch up. Different films have different reciprocity characteristics and, with colour film, the colour itself can also vary, because the three layers of film behave differently.

'nothing to work from' when it comes to printing. Overexposure, on the other hand, tends to flatten the tonal range of the black and white negative as the increase of the light builds up the highlight (or dense) areas of the film. But the exposure latitude of present-day films makes it possible to obtain more serviceable results from this type of error. As a rule of thumb, therefore, slightly denser negatives are preferable to 'thin' ones, assuming of course that development remains standard.

In **colour reversal** (transparency) films the opposite is true, but for the same reason – overexposure in reversal systems renders the transparency 'thin' in appearance and desaturates the tonal and chromatic scales and, once lost, it is not possible to retrieve it. But if the transparency errs slightly towards underexposure then overall detail remains and this can be compensated for in reproduction by stronger light.

However, it is often true that the academically correct exposure is not necessarily the one the photographer ultimately prefers. For this reason many professional photographers prefer to 'bracket' their exposures. In other words, once the 'correct' exposure has been made, two others are also included, perhaps a half stop down, followed by a half stop up, on the aperture settings. This is such a useful technique when exposure is critical that some top-of-the-range cameras actually build a bracketing function into their exposure controls. However, as a general rule that applies to

both positive and negative films, you should control the exposure in such a way that there is 'detail in the shadows' – sufficient detail in the shadows will probably hold in detail in the highlights too.

An additional by-product of overexposure, apart from increased density and a closing of the tonal range, is increased grain structure in the negative. It may still be possible to obtain acceptable results from dense negatives, but a very dense negative will inevitably lead to prints which are grainier and less sharp than normal, particularly if the prints concerned are enlargements. All these factors, of course, assume that development is standard. It is possible to overcome many exposure problems in the darkroom (see p. 82), but with a little foresight they can often be avoided at the picture-taking stage. What is more, setting exposure so that a particular result is produced is in itself a legitimate expressive technique.

The position with colour reversal films is different. While it is wholly feasible to adjust development times to a certain degree to compensate for minor errors in exposure (and many professional colour laboratories offer this service), it still holds true that this is not the best way to work with transparencies. Colour reversal material has much less latitude in exposure terms than monochrome negative materials and, save for special effects, there is little or no room for overexposure at all with reversal films. Similarly, the adjustment of development to compensate errors

Right: Exposure has a significant influence on the rendering of colour and the tonal range within the photograph. Even experienced professionals employ a bracketing procedure on the basic exposure offered by the meter. After all, the speed index and the subsequent exposure are only based on sensitometry; they tell little or nothing about subjectivity.
In this still life, the difference between the respective pictures is around 1½ stops. All three images have their own particular qualities. In the 'normal' one (centre) (as indicated by the exposure meter) the details on the small postcards are discernible. In the over-exposed image (top) these details are reduced to the point where the writing disappears. The colour on the fruit and drink is not unpleasant, although somewhat bleached. The dark binoculars are now separated from the tablecloth. In the under-exposed image (bottom), a quite different picture emerges, with the highlight on the fruit bowl becoming a dominant factor. The richness of the fruit and the tonal separation are lost though. The exposures were made by daylight on 400 ISO/ASA film.

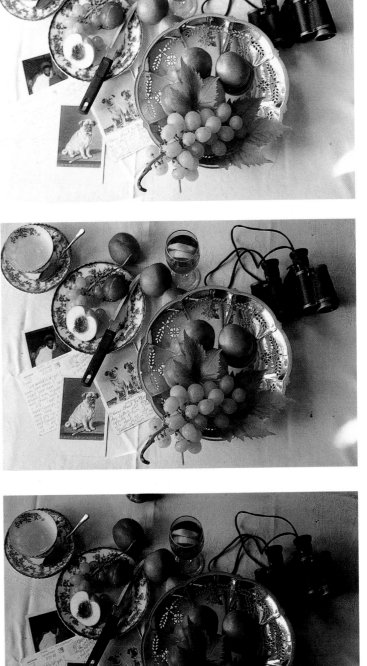

of exposure brings new problems of colour balance and shift, together with a lessening of the tonal range in the darker areas of the picture. It is a fact that colour negative materials have greater latitude than their reversal counterparts.

So the accurate use of exposure in all photographic processes is essential, and this applies as equally to the darkroom as it does to the camera. A good, well-exposed negative is the best possible basis for the highest quality print, purely in terms of tonal range alone. Other subjective considerations like contrast, grain, softness, and suffusion are a different matter and are much more to do with personal taste and preferences than with obtaining the best results from the materials available. Again, these expressive techniques will be dealt with in greater detail later (see p. 81).

It is tempting to assume that the all-important equation of Intensity × Time holds true for every photograph but unfortunately this is not so, particularly when working with colour reversal materials. Problems arise when the length of the exposure time begins to exceed 10 seconds, due either to an abnormally small aperture, or low-light conditions, or a combination of both, and continues to increase the longer the amount of time involved. This is because the three coatings of the colour film perform in unison when exposed for times of less than ten seconds. When exposed for times in excess of ten seconds they begin to respond differently and this, in turn, has a marked effect on the colour balance of the results. This is known as **reciprocity failure** and it is a serious factor to contend with when light levels are low.

It is surprising however that, of all aspects of photographic practice that are conditioned by personal preference, exposure technique should rank high on the list. A scientific photographer would argue that this is not true – a negative is either correctly exposed and developed or it is not. In more subjective areas of photography, however, questions of exposure, development and printing are all linked closely to the creative process.

THE SHUTTER

As well as controlling the exposure time, the shutter offers the photographer additional creative potential that is at the heart of picture-making. It is for this reason alone that even the most sophisticated cameras offer either shutter priority or aperture priority as a basic choice for any form of automatic setting on the metering system.

The shutter has an additional function over and above the obvious one of controlling light – it can also be used to control the degree of motion in the photograph. It can freeze subject movement or record its progress as blur, help to differentiate between static and mobile and allow the camera to 'move with the subject' by panning in unison with it and thus separate the subject from its background.

Many types of shutter have been employed since the advent of photography, some in front of the lens, some with pneumatic releases for silence, and some with a simple dropgate arrangement. A popular early design was the sector shutter, a moving blade with a circular hole in it that briefly passed behind the lens as in the Box Brownie type of hand camera. However, the two shutter systems dealt with here are the **diaphragm shutter** and the **focal plane shutter**. These are the two most commonly used shutters in photography today. Both systems have their advantages and disadvantages and particular characteristics that make them more suitable for some work and quite unsuitable for others.

In the diaphragm shutter, the opening device consists of interleaving segments of metal which are usually mounted between the elements of the lens itself and which open from the centre outwards. To facilitate this action, the shutters are designed so that they open and close as rapidly as possible, to maintain a high level of efficiency. Their position within the lens itself ensures that they have no detrimental influence on the image arriving at the film plane. This mechanism had been the mainstay of camera design for the greater part of the first half of this century but lost favour with the development of the SLR because it did not allow you to view through the lens itself while focusing (the shutter is built into the lens and remains closed until the moment of exposure). In SLR cameras with a diaphragm shutter (the Hasselblad, for example), the problem is solved in a somewhat complex manner by allowing the shutter to remain open up until the moment of exposure, before it closes and then opens for the brief *actual* exposure time, before closing again. The camera, when re-cocked, re-opens the shutter once more. The reason camera designers went to such lengths to use this type of shutter in an SLR was that it has one important advantage over the alternative focal-plane type. It will allow **flash synchronization** with all speeds up to and including 1/500th sec.

Focal plane shutter

With the focal plane shutter the principle is entirely different. It depends on a laterally travelling blind or curtain in which a variable-sized slit moves across the rear of the camera body, just in front of the film itself – hence the name. The shutter varies the exposure by the adjustment of both the width of the slot and the speed of the curtain across the focal plane. On the completion of the exposure and during recocking, the shutter has a self-capping action. This means that the film remains protected from the light not only during this process but also when the lens itself is removed. For this reason alone, the focal plane shutter is the type that is most commonly used in cameras with interchangeable lens systems.

However, the principle of the travelling slot across the focal plane has one major and undeniable limitation: unlike the dia-

Right: This diagram shows the progressive opening and closing action of a typical diaphragm shutter. No matter what shutter speed is in use, there is always one moment at which the diaphragm is fully open; this is when the flash is synchronized.

phragm shutter, in which all shutter speeds allow for total opening of the shutter blades at one point during exposure, only the slower speeds from 1/30th or 1/60th sec downwards allow this to happen with the focal plane system. It is therefore often difficult to use a focal plane system with electronic flash. This is a particular problem with specialist applications like synchrosunlight. A typical duration of electronic flash could be between

1/500th and 1/5000th sec and this would in effect arrest the action of the shutter curtain during its transit and allow only a small section of the photograph to be properly exposed.

On the other hand, the concept of the travelling slot more readily allows for faster transit speeds and thus higher actual shutter speeds. With mechanical focal plane shutters, speeds of 1/1000th sec are common. As far as the diaphragm shutter

is concerned, its opening and closing action, effectually moving one way, stopping and then reversing the process, means that 1/500th sec is the fastest speed available. Yet it remains quieter in operation compared with the focal plane alternative with its characteristic 'clonk'. This factor above all deters many photographers from using focal plane shutters under circumstances where noise is an intrusion. Also, there is a particular and unique form of

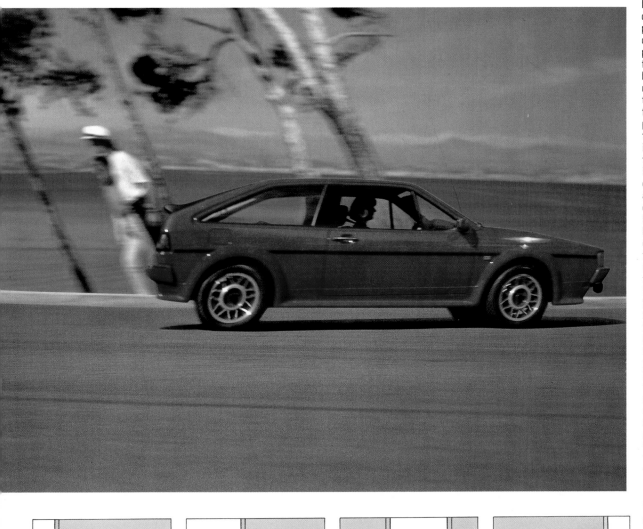

Left: A curious characteristic of the focal plane shutter is that, under certain circumstances, it produces a very particular form of distortion that can be expressive in its own right. In this photograph the car is travelling at a fairly high speed and the photographer is countering this by moving the camera in unison with the car so that it remains stationary in relationship to the camera – this is referred to as panning. In this way the car will almost certainly have a better chance of being sharp, while the blur of the landscape will further enhance the feeling of movement. It is obvious that the camera employed in this photograph has a focal plane shutter for, as the camera moved across to follow the car, the shutter blind travelled in a vertical direction. This means that, as the camera is panned, the upright trees are progressively exposed in slightly differing positions as the shutter transit takes place, and this gives a curious feeling that they are, in fact, bending backwards in the slipstream.

Left: The focal plane shutter is less easy to synchronize with flash at high shutter speeds, because the blind is never fully open and, instead, operates as a thin travelling slot across the film. Only one narrow section is exposed at a time.

image distortion that can be associated with the use of the focal plane shutter. This occurs when there is a pronounced lateral movement in a subject that is travelling in the opposite direction to the shutter itself. It is particularly noticeable when the camera is held in a vertical position to photograph a subject moving quickly across the front of the camera in either direction: the shutter travels top to bottom, or vice versa, and exposes parts of the subject, sections at a time, while it crosses the field of view. Due to this, the fast-moving subject is in differing places during the actual transit of the exposure and thus the image adopts a sloping distortion in the process.

Shutter speeds

In both systems the layout of the shutter speeds is the same and, working from a full second, the progression is: 1, 1/2, 1/4, 1/8, 1/15, 1/30, 1/60, 1/125, 1/250, 1/500 etc, which is usually expressed on the camera as 1, 2, 4, 8, 15, 30, 60, 125, 250, 500 to allow room for the engraving on the lens housing. With speeds that are actual settings, as opposed to reciprocals, the difference is denoted by a change of colour on the engraved numerals. Three further settings are included on shutter controls and these allow for long exposures and time delays. They are T, B, and V. The T is for *time* and allows the shutter to be opened by cable release and left open – to close it again the shutter release must be pressed again; B is for *bulb* and is to allow the shutter to open when the release is pressed and closed when the pressure is removed; the V (less commonly used now) was for a time delay to allow a period to elapse before the shutter is activated. Additionally, a further symbol is used for electronic flash photography. A small stylized lightning flash is engraved against a shutter speed setting, usually at the 60 mark or between 60 and 125 – this is the speed above which it is not possible to work with flash without encountering the problems described above.

With modern electromagnetic shutter circuitry even faster speeds are possible.

Settings of up to 1/4000th sec can be built into the camera as standard, and additionally the shutters allow for stepless (and thus more accurate) speeds to be set automatically by the camera to match the aperture selected on the lens. At the other end of the scale it is wholly feasible to use automatic settings for any time up to 30 seconds. The circuit board of the microelectronic component is literally wrapped around the inner shell of the camera's body and allows for an extremely complex series of operations to take place within the housing, while relaying this information to the photographer by way of a display in the viewfinder eyepiece.

Gone are the days when the shutter relied solely on the operation of springs and manual articulation for its sequencing and the introduction of flexible printed circuits and microelectronics to a focal plane mechanism gives far greater scope to

designers working on larger format SLRs. This is one reason why 6 × 7 cameras using roll film to give 10 exposures on 120 film are now able successfully to challenge the erstwhile supremacy of the studio sheet film camera on the one hand and retain a convenience and portability that is rapidly approaching the 35 mm miniature on the other.

Further, modern shutters are not only infinitely more accurate than their early mechanical counterparts but the rapid transit of the focal plane blinds are now able to accommodate flash synchronization at speeds far faster than the old barrier of 1/60th sec. The greater efficiency of the electromagnetic systems means that the shutter relies less on the size of the travelling slot and more on the rapid opening and closing of the shutter curtains and is a major advantage over the older systems in terms of timing and control.

Right: Hitherto unknown performance characteristics, especially in colour films, are now commonplace. High film speed allows the full utilization of the shutter's potential and for this reason complex lighting arrangements and multiple flash applications are less necessary than before. In this exhilarating photograph the audience is quite well defined in the background.

Below left: The creative use of shutter speed is a vital tool in expressive photography and this can involve not only high speed to 'freeze' the action but also slow speeds to afford a continuum of the action. In this photograph, the traffic has moved throughout the exposure and left a trace on the film.

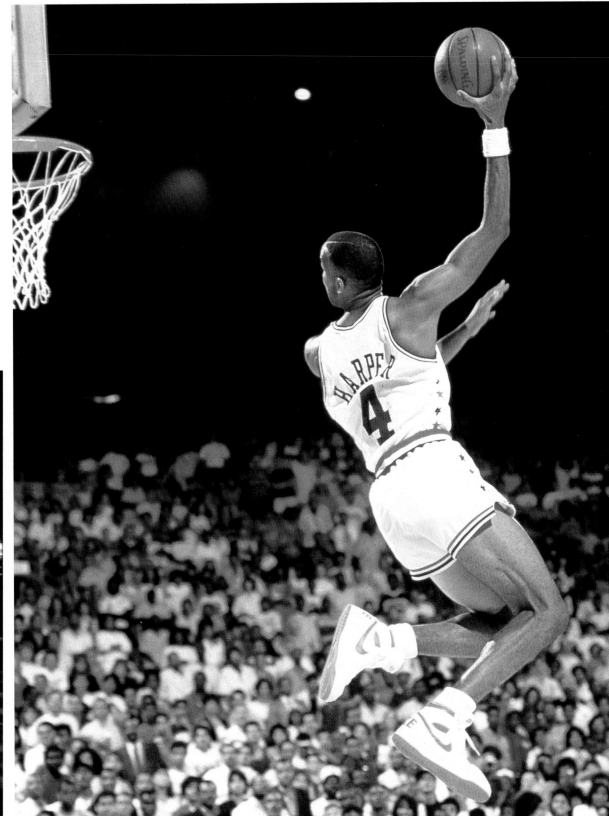

THE APERTURE

The second function that completes the equation of $E = I \times T$ (where $E = $ Exposure, $I = $ Intensity and $T = $ Time) is that of the aperture which acts as a controller of light passing through the lens. It is, to all intents and purposes, the mechanical equivalent of the iris in the human eye and serves precisely the same purpose – to enable the light to be monitored to its optimum requirement. This mechanism, together with the shutter, gives you dual control over the exposure of the film. This interchange between these two controls is at the heart of the decisions that creative picture-making demands. For the time being however, it is best to look solely at the way the aperture works and how it is universally calibrated throughout the lens range.

If you decide not to control the light reaching the film by altering the shutter speed, due, say, to a fundamental need to control subject movement, then the aperture offers a second alternative. Unlike the shutter, the aperture is not a complex mechanism and it carries out a relatively simple function within the lens, although on SLRs its 'stopping down' to its preselected setting is automatically done just prior to the opening of the shutter mechanism. This expression 'stopping down' stems directly from the system of calibration employed in all lenses. The aperture is calibrated in 'f-stops'. The resulting scale of 'f-numbers' provides the common language and reference not only for specific openings and settings of the aperture, but also the standard benchmark for the maximum light transmission potential of any given lens. This allows lenses to be classified by their maximum aperture (see p. 42).

F-stops are calibrated to precisely the same degree of adjustment as the settings on the shutter dial and for precisely the same reason – they enable the photographer, by changing one full stop, to either halve or double the amount of light that is transmitted to the film. Thus the expression to 'stop down' means to close the iris progressively, while to 'stop up' means the reverse. The numbers on the iris setting (2.8, 4, 5.6, 8, 11, 16 etc), are not normally used in practice for anything other than appropriate setting marks (although, if pressed, scientific calculations and measurements could rightly be made from the information displayed), but it is a fact that a particular setting will transmit precisely the same amount of light to the film no matter which lens is employed. This applies equally to the calibrations of both camera and enlarger lenses. Furthermore, the intermediate settings between f-stops are referred to as halfstops and expressions like 'halfstop under' or 'halfstop over' are used to refer to a setting that is either slightly smaller or slightly larger than that recommended by the metering system.

The most important point about the f-number scale is the simple rule of thumb that governs these numbers or settings: the

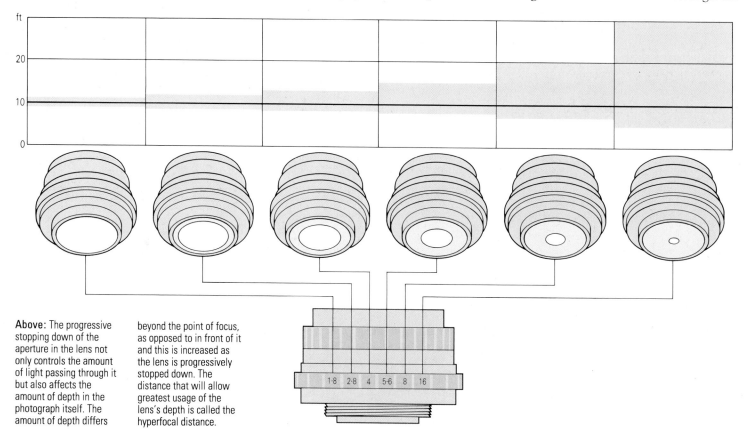

Above: The progressive stopping down of the aperture in the lens not only controls the amount of light passing through it but also affects the amount of depth in the photograph itself. The amount of depth differs beyond the point of focus, as opposed to in front of it and this is increased as the lens is progressively stopped down. The distance that will allow greatest usage of the lens's depth is called the hyperfocal distance.

higher the number the smaller the aperture or stop, so that the lowest number represents the widest aperture setting on the lens. This therefore provides a convenient benchmark for the selection of lenses. If you need a lens that will allow the maximum amount of light to pass to the film, for example if you are working in poor light or you need to use a fast shutter speed, then a 'fast lens' (such as one with a large maximum aperture like f2.8) is ideal.

Aperture and depth of field

However, the influence of the aperture does not rest solely with the control of light transmission through the lens. Like the shutter, it has another role to play. As you stop down the lens progressively, not only does the light transmission diminish, but there is a pronounced effect on the depth of focus of the image. The stopping down of the lens increases the sharpness of objects both in front of and behind the position of focus. This phenomenon is common to all lenses and is known as **depth of field**. It is an associated function of the iris diaphragm and is important to the proper use of the lens when you are organizing the depth, emphasis and selection of an image before making an exposure. Therefore, a depth of field scale is usually engraved on the lens close to the figures for the respective aperture and distance settings. The depth of field scale consists of f-numbers arranged in pairs to the left and right of a central marker or dot. The scale is placed next to the lens focusing scale, which shows distances in feet and metres. You can therefore read the range of distances that will be in focus at a particular aperture setting.

An associated phenomenon which is often misunderstood is that of **hyperfocal distance**. To understand this one has only to refer back to the distance/aperture settings on the lens and realize that, if the lens is set at infinity, then the process of stopping down will increase the depth in front of and beyond the position of focus. However, infinity is an absolute and cannot be extended, and therefore any increase beyond this focused setting is in

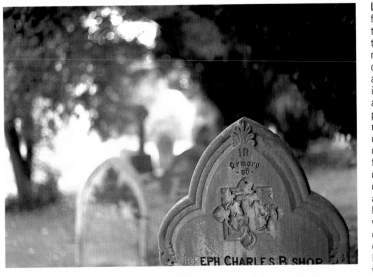

Left: Quite apart from its function in the control of the light passing through the lens, the aperture makes a unique contribution to selection and emphasis within the image itself. In the accompanying photographs the exposure remains the same, as a direct result of the product of aperture and shutter, for, as the lens is closed down the shutter has correspondingly been adjusted in compensation. However, the emphasis within each frame is different. In the first example (top) the picture has been exposed at the widest setting on the diaphragm, so the depth of field is very shallow and the eye naturally rests on the foreground object.

In the second frame, the exposure is made at the halfway position of the aperture and this brings more detail into focus and thus extends the degree of information that the picture offers. The trees at the rear of the photograph, however, remain comparatively soft.

In the third frame, the lens has been wholly stopped down and is operating at its minimum opening, with the effect that much more information has been brought into focus and there is greater clarity across the whole picture area. This greater detail throughout serves to deselect the foreground detail and set it in a broader context.

fact meaningless. Therefore, it is useful to bring the focus setting back to a point in advance of infinity, say 15 ft, and then stop down. This will then have the effect of maximizing the amount of depth of focus in the photograph by increasing the depth to a position nearer the camera on one hand, while extending it back out to infinity on the other. Nothing is lost and greater depth is achieved. This calculated position, relative to the aperture in use, is known as the hyperfocal distance. Another way to achieve this is to use the lens scales by setting infinity against the stop that you are about to use on the depth of field scale.

This is particularly useful when '**zone focusing**', even when using a reflex camera with its through-the-lens viewing system. Zone focusing entails using the distance setting scales on the lens in conjunction with the intended aperture setting. For

intimate work such as interiors or portraiture it is sometimes irritating and intrusive if the photographer is continually peering through the lens. Better far, once you have set the camera on the tripod, to use estimated subject distance and zone of depth by utilizing the aperture and distance settings, and merely allow the camera's internal metering system to deal with the question of exposure.

Using the aperture intelligently in conjunction with the shutter is vitally important when you are taking decisions at the preparatory stage and in seeking the appropriate result you had intended in the photograph. If speed is not the priority then how much depth do you need? If you want to isolate one element of the subject, with shallow depth, then what f-stop will achieve this? If the lens is fully stopped down then what will be sharp, and will the use of hyperfocal distance, rather than actual focusing distance, help in any way? These are the kinds of questions that you should be asking yourself when you select your required lens aperture setting.

No control on the camera acts in isolation. Not only does the relationship between aperture and shutter have a bearing on photographic content but so do focal length and depth. This relationship will be dealt with at greater length in the section on lenses, their properties and potential (see p. 42). Before leaving the question of camera design, layout, and application and moving on to that of visual language and the translation of ideas into photographic practice, consideration will be given to the final link in the chain of camera controls – that of exposure, its measurement and usage.

However, just as it is often useful to consider more than one way of exposing any given scene, it is often advisable to use differential focus deliberately and take more than one version of any scene. Ultimately, the question of focus, selection and emphasis is one that must rest with the photographer – it is not enough to rely on the camera alone. Automatic focus can be very useful, without question, but do not allow it to dominate.

Opposite top: The eye naturally assumes emphasis on the sharpest part of the picture, but it is well to examine the rear of the photograph too.

Opposite bottom: Selective focus can add an element of humour to a picture, picking out small details from an overall crowded scene.

Above: The great asset of the long lens and soft focus is that one is often able to design purely in terms of colour. This is a source of continuing inspiration and pleasure. An additional quality of the longer lens is that it 'draws up' background perspective and flattens the overall effect of depth.

MEASURING EXPOSURE

The way in which you set the aperture and shutter will be influenced directly by whatever system of measuring light that you use – either within the camera or without. There are three different external systems of exposure measurement that are applicable to all camera types: **reflected measurement**, **incident light measurement**, and the **spot reading**. These principles of measurement apply equally to flash metering and a clear understanding of these methods is vital for the proper use of the highly sophisticated metering methods currently offered by the latest generation of SLR designs.

One of the most difficult aspects of 'correct' exposure in non-scientific photography is the reality that often the correctly exposed photograph (according to the meter) simply does not offer the same emotional and subjective response in the final image as it did at the time of taking. Much of what we experience visually is concerned with our subjective response to a scene – something that a mechanical device cannot reproduce automatically. This problem is particularly relevant to exposure – a darkening sky, a white wall, a black cat against coal – these present few problems for the human eye, but represent difficult encounters for most metering systems. Manual adjustment of the camera controls is often necessary, so it is useful to examine external metering first, even though most automatic SLRs would appear to make this unnecessary.

Any meter – on-camera or external – must be calibrated to the speed of the film that you have selected and this will be expressed as either a **DIN**, **ASA**, or, more recently, **ISO** rating. You should set this in the appropriate window on the meter. A recent innovation for electronic cameras has been the **DX** rating system: the cassette bears a printed bar-code that the camera can read; it can thus set the meter to that particular film. This is useful for

Right: In the three examples of alternative methods of exposure evaluation shown here the conditions have remained the same. Only the monitoring of the light and its interpretation have changed. In the first example, a spot reading has been taken from the face, ignoring the water and sunlight. In the second, the meter has averaged between the face and the water. In the third, the reading has been taken as a highlight of the sun's influence.

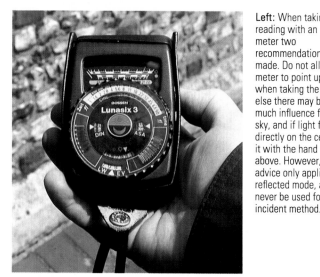

Left: When taking a direct reading with an exernal meter two recommendations can be made. Do not allow the meter to point upwards when taking the reading or else there may be too much influence from the sky, and if light falls directly on the cell, shade it with the hand from above. However, this advice only applies to the reflected mode, and should never be used for the incident method.

colour but is inadequate for black and white photography as it effectually robs you of the ability to adjust the ASA or ISO rating intentionally to suit your method of development at the darkroom stage (see p. 84), so it is important to ensure that any camera with this device also incorporates a manual override facility.

Metering methods

In reflected readings, the exposure meter is pointed directly at the subject in view and measures the light *reflected from it*. This

can often cause confusion, because of the local colour of the object or the direction of light, especially if the light is coming towards the camera. It is particularly important to shade the sensitive cell from direct sunlight and also to avoid aiming the meter so as to include too much sky within the reading. As a useful guide, a reading from the back of the hand is a good starting point.

The incident method involves an approach that takes no account of the subject but, instead, measures the *light falling on to*

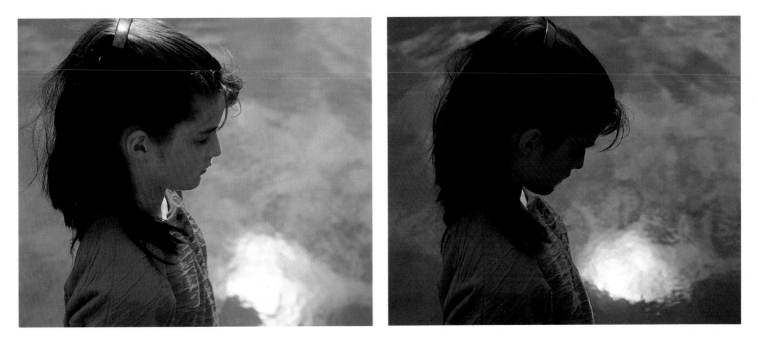

the subject. To achieve this, a small domed diffuser is placed over the light cell's window and the reading is taken towards the camera, taking care not to shade the cell from the prevailing light. In subjects of extreme contrast, it is useful to take readings from both types of illumination within the frame, highlight and shadow, and compromise between the two.

Thirdly, there is the spot reading method, which employs a meter that incorporates a very selective and highly accurate lens and cell assembly. It uses the reflected method to read the light, but has a very narrow angle of acceptance. You can therefore aim it at particular points of the subject, taking individual readings for different parts of the scene. A spot meter thus allows for very careful working methods.

Although some photographers feel that, with the increasing sophistication of integral camera metering systems, the days of external meters are numbered, this is not so – they have simply got better. At the very top of the range you can expect facilities like digital read-outs, accuracy to within one third of a stop, and an ability to aggregate and average readings from more than one position. Then there are models that offer dual incident and reflected readings for both flash and ambient daylight,

for flash alone, for spot readings, and for **colour temperature** readings.

Camera meters

The alternative to the separate external meter is, of course, one that is greatly favoured in present-day camera design – the integral metering system within the camera itself. Its convenience is obvious, but nevertheless its limitations are often confusing and frustrating unless it is supported by knowledge of application. Like the camera itself, no system is perfect and using an integral meter effectively depends greatly on selective judgement and experience. Subject failure (such as the infamous black cat in the coalhouse, or the meringue on the white tablecloth) can thwart the most advanced system and earlier types of SLR meters differed greatly in the emphasis they gave to the metered area within the viewing screen, being either averaged, centre weighted, top weighted, spot, or off the film plane (OTF).

Current microelectronic circuitry, however, has largely replaced the former limitations to such an extent that the photographer is almost spoilt for choice. In previous pages, the respective roles of the shutter and aperture have been discussed, showing how they can not only be used in

tandem with each other but have additional influence on other aspects of the photograph, for example in matters of arresting movement, depth of field or selective focus. It is therefore no longer enough merely to obtain the correct exposure – just as important is the correct selection of metering options available. To this end, manufacturers have evolved the following demarcations to indicate the relationship between the meter reading and the way the camera controls the exposure: 1 aperture-priority, automatic exposure, 2 shutter-priority, automatic exposure, 3 metered manual, 4 program normal, 5 program action, 6 program depth, 7 spot + highlight, shadow, and 8 TTL auto flash. The basis of program systems is to simplify the bewildering range of possibilities down to fundamental priorities that the photographer can readily grasp at a moment's notice. This provides one more step towards the concept of 'Auto Point And Shoot' photography. Nevertheless, however useful, it is a seductive tool that does not rule out the need for a good grasp of the fundamentals involved if you are to enjoy to the full the more creative aspects of picture-making; it is self-defeating to rely too heavily upon the concept of automation instead.

EXPOSURE PROBLEMS

The question of appropriate and suitable exposure evaluation is particularly vexed in the context of subject anomaly; ie when the general exposure content of the picture extends above and beyond an 'average' reading. Experience has a great part to play in overcoming these difficulties. To be sure, all good modern cameras acknowledge this problem and build into the film speed setting control additional compensating functions that range from +2 to −2 stops in third- or half-stop increments. Yet this measure still does not fully solve the problem because often the best solution is entirely the product of subjective choice.

A potential photograph can be said to have subject anomaly when it no longer responds to the normal range of tonal values, and this can be purely the product of local colour. A white wall in powerful sunlight is very difficult to expose, whereas precisely the same wall, painted in a colour less bright, would not pose the same problem. The main point of interest of the photograph may be set against a very dark or very light field of surrounding colour. Alternatively, the main point of interest may suffer from the influence of associated light filtering from an exceptionally bright source within the frame.

Under such conditions, it is advisable to expose some extra frames of film at different settings to compensate for this. The extra cost involved will be more than repaid if the photograph is ultimately successful. Film is usually the cheapest item in the photographic process, especially when you consider how much it can cost to get to a particular location. Do not try to economize on film, but accept that controlled experimentation is ultimately experience gained, and that there is no substitute for this. It is not possible to give definitive answers to such questions when they stem from essentially subjective responses and certainly they are not likely to come from reading an exposure meter.

Above: The charm of this photograph stems from the subtle colours within the wall behind the figure. Too much exposure would render the wall white and the figure would be lost, too little and the wall would drop back to grey and the delicate colours would lose their character. There are two solutions to this problem: either use the external meter in incident mode (measuring light, as opposed to subject) or a calculation made from respective spot readings on the figure, the wall and the shutter.

Left: It is a challenge to measure the exposure accurately when the light is almost directly at the rear of the subject. Looking into the light is likely to render the landscape too dark, if the clouds alone are exposed for. Too much exposure on the land will 'bleach' the sky and it is wise to bracket exposures accordingly. For a dramatic sky it is best to use a highlight reading.

Below: Subtle metering can have a distinct bearing on the ultimate photograph, as here. It may be tempting to give a slightly 'fuller' exposure so that the room is effectively lightened, but it is important that the landscape detail is not lost. Exposing only for the landscape would render the room darker and rob the photograph of some of its telling details. As it is, both ends of the exposure have been held in check.

Left: Careful evaluation of exposure is critical to this photograph of a flamingo, for otherwise the dark surrounding field (which is wholly unimportant) will fool the meter into giving the bird's plumage too high a reading. This would render the background grey, and bleach out the delicate nuances of colour in the feathers – which, after all, are the whole point of the photograph. A spot reading would help, but remember that the bird is almost white and it may well be best to angle the reading slightly off the full white of the highlight and allow a small cumulative influence from the background also.

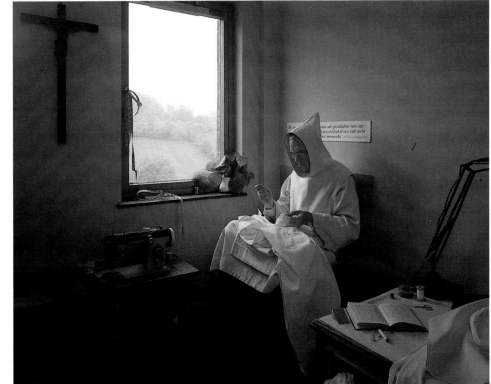

THE LENS

The lens is the eye of the camera. As such it has the greatest bearing on the formation of the image and, consequently, on the photograph. However, its influence extends into the whole area of pictorial representation – depth of field, angle of view, perspective, definition, and picture content. Lenses are classified by type – **normal** or **standard**, **wide-angle**, **telephoto**, and long-focus, together with extreme variations at either end of the respective groups for specialized applications. A wide-angle lens has a wider angle of view and a shorter focal length than a telephoto or long-focus. The expression 'normal' is used for a lens on which the basic cone of vision or angle of acceptance closely approximates that of the human eye in general use, about 50°. For a 35 mm camera the normal, or standard, lens would have been 50 mm but there has

recently been a movement towards slightly wider lenses as standards, particularly on compact models. Many of these cameras, which lack the constraints of instant return mirrors and pentaprisms, have been designed around non-interchangeable standard lenses of 40 or 35 mm, offering greater depth of field, coupled to a wider angle of view. The standard for the 120 roll-film square format is 80 mm, while that for the 6 × 7 cm is 100 mm. The nomenclature engraved on the lens barrel or mount provides a direct indication of its performance: 1:1.9/50 means that the widest aperture is f1.9 and the focal length is 50 mm. The focal length of the lens determines many factors: image size, angle of view, and its effect on perspective. Turning to the top of the lens offers further information in the form of distance and aperture settings, focusing ring and, in the case of **zoom lenses**, zooming ring, offering variable focal length.

The advent of computer technology in

lens design and manufacture has had one important effect for the photographer. More than anything else it has made possible the manufacture of progressively smaller lenses coupled to an even higher degree of correction within its design. A sliced cross-section through a modern compound lens would reveal a surprisingly complex structure with as many as 6 elements in groups of 4 in a lens of f1.8 maximum aperture. Increasing the light transmission to, say, f1.2 would involve the introduction of more elements (7 or 8 in groups of 6) and, as the focal length becomes shorter, the optical problems increase. A 21 mm f2 lens, with an angle of acceptance of 92°, would require as many as 11 elements in 9 groups.

These problems derive from the basic function of the glass lens elements in bending the light to offer a correctly focused image on the film plane. As the light transmission increases, so do the problems of correction. As a further aid to

Left: A standard lens is used to photograph a subject or scene as it appears to the human eye. Such is the lens's resolving power and its minimal distortion that it is suitable for subjects as diverse as portraiture and architecture.

proper correction of the wavelengths of light, the lens elements are coated on both sides to minimize a phenomenon known as **chromatic aberration** (a problem that can cause fringing around white objects). Nevertheless, the problem of correction at full aperture and across the focusing range is a complex one that has been greatly assisted by the introduction of computer-derived solutions to optical problems. In some more complex lens formularities, in fact, the problem is solved by introducing a 'floating' element that shifts slightly differently to the other groups during the focusing range, to minimize the loss of image resolution. It is popularly felt that, whereas the lens resolution is lowest at full aperture, progressive stopping down of the diaphragm will offer a corresponding increase in definition over the entire range of aperture settings. In fact, most standard lenses offer their highest resolution around about f6.3–f8: further stopping down increases depth of field but not resolution.

Most cameras are sold with a standard lens. In choosing a 'family' or set of lenses to complement the standard, you should remember that each focal length is particularly suited for one series of problems in preference to others. This is not, of course, a watertight ruling but it is certainly true to say that in portraiture, for example, a medium-telephoto lens of around 75 to 100 mm is ideal, because it allows you to 'stand off' from the subject (thus minimizing possible inhibitions, or embarrassment), while still allowing close-up detail. The first consideration in lens selection is that of angle of view – the longer the focal length the narrower the angle of view and vice versa; then there is the effect of perspective, which refers to the interrelationships of objects in space, distance and proportion; finally, there is the question of depth of field.

The interrelationship between angle of view and perspective is complex. The best way to explore it is to make a comparative evaluation. Move the position of the camera in relation to the subject while you change lenses to maintain the same scale on the principal subject throughout. Look

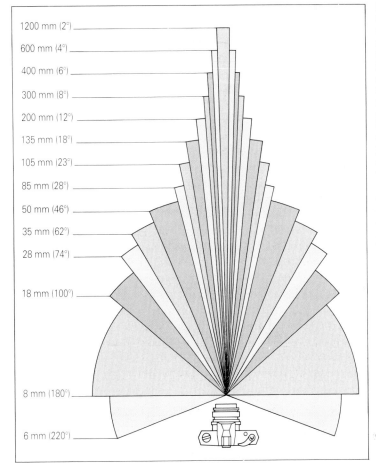

1200 mm (2°)
600 mm (4°)
400 mm (6°)
300 mm (8°)
200 mm (12°)
135 mm (18°)
105 mm (23°)
85 mm (28°)
50 mm (46°)
35 mm (62°)
28 mm (74°)
18 mm (100°)
8 mm (180°)
6 mm (220°)

Left: The diagram shows the respective angles of view that each lens can offer within the typical SLR family of lenses. The individual lenses not only differ in angles of view but also in the ways they depict perspective and relative scale. The 8 mm lens represents a view that would take in the entire horizon, while the 6 mm extends backwards across the field of vision. These lenses usually have a circular field of view and a high level of linear distortion. The 18 mm combines ultra-wide angle with conventional non-distorted uprights, and the 24 mm and 28 mm are the usual wide-angle lenses for general use. The 35 mm is the typical standard lens for the compact, and is increasingly popular as a standard SLR lens in lieu of the 50 mm lens. 85 mm to 105 mm are ideal for portraits; the 135 mm begins the telephoto range.

carefully at what this does to the scale and importance of the background. Perspective is the result of the camera-to-subject distance and the camera's viewpoint, and not the focal length of the lens. A secondary perspective change can be affected by using a high or low vantage point in conjunction with a short focal-length lens as these lenses have a greater angle of view than the eye and 'stretch' the ground plane when used off the vertical plane.

In addition to controlling image size and perspective, the focal length of any lens has an important influence on the extent and depth of sharpness within the photograph. The best way to see this is to compare the effect of using a 28 mm lens to record a subject from a relatively close distance to another representation of the same subject, from the same camera position, using a 90 mm lens. It is immediately noticeable that the longer lens offers a shallower

depth to the image and that both the foreground and background space appear soft. Further, depth of field is influenced not only by focal length but also by the distance of the camera from the subject, because the laws of optics relating to the question of focus indicate that the degree of depth beyond the position of focus is greater than that in front of it. This has a critical bearing on the use of the hyperfocal distance. Additionally, there is an added factor that governs the relationship of focal length to the f-stop and its relative size within the two lenses. Although, say, f8 transmits precisely the same amount of light to the film on whatever focal length is being used, the focal length of the lens demands a slightly different actual size aperture to achieve this; the effect of this in the photograph is to afford differing degrees of softness in the out-of-focus areas between the two lenses in question.

LENS TYPES

Lens selection ultimately comes down to choosing the right tools for the job; to do this, you must understand their respective limitations and advantages, and their particular visual characteristics. The creative function of the lens is to enable you to express in pictures an attitude that you have about the subject. The reason why lens selection is central to this is the fact that lenses are optical devices that attempt to emulate what is after all a highly subjective area of experience. When you enter a room, your eye and brain can scan the scene in a few seconds with varying degrees of attention and detail. Within such a scenario one could see the following: the mountain range outside the room, the sun setting on the ridge, that the window is unfastened, the time on the clock, a note on the piano, the message on the note, that the handwriting is unsteady, and the signature. All this takes place within a few seconds and the information conveys an emotional response. At first, only the mountain range is apparent, but within seconds it is ignored because it is the note that carries the message.

To try and convey this photographically would entail questions of angle of view, relative exposure inside and outside the room, changing viewpoints, and selected details, all legible and meaningful. No single lens could adequately represent such a complex task. We continually adjust to, focus on, and distil from reality – a continuous input of images, ideas and responses.

So it is important to appreciate the inherent qualities of lens systems and the associated characteristics of their respective focal lengths. Wide-angle lenses have a deep perspective and greater depth of focus than longer lenses; they reduce the background scale and risk distortion at close distances. Telephoto lenses have a

Right: The three basic lens types are wide angle (21 mm to 35 mm), normal or standard (40 mm to 55 mm), and telephoto (80 mm to 135 mm). Other lenses outside these ranges are for more specialist applications.

Right and opposite: The intelligent use of interchangeable lenses affords a great deal of choice when it comes to selecting, isolating, and emphasizing various parts of a scene. Without changing viewpoint, it is possible to obtain several quite different pictures by merely changing the angle of view offered by the different lenses. In some cases when access is limited, the use of extra lenses means that this is often the only way in which to function. At a sports meeting, for example, it could be impossible to change one's position. In these examples the types are wide-angle (right), standard (top left), telephoto (top right and bottom left) and extreme telephoto (bottom right).

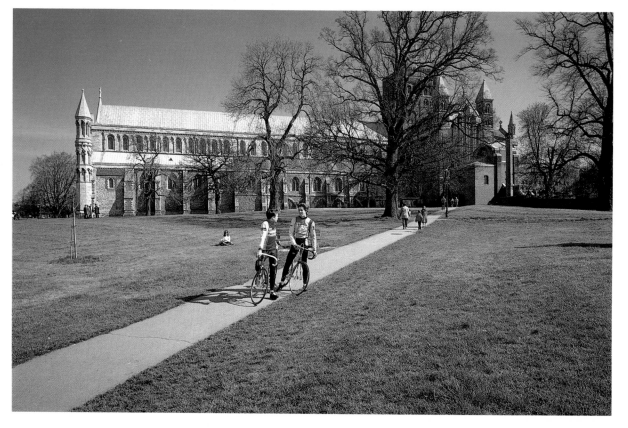

flatness of field and perspective; they tend to 'draw up' the background behind the primary subject and are less likely to distort; they enable small sections to be extracted from a scene without requiring close association. The greater depth of the wide-angle allows the photographer to close in tight to the subject matter, especially when a great deal of action is likely to take place, while the telephoto allows access to distant subjects in close-up that would otherwise have been unobtainable.

Recent developments

Perhaps the most significant advance that has been made in lens design over the past decade has been the development of top-quality zoom lenses. The variable focal length of a zoom does a great deal to offer a choice of angles of view without the need to change lenses. Earlier models were heavy and cumbersome, and far poorer in performance than their fixed-focal-length counterparts. This is no longer so, but zooms still have one prime limitation – that of light transmission. The widest aperture in use on the short-range zooms is f3.5. With two such zoom lenses, however, you can cover a wide range of focal lengths. Popular couplings are a 24–35 mm and a 35–105 mm or alternatively a 28–85 mm and a 70–210 mm. For good measure the latter could incorporate a **macro** mode that would also allow close up photography at a range closer than that of a standard lens.

Another useful development has been the upgrading of autofocus lenses. From a position of derision they have now reached one of genuine potential at the top end of the market. When autofocus first appeared it was criticized for its inflexibility. Pictures are often created by throwing the lens – or part of the subject – *out of focus*. You might decide, for example, to have the main point of focus at the edge of the frame. The original autofocus designs focused on the centre of the image and so denied the photographer the opportunity of making considered creative decisions – the camera was taking over from the photographer. But autofocus, like autoexposure, has come of age: the best systems allow for both manual override and **focus lock** within their controls. The seriousness with which the manufacturers now regard these lens types is reflected in the range of lenses they are prepared to offer; in most cases this is at least ten, ranging from 24 mm upwards, with an emphasis on zoom groups from 28–35 mm through to 70–210 mm.

Macro lenses

As well as the range of general-purpose lenses, the macro is a particularly useful specialist lens. It performs to a high level of resolution in close-up work right down to a magnification of 1:1 (life-size) and beyond. At these degrees of magnification, conventional lenses begin dramatically to lose their powers of resolution, due to the differing angles by which the light enters the lens – the optics of conventional lenses were designed for quite different purposes. To accommodate the closeness of range, you can place bellows or extension tubes between the camera body and a normal lens. Alternatively, you can fit close-up lens attachments of varying strengths over the front of the lens. Neither of these solutions, with lenses of conventional design characteristics, is wholly satisfactory. The macro lens, however, is designed to perform at close range, but to achieve this it has to sacrifice its maximum aperture, the widest being no greater than f3.5. But although such lenses also perform quite well in conventional photography, no single lens can achieve everything. It is ultimately a question of personal choice and this even extends to the range of macro lenses themselves. Macro lenses can encompass a magnification range as great as from infinity to 10 times life-size but every lens has an optimum focusing distance beyond which performance begins to fall off. For this reason, macro groups may contain up to five different models.

The focusing ring on a macro lens has an extra-long range of extension that carries its focusing down to closer limits than conventional lenses. This can offer a magnification range up to half life-size. For closer work, you attach the lens to focusing bellows. The 'normal' macro lens, of 50 or 55 mm, will focus from a distance of 23 mm to infinity and thus can double as a standard lens on the camera.

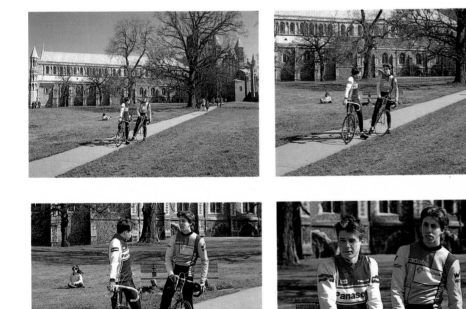

WIDE-ANGLE LENSES

A wide-angle lens has a focal length less than the diagonal of the film format. This means that for a 35 mm miniature camera a 35 mm lens marks the edge of that limit and the 28 mm begins the series; for the 6 × 6 cm format the wide-angle limit is 65 mm and the 55 mm heads the series. The obvious advantage of the wide-angle lens is that, quite simply, it is able to encompass a broader angle of view. This is particularly useful in situations where the limitations of, say, the walls of a room or the interior of a car prevent you from getting very far back from the subject. In terms of perception, you see the interior of a room or a building by tilting your head and scanning with your eyes, but a photograph is taken from a fixed viewpoint.

The wide-angle's second great advantage is its extensive depth of field compared to lenses of longer focal length. For this reason alone it is particularly suitable for landscape and architectural work, when a total control of foreground and background relationships is more important than a concern for movement or distortion – careful alignment of the camera, often by means of a tripod, being critical. Accurate alignment is of paramount importance when using extreme wide-angle lenses. For cameras employing such extensive angles of view (the Hasselblad SuperWide, for example) the use of a built-in spirit level is essential. The optical characteristics of the wide-angle mean that any tilt from the vertical is immediately apparent – and the wider the angle, the more noticeable it gets. This causes problems when the height of a building cannot be accommodated when viewed from the upright camera position. Tilting the camera up or down causes parallel uprights to converge – a particular problem in architectural work. This was, until recently, the reason why the monorail sheet-film camera, with its camera movements, held such a dominant position in architectural photography.

To accommodate the extra height without tilting the camera, the lens panel was raised or the film panel lowered to cover a wider field. This facility is now available to users of SLR systems: lenses have been introduced that provide a variable shift in the position of the elements across the front panel of the camera by means of sliding micrometer adjustments. The leading manufacturers now offer these within the wide-angle groups and they are referred to as perspective control (PC) or shift lenses. As well as allowing you to correct the viewpoint without tilting the camera, they also enable you to employ eccentric alignment in order to 'get round' obstructions in the field of view.

The superwide or wide group in miniature photography begins at 21 or 20 mm and reduces to 15 mm before entering the specialist application and role of the fisheye group. The important point for any user of these extreme angle lenses to consider is the stage at which the respective focal lengths produce curved lines of perspective instead of straight ones. The reason for this phenomenon is that such extreme focal-length lenses show far more than the human eye can normally encompass without moving the head. Therefore the lens merely registers what is a natural fact – perspective is curved, but we do no normally see it in this way.

Fisheye lenses

The fisheye group provides a vision of the world that is particularly its own. Originally developed for scientific applications as far back as the 1920s, when it was introduced for the observation of horizon-to-horizon cloud formations and weather patterns, it has now entered the standard

repertoire of photographic representation. Fisheye lenses have a bulging front element that gives them their name. They are usually restricted to the relatively small aperture of f8, a focal length of 8 mm or 16 mm and an angle of view of no less than 180°. The problems of producing a lens with a focal length as short as 8 mm mean that the image is subtended on to the film in the form of a circle within the frame. Fisheyes of 16 mm or above offer full-frame composition, but the representation of perspective remains characteristically curved in appearance. At such extremes of focal length the question of focus hardly arises owing to the extensive depth of field that they provide. It would be wrong to look on these types of lenses as merely photographic gimmicks. Their application has gone beyond scientific and observational work to editorial fields where photographers are using them in subjects as diverse as sport and architecture.

It is possible to purchase 'fisheye adaptors' to attach to the standard lens. These are not true fisheye lenses but offer a condensed image in a circular form on the film and without the total angle of view that a true fisheye can offer. Their overall performance leaves much to be desired.

Above: Landscape photography and the large panoramic view are particularly well served by the use of the wide-angle lens, although sometimes it can result in disappointing imagery; for example, when a natural desire to include as much of a given scene as possible suggests that a wide-angle lens would help to achieve this – sometimes this is simply not so. The extra angle has an added tendency to reduce, say, a mountain range and diminish it. There can be few finer ways to counter this problem than by extending the format itself into a sort of 'widescreen' format. Several cameras employ this principle, with images of 6 × 17 cm, 6 × 12 cm or 6 × 9 cm.

Right: One of the added features of the ultra wide-angle lens is that it can take in influence from both the ground plane and the sky overhead. With such lenses there is a tendency to darken the sky, in a similar way to the polarizing filter. With ultra-wide lenses the depth of field is almost infinite but against this can be an irritating risk of distortion. It is therefore not usually advisable to use these lenses for portraiture.

THE TELEPHOTO

The natural opposite of the wide-angle is the telephoto. The range begins at a focal length slightly less than double that of the standard lens. Compared to standard lenses, telephotos produce a magnified image size from the same vantage point. These long lenses, by virtue of their design, involve fewer problems in the degree to which they are required to bend light rays and so they pose far fewer problems of distortion in their representation. Indeed, the image that they produce within the range of 85, 100 and 135 mm is felt to be the most 'natural' in terms of relating to the vision of the human eye.

Telephotos are particularly suitable for applications in portraiture. Most people are uncomfortable at the prospect of a lens being, continually poked in their face and this makes for imagery that is stilted and self-conscious. Better by far to employ a tripod from a position set back from the model and work quietly and without fuss. As an additional means to this end, it can also be extremely useful to use a remote release or a motor drive, or preferably both, and, once the lens is focused, merely put the sitter at ease with conversation. You can then make exposures at the best moments as the session progresses, without too much recourse to manipulating the camera and its controls.

Telephotos are also opposite to wide-angles in terms of perspective and focus. While they tend to pull together the elements of background within a photograph and foreshorten the depth of the picture, they also allow much greater freedom for selective focus and separation of elements within the frame. The longer the lens, the more this visual effect is increased and, given a wide aperture and shallow depth of field, it is possible to isolate, say, an animal from the wire mesh of its cage by selective focus. The effect can be emphasized by using a wide aperture on a long focal length. This gives a very limited depth of field which can be used creatively in picture-making. How-

ever, as the focal length becomes even longer a different form of distortion comes into play – the 'larger-than-life' kind of distortion that enables the lens to see more than the human eye normally can. This can have dramatic effects within the photograph and yet, on consideration, is not so far removed from the manner in

which we ourselves perceive reality.

Much of our perception is conditioned by an ability to pick out small areas from an observed scene and relate to those alone. It is a kind of 'psychological zoom' that we have built into our sensibilities. Imagine a full moon rising against a hill, tree or house; its luminance and arresting

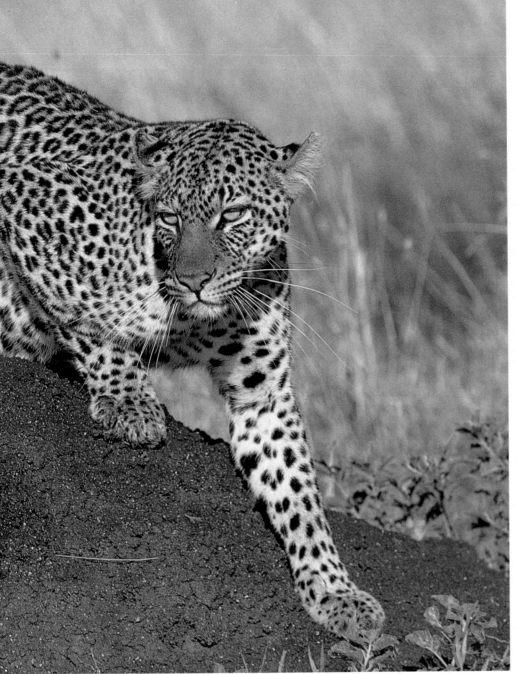

and is greatly assisted by the intelligent selection of the appropriate lens.

The role of the telephoto lens in drawing together the distance and space in a photograph means that, in effect, it is magnifying considerably a small element within the scene. Any inherent camera shake at the exposure of the photograph is also greatly magnified, so you should take extra precautions to minimize this. As a general rule, you should use a higher shutter speed for telephoto work and, if a tripod is not available, then at the very least employ shutter speeds that are less than the reciprocal of the focal length (ie, for a 100 mm lens use 1/125th sec, for a lens of 135 to 200 mm use 1/250th sec, and at longer focal lengths use at least 1/1000th sec).

In terms of ease of use, there is a great deal to be said for medium telephoto lenses of focal lengths between 85 mm and 105 mm for general hand-held photography. Computer-aided design has given this group an ease of handling comparable to that of a standard lens, while light transmission can be as good as f1.4, built into a barrel hardly longer than the 50 mm standard. The perspective is 'natural' and well-nigh ideal for conventional portraiture, while the lens affords a slight softening of the background for selection and emphasis. One problem, however, does stem from the ability of medium telephoto lenses to be combined with a wide aperture, for the configuration of the lens elements within longer focal-length designs mean that the front element is large. Despite the advances in lens coating, this type of lens is particularly prone to light scatter in the lens barrel when shooting into the light, so it is particularly important to use a lens hood. Many manufacturers build in a retractable lens hood on the front of the barrel to facilitate this.

detail make it stand out in the evening light, and the setting sun allows sufficient afterglow to put detail into the landscape. The moon, under these conditions, looks huge against the house and to convey this subjective response a very long lens indeed would be needed. Later in the evening the moon will have cleared the horizon, the ambient light gone, and against the black field of the night sky looks infinitely smaller. In fact, it is precisely the same size, but there is nothing against which to establish this and the same moon appears as a small dot of light. This effect is central to the expressive use of lens systems in more advanced photographic techniques

THE ZOOM

A zoom lens holds a unique position in that it enables you to continually vary its focal length and thus change elements of angle of view and magnification of image without changing your vantage point. The design of the lens is arranged in such a way that the internal elements may be moved to achieve this remarkable facility. The single most important advance in lens technology over the past decade or so has been the improvement in zooms to the point at which their optical quality is comparable to standard fixed-focus lenses. Until relatively recently, zoom lenses were bulky and heavy, slow to use and suffered greatly from a tendency to 'wander' across their focal lengths. In earlier models the lenses were produced as either 'one-touch' or 'two-touch' systems. In the latter, the focus and focal length settings were positioned on two separate rings, but of late the increasing use of zoom lenses has meant that more sophisticated and easy to operate 'one-touch' mechanisms are now available and these two operations are now combined within a single 'push-pull-twist' arrangement on a large ring at the head of the lens.

The great advances in computer-aided optical design have largely eliminated the former prejudices against this type of lens, although not entirely. Modern zooms are smaller, lighter, and better optically than their earlier counterparts. But to enable the lens to do its work, the optical layout of a zoom is complex and may involve as many as 13 elements in 11 groups. Accordingly, the effective light transmission of such lenses is relatively low compared to conventional lenses and the maximum aperture of a zoom is usually within the range of f3.5 to f4. Similarly, manufacturers have moved away from a desire to produce lenses with very long ranges of focal length and, instead, have accepted the principle that zoom lenses, like fixed focal-length equivalents, are best limited to one particular focal-length range – wide-angle, normal, or telephoto. Thus it is important

Right: Zoom lenses, like fixed focal length lenses, may be considered in terms of 'families' and may be referred to by their range and character. A short range zoom, for example (right), would cover the range from, say, 24 mm to 50 mm affording the photographer a useful combination when travelling. A zoom lens is also referred to by its long-to-short ratio of focal lengths and so this lens would be referred to as a 2:1 wide angle zoom. A mid-range zoom would therefore cover the range of medium wide angle (centre), like 35 mm, to short telephoto (70 mm) and would be classified as a 2:1 mid range zoom. In the longer range of zooms (far right) it is more likely to offer focal lengths from 75 mm to 210 mm, and would be classified as a telephoto zoom with a 3:1 ratio.

to select an appropriate zoom lens for the job at hand. It is therefore useful to consider the comparable size and weight of a wide-angle zoom against its fixed counterpart, for a 24–35 mm f3.5 zoom weighing 285 g is not that much heavier than a 35 mm f1.8 weighing 240 g or a 28 mm f2 weighing 265 g. The real difference is in light transmission. Therefore, when considering zoom lenses, it is useful to refer to a chart that encompasses the various options available within the zoom groups and which will indicate their respective ranges and maximum apertures.

Medium-range zooms often provide an added bonus: an optional macro setting. Although this is useful, it is not a true macro and its application is relatively limited. These lenses are also classified in terms of zoom ratios, the principle of which is the relationship of the widest focal length to the longest. Accordingly, a 35–105 mm zoom may be called a 3:1 zoom and this, in turn, gives a direct indication of its power of magnification, the telephoto setting magnifying the wide-angle image by three times; in fact, an alternative classification is a '× zoom'.

Zooms are especially useful because they allow you to vary the framing and composition through the viewfinder with-

out the need to change lenses, while maintaining a level of image definition that is not far removed from that of its fixed-focal-length counterpart. This means that in effect two carefully selected zooms can replace a whole family of fixed-focal-length lenses – which is particularly useful if you are planning an excursion where space is at a premium.

Another important bonus for the user of zooms is the potential for special effects that they offer. Zooming can be carried out during exposure, even while panning from left to right.

Leading manufacturers of cameras for the professional market offer a number of zoom lenses within their autofocus series. The electronic linkage gives great flexibility to these types of lenses and feeds information continually into the viewfinder. Thus the earlier limitations of zoom lenses are rapidly diminishing as their manufacture improves and they are no longer to be dismissed as inadequate in comparison to their fixed-focal-length lens counterparts.

It would be wrong though to assume that the mere substitution of the conventional lenses for zooms will solve all photographic problems – they may well simply complicate the question of choice. Better by far to select one zoom type (wide, medium or long) and back it up with an additional fixed lens at either end of the zoom range, according to its anticipated usage.

Another point to remember is that the longest focal length of any given zoom is infinitely more difficult to hold for sharp imagery, due to the magnification involved, as opposed to the more freely usable wide-angle settings. When considering the purchase of a zoom, look carefully at the extent to which it will hold focus during the shifting of the particular focal length settings – if it does not hold focus uniformly throughout, it is not worth having.

EXTREME FOCUS LENSES

At both ends of the ranges of focal length are lenses that fall into the category of extreme focus. These ultrawide or super-telephoto lenses are for specialist applications rather than general work. Extreme telephoto lenses are generally considered to start at over 400 mm. Within this group there are two different types, the conventional telephoto layout and the catadioptric or mirror lens.

In the mirror lenses, a very long focal length is incorporated in a very short body by doubling the light back on itself within the lens by means of a concave mirror. This mirror is strategically placed at the critical point of focus and reflects the light rays on to a smaller mirror on the central axis of the lens and close to the front of the opening. This in turn directs the light back along the lens, through a small aperture in the primary lens, and on to the film plane. The mirror lens is an ingenious solution that offers some very acceptable results under certain conditions, especially when the size and bulk of the lens are critical considerations. However, its design does not allow for an adjustable aperture, so all adjustment must be made with the shutter, or with neutral density filters, or both. Secondly, this type of lens has a visual characteristic in its imagery that reduces all out-of-focus highlights to a particular doughnut-like pattern and many people find this unacceptable.

One of the major problems of designing super telephoto lenses is one of scale. In order to focus a 600 mm lens with the traditional method of moving out the whole front assembly, the overall dimensions of the lens become exceptionally unwieldy. This shortcoming has been minimized by recent innovations that allow the lens to be focused by the internal elements alone, so that the overall length of the lens remains the same. This system of internal focusing confers an additional benefit by offering a shorter close-distance

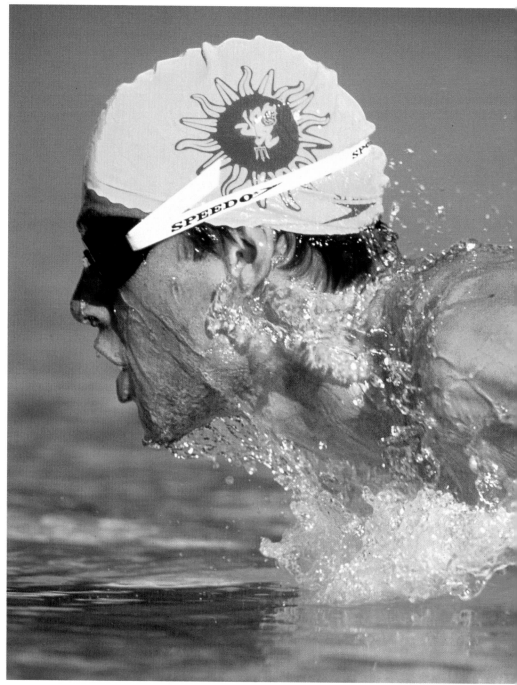

focusing range for the respective lenses.

All lenses of this focal length must be used with a tripod otherwise camera shake and blurred images will result. Extreme telephotos are therefore fitted with the appropriate socket at their centres of gravity. Within the conventional design, focal lengths from 600 mm up to as long as

1200 mm are available and all have normal aperture controls. At these focal lengths, it is very difficult wholly to correct lenses for chromatic aberration (faults in colour rendering at both ends of the visible spectrum) and the added ability to employ apertures as small as f32 is critical to performance. Similarly, the relatively small maximum

Above: It is interesting to experiment with lenses designed for specialist purposes. The fisheye lens affords unique imagery with its circular field of view and 180° angle of acceptance. It is, obviously, subject to considerable distortion and curved perspective and affords a singular way of representing reality. The original function of these lenses was for scientific recording work.

Left: At the other end of the focal-length scale, the extreme telephoto lens gives you a very close view, so that you can extract meaningful sections that may otherwise be unobtainable.

apertures of between f5.6 and f11 are not a great hindrance.

At the other end of the focal length range are the superwide lenses and the fisheye group. In the purest sense, the term 'fisheye' can only be used for those lenses with such short focal lengths and wide angles of view (even greater than 180° if the focal length is as short as 6 mm) for which the design has to rely on a huge bulbous front element, with an appearance not unlike the eye of a fish. This configuration is particularly remarkable in the light of the requirements of the SLR camera and its instant return mirror. Earlier designs had required the mirror to be placed in the locked-up position and the rear element of the lens almost touched the film plane. This is no longer so but the fisheye always retains its characteristic circular field of vision and its curved rendition of perspective. Ultrawide-angle photography has tended to move away from this restriction into either using pivoting lens systems that take in broad panoramic sweeps of view or solving the problems by extending the format of the film to allow an aspect ratio of 6:17 as a long horizontal slit, without major distortion in either perspective or linearity, on larger film such as the 120 roll-film format. However, these are not really extremes of focus in the true sense, being much more concerned with extremes of angle instead.

Specialist lenses

No lens can cover all photographic requirements, even at the extremes of the respective focal length groups, for specialist applications call for particular features that are not normally required in general use. Close-up photography in fields such as surgery and medicine, fine art copying,

and shadowless macrophotography call for specifically designed lenses, with special tolerances and their own accessories. To this end, the current emphasis on internal microelectronic circuits is critical, for these components allow the operation during very narrow bands of tolerance, not only right up to the moment of exposure but also during it.

Specialist macro-type lenses are therefore designed with limited ranges of application and it is important to marry the particular lens to its appropriate accessories, such as automatic bellows extensions and macro flash units coupled to automatic limiting devices for appropriate exposure control. A ring-flash unit is just such an accessory. This type of flash unit encircles the front element of the lens, providing full, shadowless illumination

ideal for critical work in medical and dental applications. An alternative method of achieving this type of result is to use two small flash heads on each side of the lens. You can then control the form and shadow content of the image by angling the heads.

These are specialist uses, but there is a great deal to be gained from the careful use of a macro lens in conjunction with electronic flash and bellows extension units, particularly in critical copying work. You can copy transparencies 1:1 with a bellows extension unit coupled to a good macro lens and, in the process, correct the slides for any slight imbalance in colour. There are two kinds of unit available, one with a tungsten lamp as an illuminant and the other with an electronic flash source. This means that ordinary film balanced for daylight may be used when copying slides.

Specialist lenses often provide interesting and individual visual characteristics, due to the particular way in which they have been designed. The macro lens is highly corrected for close-up work and so can afford dramatic close-ups, either as an extended standard lens or as an adjunct to work with extension rings or focusing bellows. This enables a considerable degree of magnification to be undertaken. In normal use the magnification range can readily accommodate the head of a flower (right) and its delicate nuances of colour and form, whereas closer focusing ranges may be considered if the additional use of either bellows, extension tubes and close-up lenses are considered, as in the photograph of the insect (top left). The use of integral metering though is of great benefit in such work, for the close-up requirement greatly reduces the actual transmission of light through the lens at such degrees of magnification.

At the other end of the focal length range, a mirror lens (below left), while affording small details from objects quite some distance away, also transforms spectacular highlights in the background into a characteristic 'doughnut' form of imagery. The major disadvantage of the mirror lens is that it does not allow for variable aperture settings and thus the effect is similarly limited.

FILTERS

Despite all the advances made in automation, no camera can 'think' and no camera can automatically compensate for your purely subjective response to a scene. For example, your perception of a landscape may well be affected by memories past or by happiness present and that feeling may be reflected in the patterns in the sky. In such a case, it is most unlikely that a 'straight' representation of the sky will in fact feed back that emotion to the viewer and, accordingly, it is best to adjust the contrast in the negative at the time of exposure. Although panchromatic films are designed to have a full sensitivity to the visible spectrum, any deficiency tends to exist at the blue end, where, if anything, such films are more sensitive than the human eye. This means that blue records slightly lighter on the film, and therefore it is necessary to adjust this discrepancy if this is a critical factor in the photograph.

The function of a filter is selectively to hold back and adjust certain wavelengths of the spectrum. In black and white photography the general rule is that to darken a colour in the photograph the complementary colour is used in its filtration. By the same token therefore, that self-same filter will lighten colours of a similar hue. It is commonly thought that a pale yellow filter is the correct one with which to reconstitute the natural tonality of a scene on to black and white film. In fact, a yellow-green filter is more accurate for this purpose where landscape subjects are concerned because, in addition to lowering the sky slightly, it will also 'lift' the tonal value of the grass.

The function of the filter in darkening the respective colours in the scene means that there is an incremental loss of exposure according to the filter's 'strength' and this is usually expressed in terms of filter factors. The description 'x2Y' means that the strength of the yellow filter will require twice the exposure to revert to the same negative density; a 'x30' indicates three times the exposure for an orange filter, and

so on. The table (right) shows typical uses for coloured filters in black and white photography. It should be noted that the filter factors listed in the chart are not applicable to SLR cameras with through-the-lens metering, as these accommodate the exposure difference automatically. The factors are for converting readings from external metering systems only.

Colour films are also often in need of adjustment or conversion. Again, this stems from the inability of the film to match the compensating characteristics of the human eye, particularly in the area of colour temperature and spectral emissions. In the simplest sense, whereas we grow accustomed to and compensate for the inherent 'warmth' of artificial light sources, colour films do not. Therefore, a film normally designated for use in daylight adopts an excessive amber cast in tungsten illumination. To render this 'normal', you can use an artificial-light-balanced colour film but this is inherently blue in colour characteristic if used in daylight. If you find yourself on location with the wrong film for the prevailing lighting conditions, you can 'convert it back' to the new value. Given the choice, it is a better option to take artificial light film and convert it back

FILTER	FACTOR	EFFECT
Yellow-green	× 2	Darkens skies, lightens grass, renders 'normal', darkens lips
Yellow	× 3	Slightly darker sky also 'normal' value, often used as standard filter for landscape
Orange	× 4	As yellow, but more pronounced skies
Red	× 8	Dramatic sky effect, darkens grass, penetrates haze, high contrast

to daylight by means of an amber conversion filter rather than the other way around.

Colour filtration of artificial light sources is a very complex subject indeed, as modern technology is continually offering new and unique forms of spectral wavelength illumination. If you are planning to specialize in colour photography involving such decisions in buildings, amphitheatres, and mixed light locations,

you should employ a suitable colour-temperature meter, which would offer the necessary filtration and factor as a digital read-out.

Filters for general use

Some filters have a more general use in colour photography. The pale UV filter, for example, is often employed for the reduction of the influence of ultra-violet light in landscape work. Often the results from colour films operating at either high altitudes or across water are disappointingly 'blue' and suffused over distances. This is because the film is somewhat more sensitive than the human eye to the **ultra-violet** end of the spectrum. To counter this, a UV filter is often used as a standard accessory for colour photography in the landscape in much the same way that the pale yellow is often used for black and white work. In addition to its effect on the image, it helps to protect the front element of the lens. Other useful filters for general use are polarizing and infrared types.

There is also an increasing use of 'special effect' filters in colour photography. Some employ split fields of incremental density, from top to bottom, and can be useful in holding down a sky without affecting the foreground. These filters come in many shapes, sizes, and hues. They should be used sparingly. It is a seductive, but often erroneous, facility to use such items in lieu of insight for they tend to make 'everything look the same' and, instead of offering new potential, they merely vulgarize the photograph. However, it is worthwhile to consider the neutral ones for colour and the pale ones with gradation in the yellow-orange area for black and white.

Opposite: Filters have an important part to play in black and white photography for the response of panchromatic films tends to be slightly more sensitive to blue than is the human eye. A strong orange or red filter imparts a dramatic effect, lowering the tonal value of the sky, as in this photograph of a storm in the Isle of Skye.

Above left: A further filter type for colour work is the split tone or graduated filter. This allows the photographer to darken areas of the scene selectively. They may be half grey or neutral density or else half brown (tobacco).

Left: Filters have a part to play in colour photography, especially the polarizing filter. This has the effect, when rotated, of holding back certain wavelengths of light from the sky, and thus darkens it.

FLASH

Contrary to popular belief, flash photography is not a modern invention. Flash has been in use since the turn of the century. Many photographers working in social documentation had long felt the need for more portable auxiliary lighting on location rather than the ponderous and unpractical studio lights of the day. They used magnesium powder to obtain a bright incandescent flash to light up dark areas of the picture. For a considerable time this afforded some unique imagery, although such unprotected use of a highly volatile substance rendered it hazardous and unpredictable in the extreme. It was not until the magnesium ribbon was encapsulated within a bulb for firing by electrical connection that the spread of flash became such a universal tool in photography. Indeed, it is often forgotten just how recent it is that press photographers combined large unwieldy sheet-film cameras with one flash bulb reflector for most of their work. For example, the major output of the American photographer Weegee (see p.160) was almost exclusively derived from this system of working – and this was after World War II.

With this type of flash, the most critical thing is for the flash itself to be synchronized to the opening of the shutter. As the electrical spark ignites the magnesium ribbon within the flash bulb, there is a slight delay while the bulb achieves its maximum 'burn' and output. Therefore the synchronization for such a flash bulb provided an in-built delay, and early flash systems that employed the principle of the igniting bulb had a different setting from modern-day electronic units where the ignition and emission are almost instantaneous. Another factor is that early shutter mechanisms were almost exclusively of the diaphragm between-the-lens type and thus were able to be synchronized to coincide with their opening at all speeds, while this is not so with focal-plane shutters. This had led to the two standards that are currently applicable, denoted by the

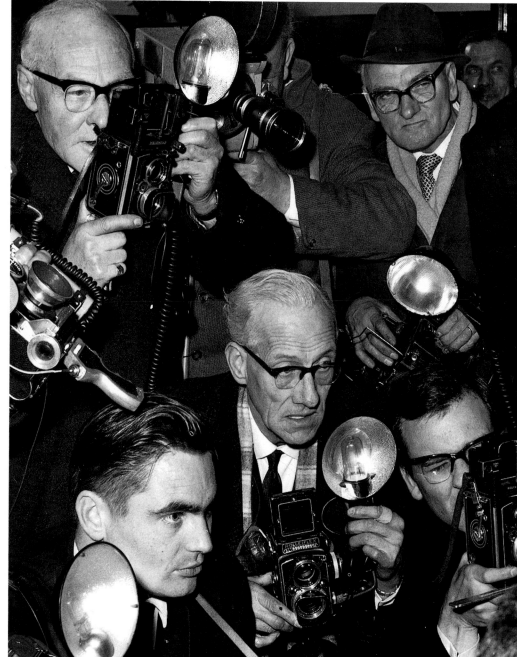

settings M and X on the synchronization input of the shutter: M is the setting for flash bulbs and X is the setting for electronic flash (for further information, see 'The Shutter', p.32).

Today, electronic or automated flash is the norm. The reasons are obvious – a flash bulb is, by its nature, expensive to make and non-replenishable, whereas current microelectronics enable manufacturers to offer electronic units that recycle in as little as a fraction of a second, cost little to run and are governed and monitored by their own electrical circuitry. A once difficult and unpredictable output is now fully compatible in every way with current photographic needs. Also, the unique quality of electronic flash stems

Left: This charming illustration of a huddle of press photographers in the 1950s is an interesting document of its time and serves to remind us of how things have changed. The preferred cameras are twin lens reflex models and the flash tubes are large and bulky. More than one photographer is using the open sportsfinder method, which shows how flash is such a reliable means of auxiliary lighting and provides adequate depth of field. However, it is important to remember that the synchronization of the shutter must be set to the X setting and not the M.

Above right: These graphs show why this is so. With flash bulbs, the build up of the light output was relatively slow but with the electronic flash it is immediate. Therefore, in the former case (bottom graph), the shutter is delayed slightly so that it takes in the full influence of the incandescent flash, whereas in the latter case (top graph) the flash fires instantly the moment that the shutter is fully open.

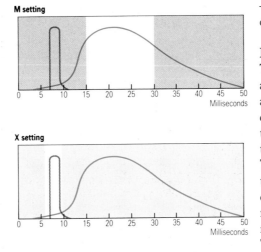

tography this is important, because the irksome question of balancing differential colour temperatures is avoided.

The quality of electronic flash in operation is uniquely photographic. Electronic flash owes no allegiance to fine art or human vision and is a byproduct of the photographic process alone. It performs to very specific and quantifiable tolerances and has recently been greatly advanced by the use of microelectronics, which not only measure the light output but can also control it during the emission of the flash. For this reason, therefore, the former reservations on flash (namely, its unpredictable nature, its need for flash factors and calculations of distance-to-subject fall off), have largely disappeared and in their place has arrived a system for monitoring the exposure from the surface of the film itself.

There are two major types of electronic flash: the large units employed in professional photographic studios and operated from AC mains electricity, and the smaller units that derive their energy from small battery sources for portable use on location. One thing that characterizes electronic flash above all else and is present in both systems is the extremely high speed of the flash itself, which can range from between 1/500th sec and 1/30,000th sec. This means that in a flash photograph, unlike one taken with continuous illumination, the shutter speed itself is not the critical factor in determining the exposure

– it is, in fact, the strength of the flash that does this.

Flash meters

To get the best out of flash photography, accurate flash metering is essential. There are two basic methods of approach, not dissimilar to those used for available light: the external meter and the internal integral type based on the camera circuitry itself. There is a third method, which controls the exposure of the flash output by means of small sensors. This method is used in most compact flash units today, but it does not provide a true exposure meter at all. The light is controlled according to a predetermined aperture setting that you select beforehand.

With an external flash meter you can measure the flash illumination in precisely the same way as with a meter for available light (see pp.38-9), either by the reflected or the incident method. This type of meter may give a reading by means of either a moving needle against an aperture scale, or by a direct readout. When such a facility is not available then you should make your calculations by means of the unit's flash factor (or guide number, GN). The emission from a flash unit obeys precisely the same laws that govern all light sources in that the fall-off of light from its point of origin is directly proportional to its distance from the subject and is therefore governed by the **inverse square law**. In other words, the amount of light falling on a surface is four times less if the distance is doubled and nine times less if it is tripled. There is a simple formula in which the output can be expressed in the form of a **guide number** for any given film speed and this is used on the basis of GN = Distance × Aperture; a GN 110 would mean that at 10 ft the aperture would have to be set at f11. However, this approximate way of working is not really sufficient for present-day materials and methods, which often require calculations to be made to a tolerance of a third of a stop or even less. Fortunately, modern dedicated flash units make such involved calculations all but redundant now.

from its operational principle, wherein the illumination is created by the surge of high-voltage current through a wire surrounding a tube filled with Xenon gas – this produces a light-source that is comparable in effect to the burst of a small mini-sun, and accordingly the light has a colour characteristic that is wholly comparable to sunlight itself. For colour pho-

AUTOMATED FLASH

The reason that the guide number approach holds so little importance today is because of the extraordinary sophistication of modern materials, methods and design – particularly the unique potential of the microelectronic circuit board. This is especially relevant to dedicated flash units in which the internal circuitry of the camera connects with that of the flash and not only triggers the light output but also monitors the illumination during the actual exposure. Not all portable units are dedicated. For example, there are portable units that collapse down into a carrying case, are driven by AC mains voltage, and yet which retain many of the advantages of the larger studio units. Slightly below these in scale are the professional press-type flash units that have the choice of either a rechargeable powerpack or a mains lead converter for location work; these can also accept an additional head for boosting the output for large interiors or wide-angle applications. The best of these have a modular construction that enables you to customize the unit for specialist applications and differing types of reflected light output. When choosing such a unit it is important to consider its potential for angling the light source not only forwards, half upwards, and fully upwards, but also backwards. This feature can be used in conjunction with the incorporated sensor unit that moderates the output of the flash. You set the sensor to a particular aperture and then it cuts off the light output during the exposure itself. The sensor offers unique advantages because it does not matter if the head is pointing directly forward or back – it will curtail or extend the amount of flash output accordingly.

When applied to dedicated units, electronic flash is capable of the most sophisticated applications like macrophotography and transillumination. When the integral circuitry of the camera itself is acting as the monitor of the flash, questions such as

Right: Linked to the camera via a hot shoe, a dedicated flash unit can receive information from the camera's meter and adjust light output accordingly.

extension factors and filter factors are merely redundant for the flash is monitored at the film plane during its exposure. The problem with dedicated units is that they have to be linked physically to the camera housing itself, by means of a **hotshoe** connection or a synchronization lead. Accordingly, without care, the results of too emphatic an on-camera flash are somewhat limiting in their character and yield disappointing results. It is best to fit a remote flash sensor in the hotshoe position, connect the flash head to this with a synchronization lead, and allow the flash head to operate away from the camera itself. Most good flash units have this facility.

Slave units

Alternatively you can use a 'slave' unit, which is a small flash accessory that will repay its cost time and again. It can be used with any type of flash output, whether from a portable, press or studio electronic unit. A slave is a small triggering device with a female connector that will plug into the synchronization lead of any flash unit and which responds to another flash by closing the circuit across its connector and firing the unit remotely. With a slave unit it is possible to activate a sizeable flash remotely and cordlessly and this allows great freedom in, say, a fashion session or location work when you need to light a large interior. Furthermore, if additional 'slaves' are used then you can employ the camera-based flash to ignite a whole battery of units from either side of an interior as the light 'bounces' across the sensitive cells.

The influence of the camera flash can easily be monitored when using a slave by its own sensor cell, and if this is set at a wide aperture such as f2.8 or f4 while the

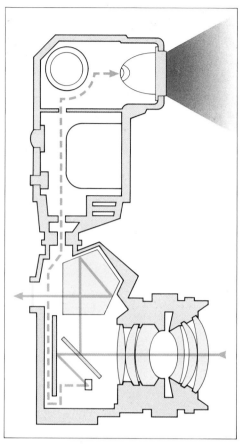

camera is manually set at f8 then there will hardly be any effect from the leading unit. The internal metering of the camera in such an application should be switched to manual override. Slave units have been introduced that actually trigger the external flash units by means of a small infrared transmitter, not unlike those that are used for remote changing of television channels.

Many independent manufacturers are now producing units that have 'customized dedication' as a feature. This allows you to buy the unit with interchangeable dedicated modules for connecting to different internal circuitry and monitoring systems. When purchasing such a unit, you should consider very carefully the types of work you may wish it to perform – a modular system is versatile and will not only allow variable angles of output but also specialist applications like infrared (black) output and the use of ring flash and filter adjustment kits.

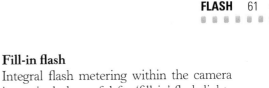

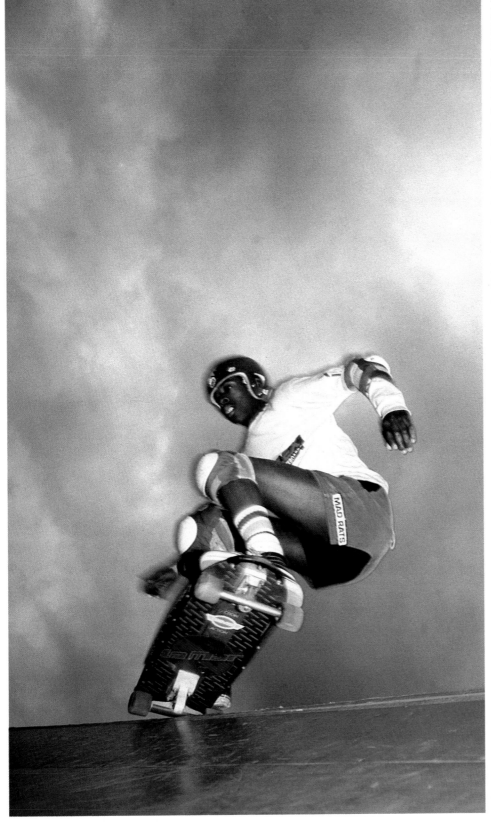

Fill-in flash

Integral flash metering within the camera is particularly useful for 'fill-in' flash lighting. This is a technique with which you can use flash to illuminate areas of the frame that would otherwise be in shadow. It allows you to make two exposures at once. Shutter synchronization with electronic flash is especially important with focal-plane shutters. For the flash to expose the film fully there must be a moment when both shutter blinds are withdrawn. To synchronize correctly, therefore, the shutter cannot exceed a certain speed. In synchrosunlight, the flash is used as a compensating 'fill-in' to match the intensity of the background and reduce harsh shadows in the foreground; it is at its best when it is scarcely discernible as an effect. To achieve this, you select a shutter speed of 1/60th sec or a 1/30th sec – slower is not advised without a tripod – and read off the suggested aperture. Whatever this is, set your sensor on the camera flash system to half a stop less. In so doing, the monitor will 'clip' the exposure of the shadow side of the subject by half a stop less than the highlight and effectually even up the amount of light falling on both sides of the subject. Given the opportunity, it is advisable to try several combinations of shutter and aperture, for it is a delicate procedure to match the two systems of illumination and, above all, it will afford valuable experience for the future.

Left: This is an admirable example of the potential of on-camera fill-in flash being used effectively. There are usually three levels of switchable flash output available to the user and therefore decisions on emphasis can be made with regard to the extent that the background is exposed in relationship to the prime subject. In this case, a shutter-aperture combination has given a dramatic emphasis to the sky.

The shutter speed was not particularly fast, due to the softening of the edge of the left hand, the helmet and the knee protectors. The addition of the flash, correctly matched to the indicated exposure for the sky, etches in the necessary information that makes the picture viable – all of the internal detail on the figure is well exposed and perfectly descriptive. A larger f-stop (or aperture) coupled to a lesser output from the flash and either the same or similar shutter speed, would have given a lighter sky and a different effect, while a yet smaller stop and the same shutter speed would have almost given a nighttime effect.

FLASH TECHNIQUES

It is a commonly held fallacy that flash is entirely different to tungsten or incandescent lighting and cannot be compared in the matter of techniques and application. True, it has a different spectral response and does not provide a continuous light source, but these are matters of detail – in every other respect flash can be used in much the same way as conventional studio lighting. It can be bounced from the ceiling or from reflectors, can be monitored for exposure by external and internal metering systems, and can be used in a wide range of applications from portraiture to fashion and still life. Indeed, flash is far better for still-life items such as food, where hot studio lights can affect the subject. Therefore, rather than thinking of flash as a separate entity, it is better to relate its function to those influences that are common to all light sources.

One of the most critical factors is the size of the light source. The smaller it is, the harder the shadows. This is as true for an outdoor landscape scene as it is for a studio interior – on a sunny day the light source (the direct sun) is small, giving sharp shadows, while on a dull day the light source (the sunlight diffused by the canopy of clouds) is large, and therefore the effect is soft. In most unsuccessful applications of flash the fault is due to using the flash head as a small point source close to the axis of the lens, giving harsh and unsympathetic shadows around the edge of the form. You can gain a great deal from increasing the size of the illumination by one of several methods. First, you can tilt the head by 45° to allow the major part of the flash to bounce back from the ceiling. This effectively increases the size of the illumination from above while the autosensor will push out more light to make up the same degree of light reaching the camera. It is vital for this technique that the sensor remains pointing to the front, and is not tilted. Secóndly, you can remove the head from the camera axis and point it into a large reflecting light umbrella that will push back the light from a larger source; you can achieve a similar result by pointing the head at the subject but cover it with a large translucent sheet of material or gauze. Again, the sensor must face the subject. Thirdly, the flash may be pointed

Left: One of the basic reasons for many photographers not liking flash is the fact that, when used on the camera direct, the result can be very ugly. A flash straight over the lens gives harsh shadows around the subject and also the risk of 'red eye' – the light entering the subject's eye and bouncing off the retina, giving a reddish colour to the centre of the eye.

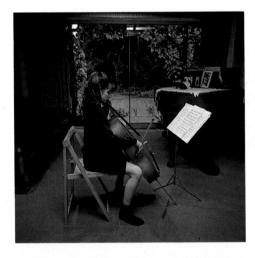

Left and opposite: It is preferable to bounce the flash, tilting the unit up to allow the main illumination to come to the subject from the ceiling. With modern units it is essential to note that the sensor for exposure is still pointing to the subject so that the flash output is automatically monitored.

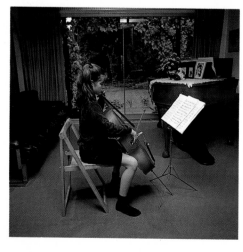

Left: An alternative way of bouncing the flash is by the indirect method. In this case the head is removed from the camera and connected by a synchronization lead. The head is angled to a large white reflector to the side of the camera and pointing away from the subject. Again, the sensor must point forward.

Left: The final method is off camera flash. In this instance the head is removed from the camera and connected by means of a synchronization lead. However, the head is pointed back towards the subject itself. It could be diffused through a transparent screen if necessary.

backwards or to a large reflecting wall so that the largest possible light source is available for a room of any given size. This technique usually requires the use of a fairly wide aperture.

These three basic positions provide a basis for working with flash, but you can devise further alternatives with the addition of extra heads, particularly if you can work with the large professional lighting packs that allow for variable output. With this type of arrangement, you should work away from the camera at the subject position, and control the ratio of one light to another by means of the exposure meter itself. Small studio flash units that work from mains voltage and have their circuitry built into the lamphead are particularly useful if they also incorporate modelling lamps. These make it possible to judge quite clearly the effect of one light against another. Without question, a lack of modelling lights is the biggest drawback in using portable battery packs and transistor units.

Using high-speed flash

There are some uses for which electronic flash is particularly appropriate. Any application that requires speed of emission and fast recycling within a darkened room is ideal for electronic flash. Recycling is fast because autothyristor circuits only use the amount of flash necessary to illuminate the subject and, therefore, if the aperture setting is relatively wide, will truncate the output and not utilize all of the charge available but simply hold it in lieu. The recharge time is cut dramatically, making it possible to fire off several exposures in rapid succession. This feature offers an excellent opportunity for using multiple exposures to analyze subject movement in a darkened room. The cumulative build-up on the film is something that is unique to photography. An alternative method of exploring this type of subject is to employ a low ambient light also, so that not only are the individual bursts of light recorded but a flowing continuum of movement as well. Flash is particularly good at arresting movement, but it is equally valuable as a light-source for still-life work. In this area you can use it not only when great depth is required with a small aperture, but also when an element of movement, such as a drink being poured or a hand moving dramatically, is an essential part of the subject. The accessories for electronic studio flash are almost limitless and in large studio sets (for lighting automobiles, for instance, or large group portraits for advertising) several units may be linked together to afford a very high output. Without doubt, however, the most indispensable accessory is a suitable meter to monitor the output and check lighting ratios – without it you cannot begin to work.

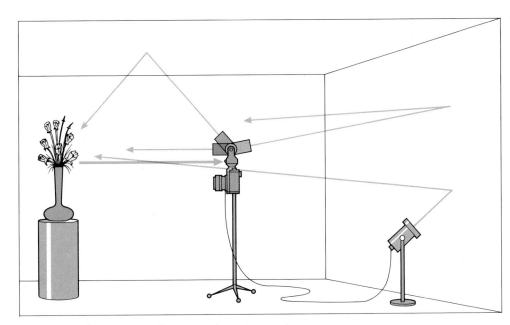

Above left: It is useful to consider several versions of these alternative methods of directing the flash to the subject within the photographic studio. In this way the flash is changed not only by direction but by the size of the illuminant; this has a definite bearing on the quality of the light (and, of course, shadow) produced.

Left: Flash is useful as a form of 'fill-in' illumination on location, by coupling it to a slow shutter speed so that the long exposure will include some of the ambient light also. In this illustration, the street musicians of New Orleans are lit by the on-camera flash, but the shutter speed is open long enough to allow the blurred imagery of the street to 'catch up' with the main subject in the foreground. The long exposure adds movement and the flash etches in the details.

Electronic flash may be used not only as an illumination in its own right but also as a method of 'filling-in' the available light in any given situation. For this, the flash head may be used either in its on-camera mode or by means of an extension lead.

Most modern flash units have integral light sensors coupled to their circuitry in such a way that it is possible to pre-select an aperture of one's choice and set the unit to illuminate the subject accordingly. Instead of merely illuminating the subject with its maximum output, the sensing device responds to the light reflected back from the subject and cuts off the output during the emission itself. Knowing this, it is but a simple deduction to meter the available light prior to establishing the setting for the flash unit. The ambient light reading will give an exposure reading and its corresponding choice of aperture/shutter settings. Assuming that the reading offered will give, say, 1/60th second against an aperture of f8 then it is possible to set the flash sensor at either f5.6, or f6.3 or f8. In the first instance, the setting will give predominance to available light of a difference of 1 stop, in the second, a half stop, and in the third it will equalize the ambient light with the flash itself.

In the last instance, it may well be that the two exposures being equalized will have an adverse effect on the nature of the photograph and that, preferably, the second option (half a stop under) will retain more of the 'feel' of the subject matter, especially when shooting against the light. These are questions of subjectivity really and it is advisable to spend some time making notes and experiments on just the type of result that is anticipated and preferred. This technique is widely known as Synchrosunlight, due to its usefulness in reducing contrast within the shadow areas in harsh sunlight, but of course it works equally well in conditions of dawn, twilight or *contre-jour*. Unlike tungsten or studio lamps, electronic flash is virtually the same colour temperature as daylight, and therefore it is wholly viable to mix the two light sources without undue problems of differing colour balances.

Far left: Flash is not restricted to usage coupled directly to the camera – in fact this can often be the least satisfactory way of using it. In this photograph of a sprinter, however, flash has been used as a direct fill-in against the setting sun and without it there would have been no detail at all in the athlete's face and clothing. It is best to take a reading of the light level of the rear illuminant – in this case, the evening sky. If this offers a reading of, say, f8 then it will be beneficial to 'clip' the exposure on the flash by setting its sensor to f6.3 – slightly lower than for the sky. This allows the figure not to be fully equalized against the evening light and gives the picture detail throughout, without burning out the highlights.

Left and below: An interesting offshoot of flash is its potential for multiple or stroboscopic exposures when recording fast sequences of action on one piece of film. It is important that the background remains darkened throughout, otherwise it will merely 'bleach out' the effect that is likely to be achieved. The gymnast figure has been exposed on an 'open shutter' position, over a period of a few seconds. When the shutter is tripped into its open position the figure is etched against the dark background by a succession of exposures. This builds up a cumulative trace on the film. In the case of the tree frog, the technique is essentially similar, employing four very high speed exposures.

Additionally, electronic flash has particular characteristics in regard to the speed of its emission, for, with close-up photography in the automatic mode, the duration of the flash may be reduced to as little as 1/4000th second; most applications are within a speed range of 1/500 to 1/1000th second however. Provided conditions are appropriate and the ambient light kept to a minimum, the very high speed of flash (and thus exposure) means that it is possible to use electronic flash not only for the recording of high speed action but also the cumulative build-up of that action. Far from needing a high shutter speed, with this technique it is possible to use the shutter in its Bulb setting and merely build up the picture by means of the multiple flash images within the camera itself. Quite apart from its aesthetic properties, it is an invaluable tool for scientific research and motion analysis.

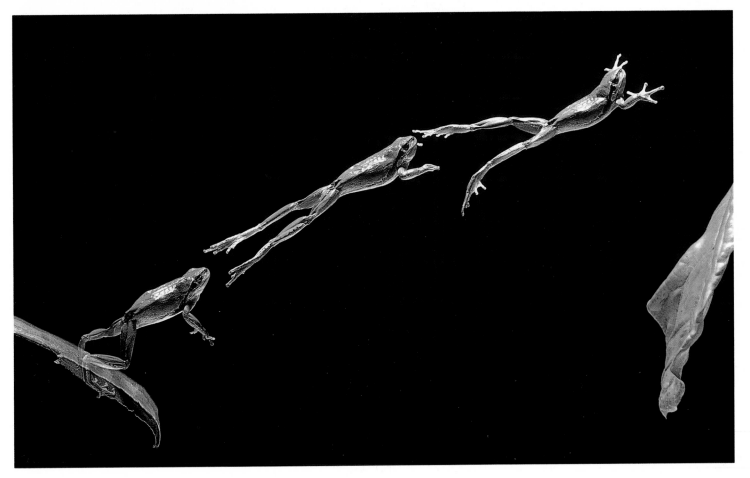

THE STUDIO

For much of the history of photography, daylight alone has been sufficient – many great photographers prefer it to all other forms of lighting. Therefore, it is probably best not to try to black out the available light from a studio but to make as much use of it as possible. You could even try to augment it. Another guiding principle when setting up a studio is not to be too ambitious – a great deal can be achieved through improvisation and pre-planning. As a priority, choose the largest window light available. If possible, make it a north light, for this will avoid the irritating fluctuations in sunlight that can occur throughout the day. Clear the floor space and give yourself plenty of room to move back from the subject. To support background materials it is best to use specially designed expanding poles. These consist of sectioned uprights that are springloaded so that they are held vertical under tension between the ceiling and the floor. The second indispensable item is a large roll of background paper – choose white, grey, or halftone amber or brown. A selection of rolls will enable you to ring the changes on making your subjects 'read' against the background and, even if you do not use it in the photograph itself, a large roll will help as a reflector.

Lights and accessories

For lighting, you can do a great deal with available light, but this can be inadequate on a particularly dark day and there is a likelihood of bluish casts ruining the day's output. You can augment the daylight with a small flash unit directed from the same angle as the available light – it will 'lift' the detail and ensure that the colour response is accurate. Colour film is particularly sensitive to unwanted casts and sun on trees in the garden, for example, may well have an adverse influence on the colour of the light coming through the window.

Better still, base your lighting on at least one portable 'monolite' electronic semi-professional lighting unit. These are absol-

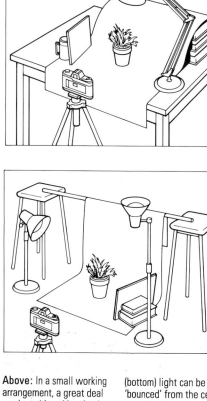

Above: In a small working arrangement, a great deal can be achieved by simple methods of improvisation. A single light source, together with a corresponding reflector, and a large sheet of seamless paper, is an excellent starting point (top). If more than one light source is available (bottom) light can be 'bounced' from the ceiling or walls. A change of eye-level can be achieved by altering the height of the background material.

Below: It is important to control the overall quality of lighting, if necessary, by using movable blinds. Boards, with white and/or reflective metallic finish, are important for reflecting

utely indispensable for the total control of both colour and light. They are particularly suitable for use in a domestic studio as their power requirement is no greater than that required for domestic appliances. You will also need a good external flash meter and a large umbrella reflector. Apart from this, you can improvise with household objects, such as greaseproof paper, white tissue paper, cooking foil, and sheets. An extension power cable is also essential for placing the lighting wherever you need it, and it is better to arrange this beforehand, not while you are working. You should also keep tape, and adhesive putty on hand for fixing things into position. From the

and masking out light. In a studio that is to be used in a temporary configuration, expandable poles are handy for supporting paper, lighting units or reflectors. Electronic flash units should be employed that allow for visual evaluation by means of modelling

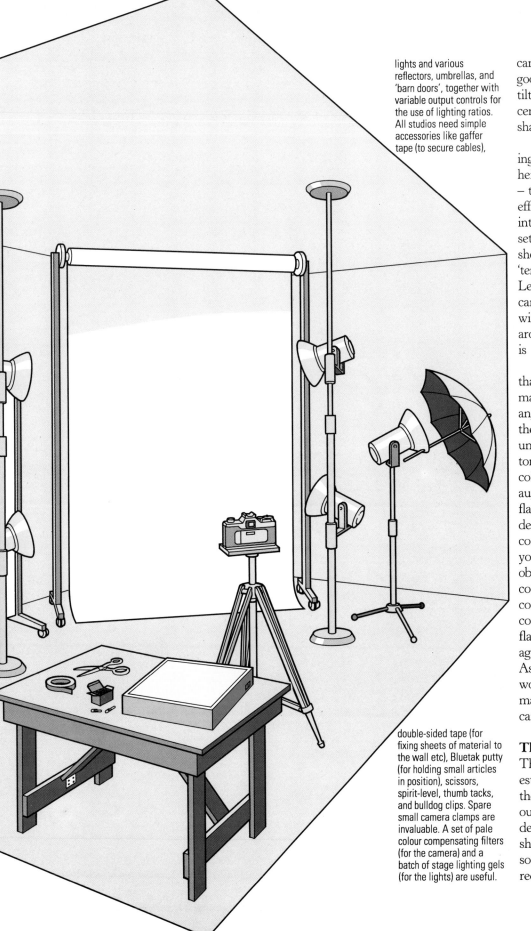

lights and various reflectors, umbrellas, and 'barn doors', together with variable output controls for the use of lighting ratios. All studios need simple accessories like gaffer tape (to secure cables), double-sided tape (for fixing sheets of material to the wall etc), Bluetak putty (for holding small articles in position), scissors, spirit-level, thumb tacks, and bulldog clips. Spare small camera clamps are invaluable. A set of pale colour compensating filters (for the camera) and a batch of stage lighting gels (for the lights) are useful.

camera viewpoint, it is essential to have a good firm tripod with a universal pan-and-tilt head, extending legs and a winding centre column. Use a cable release to avoid shake during long exposures.

One of the main drawbacks of employing a domestic room for a studio is lack of height, but try to make positive use of this – the ceiling is well placed to double as an effective reflecting light source. If you intend to work on relatively small studio sets and table-top still-lifes then you should improvise some form of translucent 'tent' within which to place the grouping. Leave an aperture at one end for the camera to view through and experiment with various ways of placing the lights around the tent so that a shadowless effect is created within the subject area.

If it is impossible to arrange the room so that direct sunlight does not strike the main window then use venetian blinds and angle them so that the light is reflected to the ceiling. Black and white photography under these conditions can yield satisfactory results but beware of the limitations of colour, especially if you do not intend augmenting the daylight with electronic flash. The eye is notoriously fickle and deceptive when it comes to judging errant colour temperature and merely adapts as you work – the camera will not be so obliging. If you do not have an accurate colour temperature meter (and an accompanying comprehensive set of colour-correction filters) then you should 'inject' flash into the lighting to regularize it, but, again, an accurate flash meter is essential. As a priority, do not be too ambitious, work well within your limitations and you may well be surprised at the results you can achieve.

The professional set-up

The essential difference between a domestic studio and a professional one is that the latter must have the potential for a high output of light. This is vital because a great deal of work is carried out on large-format sheet film (measuring 5×4 in to 10×8 in) so for large sets a small aperture is often required. Of course, daylight can still be

used, but the day-to-day consistency of daylight illumination is simply not reliable enough for work of the highest calibre. This is not merely a question of light, but of the *colour* of the light. More and more, studio lighting has come to mean electronic flash, for the following reasons: it is wholly reliable in output with negligible variation in colour; unlike tungsten light, there is no problem with the correction of daylight film or the use of ambient daylight; and portability is not a problem in a studio situation. However, it is preferable to have the facility to shut off the windows totally so that the studio may be controlled from within. Even with high output on large electronic units there may well come a point where even full power on all flash heads is still not enough. Using modern meters for electronic flash it is feasible to employ multiple bursts to 'build up' the exposure and thus it is important to use open flash technique for this.

Having installed the light, it is then necessary to control and direct it, to vary its size, output and effect, and for this a large variety of light modulators is essential. All professional electronic equipment has the ability to perform in much the same way as incandescent lighting, and can therefore be controlled by baffles, **'barn doors'**, cowls and shutters to confine and accentuate the direct light. Similarly, the flash heads come in a variety of forms, and can offer lighting that is very much like the light from a window by softening the light source behind a large opalescent diffuser. The judging of this type of light is greatly helped by in-built, switchable, tungsten lights that are used for estimating the modelling effect – these are referred to as modelling lights. From the direct use of light, it should also be possible to employ indirect reflected light, and for this movable screens are a vital part of the studio furniture. It is possible to soften the light still further by using large reflectors.

When arranging this type of studio, you should keep the work area as open and variable as possible. Build in wall hangings for seamless paper backgrounds that may be changed at a moment's notice from their rolled position high on the wall.

Right: Shot with a 150 mm lens, on a Sinar F 5 × 4 camera. Lighting arrangements: A, 2K tungsten light; B, diffusion fabric with slit to soften the effect of the 2K and to add interest; C, background fabric lifted at one corner to allow the light through; D, reflector. This lighting arrangement was organized to bring out the texture of the garment. Design and graphic composition were important elements in the photographer's conception of the final image.

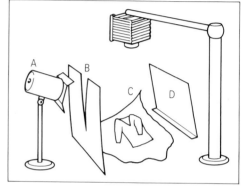

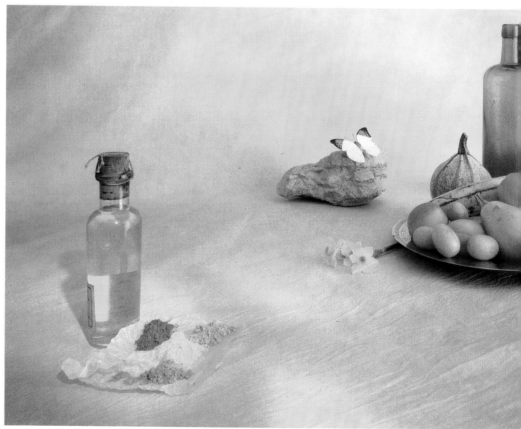

Right: Shot with a 65 mm Super Angulon lens, to give exaggerated perspective, on a 5 × 4 camera. Lighting arrangement: A, B, side and top reflectors; C, strip light through perspex (D) to throw soft light; E, hand-dyed sheet using dylon and built up in tones of ochre and yellow; F, spotlight with special filter to throw dappled light on left foreground area; G, camera. The aim was to bathe distant objects in very soft, natural light, to highlight the artists' materials in dappled light, to throw shadow and bring out the texture of the pigments and the quality of the liquid in the bottle.

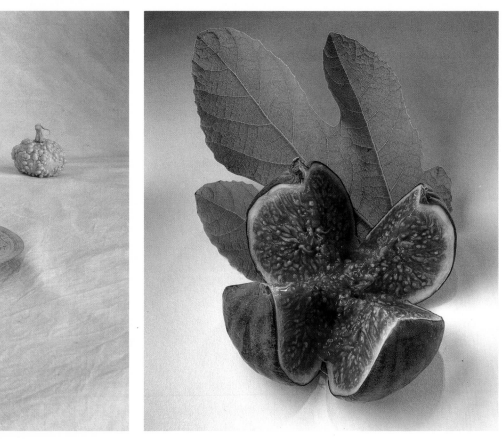

There should be at least three available in position at any one time. For still-life work, a movable table is equally important, providing the facility to introduce quickly and simply both smaller rolls of paper in the background and transilluminated baseboard (for the photography of glass, for example) beneath the work area. Another important aspect, if much work with models is envisaged, is an appropriate area for changing and make-up, together with basic washing facilities.

As a back-up, there should be a high quality studio stand, with horizontal and vertical orientation and which will readily accept heavy duty studio cameras. Do not economize on the flash meter – buy the best you can afford: it is the vital link between exposure and processing. A selection of tools is vital for improvised sets, as are clamps, batons, and wooden laths for holding the movable flats in position.

There are, of course, sophisticated accessories like beam splitters and back projection units. These items may be hired, as can extra power, from specialist dealers. Similarly with props – do not fill your studio with rubbish that is never used. Keep it spare and lean so that you can work efficiently and well.

Left: Shot with a 180 mm Schneider lens, on a 5 × 4 camera, lit with electronic flash. Lighting arrangement: A, small perspex box light to give general fill light; B, two spotlights positioned behind, to shine through the leaves; C, honeycomb spotlight, which gives a wider shaft of light, positioned directly overhead; D, small perspex box light; E, card reflector.

The problem was that the outline of one fig was perfect but the inside was raw. So, the inside of a ripe fig had to be 'transplanted' into the shell of the one shown here.

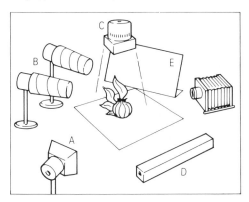

FILMS
AND
PROCESSING

'Photography is still a very new medium and everything must be tried and dared . . . photography has no rules. It is not a sport. It is the result which counts, no matter how it is achieved.'

BILL BRANDT

'HAG' (Ian Hargreaves)
URBAN GROWTH
1978

FILM – HOW IT WORKS

The most fundamental constituent of photography is the film itself. It was not the early image-forming camera obscuras (see p. 12) that had enabled photography to begin, but the production of a light-sensitive surface upon which the fleeting image could be captured and *retained*. The simple principle upon which Nicéphore Niépce had worked to achieve this breakthrough was based on an asphalt used in lithography and which hardened when exposed to light – the unexposed areas remained soluble and were washed away. It was but a short step to extend this experiment to a simple camera and by doing this Niépce took his celebrated photograph of his courtyard by an exposure of a day's duration – when the plate was washed in lavender oil the recognizable image remained.

A contemporary of Niépce and 22 years his junior, Louis Daguerre confounded the French Academy of Sciences in 1839 with the introduction of his own process, the Daguerreotype, which was in fact based on a process entirely different from that of modern photographic emulsions. The image was created by sensitizing a highly polished surface of silver coated on to a copper sheet. This was done by bringing it into contact with the vapour of iodine crystals within a dark box. After exposure in the camera, the plate was then removed to another box containing heated mercury vapour which, in turn, developed the latent image to produce the uniquely characteristic tonal quality of the early Daguerreotypes – an immensely detailed and finely gradated image that could be held, savoured, and changed by tilting as the light articulated the surface of the silver. But despite the wondrous quality of the invention, the process was limited by its construction – each Daguerreotype was an original, a one-off, and impossible to duplicate; the coating was difficult and the procedure laborious.

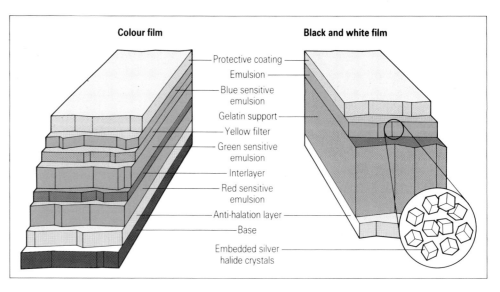

Hard on the heels of Daguerre, William Henry Fox Talbot presented a report on his own negative-positive process to the Royal Institute of Great Britain within three weeks of the announcement at the French Academy in 1839. A talented amateur scientist with a leaning towards fine art, Talbot had long wished permanently to capture the images from the camera obscura (see p.12) that he had used in his field sketches. He based his work on sensitizing paper, which he first dipped in a saline solution, with a coating of silver nitrate solution. His first results were actually what we would now refer to as **photograms** – that is, contact images formed from the original subject matter (ferns, leaves, plants, etc) by exposure to sunlight. His great contribution came from pursuing the idea of further re-exposing the negative to make a positive print, via the same process, and then to apply this to his first experiments with an actual camera system. The negative-positive process was born.

This, essentially, is the basis that still governs the medium of photography. Countless innovations have taken place and the blossoming of the photographic process towards the end of the 19th century can be likened to the vast changes in public transportation after the invention of the motor car, or to the proliferation of aviation after the achievements of the

Wright brothers. To enter into such a complex dialogue is not appropriate here other than to say that, in essence, the 'magic' that captivated both Daguerre and Fox Talbot is with us today. The magic box remains, as does the negative, and although the systems and formulae alter, it is the unique thrill of seeing the image produced by the developing agent that continues to enthral.

The process
The negative forms the image through the action of the light that strikes it, darkening in proportion to its intensity, and by the action of the developing agent upon it. The structure of a modern film is complex in the extreme but, simplified, it consists of a light-sensitive emulsion (almost always silver bromide in gelatine) coated on to a transparent support. The early use of glass as a support has been almost universally abandoned nowadays in favour of film. Film may be characterized by any of the following criteria: these are, speed, colour sensitivity, gradation, granularity or graininess, resolving power, and development characteristics.

On exposure of a modern negative film to light, the small compound salts of silver, silver bromide, silver iodide and silver chloride (which are known as silver halides and are effectually the 'grain' of the film) form new atoms of metallic silver; and

Opposite: A modern black and white film consists of a light-sensitive emulsion coated on to a suitable support. The base is usually cellulose-acetate and the light-sensitive crystals are coated with the assistance of an adhesive layer to the support, topped off with a scratch-resistant coating. At the rear of the support is a further coating of anti-halation backing to minimize the adverse effect on definition of light scatter through the support.

Right: Of the three basic types of film, the oldest and most traditional is the monochrome negative. This employs the principle of reversing the values of light intensity that fall on the sensitive emulsion. Accordingly, the densest areas on the negative represent the lightest parts of the subject and vice versa.

Centre: This is in direct contrast to the colour reversal (or transparency) system. Here the values of the latent image are first of all developed as a negative and then reversed to produce a directly viewable transparency with values that are proportionally similar to the observed scene.

Bottom: The colour negative process conforms to similar behaviour in the printing process – longer exposure means a darker print. When directly compared to its monochrome counterpart the image can be seen in reverse, but the colour values, when compared to the transparency, are also reversed. Thus it is that the lemon appears blue – which is the complementary of yellow. The overall orange colouring is due to the inherent colour masking and is common to all modern colour systems.

the developing agent (usually metol, phenidone and hydroquinone) converts this latent image to black metallic silver. This forms a residual image after the remaining unused silver salts are dissolved and washed away during the fixation process and thus represents the values produced in the camera, but in negative terms, and directly proportional to the amount of light that has activated them. The image so formed is really the 'halfway stage' to the production of the photograph and has to go through yet another stage to reconstitute the positive values in the original, either by projection (in an enlargement) or by contact printing. The process is similar for both black and white and colour negative films.

The other type of films, which are called reversal films, are used to produce transparencies and are used almost exclusively for colour photography. With this type of film, there is no production stage to concern the photographer and, as the name implies, the values of the latent image are reversed during the development process, offering direct positive images of the original subject.

The negative affords the photographer ultimate control, whereas the colour transparency limits you almost exclusively to controlling the image within the camera and at the taking stage. In monochrome, adjustments can be made to both the tonal scale of the negative and its corresponding print by both development control and using different contrast grades of paper; the colour negative, on the other hand, has a limited tolerance to exposure variations, and virtually no variable contrast.

In the development of negatives, the image quality depends a great deal on the degree of time, the temperature, and the amount of agitation of the developing agent and this has a critical influence on aspects of expressive content. Therefore, it is advisable to select films carefully, to note the way in which they perform, and to adopt a working procedure that suits you, the type of result you want to achieve, and the kind of subject matter that you are going to shoot.

CHOOSING A FILM: BLACK AND WHITE

One of the most important considerations when choosing a film is its sensitivity to light and thus its ability to operate within given light levels. As well as its sensitivity, the coating of a film has a direct influence on its ability to resolve detail: the more sensitive the emulsion is to light then, by the same token, the more coarse, or 'grainy', is its imagery. Accordingly, a simple rule of thumb acts as a basic criterion for film selection: the finer the film, the slower it is, while the faster it is the coarser it gets. Just as the choice between shutter and aperture exists on the camera as a basis for determining the priorities for any given exposure situation, so the choice for films falls between two extremes: speed against resolution. Films that are grouped between these two classifications of fast and slow are referred to as medium-speed films and are seen as having the nearest equivalent to the best of both worlds, allowing usable hand-held exposure times in conjunction with excellent reserves of definition.

Film speed is referred to in a film's specification by the emulsion speed figures or exposure indices. These are currently expressed in terms of ISO (International Standards Organization) Ratings, which have derived from the earlier systems of ASA (American) and DIN (European) standards, the ISO now being expressed in a combined form from the two figures. Thus a film with an exposure index of ASA 64 and DIN rating 19° is now expressed as ISO 64/19. Films within the range of 25/15 to 64/19 may be considered as fine-grain or slow, between 80/20 and 200/24 medium-speed, and 400/27 to 3200/36 fast.

The other factors that should influence film choice are their performance in conjunction with chosen developing agents

The photograph near right (top) has been produced using an extremely fine-grain film which is correspondingly slow – 25 ISO/ASA. But at this scale the photograph could have been produced satisfactorily on any film. In the details opposite it soon becomes apparent where the stengths and weaknesses of different film speeds lie. In the first detail (bottom, near right), at about twenty times magnification, the notes of music are crisply defined. But notice the difference in rendition in the second detail (bottom, far right, in which the film used was nominally rated by its manufacturer at 3,200 ISO/ASA: the high sensitivity degrades the recording of fine detail.

By comparison, the photographs left show the resolving power of a 400 ISO/ASA film and its equivalent increase in magnification to the other two examples. The definition remains quite good, even down to the small markings on the distant hill.

and whether or not it is intended to adhere to the original recommended exposure index. The speed ratings are a method of indicating the film's optimum potential, but they should not be looked on as something that can never be changed – quite the contrary in fact. The development of the film is a crucial part of the selection process and you should bear this in mind when first making the choice. The exposure index is only one of several factors that determine image quality and is not independent of other considerations such as the extent and method of exposure, the developing agent and method of development – and even this omits the crucial questions of printing and darkroom procedure. Therefore, the best guideline for film selection is to choose the finest film that subject conditions will allow. This is especially important when using 35 mm format, for being the smallest

serious format in current use, the degree of magnification is that much greater for prints of any reasonable size. Grain will therefore show up that much more. It is worthwhile to remember that the nature of the intended subject is also important. If you are shooting an architectural subject for example, subject movement will not be a problem, although depth of field and fine resolution are both likely to be required – the subject will be static and a tripod may be used. However, if the subject is dancing or sport the arresting of movement is vitally important and so a 'fast' film will be an essential requirement.

The trade-off between speed and resolution has been the perennial dilemma of film selection throughout this century, but recent innovations in film technology have narrowed this gap somewhat. Newly developed chromogenic films owed their existence to the concern being felt for

diminishing silver resources worldwide and, surprisingly, to colour film technology. Much less silver is used in these films and it is used only as a guiding agent for the inherent dyes that make up the image. Instead of conventional developing agents, the films can be processed in chemicals normally reserved for colour negative materials although the film manufacturers also market their own equivalents. The surprising feature of these relatively fast films (ISO 400/27) is that overexposure does not seriously or adversely affect image quality. This is because the image is formed by dyes, rather than by patterns of silver halides. Many photographers remain sceptical however, and argue that the negatives themselves are less permanent and durable.

Specialist applications require specialist solutions and films with quite particular properties exist for work such as copying and high tonal separation. Modern conventional films have a sensitivity to all colours of the visible spectrum, with a higher sensitivity to the blue end, and these are classified as **Panchromatic**. Their sensitivity means that it is impossible to develop these films visually by anything other than a very low safe-light of very selective emission. However, for high-contrast copying this is irrelevant, as is a full tonal scale, and therefore Copying films have a quite different response, being insensitive to the yellow-red section of the spectrum. These are called **Orthochromatic** films, and include high-contrast line films and even higher contrast films called lith films – the latter require a special two-part developer for their proper use and offer the highest possible contrast with no intermediate separation between black and white. Lith films are extremely useful for copying letterform text and pen drawings.

They may also be used for experimental work in high contrast and it is useful to employ them as a separation stage from conventional negatives by projection in an enlarger and then control precisely the graphic results that this gives before reverting to a new negative by repeating the process again from the positive. In all of these applications, visual inspection is recommended. The films are so slow and insensitive to quite bright red safelighting that it is wholly feasible to work with them in developing trays as in conventional printing. Most of these specialist films are available in 35 mm format.

Infrared monochrome film is also available. It was originally made for scientific applications and has unique properties. Used as a conventional film, by means of a special opaque filter, infrared can render a unique and haunting quality to landscape photographs (see p. 124).

CHOOSING A FILM: COLOUR

Unlike black and white films, there are two basic colour systems from which to choose. The negative process offers prints and the reversal process offers transparencies for projection. If necessary the systems can be interchanged, with the negative process providing slides through printing on to special film, and the reversal material allowing prints to be made from the original transparency; but these are essentially secondary options and it is infinitely preferable to choose the appropriate film in the first place for the end product that you require. It is generally accepted throughout photographic retailing that in colour film, the suffix '-color' indicates a negative type film, while '-chrome' indicates a transparency material.

Having decided on either prints or

Opposite: Two basic choices exist for the selection of colour films, either reversal or negative, but as with their black and white equivalents, slow/fine, fast/coarse or medium/general-purpose types exist for both. Again, the faster the film the coarser the grain structure and the less capable it is of rendering fine detail. Also, matters of inherent contrast are brought into play, as are questions of subjectivity and personal preference. Slow films are rated at below 100 ISO/ASA, medium general-purpose between 100 and 400 ISO/ASA and fast above 400 ISO/ASA. This applies equally to positive and negative systems. In the examples shown both full frame and extracted sections are compared. Far left: 64 ASA; centre, 200 ASA and left, 1000 ASA.

Below: In these examples similar considerations apply to the negative films as to their reversal counterparts and, equally, the same choice of speed against resolution pertains. However, modern film technology is now so sophisticated that the former limitations of fast colour films are considerably lessened. There is little appreciable difference between the film at 100 ISO/ASA, left, and that at 400 ISO/ASA, centre. There is, obviously, a fall-off in the final example at 1600 ISO/ASA, right, but this is not as dramatic as might have been thought. However, saturation is degraded – though for some photographers this might well be of advantage when a particular softness of colour is desired.

transparencies, the second question concerns the conditions under which the film is likely to be exposed. Colour film differs from the human eye in that it does not self-compensate for the difference between daylight and artificial or tungsten illumination and therefore two types of film have evolved and are known by these designations. Compared to daylight, tungsten studio lamps burn at a lower colour response, known as colour temperature; if film balanced for daylight response is exposed in artificial light then the resultant colour is unnaturally 'warm' in appearance. Therefore, artificial light (or tungsten) films are manufactured with an in-built blue shift to their colour which is opposite to, and thus neutralizes, the warmth of the studio lights. If such a film is exposed in daylight conditions then the result is unnaturally blue in character; this can be corrected, however, by filtration and it is extremely useful to have an amber conversion filter that will allow the use of artificial

light film in daylight illumination.

As with black and white film, the cardinal rule is to match the film type to the task at hand and particularly to settle the question of prints or transparencies before you do so. The benchmark for quality in colour transparency begins at ISO 25 and extends through the speed range up to ISO 1600. For negatives it begins at ISO 100 and extends to ISO 1600. Colour film follows the same basic rules as black and white film, in that as the speed increases then so does the granularity. Colour negative film has good exposure latitude, but colour reversal has not, the typical range not exceeding three stops. Careful use of the exposure meter is critical to the successful use of reversal colour film; this will be considered in greater detail at a later stage (see pp. 92–3). If there is to be any error at all with the exposure of reversal film, then it is preferable to be slightly under-, rather than over-, exposed.

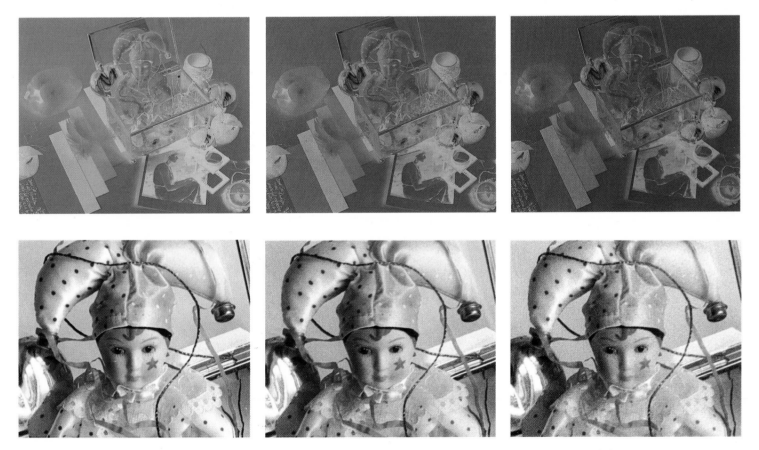

THE NEGATIVE

After the exposure of the film, its development provides you with the language of the medium itself – the negative. This particular stage, though relatively simple to perform, is a crucial one in the production of the photograph for the negative contains all the information that you have tried to capture on film and which, ultimately, you will reconstitute in the print. If the information is not there then, quite simply, there is nothing that can be done to restore it in the print.

There are three separate steps to the development procedure, each requiring a different chemical solution: the developer, the wash (preferably with a stopbath) and the fix. The developer transforms the latent image from the exposed film into black metallic silver; the stopbath arrests the action and prevents the developer contaminating the final solution, which fixes the negative permanently so that it can be viewed and handled in full light. Before commencing, you should organize the work surface into 'dry' and 'wet' areas and order the range of tools logically for use in total darkness. If you cannot darken a room, it is nevertheless possible to handle the film and load the spiral and tank with the aid of a changing bag – a large double-thickness black bag with buttoned openings and elasticated sleeves that enables your hands and lower arms to function while leaving your head clear.

The basic equipment for film processing consists of a graduated mixing flask, thermometer and funnel, a timing device with minute intervals, a suitable processing tank with its spirals, and a good supply of washing water, preferably with warm water mixing too. An additional useful accessory is a pair of rubberized kitchen gloves, especially if you have sensitive skin which may be affected by the chemicals. In addition to the three basic chemical steps, you should make provision for a suitable wetting agent to assist in the uniform drying of the film, together with two film clips for suspending the film to dry.

Before commencing the processing procedure, you should bring the solutions to the appropriate temperature, since the control of density in the negative depends on the accurate monitoring of temperature as well as the developing time. This is best achieved with a tempering unit, but if this is not available then you can use the water-jacket method – a large bowl of water at the correct temperature acts as an insulator against loss of solution temperature. In this, as in other aspects of darkroom work, it is best to evolve methods and procedures appropriate to your needs and facilities. If a darkroom is available, it is useful to decant the developing agent into the tank before extinguishing the lights. This will allow the developer to 'settle' to the required temperature before you load the spiral. Then you can plunge the film directly into the developer under controlled conditions, minimizing the risk of air-bells or developing streaks.

Another simple precaution is to check very carefully the required loading method of your film into the film spiral. Some models (usually plastic types) load from the edge by means of surface tension and a progressive 'rocking' action with the wrists, while others (usually stainless steel) load from the centre. Secondly, place the spiral on your work surface so that you can easily identify the direction that the film needs to be offered to it, for, once you are in the dark, it can be most frustrating to be unsure of this simple step. With larger films (such as paper-backed 120 roll-film) it is particularly important not to crease or crinkle the film during spiral-loading as this places small crescent moon marks on the film that are impossible to remove. Load the film into the centre-spirals with a slight bowing that straightens as the film meets the appropriate channels.

Carefully measure the appropriate quantities of developer and water according to the manufacturer's recommendations and for the type of density and contrast you wish to achieve. Prepare your tanks and spirals in sequence and check that you have the sealing lid at hand, together with the central cap that enables the inverse agitation to take place. As a last step, ensure that your timer is properly cocked and ready for activation, then double-check the temperature of the developer and its water-jacket before extinguishing the lights. If you are not using the instant immersion method in total darkness then pre-load the film and secure the lid of the tank and quickly pour the developer in through the tank's opening – the less delay the better, as this minimizes risks of 'streaking', which can occur if you take too long and the developer runs in small rivulets over the surface of the film. Activate the timer and, first of all, tap the base of the tank on the bench to dislodge any airbells that may have formed; then immediately invert the whole tank several times during the first minute of development – this bathes the film in fresh developer and activates the developing cycle. After this, agitate the tank for about five or ten seconds every minute, allowing it to rest on the bench in its water-jacket between agitations.

Above all, be consistent about everything you do, for it is very important that you work in such a way that you can repeat the process again and again, varying it intentionally, if necessary, for special needs. Many people adopt their own particular methods of working. For example, some photographers feel that the best way to minimize the problem of airbells is to pre-soak the film in clean water just before development, but if you do this once then you should always do it. Agitation is particularly important – too much causes excessive contrast and risks uneven flow marks from the wave patterns of the developer; too little leads to flatness and uneven development.

When development is complete, pour off the solution and give a full rinse of clean water as soon as possible or, better still, use a solution of an acetic acid stopbath to neutralize the developing action and also to minimize any risk of 'carry-over' of developer, however small, into the fixing bath. The fixing procedure is not a critical one in comparison to the developing period, and indeed it is often

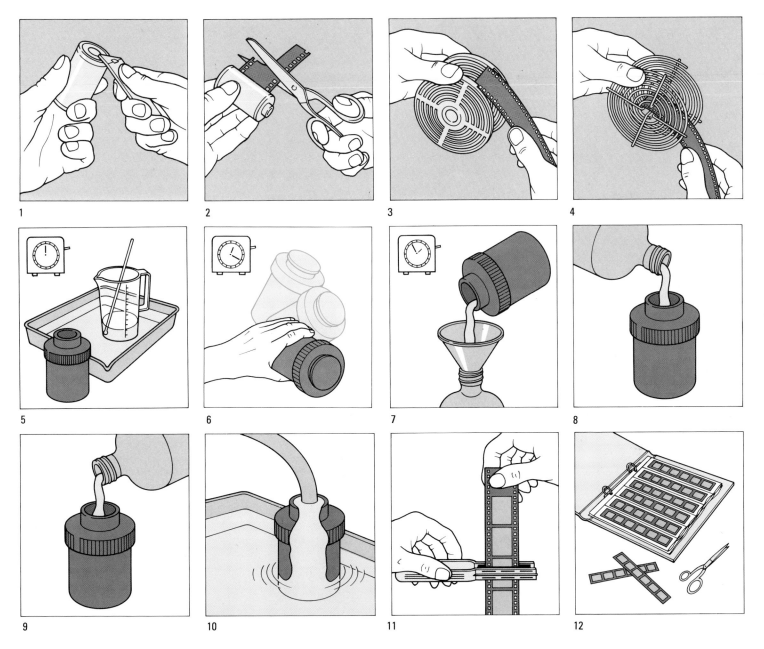

1 2 3 4

5 6 7 8

9 10 11 12

useful to remove the lid from the tank to check that everything is in order after the first half of the fixing period is over. The support of the film should, at this stage, be clear and the 'clearing time' is a useful guide to ensuring that your fix is fresh and energetic. If the film appears milky, mix a new bath of fix. Otherwise, do not throw away the fix, but use it again. During the second half of the process, the film will not be harmed by light, but an exhausted fix will limit the life of the negative.

Above: When processing it is essential that you adopt particular working procedures. If the tongue on the film is showing, trim it off (**1**). Check your spools for type and the procedure for loading (centre or edge ?) and place them in proximity to the tank and its lid sealing cap. Turn off the lights. Some cassettes require an opener (**2**) to remove the base. Check the leader and if necessary trim in the

dark before loading the film into its spiral. This will be edge-loading (**3**) or centre-loading (**4**) – check with the forefinger that the film is being offered to the spiral the correct way around, especially when centre-loading. After loading the film on to the spiral, there should be no 'extra' film left – if there is then it is incorrectly loaded. Place in tank, attach light-proof lid and its sealing cap and switch

on the lights. Mix and check the temperature of the chemicals according to the manufacturer's instructions (**5**), set the clock and pour in the developer. Start the clock and invert the tank continuously for the first minute (**6**) and thereinafter for 10 seconds every minute. Upon completion of the development time, pour off the developer (**7**) and replace it with a suitable stop bath (**8**).

After a short rinse, pour off and replace with the fix (**9**), preferably with a hardening agent – agitate and allow to stand for 10 minutes. Pour off and wash (**10**) thoroughly with running water for 15 minutes. A final rinse in a wetting agent helps drying, or small film squeegees may be used sparingly to remove water (**11**). Hang in a dust-free area; when dry, cut and store in a file (**12**) in six-exposure lengths.

TIME, TEMPERATURE AND AGITATION

The negative, as the basis for the print, contains all the information that you have sought to convey. Ansel Adams has likened it to 'a musical score . . .' and added that each successive print from the negative is 'the performance of that score'. Therefore, it is reasonable to adjust that performance to precisely the mood you are trying to communicate and, in order to do this with any conviction, you should be familiar with the particular characteristics of the elements that make up the processing procedure.

There are, in essence, four factors which condition the final appearance of the negative, provided that the solutions are fresh and uncontaminated; these are time (the length of time in the developing agent), temperature (the degree of warmth of the developing agent), agitation (the amount of movement of the solutions over the film surface during its development), and the developer itself (its characteristic properties and its relationship to the film in use).

Taking the developer first, most agents are formulated with specific aims in mind: either to provide fineness of grain structure and resolution, to give high contrast or to suppress contrast, or to enhance and upgrade the 'speed' of the manufacturer's specification for the film. In addition, the combination of the film and developer influences the final result, since one cannot exist independently of the other. So the way a film will behave in the darkroom and the chemicals you will need to develop it should influence your initial choice of film as well as your darkroom procedure. Developers are produced in many varying and complex types, with high dilution ratios, as 'one-shot throw away' types, or as stock solutions for deep-tank development and replenishment. Broadly speaking, they fall into four groups. *General fine-grain* all-round developers, in the tradition of Kodak D76 and Ilford ID11, are the 'classic' formulae for use in all photographic applications, without recourse to 'specialist' fine-grain properties. *Fine-grain*, special developers intended for optimum detail and resolution, have a tendency to 'hold back the highlights while the shadows catch up' and are often known as compensating developers because of this; they tend to lose effective speed from the original index and may require slight adjustment in exposure at the camera stage. *High-definition* developers work on the principle of adjacency, the edge-to-edge separation of the areas of tone, and thus enhance the 'bite' of the definition, with a slightly sharper grain pattern, and possible increase of film index; these chemicals are often confused with fine-grain developers. *High-energy* agents are designed to offer increased film speed from already fast emulsions exposed under difficult lighting and exposure conditions.

Each of these respective agents has its own particular role in the altering of contrast by virtue of its particular formula and emphasis, so the choice of developer should be influenced by the following factors: the original subject, its lighting and contrast; the type of film used to record that subject; the measurement of the light and its contrast; and the material upon which you intend to print the final picture. This ability of the developer to affect the

Above: The importance of temperature in development may be seen in these three negatives, all of which were exposed identically, at the same time, as per the speed index and all of which were processed for precisely the same time. The difference between them is due entirely to the variations in the temperature of the developer and its agitation. On the left, the temperature was 62°F (17°C), and there was no agitation; the centre negative was developed at 68°F (20°C) (normal recommendation) with one inversion per minute; the right-hand negative was developed at 80°F (27°C) with vigorous agitation. Note the differences in tonal scale, density and shadow detail.

Above: The third method of controlling the negative, after temperature and agitation, is time. Careful control of this factor can determine the nature of the tonal range within the negative itself and this, in turn, may be related to the question of original subject contrast and exposure. This is illustrated by the three variations on contrast and tonal range in these negatives. In the first example (left) the negative was overexposed and underdeveloped, resulting in a closer tonal range and less contrast. The second (centre) was exposed and developed normally, and the third (right) was underexposed and overdeveloped, resulting in wider tonal range and more contrast. Thus it is that the photographer can control the contrast range of the original subject in the negative by adjusting the length of development, in time, in conjunction with the amount of exposure originally given. The control of tonal scale by the variation of exposure and development is central to the 'zone system' originally devised by the West Coast f64 Group of photographers and perfected by Ansel Adams (see p. 216).

contrast inherent in the film is often expressed as its **characteristic curve**. The graph (below right) shows how extended development increases density in relationship to exposure, or how the opposite may be the case. Thus it is that a lesser exposure (in other words effectively uprating the film's index) may be compensated for by increased development times – however, this may affect contrast, density and granularity.

The effect of temperature on development is crucial because the warmer the developer, the quicker the development. Over the years, chemists have concluded that the optimum temperature for the black and white developer is 68°F (20°C). It is preferable to work to this recommendation, which is also a pleasant working room temperature. Increasing the temperature requires cutting the development time along with its levels of tolerance.

The question of time is equally important for it is the benchmark against which the density is gauged during the build-up of the latent image during development. It is also the point at which you can alter the technique for specific effects and controls, in conjunction with the way in which the

film was exposed in the first place. For example, it is possible to underexpose slightly on location due to 'flat' lighting and a desire to 'stretch the tonal range' when processing by extending the development. As a useful memory aid, such films can be marked 'plus one minute' on the leader or wrapper. If your procedures are accurate and consistent then you know precisely where you are when processing the negative. Indeed, this type of adjustment of tonal scale and density of the negative, due to the contrast or lack of it in the original, is central to the working method of many photographers. The 'zone system' is a very sophisticated extension of this principle. The great limitation of the zone system centres on the need to process each negative separately, so it is of little use to the 35 mm photographer.

Agitation, together with fresh developing agent, is also crucial in that it reflects the degree of activity on the surface of the film during the processing. Once more, consistency is the great virtue, coupled to a sound approach to the condition of the developer itself. For this reason alone, many people prefer to use the **'one shot'** principle rather than replenishing a stock

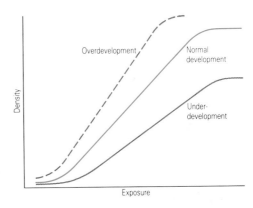

solution, for in this way the developer is fresh every time. Another critical factor is the shelf life of the chemical; some agents that have particular virtues in the form of fine grain and speed enhancement display a very rapid fall-off in shelf life. 'Classic' formulae such as D76 and ID11 have the virtue of dual usage, either as **deep-tank** or one-shot, coupled to use as 'stock', without dilution, or one-to-one (equal parts developer to water) or three-to-one (three parts water, one part developer). Others, such as Rodinal, have long shelf life and can be used in various dilutions, and thus can accommodate fine-grain and faster films with varying strengths of solution.

UPRATING AND HOLDING BACK

Once you have established a standard method of working, you will realize that changing any of the variables that influence development will alter the result. You can use this fact as part of your creative potential. After all, what is the 'correct' development of any given film, or for that matter its correct exposure? Often, it is alarming to get to a location and find that the light level is so low that your chosen film is unsuitable for use according to the recommendations of the manufacturer. In such a situation it is vital that you compensate for the low light in the development of the film. Unfortunately, there is no instant answer as to how much you should compensate: it depends on many factors, even down to the type of enlarger light source in your darkroom. This makes it even more important to standardize your procedure in normal applications before getting too immersed in 'magic' speed-enhancing formulae that probably only afford an extra stop in any case. Better by far, in all respects, is the simple expedient of taking a tripod to your location and avoid uprating your film too drastically.

Uprating
But if uprating of the film speed *is* needed, it is preferable to employ a speed-enhancing developer from the outset. Using it under 'normal' circumstances affords an extra stop in effective speed and its characteristic will favour extended development times – even though there will be a sacrifice in grain structure. You should avoid using slow films for this type of work as all their influencing factors are against it – as a simple rule of thumb, slower films are more inherently contrasty than faster ones and the process of 'pushing' their film speed merely adds to this, with little extra benefit. Faster films have a thicker emulsion and are more receptive to prolonged development times without unacceptable clogging of the highlights of the negative.

Right: There are many times when the manufacturer's film speed recommendations may be insufficient and may be altered by the use of suitable speed-enhancing developers and extended development times. In the first of the three photographs shown top right, the recommended index of 400 ISO/ASA has been extended to 800 ISO/ASA by the simple use of such a developer and then this, in turn, has been used to increase the effective speed rating further from 800 ISO/ASA to 1,600 ISO/ASA (centre) and 3,200 ISO/ASA (right). The corresponding build-up in grain structure is indicated in the sectional details (shown below each main print) from each negative. All three negatives were exposed under similar conditions.

Even so, it is essential, once the principle is adopted, to carry out extensive tests to work out precisely the kind of result you want and the particular developer that helps you to achieve this. Push processing tends to increase grain adversely but there is 'spongy' grain and there is 'sharp' grain – which suits the needs of the subject? That is a decision that you will have to make for yourself.

Holding back
By the same token, just as films can be 'pushed' in their development, they can also be 'held back'. Extended development and increased agitation can be used to extend the contrast, and hence the tonal range, of a negative that has been taken under conditions of low contrast, and it therefore follows that if contrast is exces-

sive at the time of exposing the film then curtailing the development should assist in reducing the contrast, provided that this is allowed for at the time of exposure and additional time given in anticipation of this. It is the classic dilemma of the 'groom's dark suit and the bride's white dress' and the problem of obtaining detail in both areas of the subject when such subject contrast occurs. In essence, an increased exposure and a decreased development will hold down excessive contrast, while 'clipping' the exposure and extending the development will tend to enhance the contrast of a flat subject with limited tonal range. Alternatively, in the case of the excessive contrast problem, the result can be adjusted by using a very fine-grain compensating developer. However, do note that this type of developer usually

loses an effective stop in exposure as part of its normal function and so extra time should still be built into your calculations when exposing.

Colour processing

All these techniques apply to black and white materials, which lend themselves particularly well to this type of control. This is why, in an age of colour, black and white retains its powerful hold. Colour negatives do not respond kindly to altered processing times and this is not recommended – the three layers of a colour negative perform 'out of phase' if improperly developed and therefore give unpleasant colour casts that no amount of colour correction can change. In such circumstances one area of the shadows will be shifted in, say, the green direction while

the highlights will move in the complimentary magenta direction. However, there is potential for the use of altered processing times in colour reversal (transparency) materials and many processing houses offer this as an extra service. Many professional photographers utilize this potential, but it needs careful monitoring and a great deal of experience. On a large complex shooting session certain rolls of film are set aside as test lengths for subsequent 'clip testing' at the laboratories and are then cut into lengths for processing 'normal' or 'plus half' (a stop) or 'plus one'. Within an hour the results can be checked and then the processor is advised of the photographer's exact preference.

However, it remains true to say that the extended development that is necessary with the uprating of the colour reversal

film does not afford a good tonal range and it is directly noticeable that the maximum density areas (the darkest shadows) lose their richness. Progressively the saturation of the colours deteriorates and it is probably a much better option to use a tripod and slightly slower shutter speed than attempt these rather pointless exercises of uprating. *In extremis*, it is useful, but is not to be relied upon.

Although home processing of colour films is wholly feasible, the tolerances are so much less than those in black and white work. The temperature of the first developer is critical to plus or minus $0.3°C$ and the temperature of solution is $38°C$. The shelf life of solutions is important and it is disappointing in the extreme to spoil work at home when it is so much more reliable to use a good laboratory.

BEGINNING TO PRINT

You can achieve a great deal in the darkroom with relatively modest resources. But it is better to avoid the perennial problem of blacking out the bathroom window and assembling then taking apart the equipment every time you need to print. It is better to try and use a regular space and keep it for that purpose and order your working area to suit your needs on more than a casual basis. Just as you need to be consistent in your processing procedure, so it is important to control the printing (and particularly the testing) of your photographs. This question of accurate testing is extremely important in printing because it allows you fully to justify the tonal values that exist in the negative and, particularly, it enables you to get the very best from the materials in matters of gradation and depth.

As with processing, it is preferable to arrange your work surfaces into 'dry' and 'wet' areas and to adopt quite consistent working methods. In laying out the darkroom for printing, divide it roughly in half, one for the exposing, enlarging and composing side of the work, with dry unexposed paper at hand, and the other for processing the latent image in the chemical solutions, ending ultimately in the washing area of the sink. The room will need an appropriate 'safelight' for the materials in use and it is important to refer to the manufacturer's recommendations for this. It is preferable, however, to have as little safelighting as possible spilling on to the printing easel in the dark – this is not because of the risk of 'fogging' the paper but because a lower level of ambient light on the enlarger side of the room allows you to view the projected negative and makes judgments about content, composition, and selection easier.

Your major processing steps, in fact, have a similar pattern to those for film development, except that the chemicals are held in flat processing dishes instead of

Right: The principle components of the modern enlarger.
It is important to have a facility for colour filtration or the insertion of colour gelatine filters above the negative carrier. This allows for continually adjustable contrast when printing with variable contrast monochrome papers, as well as both positive and negative colour work. A voltage stabilizer is essential for accurate control of the enlarger lamp, in terms of the fidelity of its colour output.

Below: When setting out the work bench, adopt a rational arrangement, working from left to right. It is particularly important not to contaminate the developer by dripping fixer into it from wet hands. Position the clock within easy viewing distance of the developer solution for, above all, accurate timing is critical to the proper fruition of the process. Good washing is a critical part of the process and greatly influences the permanence of the prints. A stopbath or tray also minimizes the risk of chemical contamination between baths.

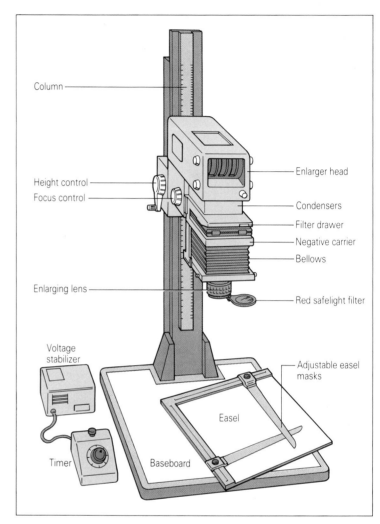

Column
Enlarger head
Height control
Focus control
Condensers
Filter drawer
Negative carrier
Bellows
Enlarging lens
Red safelight filter
Voltage stabilizer
Adjustable easel masks
Easel
Timer
Baseboard

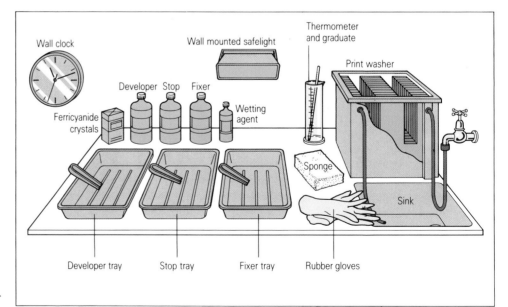

Wall clock
Wall mounted safelight
Thermometer and graduate
Print washer
Developer Stop Fixer
Wetting agent
Ferricyanide crystals
Sponge
Sink
Developer tray
Stop tray
Fixer tray
Rubber gloves

sealed processing tanks. The steps remain the same: developer, stopbath, and fix (acid hardening fixer), followed by a rinse in continuously changing water for at least 10 to 15 minutes.

Efficient blacking-out is essential, and you should use some form of effective ventilation system, for it is extremely unpleasant to work for any length of time in cramped conditions and stale air. Similarly, you should heat the room adequately to a comfortable temperature for it is important that the working temperature of the solutions does not fall dramatically below 65–70°F, otherwise the performance of the solutions deteriorates. In arranging the darkroom layout it is preferable to order the solutions so that the progression 'Developer-Stop-Fix-Rinse' naturally ends adjacent to the sink with its flow of running water. In addition to placing the print into the final rinse, this arrangement enables you to rinse your hands each time the cycle is completed. Keep a hand-towel near the sink. Another vital point is to control the ceiling lights by a pull-cord switch.

The basic working tools for printing are neither complex nor extensive. You should, however, obtain the best enlarger you can afford. This is the vital link that completes the production of the photograph. By the same token, it is essential to use an enlarging lens that will match the covering power and definition of the negative you have produced – no amount of careful printing will overcome inadequacies within the enlarging lens, which is only carrying on the standard of resolution of your original camera lens. In many ways, the enlarger possesses some of the properties of the camera, for the prime focal lengths in enlarging remain the same as in the camera – 50 mm to cover 35 mm negatives and 80 mm to cover 6 × 6 cm. If possible, it is better to have a system that will accommodate the two focal lengths and the corresponding condensers, for it is almost certain that you will wish to extend your activities in the darkroom once you have begun to produce satisfactory prints.

In addition, you will need good

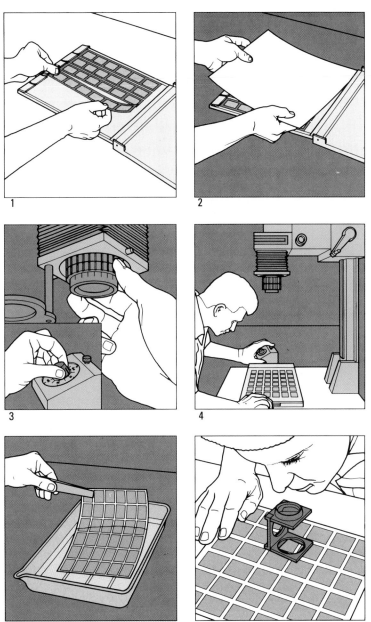

Left: When commencing work, it is first of all necessary to examine the negatives, and to select those most appropriate for enlargement (1). To facilitate this, you should make a contact print in a suitable frame. The negatives are placed emulsion-side-up on to the glass of the frame, correctly aligned and in sequence – care should be taken to allow the frame numbers to remain legible for subsequent filing and listing. Next, extinguish the darkroom lights and work by the safelight. Place a sheet of Grade 2 (normal) paper over the negatives (2), close the frame, and place and secure it on the baseboard of the enlarger. Set the enlarger diaphragm to a convenient aperture (f8 or f11) and the timer to, say, ten seconds (3). Expose the test contact in the pool of light by means of the timer (4) and, on completion, develop the print and fix it (5). Examine the results by means of a magnifying viewer (6) and mark those frames most suitable with a grease pencil or marker.

safelighting and two forms of timing – a seconds timer/switch for the enlarger and a sweep-hand wall timer in minutes and seconds for the timing of the various steps in the solutions. It is particularly useful to have a small swing filter positioned under the lens for viewing the projected image without exposing it – and for multiple exposure work this is well-nigh indispensable. Also required are a printing frame to hold the paper in place, and a magnifying finder or, as some prefer, a grain magnifier

to check focus. One system focuses on the projected image by highlighting a recognizable section, while the other takes a very small section of the film itself and focuses on the grain structure for absolute accuracy. Pressurized cans of air are extremely useful for ridding the negative and its carrier of dust. Scissors or a small guillotine are also useful items. Finally, decide whether to employ rubberized gloves, tongs, or your bare hands when immersing the paper in the solutions.

TESTING FOR EXPOSURE

Having set up your work area to match your needs, the problem at hand is to enable the photographic paper to reach its full tonal potential by combining the correct exposure in the enlarger with the appropriate developing time. As in the camera, exposure can be expressed by the product of aperture (intensity of light) and time (seconds on the timer) but, unlike film, paper should not be greatly extended in the developer for added effect – and certainly not at the initial testing time. Photographic paper is designed to give of its best in terms of tonal saturation within given tolerances of time, 2¼ minutes for conventional paper and 1½ minutes for resin-coated paper. The fibre-based, or traditional, type of paper is essentially slower, is more prone to problems of inadequate washing, and can be tiresome to dry flat if you do not have the appropriate equipment. Resin-coated paper is much faster and 'easier' to use, requires less time in the developer and less time washing, and has an ability to air-dry perfectly flat without additional heating. Thus these new papers are gaining a very considerable reputation and are more than adequate for most applications, but nevertheless there is a major body of opinion that insists that, when it comes to matters of *real* print quality, there is nothing to compare with the traditional materials. This must be a question for the individual to decide.

To begin work, first set the height of your enlarger so that it will project a cone of light which will fit over the size of paper you are using (presumably 10 × 8 in). Having set the enlarging height you may well feel that you would like to check the content of the negatives by the simple process of contacting them within an appropriate frame. It is best to buy a purpose-made frame – it is somewhat self-defeating to improvise with tape and a sheet of glass, for you run the risk of damaging your negatives and it is foolish to

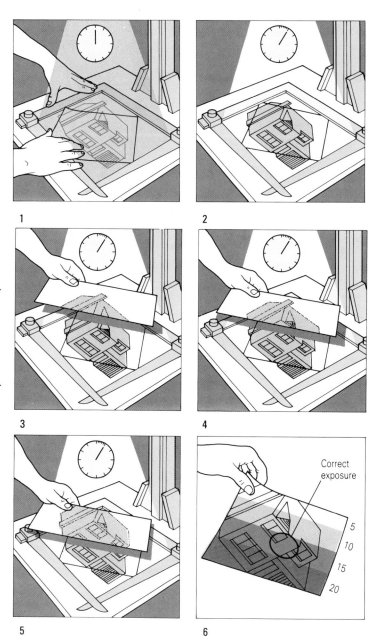

1

2

3

4

5

6

Correct exposure

5
10
15
20

Left: Work to strict routines in the darkroom every time you undertake a printing session. Having established the degree of enlargement and set the lens, the first requirement is to test for exposure and density in the print. With the enlarger safelight in position (**1**), place a piece of printing paper across the image so that it will afford maximum information. Decide on a suitable test time (say, 5 or 10 seconds) and expose the first overall step (**2**). Cover the first two inches of the print area (**3**) and repeat. Repeat once or twice more until the print is progressively covered up (**4, 5**). Then process and examine by room lighting once the test is satisfactorily fixed (**6**). In this way a successive build up of density is achieved that will enable the printing time to be evaluated. In this case, the exposure increments were of 5 seconds each, giving an exposure range of 5 to 20 seconds.

tack any form of tape to the edges of your film as this can leave irritating and damaging deposits on both the film and the negative carrier itself. With a well of light ten inches across or slightly larger, give the first exposure of 10 seconds at f8 and develop for the recommended time for the paper in use; rinse, fix, and then inspect the frames through an eyeglass. If an adjustment is necessary on time, re-expose to compensate and reassess the result.

Insert the negative into its carrier, emul-sion side down and image inverted as you look at it, so that the projected image is correctly oriented on the baseboard. Next focus, with the aperture wide open, using the magnifier, and stop the lens down to its midway position, say f8. You are now ready to begin the important procedure of evaluating the performance of the paper in relation to your particular negative. Unlike film, not a great deal of benefit can be gained from extending the development beyond the manufacturer's recommended

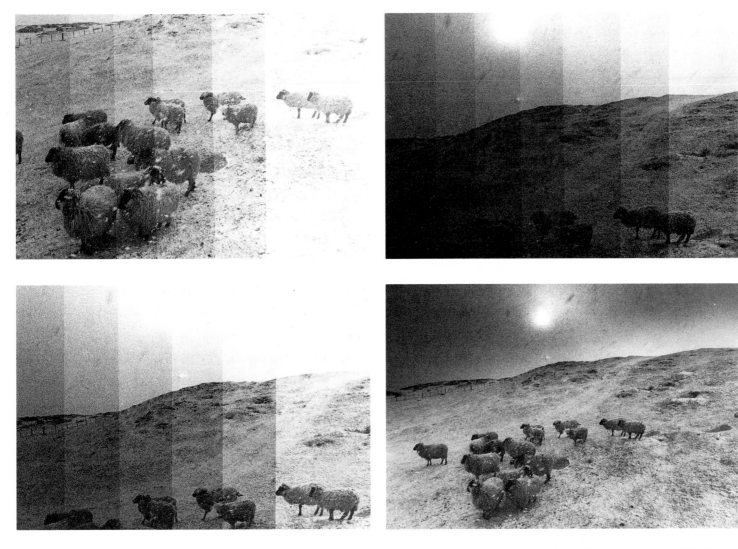

times and so you should not change the time in the developer at the outset. Instead, the development is measured not visually but by the time elapsed on the wallclock. Failure to allow the indicated time in the developer merely prevents the maximum black from fully forming in the print. Accept that the time of development is standard and alter the density of the print by length of exposure alone. Accepting this proposition, it is now necessary to place across the print a series of exposures that will enable comparative densities to form, one against the other, in what is called a test-strip.

On the enlarger timer set a fixed amount of, say, 5 seconds; place the paper in the frame and cover it with a sheet of card, except for a width of about three inches. Press the autotimer and allow its first exposure of 5 seconds. Withdraw the card for a further three inches and repeat the process; withdraw the card and repeat twice more, and you will now have placed a series of exposures on the card that span a time from 5 to 20 seconds. Alternatively, the paper may be progressively covered up. Develop for the recommended time, rinse, fix, and inspect the result by room lighting, having first of all ensured that your unexposed paper has been put away. In the first instance, start with Grade 2 of 'Normal' paper. If, however, a more contrasty print quality is desired then it may be well to begin with the next step up in contrast, Grade 3, which is 'Hard'.

Above: Tests must be made to establish the appropriate printing times that any part of the negative may require. In this instance, the first test is made by systematically placing a series of exposures across the print of five seconds each, with a double timing on the last strip. This means that the strip has been exposed for periods of 10, 15, 20, 25, 30 and 35 seconds. The test shows that at 25 seconds the sheep are beginning to 'fill in'.

The process is repeated for the sky, but as this is much denser it is well to test on the basis of 10 second intervals. This renders a series of density increments of 20, 30, 40, 50, 60 and 70 seconds. At 30 seconds, the sheep are too dark, yet the sky is only beginning to register its tonal values at 70 seconds. A final test is needed.

From the sky section we can establish that all exposures for the sky below 45 seconds are redundant. As the increment is large, the clock is set at 15 second intervals. The final test gives values of density from 45, 60, 75, 90, 105 seconds and onwards. By deduction, it is possible to ascertain that the sheep will require around 24 seconds, the land and skyline 90, but the sun will require all of 130 seconds.

THE FINAL PRINT

The procedure just completed is the necessary requirement every time you undertake a printing session. It is a kind of ritual that enables you to evaluate the materials and also helps you to get into the right frame of mind for the work ahead. It checks out the system and relates a particular batch of negatives to a particular batch of paper. From the sheet of test strips you can easily see the progressive darkening of the print with the increase in exposure, with one end of the values not reaching full black, while the other begins to lose the intensity of the whites or highlights without any significant improvement in the blacks. This is because black is an absolute and therefore prolonged exposure does nothing to increase contrast – quite the contrary in fact, as the tonal range 'closes up'.

There should be one exposure in your test strip that gives an appearance of satisfactory tonal range. If this is not the case then you should either open or close the lens by one stop, and repeat the process. If the best result falls between, say, 10 and 15 seconds then set the timer at 12 or 13 seconds and prepare the first overall test print, or if you still have doubts, then cut a sheet of paper in half and use only this for the time being. Re-expose and process, paying particular attention to the full development time from the wallclock; then rinse, fix, ensure that your unexposed paper is put away, and examine the result by normal room lighting. Particularly, look at the relationship between the whitest white in the print and the edge border and see if there is any difference. At the other end of the scale, check the extent of detail in the blacks or darkest areas of the print. Ideally, the print should have a full range of tones that complement the original negative and subject matter without 'filling-in' the highlights or over-printing the dark areas into a unified zone of blackness.

At this stage your original investment at the negative stage, by means of good exposure control coupled to exact processing procedure, really comes into its own. Remember that the negative is 'the score' – the tones are the notes and you are about to play them. A poor negative is a poorly tuned instrument – it will give an effect, but it will not be the right effect. A good negative will give you the scope to make a print that looks right. What looks right is often a matter for subjective judgment, but there are general ground rules. The print should contain a full range of tonal values, but may well be 'flat' to the eye or, conversely, too 'hard' and unsympathetic for the subject at hand. If this is the case, the remedy is not to be found in altering the processing times but in re-exposing another test on another paper grade. Paper grades are a system of values inherent to each batch, so that the contrast is different throughout the range. Grade 0 is Very Soft, 1 Soft, 2 Normal, 3 Hard, 4 Very Hard and 5 Extra Hard. You can therefore adjust the internal tonal ranges on the print by retesting the negative on a differing grade and then making direct comparison of two, or possibly three, results.

The stages of printing

The following steps take account of a negative that has its full complement of tones in the first instance and over which you have had total control, but unfortunately you will not always be in this position. In landscape work, for example, it is often the case that the tonal range between the land and the sky is simply too great to be controlled solely by the type of development at the negative stage, and this is particularly so when working in miniature or roll-film format. This is because the individual negatives are not processed separately, as they would be if they were sheet films from a field camera, and so you often have to work from the best negatives available from any given film. Also, quite apart from any problems at the subject stage (such as a particularly difficult day in the open landscape or shooting into the path of light, or against the sun, or in pouring rain), there is also the question of how you are to offer the subject back to the viewer when you have printed it. The print you are aiming for is not a scientific and predictable finite answer, it is a 'feeling', a 'mood' or an 'attitude' that you are seeking to convey. A straight print, on whatever grade of paper, may not convey this feeling in the photograph – perhaps the sky needs darkening, or the field lightening – and therefore alternative methods must be adopted by adjusting the individual areas of the print. This is known as 'dodging' or 'burning in' and consists of using various devices, particularly the hands, to restrain the light during the exposure while other areas receive more than was originally intended.

Also, it is often necessary to restrain small areas of a print in the centre of the picture. When this is so, you should use a piece of wire with a small piece of malleable putty on its end. You can attach varying sizes of card to this and use it to interfere with the path of light to the baseboard so that a particular area receives less exposure. It is particularly useful to have an enlarging 'swing-filter' beneath the lens for this. The filter is 'safe' as far as paper is concerned but allows a viewable image to be seen on the printing surface, so it allows you to make decisions on size, duration and composition at the outset.

On completion of the necessary processing steps for the finished print, allow at least 20 minutes in the final wash of running water for fibre-based materials, with approximately half that time for resin-coated materials. Do not overfix the print, leaving it in the bath while you work on other prints, for this will result in a slight bleaching effect which is detrimental to the tonal range. Similarly, do not use the same fix bath for papers as for films – keep them separate and date-labelled so that you know the throughput and physical state of the solutions. As a very simple but effective check on this, a small piece of undeveloped film dropped into the fix will establish the time it takes to 'clear' and this, in turn, is a reasonable check on the efficacy of the working strength. A fix solution taking longer than five minutes to

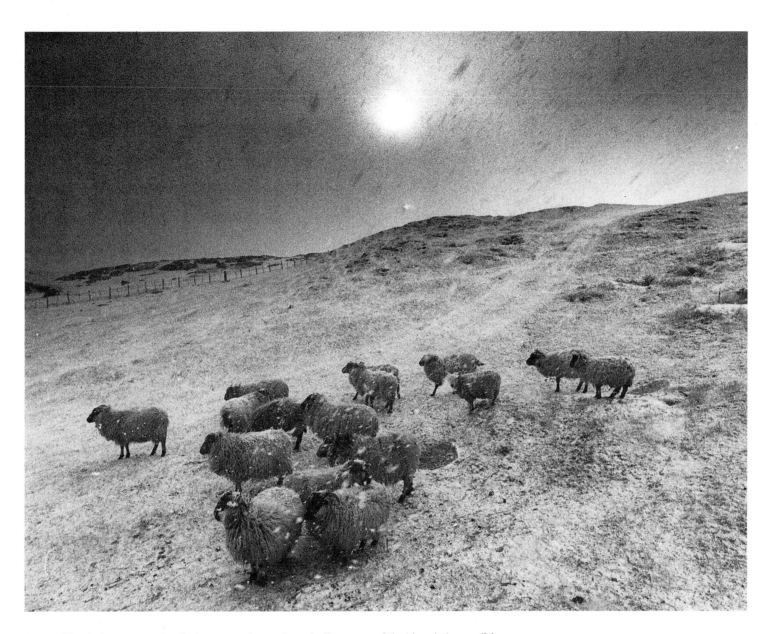

clear a film is in a poor physical state and should be replaced.

Additionally, there are methods of adjusting the final image of the print by after-treatment but, until you are very experienced in printing, and in judging and assessing the tonal values in the paper, it is probably better to avoid them. Nevertheless, localized reduction of areas of the print is wholly feasible and you can do this with a weak solution of potassium ferricyanide (often known as 'pot-ferri') and sodium thiosulphate (or 'hypo'). But this needs careful judging and experience for it

to be wholly successful. Also, it is possible to adjust the 'warmth' of blacks in the print by use of either developing agents with that inherent characteristic or paper of a brown-black hue, or both. After-treatment on fibre-based 'art' papers for exhibition work is readily achieved with the aid of a selenium toner solution. However, it is essential to eliminate all traces of 'hypo'. After a two-bath fix, immerse the print in a 'hypo' clearing agent, then wash it (about 20 minutes) in running water. Immerse the print again, this time in selenium toner, and rewash for 30 minutes.

Above: In this, the final print, the cumulative effect of the three separate exposures on the same print enables the paper to accommodate the excessive brightness range of the original subject. The sky has required more than five times the amount of exposure that the windswept sheep have yet it is essential that this is done if the original scene is to be rendered to its full potential. It may well be of course that the final result is still unsatisfactory and requires the use of a 'harder' or 'softer' paper. Grade 2 is known as 'normal', 1 is 'soft', 3 is 'hard', 4 is 'very hard' and 5 'extra hard'. With skilful application of multicontrast papers, however, it is possible to print not only differing areas of density across the paper but also differing degrees of contrast.

VARIABLE-CONTRAST PAPERS

The technique of altering the contrast of the print by means of paper grades is fundamental for the professional darkroom worker, but if you only do a small amount of printing, you will have to spend a sizeable sum of money in order to have a stock of at least four grades of paper at the ready. However, an acceptable alternative is to use variable-contrast papers (also known as multigrade papers). These have the unique facility to change the inherent contrast by means of suitable filters and make it possible to obtain a wide selection of printing grades from one box of paper. This is achieved by double-coating the paper during its manufacture with one layer of high-contrast emulsion sensitive only to blue light coupled to another layer that is low-contrast and more sensitive to the green region of the spectrum. So you can adjust the contrast of the paper by suitable combinations of the two com- plementary filters (yellow and magenta) when they are placed into the enlarging light source. You can use the relatively inexpensive gelatine filters that each manufacturer has produced for its particu- lar brand of variable-contrast materials. These are placed into the filter drawer above the enlarging lens, the numerical values being established for the respective grades on the packaging. A better system, however, is to employ a colour-head at- tachment on the enlarger and simply 'dial in' the values that you need for any given negative contrast. The reason that this method is preferable is because careful use of the colour head (and its more stable characteristic) allows you to actually print two or even three different grades into one sheet of paper during exposure. In this way a heavy back-lit sky could be effectually printed on Grade 1, while the foreground will receive Grade 3, and the middle

distance Grade 2, simply by subdividing the exposure times, employing suitable 'dodging' techniques and carefully 'shading in' the adjoining areas.

Before attempting such sophisticated techiques, it is very important to carry out a series of exposure, density, and contrast tests for a negative with a full range of tones on the principle already described in the setting-up procedure for testing in normal darkroom applications (see p. 86). The appropriate filtration for any contrast grade is given with the filters on supply, but as a guide the ratio of yellow to magenta is high for soft-grade effects and progressively changes so that, at Grade 4, the filter is almost exclusively magenta in colour. With the colour head therefore, the higher the yellow content the softer the result, and when there is parity at around 40Y + 40M the grade is effactually normal. Another factor to bear in mind is the influence that the increase in magenta filtration has on the transmission of light from the enlarger. You require a steady increase in exposure as you increase the contrast with the added filtration. If you use multigrade paper regularly, attach some results to the darkroom wall near to your working area so that the filter- contrast combinations are immediately at hand and can be read off before initial testing.

In every other respect, variable-contrast materials behave in a similar fashion to conventional materials and require neither exceptional safelights nor developing agents, although it is essential to ensure that the safelight in use is that which is wholly compatible with that particular brand of paper. A yellow-green safelight is not suitable.

Selecting the right printing paper for your needs is important – differing pro- ducts are more suitable for some work than others. The new resin-coated papers are particularly useful for rapid access to images, and the variable-contrast versions are very helpful when it comes to printing a whole series of negatives of differing characteristics in rapid succession, and with the minimum of inconvenience.

However, there is a devoted following for another type of material – the fine art paper used for exhibition-quality results for which resin-coated equivalents are simply not up to the job. The reason is relatively simple: the more silver in the paper coating the richer the blacks and the greater the saturation in tonal scale, and, of course, the more expensive it is to produce. Therefore, these papers are not ideal for general use; they are expensive and take more time and trouble to process, wash and dry and, unless they are properly used, their potential for proofing is no better than resin-coated. On the other hand, skilled darkroom practitioners argue that there simply is not the 'depth' in resin- coated materials because, by their nature, they provide a thinly coated surface, and do not have a long tonal scale. In short, the choice comes down to the question of personal preference.

Paper surfaces

All papers come in various surface 'finishes', such as matt, semi-matt, glossy, and lustre or pearl. Choice is essentially a matter of personal preference and suitabili- ty for the job in view. The higher the surface sheen then the greater the refrac- tive index of the surface and therefore the greater the tonal range from absolute white to black; but on the other hand, matt papers are very much easier to retouch or hand-colour and adjust and many people prefer the almost lithographic look that this surface offers. Some people prefer to use conventional (non resin-coated) ma- terials with a glossy finish but to omit the glazing stage that this type of material normally requires. If a glossy finish is required then RC papers achieve this with the minimum of effort and expense. This gives a print finish that is very rich and fully saturated and without the slightly 'mechanical' look that can occur on stipple or lustre finishes. Ultimately, the question of richness in final presentation is a very personal one. Additional richness can be achieved by a rinse in selenium toner but this will not embellish a poor photograph and perform a miracle by saving it from mediocrity.

1

2

3

4

5

6

Above: In these examples of multicontrast printing, the same negative has been successively printed on the same batch of paper, but through varying degrees of filtration in the enlarger head. Six different results may therefore be obtained from one packet of paper. The differing contrasts are obtained by varying the settings of the Yellow and Magenta filters in the light beam, and it will be noted that the higher the Yellow factor the softer the print, and the higher the Magenta the harder the print. However, the increase in filtration means that the time does not remain constant between each exposure and therefore it is important to make working tests first, based upon the requirement for Normal paper, and then match the results to establish the relevant exposure factors. In these examples, the tests have been made so that the density of the grey sweater remains constant throughout, while the other values vary. This kind of careful evaluation and control means that the photographer can remain wholly in charge of the tonal scales he is creating and may use specific degrees of contrast.
1, 90Y 15M (Grade 0) @ 6in;
2, 65Y 30M (Grade 1) @ 8in;
3, 35Y 45M (Grade 2) @ 9in;
4, 20Y 60M (Grade 3) @ 10in;
5, 05Y 90M (Grade 4) @ 13in;
6, 00Y 130M (Grade 4½) @ 17in.

COLOUR PRINTS: NEGATIVE

Of the two colour print systems available, the negative system and the reversal system, the negative is technically the best equipped for the purpose. This is because the process, from the outset, has been specifically designed with printing in view, while the reversal or positive-positive system has not. Because the negative process is, as its name implies, based on a negative image, it is rather difficult to judge in comparison to a colour transparency, as all the values are reversed from the original subject. By the same token, it is not possible to assess visually the starting balance of the colour negative merely by looking at it. Printing must therefore begin with a series of trial exposures to establish a working balance for both the negative and your particular batch of colour paper. A very limited safelight is possible, but is useless for anything other than avoiding colliding with the enlarger. The enlarger will require a colour head with variable filtration levels of the Subtractive Principle, yellow, magenta and cyan, and the mains circuit should be voltage stablilized. It should be noted that only two filters, never three, are used at once. This is because the combination of all three merely introduces neutral density and thus is ineffectual. You usually begin filtration with yellow and magenta in proportions of three to two. The colour head allows for continually variable combinations of the two filters needed and thus, with accurate plotting and testing, any imbalance in the negative's colour can be removed. You alter the filtration in the head in the same direction as the cast and so, if the print is too yellow then you *add* yellow; if it is too red then you *add* red, which in turn is yellow plus magenta. The two filters in use can offer six shifts of balance, by either adding or subtracting them singly or individually from the colour head. The chart (opposite page) shows the corrections to make.

To process the colour paper, you will

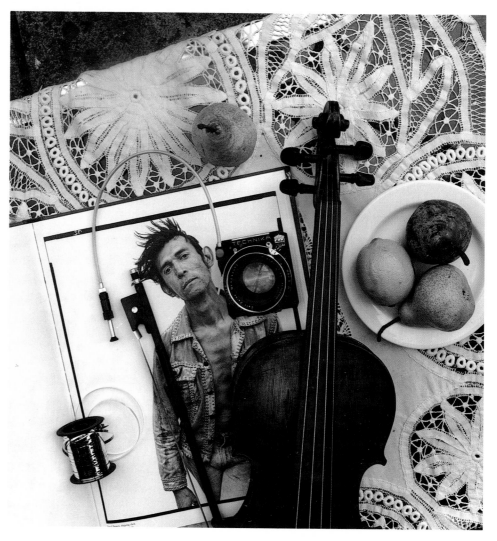

need some form of drum with its accompanying rotary motor, a tempering unit for the solutions, an accurate thermometer, and an accurate timer. Accuracy is vital: the tolerance for the processing solutions is close and must not vary more than $\pm 0.2°C$ at $37.8°C$. As a basis for starting you will have to make certain assumptions, and a rough guide could be for 35 mm enlarged to 10×8 in, 10 seconds at f8, with a starting filtration of $50Y + 30M$. But you should make your own tests with a special printing frame that will allow several exposures to be made on one sheet of paper. In this way you can make a comparative evaluation. This will be money well spent as the same equipment may be used in the evaluation of variable-contrast papers in black and white work. There are several types on the market primarily designed for use with colour materials. With such a frame it is possible to print the following combinations: $50Y + 30M$, $40Y + 35M$, $60Y + 25M$, $65Y + 40M$. In so doing, you can establish the 'direction' of the paper's shift in colour. Applying the principle of adding the colour you wish to get rid of, it is possible to refine the process quickly. The great advantage with the negative system is that it conforms to the cardinal laws of monochrome printing: if the print is too dark it is overexposed. Similarly, it is wholly feasible to 'dodge' and 'burn in' the colour print in a manner similar to that in black and white printing (see pp. 86–7).

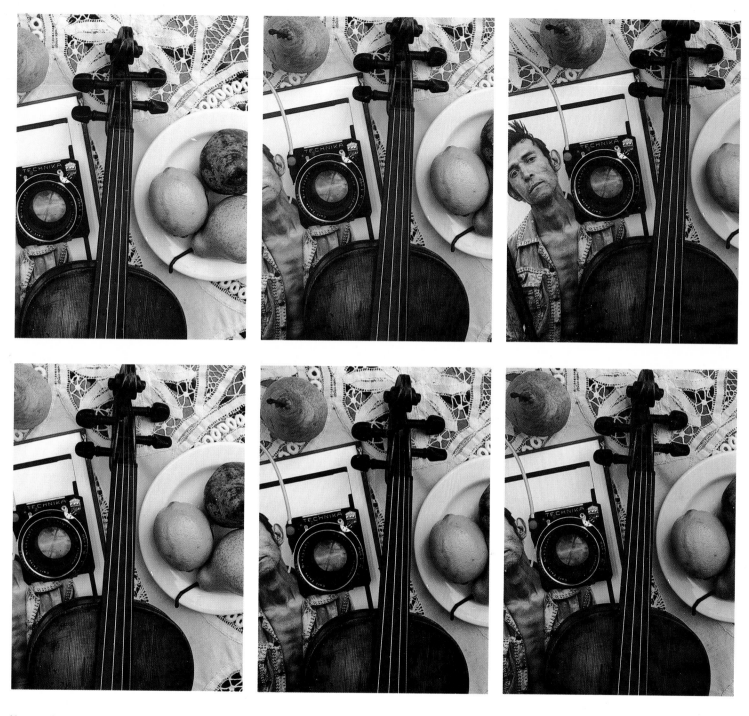

Above and opposite: In a colour negative all values are reversed and the image is covered in an orange masking system, so it is not possible to evaluate the negative visually when commencing work. It is therefore necessary to calibrate the particular batch of paper to the enlarger in use. It is best to use a negative with a known neutral balance within its field. In this case, the neutral section is the monochrome photograph to the side of the violin and it is to this that direction must be turned for establishing the colour shift of the negative. The illustrations show the types of cast that are commonly found.

IF THE PRINT IS	YOU MUST ADD	or SUBTRACT
Yellow	Yellow	
Red (Y + M)	Yellow + Magenta	
Magenta	Magenta	
Blue (the opposite of yellow)		Yellow
Cyan (the opposite of red)		Yellow + Magenta
Green (opposite of magenta)		Magenta

COLOUR PRINTS: POSITIVE

Without doubt, the simplest and most reliable system of making colour prints in a non-professional darkroom is the positive-positive process. It is much more tolerant as far as temperature control is concerned and is very easy to assess visually without prior knowledge of colour theory. That is because, quite simply, in printing it is a question of matching two identifiable positive images – the original colour transparency against its corresponding print. Nor is the processing procedure particularly demanding or lengthy in time and the rotary drum system of chemical agitation is excellent. Due to this inherent latitude with the **Cibachrome** process, it is in fact not only feasible but advisable to set up the processing equipment in an adjacent room if space is at a premium. In this manner the paper may be exposed and loaded into the drum in the dark and actually processed in full light next door. It is thus possible to prepare all the solutions in advance and feel at ease with the process away from the darkroom work area. The only really difficult idea to grasp in the reversal process of colour positive printing is that the laws of exposure are in reverse to those of normal darkroom procedure: the more the print is overexposed the *lighter* it gets. The film behaves in similar vein to the colour reversal film in your camera and so, if a step test for density is made you should remember to assess it from the correct end. The other important difference is that, unlike negative printing, the colour balance needs quite a substantial alteration of the colour filters in the enlarger head before a great deal of change is noticeable and therefore it is best to work in values of at least 10 units of any given colour when changing the balance of the print.

Another major benefit with this system of colour printing is that, although an enlarger with an appropriate colour head filtration system is the best, it is not the only way in which to work. Indeed, a great deal can be achieved with an ordinary monochrome enlarger – provided that it has a colour filter drawer within its light source. The proviso is important, because placing the filters beneath the lens is inadequate – they must be used between the light source and the film plane. A **cold cathode** light source however is not viable for colour printing. The filters are supplied in full sets of the three subtractive colours, yellow, magenta and cyan, with incremental strengths of 05, 10, 20, 30, 40 and 50, together with a UV filter *which must always be used* in the pack.

Processing is also comparatively simple and is free from the strict tolerances necessary for the negative process. This fact, above all others, makes Cibachrome ideal for non-specialist colour printing in a domestic situation. Although the recommended developing temperature is 24°C, perfectly acceptable results may be obtained within the range of 20–29°C. By far the best and most convenient method of processing is by means of a rotating drum, and the principle of 'one-shot' use of chemistry. Small rotary motor units are available for this, but it is quite feasible to carry out the development procedure by the simple method of rolling the drum back and forth along the worktop. Dish processing is also viable, but this is less convenient as it has to be used in total darkness; also there is not such consistency in the use of the chemistry.

All work must be carried out in total darkness during the exposure period, and for this reason alone it is well to make certain procedural precautions when beginning a print session. The paper, for example, is rather difficult to identify (especially the matt surface material) in total darkness and so it is useful to remember two basic methods of assisting in this. In the first instance, Cibachrome is packed in such a way that the internal light-tight envelope has a seam down one side and a label on the other – if the bag is placed on the work bench with the label uppermost, the paper will be extracted *emulsion side up*. If, however, you find you are in the dark with a sheet of paper in your hand and this procedure has been omitted, the second method is to hold the sheet close to your ear and gently run your forefinger rapidly across the surface of the paper. This is called the 'whisper test', for the support side of the material gives a slightly higher pitched sound.

The same basic starting procedure is recommended for colour positive work as it has been for both negative and, indeed, monochrome work. Until one knows the speed of the material, its inherent characteristics, and how these relate to the enlarger in use, then one is quite literally groping in the dark. A typical exposure for Cibachrome material, enlarging a 35 mm transparency to 10 × 8 in by means of a 50 mm lens set at f11, would be 10 seconds. Using this as a basis, tests (preferably four on one sheet) are then carried out to establish the fundamental shift characteristic of the batch of paper that is being used. Because each batch of paper is different, the makers recommend a guide filtration value and to this it is useful to create a 'ring-around' series of exposures and filter settings by adding nominal values, thus 00Y + 00M, 10Y + 10M (red), 10Y + 10C (green), and 10M + 10C (blue) which, if we assume the filter recommendation on the packet is 40Y + 30M, will give us the following sequence: (1) 40Y + 30M, (2) 50Y + 40M, (3) 50Y + 30M + 10C (subtract 10 neutral density) = 40Y + 20M, and (4) 40Y + 40M + 10C (subtract 10 neutral density) = 30Y + 30M. From this series it should be quite easy to establish any discrepancies between this particular batch of paper and your enlarger. Process the print, following the times recommended by the manufacturer, and thoroughly wash it before assessing it – this must be done from a *dry* print. With Cibachrome, the paper itself has a curious chocolate colour when unexposed, and, when it has been processed and is still wet, it retains a degree of warmth that ultimately disappears during the drying stage.

In assessing the print, remember that the change in shift conforms to that which

Above: The Cibachrome process. First, mix the three chemical units as per the manufacturer's instructions (**1**). These are Developer, Bleach and Fix. Label them carefully. Select your slide and insert into the enlarger (**2**). Select the recommended starting filters (**3**). Place these into the filter drawer, together with the ultraviolet filter. Switch off the light and align the baseboard and focus to scale (**4**), set the timer at, say, 5 seconds and stop the lens down to f8. Carry out your first test. Progressively print a series of exposures across the paper (**5**) and insert the exposed paper into the developing drum (**6**). Put on the lid and switch on the light. Now measure the appropriate quantities of solutions (**7**) and pour them in at an angle (**8**). Note: the drum in its upright position retains the chemicals in its reservoir at this time. Set the timer and place the drum on its side, rocking it gently back and forth (**9**) to bathe the print surface. Ensure that your benchtop is level but as a precaution rotate it every minute to minimize risk. After the completion of the three steps, wash the print in running water (**10**) and hang to dry.

is seen. Therefore, if the print is, say, too yellow, yellow is simply taken from the enlarger's colour head. This, above all, makes for simplicity when assessing the results from reversal colour printing and making the necessary corrections. If the test result appears dark, you must increase the exposure. If it looks weak and bleached, check that the lens has been 'stopped down' after focusing and, if it has, take another step further down. Run a second test with the observational corrections forming a basis for evaluation –

process and compare to the original.

Having expressed reservations about positive-positive printing, compared to negative, it should be said that the colour transparency process based on the dye-destruction process (Cibachrome) is far sharper than that offered by the traditional negative system. Further, its dye structure and method of producing the image is the most permanent method of retaining a faithful colour print over a long period of time. Also, its tolerance being that much greater than its negative counterpart, it is

extremely viable as a print system for the user who is not committed to learning a great deal about colour theory. Cibachrome requires only three chemical processing steps to achieve its results. Its major drawback is its expense. One final point: do not assume that you will be able to casually tear a sheet of the paper in half when preparing a second test strip – the material is, in fact, not paper but a very thin, yet nevertheless tough, plastic. It cannot be easily torn and a pair of scissors is essential.

EXPERIMENTS IN PRINTING

There is a whole realm of picture-making potential to explore that is beyond the mere use of à camera and its conventional application. Photography is a language that communicates ideas, and there is a great deal to be learned from the process of interpreting images and what they imply, suggest, or convey to the subconscious. One of the major differences between photographic imagery and human perception is the fact that the latter cannot 'hold' an image for any amount of time; nor can it take one image from one event in time and match it to another from a quite separate event; nor can it see by juxtaposition two different events or see them by negative value or increased contrast. Yet all these things are the natural preserve of the photographic process. Darkroom manipulation, of multiple printing, of double-exposure, and negative values superimposed against positive ones, can be highly rewarding, allowing you to take moments selected from time, use them in another context and explore a new area of representation.

There are several methods of after-treatment of the photograph to change its effect. Selenium toning is a method of increasing the tonal saturation by immersing the finished print in a proprietary bath of the chemical. This imparts a particular richness by slight deepening and coloration of the darker areas of the print; this is not to be confused with dye-toning, in which the image is first bleached by a dilute ferricyanide solution, then re-developed in a toning agent that can impart, according to its chemistry, various shades of blue, sepia, red, green, or purple. It is best to start by purchasing ready-made toning kits rather than spending too much time mixing complex formulae that may well come to nothing. It is possible to 'double dip' the toning process by a second bath and regeneration through a different hue, while holding certain areas of the print

back by either a resist or else by selective bathing of the surface. This requires careful experimentation.

However, the enlarger and photographic paper have a great deal to offer as the basis for juxtaposition and multiple printing, and for the purposes of this brief overview it is probably best to list the various techniques separately. In all cases, better results are achieved through the use of conventional, as opposed to resin-coated, materials for they are slower working and have a longer and more even build-up of the developing image.

The first, and most obvious method, is the technique of 'sandwiching' two negatives in the enlarger's carrier and printing the two images simultaneously. The advantage of this way of working is that it is very easy to predetermine the relationship of the two images, one against the other, before printing in the conventional way.

In double printing, the two negatives are printed separately, by careful planning and procedure. You select the two areas to be brought together and then print the first image on the paper. After a short while the paper is removed from the developer the moment the image begins to appear, and placed into the waterbath to arrest the development. You then sponge off and replace it on the baseboard in a damp state. Using the enlarger swing filter, the second image is placed in the unexposed area of the paper. The filter is removed and the second exposure given. The paper is returned to the developer and both images are developed together. The critical thing to remember is that the two areas of light and shade should be distinct.

Another process is 'pseudo-solarization' and the technique involves two levels of exposure and development on the same print. First, you expose a conventional negative in the normal way and develop it for at least threequarters of its recommended development time. In so doing, those parts of the print that have received both exposure and development begin to 'slow down' in their darkening process while the remainder of the silver remains untouched and still active. After the image

has begun to appear, subject the developing print to a second overall exposure from a random 25 watt bulb held about four feet from the developing dish, and continue the development as before. The effect of the second exposure on the virgin silver rapidly accelerates the development of that area of the print so that it 'overtakes' the development of the area that was first exposed. This is because the silver has already been affected by light and development and is therefore 'tired', while the other areas are not. However, the most interesting phenomenon derives from the mixture of the two silver areas for between them is a sort of half-and-half zone of quarter tone that does not fill in as quickly. This gives solarized prints a distinctive quality, though it often takes time to arrive at the right combination of first exposure to second and at the correct time in the development at which the second exposure should be made. The solarized print is particularly helped by a dilute bath of potassium ferricyanide to 'lift' the quarter tones further. Conventional papers are best suited to this type of work.

Placing objects either in the negative carrier or on the printing paper itself produces a negative image of its form known as a photogram. You can make a bas-relief from an original negative by making a contact positive on fine grain copy film with a sensitivity similar to that of printing paper. Develop it visually and dry it off. On a light table, you then re-align the positive and negative before shifting them slightly off register and printing the combined image of the two from the negative carrier.

There are, of course, many other ways of experimenting with the enlarging process, but these are complex and require personal research. Use the properties of the materials themselves as the basis for your experimentation. You can introduce mirror-images, paper negatives, high-contrast lith papers or films for interstages; you can contact reverse the prints, or sandwich positive and negative together in the enlarger. This area is engrossing, but requires patience, skill, and experimentation.

Left: There is tremendous scope for creative work in the darkroom by means of multiple printing and assembled imagery and this is well shown by the accompanying work by the British photographer Hag. Much of this type of work is essentially allegorical in nature, with considerable leanings towards Surrealism. The viewer is allowed to interpret and distil information from the complex assemblage of visual material. Still life may be linked directly to landscape, the elements, enigmatic visual codes and symbolism. The principle depends on the property of the photographic paper and its development – by exposing the paper and only part developing it is possible to 'drop in' other elements over the primary image. It is a source of continuing stimulation and research.

SLIDE DUPLICATING

Although it is possible to obtain slide duplicates from any reputable laboratory, a slide copier is a useful tool as your colour-reversal work accrues. It is often the case, for example, that a colour negative may be required from an original transparency, or a black and white print, or that selective adjustment may be required for the exposure, density and composition of the original. For these tasks there is no better solution than accurate work through a slide copier.

The configuration of the slide copier allows you to fit a bellows attachment to your own camera so that the lens may be sufficiently withdrawn from the body to enable one-to-one copies to be made. You can also adjust the composition slightly by direct viewing through the camera's pentaprism. There are slide copiers that are based on tungsten illumination, but most employ electronic flash beneath the transparency as this involves fewer problems with heat dissipation within such a confined area. Coupled to the flash is a small switchable modelling light for accurate focusing, which is removed during the actual moment of exposure. The degree of intensity of the light source is adjusted by a large knob that is calibrated to a needle alignment that raises or lowers the flash tube. This means that you can alter the effective output to accommodate differences in density from one slide to another.

Before you begin work, the machine must be calibrated by a series of exposures that employ half-stop increments throughout the range, on a standard or reference transparency. After processing, these are re-applied to the zeroing mark on the needle of the exposure indicator and the machine is then able to adjust the light output for each individual slide by raising or lowering the light source. The use of a standard reference transparency should also involve a suitable greyscale index so that both density and colour balance can

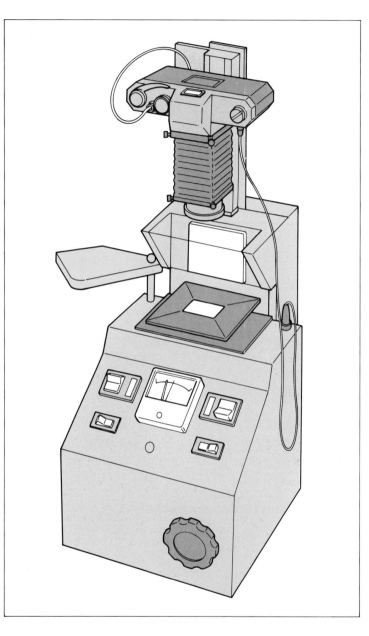

Left: The slide copier not only allows for the successful duplicating of favourite slides but also the potential for correcting them. For the best results, it is essential to use duplicating film, for this has a different contrast to normal camera film, which is prone to excessive contrast when copying slides. However, this can be useful when making derivative duplicate slides.

be evaluated. Indeed, the question of copying may well arise solely through a desire to improve upon the original in matters of colour. For this purpose you will need a full set of colour correction filters that manufacturers of colour materials offer for colour printing.

It is possible to obtain usable results from merely duplicating an original slide on to another colour film in the camera but this involves an extra amount of contrast, due to the characteristics of the film itself. Instead, it is preferable to employ either

duplicating film or internegative material. This has inherently low contrast, and has been manufactured with duplication in mind. Both of these films are available in tungsten balance and therefore must be corrected by a suitable colour conversion filter when used in conjunction with electronic flash, but there are also duplicating films that are balanced for electronic flash illumination, while retaining their low-contrast characteristics for duplication.

An additional use of the slide copier is to provide a monochrome negative from a

colour slide. This is more readily achieved by employing standard panchromatic fine-grain film via normal darkroom projection in an enlarger and by inspection. In duplication via a normal black and white film, however, it is useful to employ a yellow or orange filter beneath the transparency, to correct and slightly increase the blue areas of the original. All copying procedures have an inherent contrast-increasing characteristic and, when using conventional black and white film, it is possible to minimize this by suitably increasing the exposure and then cutting the development time slightly when processing.

The slide duplicator can also be used with graphic arts materials such as lith and line films. Excellent lecture slides may be made by copying original black and white negatives on to 35 mm lith film by means of the slide copier and visually developing the results in a suitable conventional print developer. This technique affords a projection transparency of ·wide-ranging tonal scale and is very economic when done in conjunction with the slide copier. By the same token, such derivatives can then be recoupled to the original and copied yet again in the copier, yielding interesting variations on the original theme.

Left: Working from the given original, it is possible to create several versions of the transparency by introducing pale colour filters into the light beam of the equipment, and thus an element of control may be exerted over the original slide. However, to do full justice to the potential of the slide copier, it is first of all essential to carry out calibration tests on matters of exposure, density and colour hue. This is best achieved by taking extensive notes and by making comparative tests through filters of subtle colour characteristics. These are obtainable in both gelatine and glass. Once the original calibration tests have been made it is useful to make alternative copies on other types of film. In this way, rather than merely duplicating the original, it is possible to make new negatives in monochrome or internegatives in colour. Further, interesting graphic effects may be obtained by the use of high contrast blue-sensitive films and special developers.

FLAT COPYING

A logical extension to the still life is the use of flat copy techniques, not only for the assemblage of artefacts and iconography into some form of photographic statement, but also for the primary requirement of faithfully reproducing a flat copy of a document or artwork in either colour or monochrome. By far the most difficult problem is to faithfully record in colour. Once this has been successfully accomplished, it is relatively simple to work equally well in black and white. Problems in black and white are centred much more on matters of matching film spectral sensitivity to tonal characteristics in the original and the adjustment of respective areas of colour by the use of filtration.

Due to the fact that daylight is seldom, if ever, consistent in its colour characteristics, you should not attempt serious colour copying by natural light. Instead, you should exclude all extraneous light and illuminate the subject by means of the appropriate **tungsten lamps**. You should match these with a suitable artificial light film balanced for a colour temperature of 3,200 degrees kelvin – these films are sold under the title of 'Tungsten' film. For the highest quality results, a colour temperature meter is essential, but if this is not available then you should ensure that the lamps are reasonably 'fresh' and have not been subjected to over-long periods of burning, otherwise they will tend to darken and not retain their original characteristics.

By far the best method of working is offered by a unit that has been specifically designed for photographic flat copying (see illustration on this page) for this will ensure accurate parallelism and even illumination of the correct colour temperature. Further, it will offer a racked system of raising or lowering the camera position and also a copyboard with a suitable marked grid of rectangular reference points. The most sophisticated models also incorporate a rheostat to enable the focusing and alignment of the camera to be carried out under the lamps at a low level

of output. This ensures that the working area remains cool and that the lamp life is prolonged. However, if such equipment is not at hand then a great deal can be achieved by relatively simple methods, provided that certain precautions are taken.

You will need a right-angle tripod that will allow horizontal alignment of the camera, with an option to check this accurately with a spirit-level. You will also require two lamps (or preferably four) placed equidistant on each side so that the light falls on to the subject at an angle of

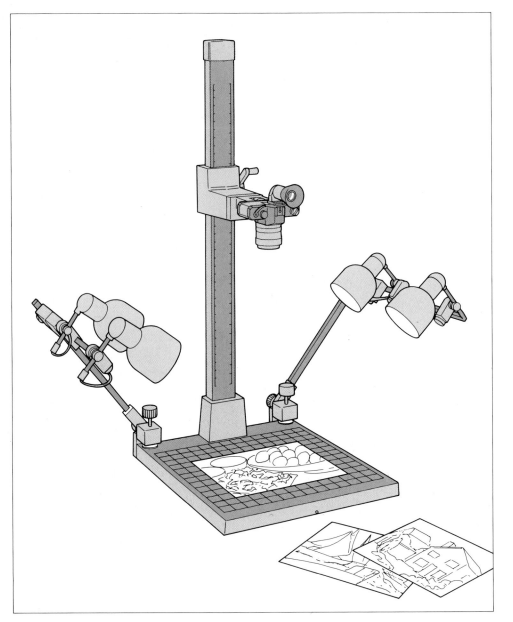

45°. In each case the illumination should fall on the opposite side of the artwork so that the light paths effectively cross. For really critical horizontal alignment of the camera, a small mirror may be placed on the baseboard for checking through the viewfinder. When the camera subtends its own image centrally in the eyepiece then it is at right-angles to the copy bench. The lamp housings should be identical and the distance from subject to lamphead should be measured and equalized in both cases. Check the alignment and intensity of the lamps – place a piece of white paper or card across the artwork and then hold your finger above it at a height of three or four inches, and the shadows falling on each side of the finger should be equal in intensity.

Having set up the tripod, camera and lamps, measure the exposure carefully, using a consistent procedure. The most accurate method is to employ a grey card known as an 'eighteen per cent card' (see endpapers), which reflects only 18 per cent of the light striking it and this, in turn, places the exposure at its optimum on the colour film. The card gives you a precise index of exposure by the reflected method when you start work, which should then be confirmed by the incident method (see pp. 38–9).

Another precaution to take, especially when copying artwork that is covered by glass, is to shroud the camera with dark cloth or else by means of a piece of black card fitted over the lens housing. To obtain this, place the camera lens hood on the card and cut a hole that will fit over the lens barrel behind the lens hood itself. In this way, irritating reflections are minimized. Also, be very careful about light 'spilling' from a white ceiling above your work area, especially if short time exposures are to be used.

If the reproduction is for the benefit of publication, or colour printing by the negative method, it is also important to include a frame with a density step wedge so that the printer has a precise guide to matters of density and colour balance, upon which to base the initial tests for

density and colour cast correction. The best method is to provide such a reference scale alongside the artwork itself so that all aspects of exposure and '**bracketing**' are applied equally to the original artwork and the test chart.

It is advisable to take some time in making the test chart wholly effective as a gauge of the colour hue, density, saturation and balance of the given subject matter. In the colour test chart above, six neutral patches and six colour patches offer readings from white to black with a density difference of one aperture stop between each, followed by colour patches of the additive primaries, blue, green and red, together with the subtractive complementary colours, yellow, magenta and cyan. Properly exposed, this information is vi-

tally important if the painting is to be reproduced accurately without reference to the original; similarly, if produced on to colour negative film, the neutral patches would be the perfect method from which to begin to make initial colour printing tests, or indeed, to calibrate a mechanical colour analyzer.

One final point: all colour films are different, even those that are rated at differing speeds from the same manufacturer, and it is extremely useful to keep a good reference transparency for subsequent comparison of colour characteristics in another film. Further, it is very useful, once you have calibrated your colour enlarger by such an equivalent colour negative, to periodically check that your starting figures are still accurate.

SUBJECTS
AND
APPROACHES

'A photographer needs a short circuit between his brain and his fingertips. Things happen: sometimes expected, more often unexpected. You must be ready to catch the right split-second because, if you miss, the picture may be gone forever.'

ALFRED EISENSTAEDT

JOEL MEYEROWITZ
PORCH, PROVINCETOWN
1977

LANDSCAPE

Landscape is one of the most enduring themes of representational art. From the cave paintings of Altamira, through the Italian Renaissance, the Impressionist movement, and the Expressionism of Van Gogh, right to the present day, landscape has remained popular among both painters and their public. This has also been true throughout the history of photography. From the moment that the first exposure of Nicéphore Niépce appeared, there has been a continuous flow of landscape images that has never diminished. So accustomed are we to this reality, that we often travel to foreign regions knowing full well the kind of terrain that exists there long before we have even set foot on the soil.

Yet the contribution that photography has made to the landscape does not merely rest with the production of photographs: it has made significant and lasting differences to the way we perceive and represent the world around us. Indeed, this principle has extended beyond this planet and into space itself. Photography in recent decades has given us a knowledge of our nearest moon and the adjacent planets to an extent that Earthrise, as a concept, is now part of our language and experience.

The artistic context in which photography developed gives important clues to the history of the photographic landscape. By the time the first images of Niépce and Daguerre were being made in France, followed shortly by the first negatives of Fox Talbot in England, both Constable and Turner had already laid the foundations of what was to become the Impressionist movement in painting. They had sought to establish a new approach to the landscape by casting aside the studio tradition in favour of the 'plein air' technique of actually sitting in the landscape itself while creating their notations of light, transition, and the passing of the day. The sketchbooks of Constable show this particularly well, with their images of clouds, weather patterns and atmosphere laid down in small, sample-like books and

notepads. Yet, within fifty years the Box Brownie had arrived and Impressionism had waxed and waned.

For many, the camera was the new 'Monster of the Arts', without tradition – a mechanical contrivance with little or no inherent creative potential; for others it was the precursor of a new Age of Enlightenment. But in a paradoxical way, photography was worst served when its advocates tried desperately to imitate the traditions of painting. Many of the early examples of its use are directly linked to the academic rules of Victorian painting. Henry Peach Robinson had obvious aspirations to become the photographic equivalent of Raphael with his carefully crafted reconstructions and assemblages of several negatives based on quite meticulous preparatory sketches, as in 'Fading Away' or 'The Lady of Shalott', while Oscar Rejlander produced large and somewhat ponderous allegories of Victorian morality, also by means of the assemblage technique.

This slavish adherence to the aesthetic fashions of the day bore little charm for Peter H. Emerson. He had long felt that photography's great strength lay in its objectivity, in its truth, without frills, without artifice, and without guile. He was committed to the 'real' view of the English landscape and its population by 'the common man' and thus began what was to be his life's work, major essays on rural Norfolk that, published in his book *Naturalistic Photography* in 1889, remain with us today. However, photography did not remain insular. It brought significant and lasting influences to bear on the painters of the late nineteenth and twentieth centuries – Degas was fascinated by the compositional arrangements that the photograph offered, with figures on the periphery of the frame and with its unique ability to record movement and sequence, and its language also had a profound bearing on the work of the Surrealist, Futurist, Dadaist and Bauhaus movements.

In America people were much more willing to acknowledge the artistic potential of the photograph in its own right. To this day, photography is held in higher

esteem in America than in Europe, and this is reflected in the fact that all of the major museum and art collections possess a collection of photographs as a natural part of their activity. To see why this is so, one has only to look at the early days of photography in North America. Here, photography was established as a serious medium with its own aesthetic guidelines by one person above all others – Alfred Stieglitz. He started his influential magazine, *Camera Work*, in 1903. Of course, the great foundations of the American landscape photograph had been laid in the latter half of the nineteenth century, while the West was still being won. But without doubt it was the linking of finely reproduced photogravure images alongside those of Rodin and the other prominent artists of the day that gave photography its Great Leap Forward in *Camera Work*.

This pursuit of a photographic aesthetic ultimately bore fruit in the work of a number of photographers from the West Coast working in the 1920s and 1930s. Known as Group f64, they included Ansel Adams, Imogen Cunningham, and Edward Weston. The name of their group gave insight to their ideals – they called themselves after the small aperture stop that produces the greatest depth of field and thus allows as much as possible of the photograph to be in sharp focus. They were to have a lasting influence that persists to this day. In France, the Surrealists were besotted by the ghostly landscapes of the enigmatic and reclusive Eugène Atget and there are many parallels between his work and the early output of Edward Weston. Even in the Depression years, Group f64 had obvious influences on the socially committed landscapes of Walker Evans and Dorothea Lange.

In marked contrast to this, the landscapes of Henri Cartier-Bresson, produced with the hand-held 35 mm Leica camera, and the recent work of Robert Frank, Lee Friedlander and Garry Winogrand, have gone a great way towards the founding of a new school of landscape photography through the use of the miniature camera. It is not surprising that a recent collection of

photographs was published under the title *Photography – A Facet of Modernism*. More recently still, however, there has been a noticeable return to the use of the large field camera and the colour negative with the New Topographic school of photography in America. Its leading standard-bearers are Joel Meyerowitz, Stephen Shore and Joel Sternfield. In Meyerowitz's case, the lens is stopped down to f90 and everything is sacrificed to the large negative and long exposure.

With such divergences in viewpoint and stylistic approach, it is important to address the landscape from a personal point of view. It is, after all, not a fixed and finite entity but something that is, quite literally, all things to all people. The red morning sky may well appeal to the itinerant photographer but is not welcomed by the farmer who knows full well that the rosy hue forbodes rain when there is work to be done. The craggy landscape of the Western Isles under rain is fine for an orange filter and black and white film, but dreary to the crofter who has to live and work there. The romantic stones of a roofless shepherd's hut can disguise the anguish of history when its tenants were forcibly burned out and evicted a century earlier.

Above: The great quality of Ansel Adams' work rests in its order and control, features that owe a great deal to Adams' mentor Edward Weston. This is American landscape on a heroic scale, with little or no reference to documentation as such. It is concerned with the sheer visual pleasure of varying depths of grey, shafts of light and surface qualities, and is achieved by meticulous attention to detail prior to the exposure, coupled to impeccable printing.

It is essential to develop one's own sense of value and commitment when working in the field of landscape. When that has been done then you can give thought to exactly what equipment you will need and how best to achieve your desired mode of expression.

EQUIPMENT AND APPROACHES

The 'trading off' of the advantages and disadvantages of respective camera systems is at the heart of camera selection for the job at hand and so your choice of equipment should be a direct consequence of what you are setting out to achieve and represent. A large-format camera will render the finest detail, but it will be slow to operate and cumbersome to carry and it will not lend itself to quick, improvised image-making. Working with such a large camera is almost a form of ritual performance when you are preparing to expose the negative. Indeed, it is for precisely this reason that many photographers choose this type of camera. It forces you to slow down, to think hard and to make a few exposures – and how else can you produce negatives that may be individually developed? This principle in fact is at the heart of the Zone System that was pioneered by Ansel Adams. In this system the individual steps of tonal range were carefully measured and specifically developed to a method based on extensive testing and note-taking. Known as previsualization of the subject, this notion was based on the premise that all the decisive factors should be considered before the exposure and so carefully measured and processed that accordingly the negative need only be

printed on one type of printing paper – 'normal'. The critics of this classical approach, however, point to this very factor as being its Achilles' heel – it is so painstaking that it actually runs the risk of preventing interesting pictures being made, largely because it reduces photography to the status of a craft, as opposed to an art, with subject matter being subservient to technique.

In spite of many photographers' use of large format, the 35 mm miniature camera is also capable of producing first-rate results in landscape photography. The area of landscape, after all, encompasses many facets of photography other than meticulous studies in the style of Ansel Adams – for example, portraits in a landscape, buildings, events, and the transition of weather and atmosphere within a social context are all aspects that provide opportunities for the 35mm miniature to demonstrate its virtues. The adaptability of the 35 mm SLR is especially useful in landscape work. If, for example, the priority is to relate people to the environment with maximum depth, a short focal length will more readily achieve this; if the influence stems from random wanderings across the terrain on a casual basis, designing pictures from eye-level while walking, there is little to better the 35 mm SLR for convenience and portability. The medium format may well hold the virtues of both systems, but it could have the disadvantage of a waist-level finder which affords a quite different viewpoint to that of the eye-level finder fitted on 35 mm cameras.

Left: Miniature-format cameras can also be used for landscapes. In fact their portability and their impressive range of extreme-angle lenses make them particularly suitable. Great advances have been made in film technology that allow the quality of the 35 mm SLR to rival its larger counterparts. Another asset is the camera's potential for eye-level designing with the viewfinder.

Left: Without doubt, the large format still has an unrivalled position because of its excellent image quality and rendition of details in the landscape, as in this view of Machu Picchu, Peru. The view camera may be slow to use, but it affords a large image with which to view and design the photograph. In fact its tripod-bound slowness is the very factor that attracts so many to it. However, because each sheet of film is loaded individually it is difficult to use a large format camera for sequences or action work.

Right: For high-quality work when speed is important there is a growing recognition of the value of medium format roll-film cameras. Here the former supremacy of the 6 × 6 cm format is now being challenged by the 6 × 7 cm. This affords a useful aspect ratio which is similar in proportion to 5 × 4 in.

READING THE LANDSCAPE

'Reading' the landscape and translating the information you see to the photograph is the most fundamental requirement of the landscape photographer. In approaching the landscape, questions of choice abound and are as much to do with individual psychology and perception as anything else – are you looking at the view in a romantic context, or a social one, or a historical one? The landscape, like a human being, changes its moods and its expressive appearance with time – it is not finite and fixed, but flexible and ever-changing. It is subject to atmosphere, the elements, the seasons and, above all, light, which in turn changes the form and appearance of things. In the early morning in winter sunlight the landscape is entirely different to during the daytime in summer when the sunlight is high-angled. The landscape can also be subject to other conditions, such as social or political history, and it is often advisable, before travelling to a new region, to read about an area's formative history. Photographers often make the mistake of merely referring to photographic books when other works may be infinitely more important, particularly in matters of history and sociology.

The question of viewpoint is not merely a matter of what one sees in any given situation. There are infinite variations on any visual theme – the quality of light, the family history of the person in the foreground, the details in the middle distance, the silhouette on the skyline, the marks of agriculture or history on the land itself, the way a fence is made, or the markings on the back of a sheep – they may all be part of your response to the occasion and will need careful nurturing to transmit them through to the photograph. In order to be able to interpret these different details, to emphasize some and play down others, you need to know exactly how to use and control your equipment and materials. These techniques are the basis of communicative skill and form an essential part of the language of photography. The compression of space by a telephoto lens, the 'stretching' of perspective by the wide-angle, the lowering of a sky or the lightening of a colour by a filter, the long exposure to allow organic movement across the picture plane, or the cutting of the exposure level to accentuate the dramatic play of light and shade on the surface of the land — all are part of the landscape photographer's vocabulary of technique.

You can achieve a great deal in landscape work with a standard or slightly wider lens. This approximates to the range of the human eye. It is a good discipline

All these photographs vary largely due to the emphasis placed on particular aspects of weather, history, colour, atmosphere, light and in their perspective.

The differential use of colour contrast (top right) can emphasize the cold of this landscape, as opposed to the implied warmth of welcome extended in the homes.

By employing a long lens with a narrow angle of view, it is possible to extract details that contrast with the rugged environment. The small house (bottom right) is dwarfed by the mountain ridge.

The end of a warm summer's day brings cold air that makes the mists roll down the hills (left). Again, a long lens has been used to isolate one small detail.

In summer strangers come in their coaches (far right); for them the place is typified by the rustle of grass, the scattering of sunlight and the panorama of sea, mountain and mist.

not to depend too heavily on a huge battery of lenses to create somewhat shallow and novel effects – better far to spend more time *looking* at the subject than changing lenses for the sake of it. A clear basis for this is the use of the horizon in the photograph and the subdivision of the viewfinder rectangle, the ratio of land to clouds, and the expression of distance within a vertical or horizontal format. Above all, restrict your technique to expressing the quality of the landscape as it appears to you, or to accentuate or underline an emotion that you feel at the time. You should try to convey this in your finished photograph. Avoid sensational tricks and effects, and, above all, be patient. Remember that the light source in a landscape is not fixed and, as it moves from left to right, it can encompass many moods and changes of emphasis before finally leaving the landscape in an afterglow. So be prepared to wait all day if necessary for the quality of light that you need for descriptive form. It is not easy, and it takes time to arrive at the point at which you feel you have made the definitive statement.

THE SEASONS

The moving light and the shifting patterns of the seasons have always been central themes of landscape work, both in painting and photography. Light continues to be the most formative influence in structuring the character of the picture. Impressionist painting was concerned with a desire to rid the palette of black and to cover the picture surface with colours that mirrored the ever-changing effects of the light. For the painter Claude Monet this was such a major factor in his output that he would often take more than one canvas with him into the French landscape, content to spend only two hours in any given light, before starting another in the differing conditions. For his studies of the dappled and changing sunlight on the façade of Rouen Cathedral he returned again and again to depict precisely the same viewpoint at varying times of the day and different days of the year.

Our response to the changing character of the seasons is a deep-rooted and fundamental one. It involves not only the light and the weather but our psychological reactions to colour. This stems primarily from an animal response that goes back deep into the subconscious and which offers an emotional reaction to the nature of colour itself. Hence the different seasons are associated with both colours and moods. Winter is repressive, blue, cool, sad, restrained, inhospitable, dormant and dark; spring is green and represents rebirth, the environment, growth and hope; summer is joyous, multifarious, fruitful, light and warm; autumn is brown, melancholy, dying, reverting and going downhill to the deep stillness of winter and the long dark evenings.

Our psychological response has a significant bearing on how we express ourselves in terms of pure colour. In turn, it forms the basis for differing styles of approach and interpretation, from the Romantic to the Descriptive or from the Graphic to the Environmental. It is a fascinating challenge to extend the Monet

Right: Much of our response to the ever-changing seasons is due to an intrinsic part of our make-up; this stems from the very roots of our being and is often related directly to colour. We see the basic colours of the seasons as markers for our emotions; by the same token we respond to the indicators of the skies, the sun, the rain, the night, the day. For this reason alone we can revisit the same scene again and again and never see it in quite the same way. This fact is fundamental to the expressive content of landscape photography.

A lack of colour need not necessarily mean a lack of emotion, for we equally respond to atmosphere, wind, rain, storm and cloud, and for the most part these elements are just as easily expressed without colour. Indeed, the black and white print can be an ideal vehicle for landscape work, because of the total control of tonal values that it allows. Ansel Adams was wholly aware of this potential in his major essays in Yosemite Park (far right). When a need arises for a 'heavier' sky in a monochrome context, it is easy to alter the whole quality of the image by darkening it in the actual printing.

principle across the seasons by revisiting the same site again and again under the influence of differing prevailing light and atmosphere.

Quite apart from colour, the added influence of the seasons on light adjusts the angle of its incidence to the surface of the land. Despite the fact that winter lacks much in warmth for the photographer and that growth is at its lowest ebb, the quality of light is particularly beautiful during the shortest days. This is because the angle of the sun is low and the shadows are long and rapidly changing. The clouds hold more water and respond to the mono-

chrome orange filter in a way that allows the contrast to be held in check within the exposure range and affords greater freedom of expression and mood. In much the same way as we respond to the colours of the seasons, we also respond to the quality of a sky and its attendant clouds, and this has always been the strength of black and white landscape photography. Here the nature of cloud, mood and atmosphere can be extended by manipulation during the printing process. For many photographers, black and white remains the true route to expressive work in the landscape.

Yet the most obvious facet of seasonal change is still to be reckoned with – the growth and decay of organic matter, the waxing and waning of the flowers and leaves, and the continual recycling of life itself. No matter how many times you visit a site, it is never quite the same on any two occasions. This is particularly noticeable when you go back to reshoot an aspect of a scene that you felt to be slightly inferior the first time around. So many things will have changed to confound what you had thought was there and the original idea behind the picture may no longer seem to be valid at all. But wait, set up the tripod and be patient. The landscape is still in the process of changing. Do not expose an unsatisfactory picture. Wait, observe and distil – it is getting better all the time.

LIGHT THROUGH THE DAY

Not only does light vary considerably throughout the seasons but also throughout the passage of an average day. Essentially, the light source is a single point, the sun, but it moves across the sky in varying degrees of strength, often diffused by cloud and atmosphere, and the character of the landscape is influenced by this change. The quality of light and its contrast, edge and shadow are directly related to the size of the light source, much as they are with a spotlight in a studio. The smaller the light source, the harder the shadow and, as direct sunlight is in effect a small light source, it produces a starkness in the definition of an object's form that is absent on a cloudy day. When there are clouds in the sky, the sunlight is diffused and the whole sky itself becomes a large light source. This makes form much softer and contrast lower. Many photographers feel that these are the best conditions for colour films as the light is more evenly spread and the tonal range fits well within the response of the film's sensitivity.

The movement of the sun, from east to west, provides yet another mode of control

that is as critical to the landscape photographer as it is to the portraitist in the studio – the angle of incidence of the light falling on to the surface being photographed. The day begins with a low angle of incidence that forms long descriptive shadows across the surface of the land. The angle gradually increases throughout the morning until the sun arrives overhead by noon in the south, before it ascends again to the west throughout the afternoon and evening. However, not only does the angle influence the rendering of form and texture but also the quality and colour of light itself. The human eye readily adapts to varying conditions of light and, to a very great degree, accepts what it sees without question. If a barn is white then we assume that it is white, whereas colour film used at different times throughout the day will record its ever-changing hues. It may well be pink at sunrise or bluish as the sun disappears behind a cloud at noon and leaves a large expanse of reflecting sky; it may be greenish as the light strikes an adjacent tree, or delicately purple as mist descends.

The great contribution that the Impressionists made to painting was that they actually spent an enormous amount of their working lives simply looking at and evaluating the minute differences of

One of the most fascinating elements of picturemaking for the Impressionist painters was the everchanging light throughout the day. This continues to be a source of inspiration for the landscape photographer. In this view of the Cuillin ridge at Sligachan on the Isle of Skye, the view remains identical throughout, as does the focal length of the lens and the fixed tripod position. The only changing factors are those of time and exposure.

The sequence begins before dawn, the setting moon leaving the clouds and sinking to the right of the ridge, whilst the unseen sun rises on the left, and lights the small clouds that remain. The mist clears and the sun enters the frame from the left, before mists gather and block it out. A rain shower develops and almost as quickly disappears, leaving the evening sun setting to the right of the ridge in a clear sky. The last frame is the afterglow.

colour, light, atmosphere, reflection and shadow before their eyes. Colour film is particularly sensitive to these slight changes in atmospheric colour and if you are doing serious work in which colour is critical, you should take into account differences in colour temperature. It is surprising to realize, for example, that there are only about two or three hours in the day when the ambient daylight can be said to be correctly balanced and this period is even shorter during the winter.

Not only does the angle of incidence alter the nature of the illumination, but in purely physical terms the sunlight has to filter through a much deeper belt of the earth's atmosphere and thus it is that the nature of the colour is also changed during the beginning and end of the day to give a much warmer effect. Colour is also influenced by the amount of ultra-violet light at high altitudes or across large expanses of water and it is advisable always to filter this bluish cast from the colour film under these conditions. Such a filter is also used to minimize the effect of haze. A secondary alternative is the use of a polarizing filter, for this has the effect of restricting the wavelengths of light reaching the camera when the sun (or direction of illumination) is more or less at right angles to the direction of view.

DISTANCE AND PERSPECTIVE

With so many variables at your disposal – visual, physical, psychological, historical, and aesthetic, not to mention the photographic materials and controls of the camera – how do these come to add to expressive control in the landscape? What is the process of elimination and selection that brings the landscape photograph to a level higher than that of a mere 'view'? In fact, the landscape is inherently more restrictive in its potential for selection than most areas of subject matter. There are really only two major areas of control: viewpoint and the dual elements of time

and exposure. Unlike a still life, it is often difficult with a landscape radically to change the position of a major element of the scene other than by the process of shifting the viewpoint, and for this reason alone the careful consideration given to the potential of lenses and their angles of view is a vital part of the selective process.

When starting landscape work, it is often beneficial to invest some time in reading about the region you are to photograph before planning your work. Careful insight is often a vital part of expressive content. As you read, and later as you explore the area, ask yourself questions about the nature of the region. For example, what is the history of the area? What is it like to earn a living on this land? Who are the people who live there today?

In considering these starting points you should be able to dispel that apprehensive feeling that often afflicts the landscape photographer as the camera is unpacked and the doubts linger about the form that the photograph should take.

An essential ingredient is that of time, for nothing is to be gained from the brief sojourn in the car and the two-minute snap from the vantage point mentioned in the tourist brochure. It is far better to set aside a day and wander at will until the visual elements begin to knit together. A high vantage point is usually very useful. It affords additional selective potential, allowing you to use different focal lengths.

Above all, carry a good firm tripod with an elevating centre column. This will help you to minimize one particular problem of

Left: It is well to remember though that landscape work can and does involve the sky too and another approach is to place the eyelevel low in the composition and expose for the sky. Remember that the sky is continually changing, and that, like the land itself, is subject to the angle of light and the quality of atmosphere, time and season.

Left: The great advantage with using the miniature camera for landscape work is its flexibility. Decisions on depth, angle of view and perspective can be taken by interchanging the lenses. In this beachscape a 24 mm affords a deep perspective, especially when the camera is angled down and the horizon placed high in the viewfinder.

Above: The converse of the wide angle is the telephoto, for this offers quite a different type of perspective, 'stacking up' the space so that elements of the landscape become abstracted and formal. In this way the colour can be seen in a more detached way.

the camera's movements. Speed is not of the essence, and many feel that the almost ritualistic and contemplative use of the large camera still makes it the finest tool for the landscape photographer.

Yet many aspects of large-format work can be reconstituted through the miniature camera, particularly if you use a good tripod and a cable release. Such a tripod will allow you to select slow shutter speeds, allowing the use of slow, fine-grain films coupled to the selective viewpoints from interchangeable lenses. Design your picture in the abstract, move up, down, left and right, and then couple this to the other variable at your disposal – the critical question of time. It costs nothing to wait and watch. Indeed, this is one of the most rewarding aspects of landscape work – the mellowing of the day, the shafted sunlight, the highlighted rock, the shining stream and the changing elements themselves. Be prepared to work in rain, if necessary, and sleet and snow – not merely in flattering sunlight. Go well shod and wear water-proof clothing.

Viewpoint and camera position are critical in the context of interchangeable lenses and it is usually worthwhile trying different viewpoints. Of course, it is not possible to change your viewpoint when perched on a cliff or if you are overlooking an expanse of water, but when circumstances do permit it try altering the perspective relationships in the viewfinder by the dual use of variable camera position and interchangeable lenses. For example, you can change the scale of the background dramatically by altering the relationship of a foreground element to the camera position by using a wider lens and a nearer viewpoint. It is worthwhile experimenting with the various combinations of perspective that this will offer. A long lens, used further back, will 'draw up' the scale of the background, while a wider lens used closer up will reduce it considerably, without changing the basic scale of the foreground object. This is a useful device for environmental portraits and often the scale and selection of the background can completely alter a photograph's interpretative quality.

landscape photography – wind-shake during longish exposure times. In considering what other equipment to take with you, it is worthwhile remembering that the f64 school of American West Coast photographers all used large formats in their work. Their reason was not only the potential of the large negative, but also the large inverse image on the ground-glass screen and the infinite variety of selection by both lenses and the swings and tilts of

DETAILS IN THE LANDSCAPE

Much landscape photography deals with the grand scale, the broad horizon and the panoramic view. But it is also interesting to look at precisely the opposite – the small details that can give an indication of what a region is really about. Also, landscape photography is not restricted solely to rural subject matter: the urban landscape is also a worthwhile subject. In either rural or urban landscape, details can often provide extremely revealing insights into life and tradition within an area when evidences of past settlements and present-day living are at hand on an intimate scale. The structure of a wall, a sign, a fence, a window – these are all part of the rich tapestry that ultimately adds up to the quality of an environment.

The recording of such details may be approached in one of several quite separate ways. You can employ the selective potential of the long lens, use a standard focal-length lens at close focusing distances, or even use a zoom. By using a long lens, it is possible to take very small, narrow-angle sections from the landscape and isolate relevant details of location and scale (such as an isolated house beneath a towering hill or a small copse on the skyline) and make a particular point about lifestyle in a rural situation. Furthermore, such lenses have great potential for the use of differential bands of selective focus and assist greatly in picking out small items within an otherwise cluttered view. The drawback of using the long lens for this purpose, however, is its limitation with regard to close focusing. It is less flexible than the standard lens in the types of photographs it can produce. On the other hand, it is quite normal for a standard lens to focus down to as little as eighteen inches.

A zoom lens is normally looked upon as being ideal for fast-action photography, in which you may need to alter the composition without changing lenses. But it is equally at home in static situations when

mounted on a tripod for it enables you to employ careful selection and cropping of the composition by the variable angle of view that its range of focal lengths affords.

The Welsh writer Dylan Thomas once described a village by the fact that the Post Office sold treacle and this type of subjective response based on telling detail is wholly valid within a photograph. Further, just as a piece of writing or music has its own particular series of patterns and ideas then so may it be that a selection of several significant details may be put together to form a photographic essay, with one detailed image complementing the next. By this process you can indicate aspects of lifestyle, history, tradition or culture and greatly enhance your descriptive portrayal of a region. When photographing the plight of the sharecroppers in the American South during the Depression years of the 1930s, Walker Evans was often content to make his statement through details of walls, bedrooms and windows, or, poignantly, the small unmarked graves of children in the dust. He was at that time working with the writer James Agee, who

had described much of the village life by the inclusion of small items on a mantelpiece, a tin can, or a hat. It is not unreasonable, therefore, to see in photography a similar vein of descriptive potential, concentrating not on one singular image but rather on a series that will ultimately afford an intimate insight into a community or a region that the distant view often overlooks or, by its nature, is unable to express.

A great help to this way of working is the intelligent use of preparatory reading and research about your chosen subject. The fascination for the landscape stems both from its elemental quality and its support for human life. It is a source of continual fascination to explore details of culture, art and tradition at close quarters, particularly when travelling. When land has been populated and cultivated, people leave markings, carvings, signs, icons, graves and artefacts that unconsciously indicate the value given to a particular way of life; they leave ruins and tantalizing clues to an existence that might otherwise have been forgotten.

Left: Whenever a long walk through the landscape is considered, do not forget the value of looking at small details as they present themselves – details of history, industrial archaeology, agriculture and the changing patterns of existence within the landscape. For this reason alone, it is very valuable to spend time reading about the environment before beginning work.

Right: The notion of leaving a mark or impression of a lifestyle need not, of course, be exclusively sad. This wall in New South Wales bears telling testament to improvised graffiti, which in itself may well provide the basis for social documentation.

Below: The passing of life itself, though, is the most universal marker on the landscape – the waxing and waning of the seasons and the cultivation of crops, year in, year out, and the combined influences of weather, light, atmosphere and time.

THE URBAN LANDSCAPE

The obvious alternative to the rural land-scape is the urban one. This is a rich basis for photography in all its varying degrees. Buildings are not natural, they have been built by someone, for a purpose. As a consequence they reflect that person's culture, aspirations or faith. Of all the great creative movements, architecture alone can be said to span the fields of both painting and sculpture while continuing to serve an essentially practical function in its own right – from the noblest palace down to the simplest hovel. Thus the recording of buildings is a rich source of inspiration. Like rural landscape photography, this field will yield even better results if you are prepared to research your subjects, both reading and travelling in support of the actual process of the photography. If you are suitably prepared in this way, so much more of your subject will reveal itself to your camera's scrutiny.

Urban landscape photography has not been hindered by an early tendency to mimic the sentimental landscape painting of the Victorian era. In fact, it has been influential in its own right. It was the photographic street scenes of Paris in the 1890s that so intrigued Degas for their compositional viewpoints and it should be remembered that one of the earliest photographs – Louis Jacques Daguerre's 'Parisian Boulevard' of c.1839, pp.204-5 – was an urban landscape. Much of this pioneering spirit remains in the street photography of Joel Meyerowitz, Lee Friedlander and William Klein. Current exponents of the urban tradition have a tendency to make use of the very singular qualities of the photographic colour print – with its inability to cope with differential colour temperatures and colour responses of the various street lamps – as a virtue in itself, a new kind of realism that owes no allegiance to painting at all.

However, as with the rural landscape the representation of the urban landscape

finds many forms. It is best to begin with the photography of architecture itself. Although obviously different, many of the basic principles that govern the natural landscape are equally important to the photography of buildings. This is particularly true of the selection and angle of light, which is important if you are to express fully the form and structure of a building. In the purest sense, however, the photography of buildings has a functional root that primarily serves the needs of either the architect who designed them, or the builders, or the historian, yet there is a great

deal of satisfaction to be gained from the informal recording of architecture for its own sake and from the making of more personal pictures of architectural subject matter.

From the formal point of view, it is usually only one building at a time that is being photographed and there are certain disciplines that have to be adhered to in the production of the photograph. For example the building should look as if it is actually standing upright and it is often useful that it should be recorded in the context of its surroundings. Both of these

Left and right: The urban landscape has always held a prime position as a photographic subject. It holds as great a fascination for the modern city photographer (left) as it did for pioneers like Frederick H. Evans at the end of the nineteenth century. In his rendition of Lincoln Cathedral (right) Evans uses the interesting compositional device of setting the medieval structure in the context of nineteenth-century houses. He was greatly influenced by the architectural watercolours of Turner and sought to instil atmospheric contrasts into his own work.

Below: Modern counterparts to F.H. Evans have, of course, a great advantage in the potential of extreme-angle lenses. In this photograph the perspective has been greatly compressed by the use of a long-focal-length lens. This has the effect of 'stacking-up' the buildings, contrasting the dynamic visual appeal of the skyscrapers with the associated feeling of claustrophobia.

criteria impose quite specific limitations on the photographer. For formal architectural photography there is no finer instrument than the monorail sheet-film camera. The sole reason for this is the fact that the monorail alone allows for the widest range of camera movements. Manipulating the lens and film panels enables you not only to control perspective but also to employ lateral shift in order to exclude extraneous objects at the photographic location. For this reason alone the classic approach to architectural photography has remained constant over the years and the equipment

itself has changed little with the passing of time. In fact, many would argue that one of the discipline's earliest exponents of the interpretative approach to architecture – Frederick H. Evans, with his studies of English and French cathedrals between 1890 and 1910 – has never really been bettered. In France the same could be said for the haunting and evocative images of Eugène Atget in the first two decades of the twentieth century. In both cases the photographs suggest more than a mere building and give an aura of the spirituality of humankind. The reason is relatively simple: these photographers used large glass plates and made contact prints from the originals, without resorting to an enlarger. The resolution of the original was never impaired and the results are images of impeccable beauty that have diminished little over the years.

LOOKING AT BUILDINGS

The essential quality that defines a building, as opposed to random growth in nature, is that it has been designed, structured and ordered. It is the extension of the builder's particular vision, and this in turn is a fundamental way in which to appreciate its conception and to mirror this in your photography. Above all, architecture is about people – space, yes, form, yes, but ultimately people – and it pays good dividends to undertake preparatory reading into the history of a building and the architect's intentions in designing it before attempting to interpret it on film.

Whether or not you consider its historical context, a building's design is inextricably linked to its character. When you are trying to reproduce this on film, the intelligent use of interchangeable lenses helps a great deal. Different lenses provide a range of views from broad, all-inclusive shots to close-ups of different details. You can use them to provide answers to many different questions you might ask when looking at a building. How were the arches sprung and with what material? How is the building lit? What is the best way to express this in a two-dimensional image? Without doubt the severest limitation the architectural photographer has to overcome is one of accessibility, for it is not always possible to secure significant close-up detail without the benefit of long lenses in many large buildings. Also, there is the question of restricted viewpoint. When you enter a building, you perceive it in several stages and at varying degrees of detail, as you walk, stop, look, lift your head, or turn full circle in one position. None of these elements may be captured in a single image and so you should adopt strategies that will allow this impression of your subject to build up. Often it is best to portray the building by means of a photographic sequence made up of parts, details and design elements coupled to the overall view. Initially, the use of a wide-angle lens

is essential but do not minimize the potential of its opposing counterpart, the telephoto. It will support that which is missing in the wide-angle – those significant details that are so fascinating for the photographer to return to and savour again and again.

Light

In interior work, the lighting is almost always daylight in historical buildings, perhaps with low level auxiliary incandescent lighting, or even candlelight. It is therefore best to employ some electronic 'fill in' flash when the light level is too low or the contrast too high. To this end, it is very useful to use the open flash technique and not necessarily the synchronized method. This is achieved by adding a flash during the basic exposure, but from the side, and frees you from remaining too near to the actual camera (see p. 123).

In modern buildings, great emphasis is usually placed on the use of the available natural light. When this is low, the architects may have made creative use of

Left: This simple image by Frederick H. Evans has retained its qualities over the years. The visual metaphor of the worn steps resembling moving water is just as valid now as it was in 1898, when the photograph was taken.

Right: Here in the great dome of St. Peter's in Rome, the whole concept of Italian Renaissance architecture is echoed in the beautiful structure and the quality of light, colour, and symmetry. The interplay of the shafted light, the cross and the dome itself literally raise the eye heavenwards.

Below: Within this Abbey, the exposure indicated was three minutes at f22, which allowed for additional exposures to be made by electronic flash. Having tripped the shutter, the long exposure gradually records the small tungsten lamps in the huge nave. A portable flash was then used behind each column in turn, 'building up' the exposure on the darker recesses.

artificial lighting. This poses considerable problems for the photographer using colour – each different light-source will have its own particular colour characteristics. For really serious commissioned work, the use of a colour temperature meter is essential in this situation. The best of these meters will not only measure the colour temperature (in degrees kelvin) of the existing light, but will also indicate the optimum filter for its correction. But the major problem with this way of working is that if you correct for one lamp, the effect of the others will change. Experience in this type of work is invaluable, but be prepared to experiment not only with various types of colour film, but also with a range of different correcting filters. An additional problem may be reciprocity failure with long exposures. Again, you should carry out your own tests on various makes of film.

EQUIPMENT AND APPROACHES

In the past, the single most important factor against the use of a 35 mm camera for architectural work has always been the fact that the camera does not possess the movements and adjustments of the lens and film plane that are commonplace in a monorail design. Even with a wide-angle lens you often have to point the camera upwards to encompass the full height of a façade. If you do this, the verticals converge on the uprights of the building and at the edge of the frame. The only way to avoid this is to keep the film plane and the façade of the building parallel, but this would often mean that its full height could still not be included in the frame. It has always been an impossible quandary for the user of the miniature SLR camera.

Lately, however, this problem has been greatly alleviated by the introduction of a lens type that allows the front of the lens to move vertically while leaving the camera in its upright position. This type is known as a shift or perspective-control lens. It achieves its movement by shifting the axis of the lens group by means of a small geared mechanism, and the precise alignment can be accurately monitored through the SLR viewing system. If you cannot use a shift lens it is better to retain the upright position and use an extremely wide-angle lens (like a 20 mm) and include much more of the foreground than originally intended. You can crop this out of the composition when printing although it will have to be left in if you are using colour transparency film.

Another technique of perspective control may be adopted in the darkroom. You can use the principle of the tilt of the monorail camera movements and apply these to the bellows of the enlarger to correct the converging verticals in the negative. If the assembly allows for the

Above: Refinement of film technology has naturally led to an increased use of the 35 mm camera for architectural photography. But a more significant reason for this has been the introduction of specialist lenses – particularly the shift lens. This objective allows the photographer to keep the verticals in a building upright (thus minimizing perspective distortion) and yet still encompass the full height of the building by shifting the lens via a micrometer adjustment. In this photograph the rear of the camera was parallel to the tall buildings, although the photographer was working from ground level.

enlarger head to be tilted, then you can adjust the baseboard in a similar way, but in reverse. This will produce a correcting effect when the verticals are projected on to the baseboard. But it will still be difficult to get right the relative vertical and horizontal proportions.

Architectural work involves many unusual and interesting techniques, especially those that provide greater control of the image before exposure. Photographing of large, dark interiors is a particular challenge. Long exposures are needed, and times of one minute are by no means rare. Buildings that are very dark may still contain excessive contrast with little detail in the shadows. For some interiors it may be important to capture some of this detail on film. Fortunately, the combination of a sturdy tripod and small lens aperture means that you do not have to remain behind the camera during the actual exposure. It is therefore quite feasible to move in and out of the subject area while the shutter is open without being recorded. By strategically positioning yourself behind a pillar during this time it is quite possible to use auxiliary hand lighting to fill in the shadow areas. The effect will be to 'paint' the interior details with auxiliary light. Subject movement is not a problem for architecture, and it is wholly reasonable to stop the lens down so much that the necessary exposure could be between one and five minutes. Remember that often an exposure increase of one minute is, in real terms, only the equivalent of an extra half stop if the primary exposure has been calculated as two minutes. This allows you plenty of time in which to trip the shutter and then walk to a selected position behind an arch or a pillar and fire off two or three flashes from a portable unit. Aim for the shadow areas, in the general direction of the prevailing light. This will 'lift' the shadow area slightly in its exposure level and is an extremely useful technique for large, photographically dark interiors.

Below: Specialist wide-angle lenses for the 35 mm format are also useful in architectural photography. In this example, the entire house is encompassed from close range, but the distortion is minimized by the careful use of the camera in the upright horizontal position. The wide angle means that there is no need to tilt the camera and it should be noted how steep the angle of the foreground fence is. Note too the dramatic darkening effect of the ultra-wide-angle lens on the sky. This is particularly noticeable if a polarizing filter is also used.

SPECIALIST APPROACHES

In both landscape and architectural work there is great scope for breaking away from the purely academic recording of a scene. This can make these areas very rewarding to explore. One technique that can yield particularly rich and unusual imagery is night-time photography. During World War II Bill Brandt created many memorable images of London by night during the blackout, when no artificial or auxiliary lighting was possible. He took his pictures in the darkened streets entirely by moonlight and created a haunting evocation of a capital under siege. One is unlikely to find deserted and unlit streets today, but the landscape – both urban and rural – is greatly enriched at night when moonlight

Above: The rendering of this house has taken on an eerie quality through the photographer's use of infra-red monochrome film. This material has a characteristic response that is quite unlike any other. Its sensitivity to the visual spectrum is limited, being restricted to the red end, and it can be used with a special filter to hold back parts of the visible light in preference to the effect of rays that are invisible to the eye. As this is a print material, the effect can be further enhanced in the darkroom.

Left: In this sunset, conventional film has been used, but the exposure has been built up by successive images of the setting sun. By dramatically cutting down the initial exposure and tripping the shutter after a set interval of time, it is possible to expose the landscape gradually within the camera, whilst the sun, between exposures, shifts its position. In this way, the sequence of the sunset is revealed.

that may become tiresome in due course, but the black and white versions can provide a good source of imagery.

The reason black and white infra-red films give such a unique insight to a scene lies in the fact that they have a sensitivity different to that of the human eye. While they respond to some of the wavelengths that are picked up by the eye, they are also sensitive to wavelengths that are slightly longer than those from the visible red area. In practical terms, when exposed through an appropriate deep-red filter, leaves and grass in a landscape take on an eerie pale glow, while the sky plunges down to a dramatic near-black (due to the deep-red filter) and the clouds stand out sharply (due to their water vapour content). Because the character of the response of such a film in a non-scientific application is essentially subjective, it is highly advisable to carry out tests to establish the performance that you can expect and to find out your own personal preferences.

An additional facet of infra-red film is that its particular response extends to matters of focus. On some makes of lenses there is a small red R, or a dot, just to the left of the central marker on the focusing scale. When focusing through the lens with infra-red film, you refer back to the engraved scale and reset the focus by placing the R where the first focus position had been set. This will constitute the correct focus for the infra-red film.

In addition, the particular sensitivity of infra-red film is extremely useful when photography is likely to be hindered by the presence of too much haze and mist over a distant landscape view. The particles that obscure the detail in the distance on normal film have little effect on infra-red. Accordingly these wavelengths are able to reach the film in significant amounts and under such conditions the rendering of small distant details is greatly enhanced.

may combine with the ghostly glow of a nearby town to bathe the scene in subtle colour. It is advisable not to include the moon in the photograph itself, for although it will register, the difference in light level between the moon itself and the landscape is too great to permit both to be included in the frame; also, the moon's movement across the sky is relatively quick and it will produce an elongated image in the photograph with long exposures. Very interesting effects are possible if you use the camera in its multiple-exposure mode (in which the shutter is recocked but the film not wound on) – several images of the

moon may be taken during its transit. This produces a trace of its actual path across the heavens. On a moonless night it is possible to record the moving stars around the Pole Star, to give further dramatic and unique effects.

Another unusual technique is to photograph in daylight using an infra-red film, which is obtainable in both colour and black and white. They are exposed through filters that are specially made to match their sensitivity to particular wavelengths of light. Infra-red colour film tends to suffer from reducing everything down to the same equivalent, with an artificiality

THE PORTRAIT

There was one area of photography that was destined to develop hand in hand with fine art – the portrait. Indeed it is arguable that the photographic portrait will in many ways eclipse the painted one. If there is one thing, next to intelligence, that differentiates us from our animal counterparts, it is the infinite variety and individualism of the human face. This fact and the use of the camera to record it, have always been at the heart of photographic practice, for the face, above all, mirrors so many aspects of humanity. Furthermore, the ability of photography to preserve forever individual moments of passing time makes it especially appropriate to record the changing expressions of the face. So the photographic portrait, in all its varying guises, is one of the major art forms of our age and continues to hold a unique niche in its documentation.

The face and its portrait are fundamental to human relationships. They offer us so much in the way in which we respond to a person that the process of portraiture itself cannot be merely confined to studio convention – it should be seen in the widest context of interpretation. We meet people in many different circumstances, joyful and sad, formal and improvised, and under varying conditions of emotion and response. This variety should be mirrored in the portraits that we take. The basis of a portrait may well be simply the expressive features of the face, but, equally, it could rest in the surrounding environment, the timing, the quality of light, the drama of the moment, or the sitter's response to the camera. You can bring all of these factors into play in your photographic portraits.

There is another important reason for taking portraits. The one certainty in life – that one day it will end – is a powerful reason for setting down markers in time before that eventuality occurs, and the camera plays a strong part in achieving this for a nation's archive.

The early photographic processes of the Daguerreotype in France and the calotype

Right: Arnold Newman uses pattern, environment, colour or association in his portraits to convey his response to the sitter's personality. This has rarely been better expressed than in this masterful study of the great composer Stravinsky. The image is dominated by the dramatic form of the piano, with the figure placed left and to one side so that the sitter becomes directly linked to the origin of his greatness. The piano lid forms a large shape, reminiscent in itself of a G clef, and the pensive figure rests against the basis of his creation. It is simple – indeed, it could hardly be simpler – and yet it makes its direct statement without ambiguity. The composition is formed from the intelligent use of the frame of the ground glass screen, with all elements ordered and carefully considered and, in the process, one feels one knows a bit more about the humility of the composer. There are no strident gestures, no dramatic distortions, no distracting details – just a simple concept beautifully expressed.

in England required exposures of anything up to ten minutes in sunlight and were therefore far too long for portraiture. But technical improvements made such rapid progress that by the mid 1850s there was a portrait studio to be seen in every major city of Europe and North America. The unique quality of the Daguerreotype was its highly polished, mirror-like surface that seemed to change from negative to positive in the hand according to the angle of the light in which it was viewed. Its small format, often hand-coloured, and set into small gilt frames, gave an icon-like quality to the photograph that totally eclipsed the hand-painted miniatures of the day.

Within twenty years, the American Civil War was raging, and the likenesses of Lincoln, Lee and Jackson had been set down for posterity. Meanwhile in England

the remarkable portraits of Julia Margaret Cameron, with their haunting softness, movement and insight, were confounding previous approaches to the portrait. They were a product of a remarkable pioneering approach and determination – sitters had to put up with exposures of as long as four minutes at a time. Mrs Cameron's friendship with Lord Tennyson resulted in portraits not only of the great Victorian writer himself but also of the gifted scholars and intellectuals of the day, such as Herschel and Carlyle. In France, her contemporary Nadar (Gaspard-Félix Tournachon) was working in a quite different way, reproducing exquisite detail with the wet collodion process. Like Mrs Cameron he also left a legacy of images of the leading figures of the arts and the theatre from his sittings.

It is this ability to preserve images of the famous and the not so famous over a long period of time that lies at the heart of the fascination that portraiture continues to hold. This is equally true, however, of those portraits in which the subject is seen in a domestic or some other setting, for these can give us insights to aspects of sociology or the domestic arrangements pertaining to a particular age and society.

APPROACHES TO THE PORTRAIT

Because the portrait so readily mirrors our response to human relationships, our approach to portraiture can stem from many varying viewpoints and attitudes. The results may also be conditioned by the very materials and methods available to the photographer, since different camera systems have their own stylistic characteristics. The small hand-held miniature camera, for example, can be used quickly and is ideal for capturing the carefully chosen 'moments of truth' in a portrait. The large-format sheet-film camera on the other hand affords a more monumental and contemplative approach.

In a similar way, the question of location is critical and, as in landscape painting, there has been a marked movement away from the restricting tyranny of the studio to a freer, more interpretative relationship of the sitter to the environment. After all, the landscape around the sitter, or the buildings, or the geographical location, can have a profound effect on the final result. So there is no direct and simple answer to the question of approach until you have made the initial decision about your sitter, and this will have a great influence on the selection of equipment for the job at hand.

There is very little in photography that is actually new, so it is wise to approach portraiture with a firm grasp of the history of the medium. It is more important to put aside esoteric questions of specialized lenses and other equipment, and prepare yourself by looking at the great images of past photographers. It is also worthwhile extending this further into questions of painting and the history of ideas. Very often, the simplest idea is the best, and the notion that complex lighting and expensive sets are somehow virtuous in themselves is misguided. Recently, there has been a movement by leading exponents of portraiture and fashion almost to revert to a purer vision of early times. Examples of this can be seen in the work of Irving Penn,

with his itinerant studio; Richard Avedon, in his portraits in the American West; and Bruce Weber, with his Olympic series that preceded the Los Angeles Games in 1984. In all cases, the studio and its accompanying paraphernalia was abandoned in favour of available daylight and a 'straight' approach. Penn quite literally took a folding canvas tent-like studio around the world with him, Avedon kept the background down to a simple sheet, while Weber used old canvas informally draped behind the posing subjects.

Yet even these approaches remain too artificial for many photographers who use miniature cameras in the tradition of Henri Cartier-Bresson. In their work, any form of organization of the background is anathema to the selective process – their priority is to remain detached, not to interfere, and to watch and wait with great patience for that all-important decisive moment to crystallize.

Left: The miniature camera has an important role in portraiture. This is perfectly illustrated by this photograph by Burt Glinn of Sammy Davis Jnr in the early dawn of the New York skyline. It readily shows the intimate side of a performer's world, when the applause is over and the crowds have gone, and the sun greets another day to the clink of ice in a cooling drink. This is the time to reflect on the past performance and the impending reviews and, for a brief moment, to rest before taking the stage again.

Above: Karsh used a more controlled and essentially romantic approach in his portrait of Ernest Hemingway. The sitter is clearly aware that he is being photographed and that the photograph is for posterity. It is formal and impeccable, rendered by a large negative in studio conditions, and lit by artificial lighting.

Right: Different again is this informal street portrait of a busker, neither famous nor important, but no less worthy a subject for that.

THE ARRANGED PORTRAIT

There is a distinct quality to the arranged portrait because the sitting is by mutual consent. There is no delusion – the sitter is there to be photographed, accepts being subject to your direction and taste, and so the process becomes almost ritualistic. For many, this is the true art of the portrait photographer, providing the ability to control all elements of the portrait right up to the moment of exposure and beyond. This control applies not only to matters of background and detail, lighting and viewpoint, but also to the person being photographed. For this reason alone, many photographers prefer the bulky presence of the view camera, since the large tripod-fixed instrument quite literally becomes the focal point of the proceedings.

With such control it follows that careful attention is essential to the elements of the picture that directly influence the nature of the interpretation, and none is more important than lighting. Light, quite literally, describes the form of the subject in a particularly characteristic way. Its angle, direction and intensity have a powerful bearing on the resulting image of the sitter. Even photographers who have reverted to the earlier approach of lighting by the daylight studio method go to some lengths to keep control over light direction by means of movable reflectors or baffles.

However, the selection of lighting does more than merely describe form, for it can also have a direct bearing on the way in which the sitter's character is portrayed. Low, angular lighting affords menace and mystery, harsh point-source lighting gives 'realism', a back-lit spot light (due to the traditions of the 1930s film-studio style) affords 'glamour', and simulated window-light offers a particular form of naturalism. Then there is the question of the effect of light on colour, and whether the lighting will be based on the classical tradition of Chiaroscuro (the light and dark expression of form so evocatively used, for example,

by Rembrandt) or by the more modernist approach of colour for its own sake, allowing the juxtaposition of value, harmony and contrast to predominate.

Despite the fact that you create an arranged portrait within a formal setting, you can use any type of camera. Choice of lens is more limited, however. A medium long-focus lens allows you to stand away from the sitter and yet be able to view the subject comfortably. You will also be less likely to inhibit the sitter at this distance. In the arranged portrait, time is rarely a significant problem and therefore, once you have established the band of focus, taken light readings and set the aperture, then the sitting should be mainly concerned with the dialogue between sitter and photographer. Music can sometimes help, as can conversation. There is a lot to be said for using a motor drive and a cable release when working with a miniature camera to free you as much as possible from the intricacies of working the camera during the sitting itself. On the other hand, many photographers welcome the needs of camera operation as a form of relief to interest the sitter.

The alternative to the studio arranged portrait is its equivalent on location. Here you carry out the formal arrangement in a

given situation that is felt to be central to the person's character, background or influence. In such circumstances, it is not usually possible to change many elements of lighting and accessories, but this is all the more reason to pay close attention to the quality of the existing light in relation to the subject, and also to look for the telling details within the environment that might offer additional information about the sitter. Also, limitations of viewpoint may well mean that the pictorial space must be controlled much more by the use of interchangeable lenses than in the studio. You may want to relate the sitter to a panorama or a large building interior and the scale of this can be greatly influenced by the selection of lenses.

Having established a working rapport with the sitter, you should try several variations on the given theme by changing the camera angle and viewpoint slightly as you work. Keep watching for those small movements and mannerisms that typify the sitter's personality. In the studio, pay particular attention to matters of dress, carriage, gesture, and expression. On location you must also give equal attention to the setting, the background, and the details that throw light on the sitter's working life or character.

Left: In setting up the arranged portrait, the photographer works from a fundamental advantage – the sitter is wholly committed to what is being done. It is advisable to work up gradually to the final shot by a series of developing poses and gestures, not only for the purpose of taking the photographs but also for the benefit of getting to know the subject better. At first, keep the lighting relatively simple, even if it is, as in these examples, studio based. A simple 'window light' with a large reflector from the side will suffice to begin with. Keep the background uncluttered and use a medium telephoto lens so that you can study the face without being too close.

Having established the basic lighting and working position, engage the subject in the process of assembling the series of images, and be willing to discuss various approaches with the sitter. When using roll film, be prepared for the fact that as soon as the shutter fires the sitter is likely to relax – thus affording another facet of character and, possibly, a better and more vital image. While you have the time and opportunity, expose plenty of film, for it may take some time before a meaningful dialogue between photographer and subject develops. Remember the role and value of the contact sheet afterwards and try many variations on a theme before settling on one solution. If you find the session difficult, do not communicate this to the sitter, but take a break and try another approach. To give the session some direction it is worthwhile to begin with a firm idea, even if this is readily abandoned as the session progresses.

GROUP PORTRAITS

Of all the types of portrait, the group is the one of which most people have experience. This is due to a very fundamental response in all of us to record passing moments, perhaps to celebrate an event – a victory of some sort, a game, an academic award, a wedding – or, conversely, to commemorate the passing of a loved one, or a loss, or to pay homage in one form or another. Even the most austere occasion carries with it the realization that this one moment is unique and can never be re-lived.

The most common group to which we have direct access is the wedding, for this is normally the highlight of family activity and unites people in a common cause. Clearly there are basic requirements when you are recording such an event – you will be expected to take portraits of people grouped formally in certain ways. But you should remember that apart from the contrived atmosphere of the formal group portrait it is also rewarding to record the activity that builds up to and follows the actual exposure. You can use a small hand-held camera to distil those unique moments of humour and pleasure that may not appear in the final formal group photograph. Such images often form a unique record of a human event. When taking a group portrait, start by considering the circumstances that have brought the individual people together. Look at the surroundings, the buildings, the landscape, and what the single element is that binds these people together.

The group portrait is usually the result of a pre-arranged plan. The sitters will be wholly aware of what is happening, so you will be able to arrange the elements within the group itself. It is particularly useful, if possible, to arrive at the scene at least one hour in advance and to examine the site. By the time the participants arrive, you should have several ideas about how best the session might proceed and where the best place will be to take advantage of the available light and its direction. Be prepared, well in advance, and do not show indecision in the process as this readily communicates itself to the subjects.

Another essential and important help for groups is the potential of interchangeable lenses and selective angles of view. The group may well be large and some-

Left and right: When Edward Steichen made the memorable exhibition *The Family of Man,* he realized that we are all members of a large family. This is one reason why group photographs have a lasting fascination. Differing social conditions, class, and race contribute to this interest – we gain greatly from seeing how others live, and the things that infuse their lives with pride, affection and dignity. In this family group (left) the environment makes a vital contribution, while in the group of tennis champions (right) this is less important. The overriding message is that even great champions are human beings too. They sit, slightly self-consciously chatting while the photographer works, even missing the point of exposure in one case. The image is no worse for that.

Above right: The balcony scene after the royal wedding is equally memorable for the same reason. On a day in which literally thousands of photographs were taken, this stolen kiss remains the lasting image.

what difficult to assemble and it is often a great help, once the tripod and camera have been set up, to try altering the camera's angle of view, particularly after the initial exposure has been made. Once the formal function of the group photograph has been satisfied, then the atmosphere usually softens somewhat and people are willing to consider other alternatives. A wider-angle lens, from the same viewpoint, offers an extended insight into the location or, alternatively, as the outside members of the group peel away, the use of a telephoto lens and gentle persuasion yield good dividends for informal small group portraiture. The essential rule to follow is, at all costs, get the main group picture – afterwards you should be prepared to seek out and record those delightful moments that are 'not in the script'.

CHILDREN

The photography of children is one of the most rewarding branches of portraiture. The fact that the camera is the perfect instrument for capturing the passing moment makes it particularly effective in the case of children, since the potential for change is greater than at any other time. As sitters, most children are natural extroverts, happy at the prospect of being both seen *and* heard, and quite content to undertake a whole range of theatrical gestures in the process of relating to the camera.

The small, hand-held miniature camera is especially suitable for this type of photography. Ideally, you should use it with a medium telephoto lens, for this will make it sufficiently fluid in handling for it not to hold up your progress when taking the photographs. This is important because it is useful to be able to work quickly when photographing children. Also, the nature of the small camera allows for a liberal shooting ratio when you are using 36-exposure film – it may well be that you will need to take such a number of shots for the session to be in any way successful.

It is very useful to talk to the children before starting to take pictures. Find out whether they have a favourite pastime or pleasure. This may involve an activity such as dressing up, and you should attempt to encourage them to indulge these flights of fancy. It is especially important to try and get beyond the initial difficulties of a child's being overconscious of the camera's presence – it is certainly wrong to over-emphasize the camera's needs by insisting that the child holds still for you. If you are planning a photography session with a small child, it is better far to load a high-speed film in the first place and avoid the need to interrupt your subject continually or slow his or her movements down.

Above all, a prime requirement of child photography is patience. You must also realize that children too have feelings and responses, and that their reservations about being photographed may well run

Left: In this memorable photograph by Henri Cartier-Bresson of a little boy gleefully returning home with two bottles of wine, the master of the Decisive Moment principle again proves its worth. It comes from the intuitive work of a lifetime's experience of watching, waiting and choosing the precise moment as it presents itself. The small camera, the quiet shutter and the unobtrusive presence of the photographer all blend to make this moment the right one – a second earlier and it would have been ruined, a second later and the child would have been gone. For this type of approach it is best to take the exposure reading first, and to set the lens to its midway position. Refinements can always come later, but it is better to shoot from instinct, having first of all set the controls, rather than fumbling with comparative readings and averaging systems when the moment is so fleeting.

Left and above right: Both of Ken Griffiths' photographs show a very different approach. On the right, the camera is larger and the children are fully aware of its presence whereas in his colour photograph of children playing street games (left) the emphasis rests on the environment. The children may well remain oblivious of the camera but the joy of the occasion is apparent, with the slow shutter speed accenting the movement of the circling children at the height of their play. The scene is reminiscent of a Breughel painting.

deeper than mere shyness. It is best to allow them their full and natural range of expression, even if this renders the task more difficult. You should not impose an attitude of 'do as you are told or else' – this would be pointless for everyone concerned. A useful technique may be to begin by asking the child to take your portrait and then to ask them how best they think you should proceed to take theirs.

The recording of children should not be limited to traditional images, such as the photograph of the child with the kitten on her knees. One way to avoid this sort of approach, especially when travelling to other regions, is to use the photography of children as a natural way to get to know other people better. If you want to document a region seriously, there are few better ways than to work within the framework of the local school and its staff. It is vital to do this with tact and discretion, however, for a failure to do so will mean either poor results or no results at all. One of the great disciplines of photography, and thus one of its lasting pleasures, is that it involves one in direct relationships with other people and this can have rewards that last a lifetime. So do not abuse the confidence given to you, but feed back your own particular skills as a photographer. It is more than likely that your subject would appreciate a copy of your photograph – so make sure that you send it.

All of this advice is relevant to the formal studio session with children, and much of what has been said for the formal portrait relates equally well to the photography of children. Be patient, watch, wait and expose – don't chase the butterfly, but let it come to you.

CANDID PORTRAITS

The converse of the formal portrait is, of course, the candid, and this is an area of photographic activity that has a powerful tradition. In the early days of the medium, candid work was less common, largely because of the size and bulk of cameras before the advent of the 35 mm format. It was therefore seldom that the sitter was not aware of the process of the portrait being taken. This is no longer so, and indeed there are many photographers whose major output is directed towards the 'poaching' of subject matter without recourse to interference or organization of

any kind. Such an approach is an extension to the tradition of photojournalism, and it affords a different kind of result altogether from the formal and sometimes contrived atmosphere of the studio approach. The lightweight portability of the miniature camera means that photographs may readily be taken in situ, and without prior arrangement, by simply selecting a site and watching and waiting for the right moment to present itself.

However, the subject of a candid portrait may have foreknowledge that a picture will be taken – the picture will still be candid if it is arrived at without formal arrangement. It is quite reasonable to adopt the candid approach, for example, within a pre-planned location setting but without prejudging the moment of expo-

sure or allowing it to impinge on the relationship with the model. The strength of the candid portrait derives from the fact that very often the subject's singular character is best reflected in an off-guard moment, whether by facial expression, a tilt of the head or the carriage of the body.

Portraiture at its best is the product of two people working together and relating to each other in a meaningful way and this, frankly, can derive as much from hostility as from affection or respect. There is a tendency to look upon anyone who indulges in candid portraiture as an exploiter or voyeur but this is simplistic and somewhat irrelevant – all expressive content in the visual arts derives from a firmly held attitude or feeling about something and a sort of mild sentimental anonymity of

attitude is unlikely to lead to interesting work. It is quite a different matter however to ridicule or degrade the subject by personal prejudice and this, above all else, sets many people against the notion of the candid portrait.

It is essential, therefore, to base your work on a positive feeling for the subject and, if necessary, to resist the temptation to work against the wishes of the sitter if a degree of hostility to the process is felt. The cardinal rule should stem from the principle of not infringing on someone's privacy and dignity and it is always important to remain aware of the possibility that the attentions of the camera are often not desired.

At its best, the candid portrait is a unique facet of the photographer's reper-toire. It is perfectly exemplified in the work of the major photojournalists of this century, such as Henri Cartier-Bresson, Alfred Eisenstaedt, Garry Winogrand, Lee Fried-lander, Bruce Davidson and Robert Frank, whose insight and perception related their portraits to the major events of their time. As in the case of Julia Margaret Cameron almost a century earlier, they have left us enduring perspectives on the events and lives of some great figures of the era and yet, together with this, there were also examples of everyday life of anonymous subjects and unsung heroes, of lift attend-ants, servers in restaurants, coffee drinkers, lovers, and children, that give us powerful images of a changing way of life.

With candid photography it is often essential to set down many exposures during a single sitting or session. The quality of the event may require a steady build-up of sequence coupled to a variation in viewpoint. When this is so, it is very important to ensure that you contact all of the films after development and examine them closely with the aid of an eye-glass. This is because, unlike drawing, photogra-phy often involves very rapid successive images and these can rest dormant unless examined carefully in hindsight. Also, as the nature of the candid photograph is that it is not pre-planned, then by the same token the contact sheets may well contain beautiful moments that you did not realize you had recorded at the time of exposure. It is essential if you are to do your work justice that these images should have the opportunity to see the light of day.

Left: The principle of the Decisive Moment in the work of Cartier-Bresson was not restricted to fleeting moments and elusive actions – it also informed his exquisite subdivision of the viewfinder's rectangle. In this portrait of the great painter Matisse, it is possible to feel the sensitivity and skill of the old draughtsman as he gently examines the dove in his hand. By the same token, Cartier-Bresson shows his own affection for the sitter by the beautiful composition of the doves to the right of frame, with their soft and beautiful forms and their relationship to the central figure of the composition.

Right: The use of the controlled pictorial elements is also seen in this intimate photograph of an old man in a Greek village, in which the abstract qualities and the subtle use of colour predominate. At first sight the two photographs appear entirely different, but in both the use of formal values within the rectangle and the subdivision of the frame are critically important.

INDIVIDUAL PORTRAITS

To make an expressive portrait of any sitter you must draw on your creative potential and relate your techniques and equipment to individual subjects. The way you approach a portrait may depend as much on their complexion and colouring, as on their stance, gestures and facial characteristics. The problem with school or passport photographs, for example, is the fact that, no matter who the sitter, the technique, viewpoint and exposure are precisely the same. Their purpose is to record as many people as possible in the least amount of time, and with the minimum of fuss, trouble and thought, and the notion of individualism at any level simply does not arise.

In the interpretative portrait, on the other hand, the individual sitter is the vital constituent, and it is from the fundamental response of the photographer to the sitter that all else flows. Human beings are infinitely variable and essentially individual and therefore it is inappropriate to attempt to portray a person by means of a preconceived formula. How does the sitter best express individualism and what is the most interesting facet of that person? It might be his or her height, age, silhouette, or even the immediate surroundings. A portrait should be more than a mere likeness and should

Left: The best of portraiture stems from the principle that the subject is, after all, a human being, and no amount of fame, notoriety or money can dispel that. When the spotlight is no longer on them, famous sitters can still reveal aspects of their character by subtle means. In his portrait of Marilyn Monroe, Sir Cecil Beaton has captured that very quality in the quizzical look of almost childlike naïvety of which so many people have subsequently written. It is clear also from the photograph that she has a sympathetic response to him too. It is almost as if the two people, each famous in his or her own right, are communing with one another through the process of the sitting.

Right: In Ken Griffiths' portrait of Keith Richard the lines of distance are very tightly drawn, yet there is still a feeling of mutual respect between the subject and the photographer. The clothing, gesture, stance and position of the subject within the frame all add to the feeling of this distinctive imagery within the portrait.

convey an element of the subject's personality.

If it is not possible to meet your sitter in advance (and this is often the case in professional practice), take with you only those items of equipment that are easiest to use, together with a limited number of auxiliary lenses and an additional reliable light source for good measure. Before commencing work, take time to involve the sitter in what you are trying to achieve. This will have the dual advantage of

beginning the session on a note of informality, while giving you the opportunity to assess the sitter's response to your presence and, hopefully, giving some clues to the person's individual attitudes and responses. Do not rush your fences, be patient and stay in control of your aims and intentions and, even if you sense that things are not progressing well, do not communicate this as you work. If there are problems, it is better to ask the sitter if he or she would like a break and rethink your approach in the

interim, before restarting with a fresh viewpoint.

There are many elements that reveal a person's individual character. It may come out in clothes or surroundings and it will also repay good dividends to ask your sitters about their favourite hobbies, their aspirations, their taste in music and the like, before considering questions like what they do for a living, and what their family background is, or how long they have lived in this particular place. Remember that most people are interested in the role of the camera and hold a degree of fascination for its potential. So it is worthwhile talking about this to the sitter, even to the point of inviting him or her to have a glance through the viewfinder. This feeling of being involved does a great deal to encourage sitters to be sympathetic to the photographer's aims.

It is important to remember, however, that the sitter has feelings too. It is not a good practice habitually to go to the extremes of provoking the subject in the hope that some form of extra truth may emerge. This is most unlikely. This method is the resort of the cheap newspaper photographer for whom nothing is as important as tomorrow's deadline. That type of work, like the mythical deadline, is all too quickly forgotten. It is far better to treat your subject with patience and respect and, if the session becomes strained because of a particular line of approach, to try other ways of solving your problem. You are not likely to succeed if the sitter feels that you are taking advantage. Good portraiture is no different from anything else that is worthwhile – it takes a lot of time and a lot of practice and much of the skill has nothing whatsoever to do with the mechanics of photography.

In portraiture what is ultimately important is how you deal with and respond to other people. It is more than likely that the photographer needs the sitter much more than the other way around and so you are, by the nature of things, duty bound to work within the limits of your sitter's privacy. In a nutshell, good portraiture is to do with how you relate to and respect the subject – no more, no less.

THE EXTENDED PORTRAIT

In painting, there is a tradition, dating from as far back as the fourteenth century, of including within portraits details that reveal facts about the person's life, country or profession. This is a technique that could well be considered when extending the concept of the photographic portrait. In addition, photography has singular qualities that can be used in portraiture and which held great fascination for the modernist artists of the Twenties and Thirties. These include double exposure, collage, solarization and juxtaposition. Such effects were great influences on the work of artists such as Giacomo Balla, Gino Severini, László Moholy-Nagy and Man Ray. It should also be added that the history of multiple negative work goes back to the origins of photography itself and formed a great part of the output of Henry Peach Robinson, whose photograph of a deathbed scene, 'Fading Away', was created in 1858 (see p.208). If you have access to a darkroom, this is a fascinating and rewarding area.

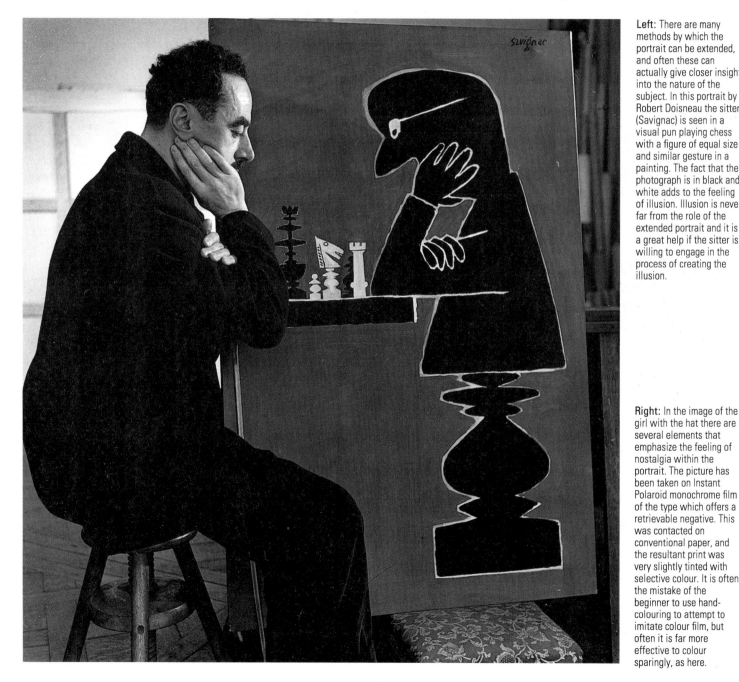

Left: There are many methods by which the portrait can be extended, and often these can actually give closer insight into the nature of the subject. In this portrait by Robert Doisneau the sitter (Savignac) is seen in a visual pun playing chess with a figure of equal size and similar gesture in a painting. The fact that the photograph is in black and white adds to the feeling of illusion. Illusion is never far from the role of the extended portrait and it is a great help if the sitter is willing to engage in the process of creating the illusion.

Right: In the image of the girl with the hat there are several elements that emphasize the feeling of nostalgia within the portrait. The picture has been taken on Instant Polaroid monochrome film of the type which offers a retrievable negative. This was contacted on conventional paper, and the resultant print was very slightly tinted with selective colour. It is often the mistake of the beginner to use hand-colouring to attempt to imitate colour film, but often it is far more effective to colour sparingly, as here.

Hand colouring

Hand-colouring is another effective way of extending the scope of your photographic portraits. When working with hand-colouring methods, you should carry out careful tests on the types of pigments that are available before committing yourself to any hard-and-fast method of working. There are photographic colour dyes expressly produced for the retouching of colour photographs but these tend to lack any degree of colour saturation, largely because their prime function is to merge into the colour of the photograph rather than be seen. Watercolours are excellent but some hand-colourists prefer vegetable dyes like those that may be purchased for colouring icing sugar on cakes – although it should be noted that these are not permanent and will fade in time.

There are two basic methods of application, the thin sable brush for fine detail and the airbrush for soft edgeless areas of flat colour. This edgeless quality is particularly appropriate for hand-colouring photographs because it responds in a similar way to the tonal increments of the photograph itself. Where a hard edge is required, however, it is possible to mask over the adjacent area with a special self-adhesive film, available from graphic design suppliers. An expensive compressor unit for applying the paint by means of an airbrush is no longer an essential item of equipment, as it is now possible to purchase cans of compressed air for this purpose, together with the necessary attachments.

Where translucency is not important then normal gouache water paints are perfectly adequate for most needs and are much easier to use than the translucent dyes. With opaque colours it is easy to correct mistakes by overpainting, but with pure watercolour it is essential to start with very pale solutions of colour and gradually build up the density with successive overlays. In truth, however, one uses the materials that are best suited to the job and often one can improvise – never throw away your bad prints but keep them to experiment on, with coloured pencils, rouge, tan boot polish or whatever.

Left: This portrait has been treated by the process known as solarization, which was greatly enjoyed by early experimental photographers such as Man Ray. To be properly done, this requires a great deal of initial testing. It depends on two levels of development and exposure taking place, one after the other, in the print processing stage. The critical element is in judging the precise amount of initial exposure and development to be given before subjecting the printing paper to a secondary exposure and redevelopment. It is often necessary also to after-treat the image with a very dilute bleaching agent or reducer so that the original whiteness of the paper can be regained.

THE NUDE

There are few subjects more certain to arouse hostility on one hand and enthusiastic support on the other than the nude. This subject is more than merely an image of a person without clothes – it is the basis for images that can be either sculptural or erotic. Indeed, many people feel that the nude is the finest, most demanding discipline with which the artist has to come to terms. Painters have always acknowledged this and drawn, not only from life, but also from casts of the great sculptural works from ancient Greece and the Renaissance. Artists have valued this sort of work because it trains the eye to appreciate form, structure, proportion and space. Alternatively, at its crudest level, the nude may be nothing more than the basis for sexual arousal. This has now become such a debased and discredited form of popular illustration within the vulgar arts that it has lost any fascination it formerly had. Much of what passes in this idiom is, frankly, uniquely boring. For many this is the central reason for its offensiveness, aside from any reasons to do with the politics of sexuality.

Another concept fundamental to the nude is the notion that the naked body is the greatest achievement of the Creator and, as such, is the height of beauty to which all art ultimately aspires. This is a belief that stems from early Christian ideals and continues to occupy a very particular niche in representational art. But such thinking has always been based on an attitude that sexuality stems from a concept of Original Sin, and this has a powerful influence on the role of the nude that persists to this day. It is for this reason that the nude is at the centre of so many kinds of imagery. All of these considerations have had substantial influences on photography from its earliest days, and the nude, as a subject, remains a continuing motif that appears in many forms of photography today.

In much the same way as the nude has figured prominently as a motif in twen-

tieth-century fine art, it has also been the basis for unique work by photographers such as Bill Brandt and André Kertész, both of whom have distorted the human form in their imagery, or Robert Mapplethorpe, Helmut Newton and Leslie Krims, who have made expressively sexual statements with their photographs. None of the latter three photographers' imagery is exclusively concerned with the female nude. In the more modern and less classical approaches to the photographic nude there is a greater concern for psychology and perception, narrative and association in the work. Here the influence may stem more from the Expressionist cinema of the 1930s than from ancient Greece, and much expressive use is made of the associative influences in the picture, the setting, the lighting and the implied narrative within the frame, as well as from the figure itself. The nude in contemporary photography can form the basis for social documentation or be used in experimental aspects of performance art. It can also be used to further enquiries into the accepted norms of sexuality and race, often challenging both of these in the process. Joel-Peter Witkin has devoted a great deal of his output to the use of the nude in one form or another, often with disturbing undertones. He uses references to modern attitudes to propriety on the one hand and to Greek mythology on the other. Lukas Samaras also creates complex scenarios of light and the unclothed figure in his experiments with form and colour.

Right: Edward Weston's nude on a sand dune of 1936 is possibly the most famous image of its kind for it readily illustrates a particular way of working. It obviously owes a great debt to Classical Greece, and has elements that recall the paintings of Velásquez and Degas but it is in one sense a dated image. The photograph is not about a person, nor an explicit sexual response, but about form, abstract values and the quality of the photographic process itself. This was not the case in all of Weston's nudes, but this figure remains detached and anonymous. Weston used a 10 × 8 in view camera, affording the largest negative, the potential of total control during its processing stage, and the vital element of previsualization. It was the purity of form and attention to detail, coupled to a meticulous technique, that was to make Weston's influence so far-reaching.

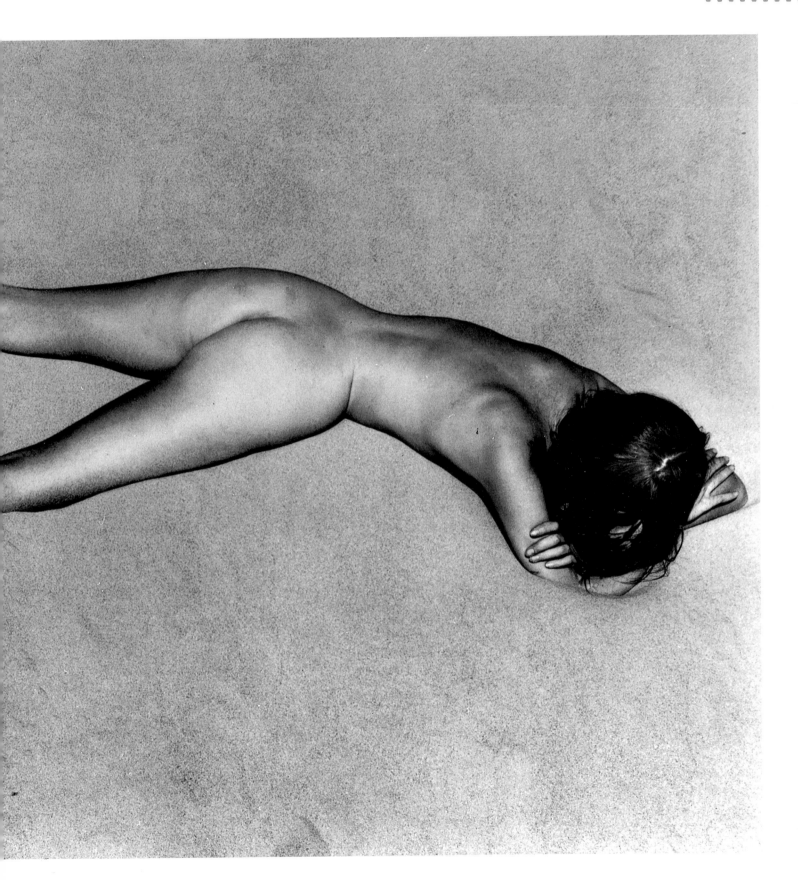

THE CLASSICAL APPROACH

The very concept of a 'Classical' approach owes its origins to the art of ancient Greece, Rome and the Renaissance. Its central concerns are for form, proportion and beauty. To express this in photographic terms therefore, you should direct your attention especially to matters of lighting and form. As often as not, the best approach is by the simplest method – uncomplicated lighting and an uncluttered background that allows the natural quality of the form to be fully expressed in two dimensions.

Accordingly, it is better to restrict the lighting to a single source that is similar to a large window, giving directional light from above eye-level. If you cannot achieve this directly by available light, it is best to simulate it by 'bouncing' studio light from a large reflector in such a way that the light-source becomes soft and diffuse. The process of bouncing light from a reflector greatly increases the actual size of the light-source and as a result bathes the form with a particular kind of softness. You can also use a secondary 'fill-in' source from the shadow side, but you should keep this considerably lower in intensity than the primary source, so that the descriptive quality of light on the form is not too greatly affected. This type of secondary fill-in is extremely useful in creating the effect known as the 'turn of the form' and is characterized by the variation in tonality that it affords when describing the actual nature of the form. In purely photographic terms, it is well to consider the concept of lighting ratios (ie, the relationship of highlight to shadow) when lighting the figure. This is particularly important when using an external metering system to measure the amount of light falling on the form.

The light does not necessarily have to come from one side. One useful technique that does involve directional light, however, is valued by still-life painters. This is the use of light coming from an overhead

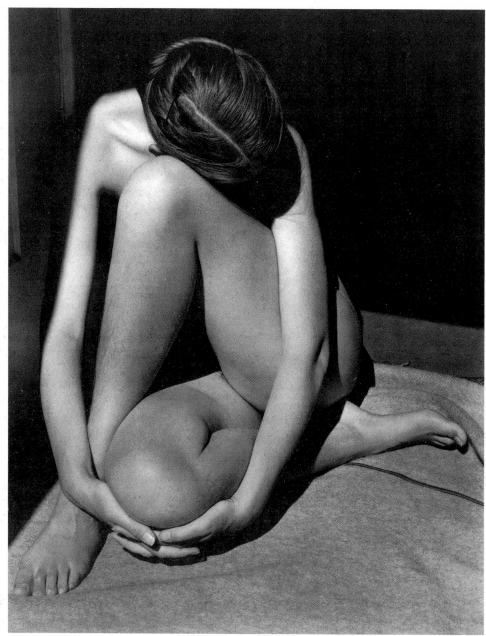

window illuminated by a north-light sky. North light has a particular quality that has always been prized for its uniquely descriptive character, particularly by photographers like Irving Penn for, by definition it never receives direct influence from the sun and thus the illumination is a form of bounced lighting from the sky itself. Penn has expressed it thus: 'I share with many people the feeling that there is a sweetness and constancy that falls into a studio from the north sky that sets it beyond any other illumination'. A glance at any photograph of early portrait studios of the Victorian era will reveal a great fondness (and, of course, necessity for) natural window light as a suffused light source. By the same token, the classical approach requires an undistorted image. This means that you should use a standard or medium telephoto lens, for these, above all other lens types, will be most effective in restricting

Left: This is another example of the pure imagery of Edward Weston allied to the concept of the nude. It was Weston who coined the term 'equivalents' and in many cases his imagery becomes a metaphor for something else. This coiled figure bears a remarkable similarity to some of his photographs of peppers. He had already been working on his close-up studies of organic forms in the late 1920s. He long held the conviction that close scrutiny of natural forms, immaculately realized through first-class technique, revealed a singular form of truth and vision. 'The camera should be used for recording of life, for rendering the very substance and quintessence of the thing itself, whether it be polished steel or palpitating flesh,' he wrote. He had scant respect for the members of California society that he had to photograph to earn a living. Yet some of his nude work in the Mexican series was altogether more sexual, and it is wrong to classify his entire output as detached and purist in concept.

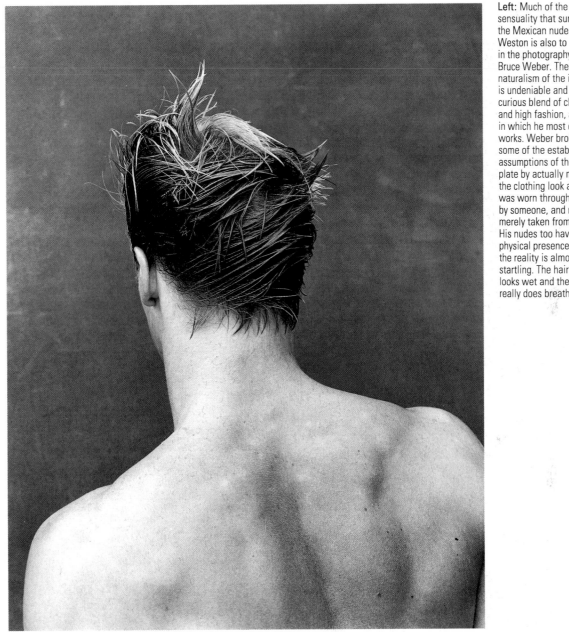

Left: Much of the sensuality that surfaced in the Mexican nudes of Weston is also to be found in the photography of Bruce Weber. The naturalism of the imagery is undeniable and is a curious blend of classicism and high fashion, an area in which he most often works. Weber broke down some of the established assumptions of the fashion plate by actually making the clothing look as if it was worn through the day by someone, and not merely taken from a box. His nudes too have that physical presence in which the reality is almost startling. The hair really looks wet and the body really does breathe.

unwanted distortion to a minimum.

The classical nude should derive entirely from a direct and objective approach to the subject. You should not be concerned with elements of realism or the model's personality. For many, the early criticism of the photograph as a poor instrument for the recording of the nude rested in this very factor, for it was considered far too literal and too real to surmount this limitation. The motto has to be: keep it simple, and spend more time looking, and looking very hard, than in merely making changes for the sake of it — work slowly and deliberately in a process of gradual refinement.

Currently, there appears to be a renewal of interest in the concept of the classical nude, albeit in a slightly different guise to that which had so fascinated Weston. Modern photographers use the classical nude to explore present-day sexual politics. This approach has always had its advocates of course, with the somewhat sinister repercussions of the earlier works of Leni Riefenstahl at Munich, and the concept of the master race. Latterly, Bruce Weber has rekindled memories of this type of classicism with his Olympian series taken just prior to the Los Angeles Olympics of 1984. In this instance, however, there is a direct link to naturalism within the series.

IMAGE BY DESIGN

The classical approach depends greatly on getting away from the concept of the nude as a person, and placing the emphasis much more on the formal and anonymous aspects of the figure. A further step in this direction may be taken by representing the figure entirely from the point of view of its design. Whereas the former approach is conditioned by notions of classical beauty the latter is concerned with quite different elements that owe little or nothing to early art. The human form is a highly complex system of organization that is structured in a very particular way to serve its various functions, such as walking and standing, and thus it has elements of symmetry and ergonomics that are uniquely its own.

There is no particular reason why this type of image should not be a distorted one, and so it is worthwhile trying lenses such as ultra-wide angles and others outside the main series. However, it is important that the lenses you choose should enable you to work closely or extract small details from the figure that remove it from its immediate surroundings. A lens with a macro mode can be very useful in this respect.

It is best to keep lighting as simple as possible. Try placing the light-source almost in line with the camera so that it produces little or no shadow at all and, instead, directs the eye to matters of line rather than form. By the gradual process of simplifying the lighting, it is possible to detach the model from his or her surroundings and render only elements of the body's formal design.

Another approach to the body's structure is to look carefully at the way in which the figure uses elements of design to carry out its functional requirements – walking, running, balancing, and so on. For examining and recording the whole issue of equilibrium, carriage, movement, and sequence the camera can hardly be bettered as a tool. It was as long ago as 1883 that

Eadweard Muybridge made his first series of sequential exposures in the study of human locomotion. These were individual images taken by multiple cameras. In similar experiments within the same decade the French natural historian and physiologist E. J. Marey took the process further, assembling several exposures on one plate and thus revealing the continuum of movement. These revelations were to confound the artistic thinking of the time and had a great influence on the work of both Manet and Degas. It is interesting to note that neither of these

photographers was centrally concerned with any notion of 'art' as such, but pursued quite different avenues of enquiry.

There are two basic methods of exploring the continuum of movement – either by individual high-speed flashes in a darkened environment on to a single piece of film, or by using continuous light and interrupting it by some form of continually revolving shutter mechanism in front of the lens. Both Muybridge and Marey had been quick to realize that under these circumstances the camera sees imagery that the human eye does not.

Left: The major part of Bill Brandt's work has been directed towards an exploration of form and spatial design. In particular, he has experimented with unusual focal-length lenses in some of his most influential work with the nude. He has also extended his imagery by means of high-contrast printing. In this example the figure is harshly lit by directional lighting, so that the form is simplified into broad areas of light and shade. The composition is daring and dramatic, allowing the shadow area of the figure's nose to be echoed in the crook of the arm. This is accentuated by the printing on to high contrast paper so that only the highlight areas are left, with no detail in the shadows.

Left: Brandt's work may be directly compared to that of Ralph Gibson, whose feeling for strong pattern and formalist values endows his photographs with enigmatic and puzzling meanings. His work often involves narrative ambiguity, and the starting point for many of these images of dream-like preoccupations has been the nude. His first major allegorical work, *The Somnambulist,* was produced in 1970 and established his reputation for this type of fragmentary sequential logic. Parts of figures, suggested in a landscape, sometimes moving, sometimes still, evoke the feeling of *déjà vu* and combine to offer a sense of storytelling that, ultimately, depends on the viewer's own experiences. It is a highly personal style and depends greatly on its use of icon and metaphor.

IN A SETTING

Despite the concepts of classical beauty and design, it is nevertheless essential to remember that the nude is, above all, a human figure. As such the subject affords responses far broader than pure beauty or abstraction. One such response is to treat the nude in ways that are not dissimilar to those you would use in a portrait, emphasizing the model's individualism and placing the figure in an environment. This can be in the form of either an interior or a landscape. The resulting images provide a quite different set of values for the nude. Questions of identity, personality and the human condition arise, together with elements of sexuality and attraction, or conversely of alienation and rejection.

Many photographers use the emotional power of the nude, together with its sexuality, to create images with a narrative content. They have also used the psychological theories of Sigmund Freud. These provided a great driving force for many artists of the Surrealist movement, who also gained greatly from their investigations into the expressive use of photography as an adjunct to their art. From the almost 'pure' formal approach of Edward Weston and Imogen Cunningham, photographers like Paul Outerbridge in the 1930s employed an interest in psychological influences to produce a series of uniquely disturbing photographs that owed a great deal to fetishism. Others, like Man Ray, carried on the traditions of the Surrealists and used the nude as the basis for challenging classicism. Indeed, one of this century's finest users of the nude motif – the British photographer Bill Brandt –

was at one time his pupil. Clearly, the nude is not the mere icon of pictorialism but is the basis for many of the great landmarks of twentieth-century photography.

The role of the setting in nude photography can therefore have a great influence on the quality of response that it evokes. The enigmatic nudes of Wynn Bullock are usually set in carefully considered locations, such as luscious woods rendered in perfect detail but which, nevertheless, do not tell the viewer too much – instead they pose as many questions as they answer. Is the figure dead, or merely sleeping? Why does it recline in this mysterious forest, and are the circumstances sinister or idyllic? These questions of course spring from the basis of life and human relationships themselves; the figure reminds us that we are mortal, that we are

poignant posthumous essay on human relationships.

This extension of the nude beyond mere form and into matters of personal relationships and environment has been at the heart of a great deal of photography in the latter half of the twentieth century. Harry Callahan, for example, has devoted a major part of his output to the recurring theme of his wife Eleanor and her nude back, set in both landscape and interior situations, or in water, half submerged.

Duane Michals, on the other hand, employs the nude within assemblages of sequence photographs that describe or offer narratives and, as often as not, unresolved enigmas. Sexuality, both male and female, figures largely in his work, and there are also psychological implications in many of his storyboard sequences and their attendant prose. Often the story is unresolved, and may even be the figment of the imagination of the viewer, but the nude has a very important place in Michals' work, as has the setting. Additionally, other elements of photographic language are brought into play, such as aspects of time, blur and double exposure, so that no single image entirely expresses all that he wishes to say.

Thus it is that the nude may be part of a statement that is more than the mere representation of the unclothed figure and, because of the many and varied human responses to the nude – sexual, psychological, historical, aesthetic, religious, and philosophical – it remains one of the most consistent themes in representational and figurative art. Robert Mapplethorpe has expressed this diversity particularly well in his major document on the female bodybuilder Lisa Lyon by continually revisiting the theme of her body throughout a long-term collaborative project. In this he allowed the personality of the model to hold equal sway with his own and continually re-worked the theme of persona and image by varying the setting, the lighting, the angle, the composition and the 'look' of the figure. During the project more than fifty images were produced, all of which looked different in character, theme and content.

Left and above: Another example of the naturalism of Bruce Weber employs the nude in a rural setting (left) which has some similarity to the work of Robert Mapplethorpe (above) in his major series on Lisa Lyon. Much contemporary work with the nude challenges assumptions that have gone before. The Lisa Lyon series started from the premise that there was no reason why a single person could not become anything she wanted. She could be a weightlifter, a striptease dancer, an animal trainer, a high-fashion model, an athlete and, of course, a natural nude. There were also references to the whole idea of 'Man' and 'Woman' as stereotypes. Thus it was that Mapplethorpe set out to explore all of these attitudes by working with only one model – a model who was equally challenged by the prospect of working with him. The Lisa Lyon series worked by the simple expedient of changing aspects of visual style to suit the purpose of the particular photographic idea; it was sometimes harsh, sometimes soft, delicate or sensitive, sometimes blatant and bordering on fetishism or pornography. This is a remarkable series of images to be recommended as the basis for a whole lesson in the photography of a woman and of the nude.

part of nature, and that time is passing.

The nude may also tell us much more in sociological terms and can offer us a particular insight into social conditions in the earlier part of this century. The American photographer Lee Friedlander happened across just such a collection of photographs in New Orleans, taken by a secretive and almost unknown photographer of the Storyville red-light district at the time of the First World War (see p. 220). The collection had lain hidden in the photographer's desk until the time of his death. These large glass plates, when later printed, gave a touching account of the women who worked in the area and the social condition of the times – the rooms, the wallpaper, the furniture, the responses of the women to the camera, the framed photographs, and the pets all added to a

THE EXTENDED IMAGE

The nude is also a valuable theme for image exploration in itself. One of the special qualities of photography is the fact that it introduces concepts, like focus, focal length, negative value, depth of field, and soft focus, that are unique to the process itself and which have little precedence in the other arts. This is one of the reasons why photography offers a unique vision of the world around us. For example, Bill Brandt was fascinated by the potential of a lens that had been originally designed for use in wartime reconnaissance and in which he had noticed a particular kind of almost infinite focus and depth. He used it to produce distortion of a very special kind, with which he explored the spatial relationships of the nude to both landscape and interior surroundings. The resulting series of photographs produced a vision quite unlike earlier nudes in photography and, although it owed a great deal to the pioneering spirit of Man Ray and the Surrealist movement, it was the product of a uniquely photographic vision.

Distorting the nude was, of course, nothing new. André Kertész, in the 1920s and 1930s, had made a major series of images involving distortion. Nevertheless, these photographs were the result of distorting a reflective surface and did not have the uniqueness of the Brandt nudes. It could be argued, in fact, that they owed a great deal to Expressionist distortion, whereas the Brandts were expressly the product of the photographic process itself, of optics, of focal length and the singular potential of a unique lens.

Another technique that can give interesting results with the nude is the process of projecting light and colour on to the subject. You can employ a darkened room to explore the variety of images created by projected shape, pattern and geometry, by movement, and by the combination of multiple and superimposed exposures. This technique can be extended by superimposing an image of one colour over an image of another colour. This often gives surprising results – a red image exposed over a green one will offer a tertiary image of yellow; a red over a blue image will give a magenta one.

This kind of experimenting with pure form, colour and light can be taken further by having colour positive film processed by the laboratory as a negative. The values will then be reversed yet again. A further extension of this principle can be applied by referring to the property of light and the

Below: Although a great deal of Bill Brandt's work is in a straightforward documentary tradition, his early years spent with Man Ray had a lasting influence. Brandt felt that as photography was such a young medium it should not be bounded by rules. He challenged special concepts, both in rooms with figures and with nudes in landscapes, employing an ultra-wide lens that was originally designed for scientific use.

Right: The influence of Surrealism is never far from many photographers' work and this is certainly the case with the English photographer Hag, whose arresting imagery is mostly built up by assembling more than one negative on to a single print. In this case, a crab's claw forms the head of a nude, set on a moonlit shore. The image is formed in the darkroom, using the safelight filter of the enlarger.

spectrum and the way in which colour film has three sensitive layers that will record the three parts of the spectrum, and thus has the potential to offer all visible colours from the resulting mixture. Put simply, tri-colour filters, designed for colour separation purposes and photographic reproduction, have the property of allowing only one-third of the spectrum to pass through. Thus it is that the three colour primaries, red, green and blue, when projected together, form a pool of white light. If this pool of light is interrupted, therefore, it will produce shadows of the secondary colours within its immediate surroundings, and this is a rich source of colour experimentation with the nude.

In a similar way, you can work in a darkened environment with a hand-torch and actually 'paint' the form of the subject with moving light during a long time-exposure. This can give a particularly interesting effect when the figure is also allowed selective movement. Again, this is a uniquely photographic technique and cannot really be likened to any other visual discipline.

An alternative method of experimenting with colour is to use the figure as the basis for painting and colour in its own right. The former fashion model Veruschka has made several extended enquiries into this method of adjusting the colour of the figure in relation to its immediate surroundings. In much of her work the make-up is designed to confound normal percep-

Above: André Kertész produced some remarkable images by means of distorting reflectors. In this photograph, made in 1933, he stretched the image by means of a curved surface. Curiously, the pictures sprang from a request from a pin-up magazine and it is debatable how successful they were in their original context. During this period of experimentation Kertész produced more than 200 variations using a fairground mirror.

tion by allowing elements of the background to apparently merge into the boundary of the figure. However, this is extremely painstaking and difficult work to control successfully and it is absolutely essential that assistance is given by someone with a commanding grasp of the intricacies and techniques of make-up.

THE STILL LIFE

If it is accepted that the two most enduring genres of art are the landscape and the portrait, then the still life must come a close third. It continues to hold its fascination for painters and is also thriving in photography. It is understandable that the still life should have had such a strong hold in the early days of the process, from the very first exposures, which were so strongly influenced by Dutch and Victorian still-life painting. It had all the direct advantages of static detail, coupled to a large singular light source and an ability to satisfy the early photographers' need to record intricate detail by means of long exposures. It posed no problems with changeable weather and an inability to record the tonality of the sky, and no problems with models who found it impossible to remain still for anything up to a ten-minute exposure. If Paul Cézanne, when painting his wife's portrait, was prepared to ask her 'to sit like an apple', then how much better to use an apple in the first place. The still-life photograph was the ideal way to begin the assault on the preserves of the Victorian painter.

Yet this type of mimicry is no longer valid, for the highly detailed still life is the one area where photography can justifiably claim to have virtually outstripped its fine-art counterpart. There is little to match the breathtaking quality of a finely organized and recorded contemporary still-life colour photograph. The sheer physicality of the resolution, the colour, the moisture, the subtle nuances of hue and harmony, the tactile qualities and, above all, the high order of surface detail, make even the most skilful realist painter somewhat redundant by comparison – there is, frankly, little point in competing.

The still life was at the heart of the work of those photographers who sought to establish an aesthetic for photography in its own right. Edward Steichen, for example, had gained great encouragement from the publication of his work by Alfred Stieglitz in the seminal journal *Camera*

Work, in which he had expressly attempted to establish photography as an art form in its own right. In his early work with the still life, Steichen took painstaking efforts to achieve his results, often shrouding the subject with heavy blankets and illuminating the objects, usually simple arrangements of two or three apples or pears, with a tiny area of reflected light from a small aperture at the top. This low illumination,

Above: The early work of the great still-life photographers has not dated in the least, as can be seen in this photograph by Imogen Cunningham, exposed in 1929. The reason is that the values to which these early photographers directed their attention – the quality of light, form, texture, shape and pattern – have not changed over the years. The beautiful rendition of the gently curving flowers has been modulated by a suffused overcast day and the negative has been made in a large-format view camera.

Above: The image of the three pears and an apple is a perfect indicator of the trouble which photographers like Edward Steichen were prepared to take in the early 1920s. Steichen's preoccupation was for the rendering of form and to this end he employed a large camera and as small an aperture as he could conveniently use – so small that he calculated its effective aperture as in the region of f128. He then enshrouded the fruit under a black tent with a small opening and captured the images through a series of experimental exposures ranging from 6 to 36 hours in duration. To photographers like this the still life was a continuing source of inspiration.

coupled to a tiny working aperture of something like f128, required exposures of up to 36 hours and involved the nocturnal expansion and contraction of the fruit!

This is an extreme example, but other influential early photographers also took great pains in this subject area. Such concern for the still life was at the centre of the output and philosophy of Group f64, the group of American West Coast pho-

tographers, founded in the early 1930s with Edward Weston as its great advocate. The overriding concern was for the organization of the tonal elements within the picture by a method known as previsualization, accepting that each area in the picture should have its own tonal value and would be developed according to the range of those tones. The still life photograph was an admirable starting point for such a philosophy, with much of the work being carried out on 10 × 8 in black and white negatives, which were subsequently printed with meticulous care.

The still-life photographer's most important resource is time – time to arrange, light, and focus the subject. This is one of the main reasons why still-life photography is so close to painting. Particularly when you are using the large sheet-film studio camera with its ground-glass screen and inverted image, the process takes on a quality of abstract refinement, of honing down to bare essentials, whether in terms of tonal value for black and white, or harmony, hue and pattern for colour. The principle of previsualization meant that the organizational work was done in advance of the exposure and in precise knowledge of the development of the negative. In short, it is the exact opposite of the working approach of the catch-as-catch-can photojournalist. Although the requirements of previsualization demand an individually developed negative, there is no reason why a great deal of still-life work cannot be done with a 35 mm SLR camera. Films of such fine grain are now available that you can produce results of impeccable quality from the small negative and, indeed, the 35 mm format now offers a good basis for the production of really first-rate negatives. Essentially, this is precisely the type of exercise that preoccupied the early pioneers of still-life work and there is no reason why it cannot be attempted using the smaller camera. Organize the artefacts expressly to test out the limits of both the film and the resolving power of the lens and then extend the results into the area of darkroom techniques and printing.

COMPOSING A STILL LIFE

The slow, considered way of working with the still life means that you should begin with a clear set of aims and motivations. A still life can fulfil any number of requirements (whether purely commercial, aesthetic or instructional) and this basic motivation is a vital ingredient to the taking of the photograph. Selling a product requires quite a different approach to explaining its function and how it works. Yet another worthwhile approach would be to make a pleasing photograph of an object whose useful life is over and which is suitable neither for selling nor using (see pp. 156-7).

Additionally, as a still-life photographer you have at your fingertips various methods for controlling the subject or emotional quality that any given photograph may have. You can alter the viewpoint, the character and direction of light, and, of course, the design elements within the photograph itself. So with all these considerations, it is vitally important to have a clear idea of the main direction in which you wish to move and the function that the picture should ideally serve. Without this, it is difficult to begin the process of successfully blending these variables together in a way that is personally satisfying. Avoid the temptation merely to tamper with the content in the hope that 'something will turn up' – almost certainly it will not.

It is best to start still-life photography with a subject that allows two simple alternative views. For example, if it is a table containing several elements, set yourself the task of either a suggested narrative that implies an event (perhaps that a meal has just been enjoyed), or a picture that will revolve around the sheer physical beauty of the materials themselves. Do not spend a lot of money on valuable items for the picture. Begin the exercise with the simplest basic ingredients, such as two appetizing pears, an apple, a white ser-

viette, and a knife, and simply accept that this is the 'theme' for the picture. Just as in music the 'theme' can be a recurring motif that may be adjusted, extended and embellished throughout a composition, so in visual terms you can stick to an essentially simple concept and adjust and refine it over a period of some considerable time to

get the most from the chosen subject matter.

The process of still-life photography is probably the slowest in which you are ever likely to work. Therefore, it is essential that you use a good firm tripod for total support of the camera. In this way it is possible to retain a very singular view of

Left: Visual style is an important ingredient in good still-life work and can stem from an interest in fine art, the cinema or the history of photography itself. In this image, a great deal of care has been directed towards the quality of both the artefacts and their colour, an approach reminiscent in many ways of Dutch painting. Using the ground-glass screen of the view camera, the photographer has paid meticulous attention to the detailing throughout. The simple, uncluttered approach is often difficult to achieve because there are so few devices or tricks to fall back on.

Right: Often the most successful pictures depend on very little, as illustrated by this beautiful photograph of cloves of garlic. The picture succeeds because of the delicacy of the colour and the tactile quality of the vegetable itself. Again, it is the product of the view camera.

the still life while making the refining decisions and adjusting and changing the individual items within the layout.

Having decided what type of ingredients the picture will have, the next question will deal with how it is lit, for lighting has a critical part to play in the way in which the picture communicates the idea. Soft suf-fused directional lighting, due to the like-ness it has to natural window light, lends a quality of timelessness and classicism to a subject, giving an appearance like that of a Dutch still-life painting. For this reason alone many photographers employing large window light flash units in the studio place a large cross of black tape in the diffuser to give an even more authentic window-like quality in the reflected high-lights.

The alternative is to use natural light itself; with this method, the greatest risk lies in the quality of the daylight when you are working in colour. Often the vagaries of dappled sunlight and reflected cloud cover can have a very unpredictable effect on the colour rendition of the subject. This is unlikely to be such a problem in monochrome. But if you do use daylight, it is best to minimize the problems by avoiding the risk of direct interference from the sun. You can do this by working against a backdrop in a southerly direction and with the north sky behind you. This will minimize the fluctuation, and the light will come indirectly from the sky itself, as opposed to the sun. If the sky is suffused by cloud, so much the better.

Many photographers, however, prefer to use a studio that offers total control from within, particularly when working with expressive lighting to create mood and atmosphere. Small point-source lighting gives harsh, dramatic illumination and sharp shadows. It can pick out the tactile surface detail in objects, and allows scope for the use of bounced light to control contrast within the setting. For specialist subjects (such as glass) particular tech-niques like transillumination may have to be employed and in this regard it is absolutely vital to use a studio that will allow total blackout.

FOUND OBJECTS

One of the most important skills in photography is to use your eyes in the pursuit of subject matter, looking afresh at things that had formerly been passed by, and never being content with a view of the environment that merely reinforces glib assumptions and generalities. In still-life work, it is worthwhile starting by avoiding the issue of constructing and interfering with the subject matter and instead using objects within the observed natural environment. If you are going to adopt this approach, it is extremely useful to employ a miniature camera with colour reversal film as a visual notebook that will enable 36 different statements about colour, texture, shape, form and pattern to be culled from a morning's walk.

Extending this principle, many people find considerable pleasure in gathering small artefacts (such as tickets, paper, metal, natural objects, shells, and fruit) while on a walk. These provide a good way to begin work with organized still-life. All such found objects have qualities that are particularly their own, and they greatly vary in matters of surface, texture, local colour, material and value. You can look on these objects in much the same way as a painter would look on the colours and values of the working palette. This being so, there is every reason to organize the still life from the viewpoint of the object's abstract qualities. This is another reason why many photographers prefer the formal and abstract qualities of the sheet-film camera, for its layout and function are very helpful to this way of working. It is easy to regard the upside-down image on the ground-glass screen as abstract, so that you tend not to think of the natural states and functions of the objects. In other words, one does not look *into* the sheet-film camera, one looks *at* it. This does not, of course, mean that the miniature camera cannot be a suitable tool for still-life work, although in many ways it is less satisfactory than the studio camera. Its prime advantage is its large number of exposures,

for this equips it admirably for ringing the changes in layout and trial exposures.

Organization is the key to good still-life photography, so avoid too dramatically complicated sets in the first place, in favour of approaching the subject from the viewpoint of continual refinement and improvement. To this end, try to think in terms of purely abstract elements of design and value on the picture plane and to organize the picture space by a series of questions and responses. Is it preferable to

have the main structure of the composition symmetrical or asymmetrical? Is the background light or dark? Does that yellow harmonize or clash with that blue? Does the picture need a 'warm' look or a 'cool' one? Where will the light need to be placed to pick out that reflecting surface?

Once you have decided on the function of the photograph, its ingredients and its layout, the final decision must rest with the nature of the lighting and how this conveys the mood that you require.

Left: It is not necessary to go to a great deal of expense to find objects for a still life; fascinating artefacts can be found anywhere. The constituents of this photograph are the fruits of the field – leaves, berries and ferns – gathered at random and then organized into an assemblage for an editorial photograph. The background has been transilluminated to add luminosity to the colour.

Right: Another way to work is to juxtapose elements for their interplay of colours, textures, shapes and patterns. These are also elements that are commonplace and surround us each and every day – a rusty lock, some bark, and a piece of blue string. Subjects like these form the colours of the photographer's palette, and they have been carefully arranged here to harmonize within an overall colour scheme. The illumination, if not daylight, is softly suffused to give the same impression of an overcast day – a large soft light source has been used. This is most sympathetic to these objects. The light reading under such conditions should be by the incident method rather than the reflected.

THE USE OF STILL LIFE

There are many variations on the theme of still life and their imaginative use covers many fields. Obviously there is widespread use of still life in sales and advertising, as well as in illustrative work for catalogues and instructional handbooks, and for the illustrative support of articles on subjects from cookery and furniture to jewellery and glass. All of these serve essentially practical and functional ends and it is worthwhile spending some time looking at examples of differing types of interpretation and trying to establish the basic technical skills that were harnessed for particular effects. Similarly, it is worth noting the style of the photography, and whether it has been influenced by movements in fine art like Constructivism, Abstraction, or Surrealism. It is a useful starting exercise to take a simple theme and a few objects and try to create several differing stylistic versions.

However, there is an area of work that falls into none of the above categories and into which some contemporary photographers place a great deal of their creative output. This is the 'fine art' still life, which exists entirely in its own right as an extension of the photographer's own creative impulse, which sells nothing, is answerable to no one and may be a symbol of a personal belief or statement. Generally speaking, this type of work is best fitted to a sheet-film or medium-format camera,

but it is also possible to use a miniature camera. The tradition owes a great deal to the work of Edward Steichen and Edward Weston, whose photographs were often based on a single simple motif - a pepper, a shell, an artichoke, two pears, or a pair of pliers – photographed in such a way that it took on a new kind of inexplicable beauty and significance. There are few photographers who have gone further in this field than Irving Penn for, although a great deal of his output is concerned with commercial assignments, he nevertheless continues to produce the most exquisitely ordered and refined still-life photographs that transcend mere applied photography.

The still-life photograph, with its slow contemplative build-up, is an admirable medium for subjective photography and the finest of this type of work is to be seen in the series of elegant essays by Jan Groover, together with those of Olivia Parker and Marie Cosindas. Olivia Parker's work, particularly, has an indefinable elegance and mystery, with conjunctions of small objects and handwritten script, the contrast of organic and inorganic materials, and the suggestion of elements of time (see p. 247). To produce these images, she uses a large 10 × 8 in view camera employing Polaroid instant-picture film. This is also the working method preferred by Marie Cosindas. In Jan Groover's work the artefacts of the kitchen are the basis for superbly ordered arrangements of tone and value, and she takes great care to use the conjunction of edge and corner in a particular way to strengthen the design.

Quite separate issues were involved in the creation of these images. The first (far left), by Jan Groover, has no need for colour or an assigned purpose. The large camera persists, as do attention to image quality and careful organization of space, but the image is in monochrome. For advertising (top), detail, composition and lighting are very important. Here the emphases are on image quality and mood.

What may appear as daylight in such pictures is often artificial light exposed onto tungsten balanced film, or electronic flash used in conjunction with daylight film. In Robert Mapplethorpe's orchid (left), the essence of the picture is in the quality of the colour. The colour negative process allows for careful control in the final image, which is crucial when the picture involves subjectivity and metaphor.

PHOTO-JOURNALISM

There is often confusion over the terms 'photojournalism' and 'photodocumentation'. The former stems from an expression that is now largely redundant and seldom used – press photography; the latter has developed over the years from the realization that news stories can often take on qualities that go beyond the particular moment and offer us a statement that is more akin to a valued document. Photojournalism, therefore, is the more inclusive term, encompassing old-fashioned news work as well as photographic essays and definitive photographic documents.

One reason for the demise of the once powerful press photograph, or news story, was the development and importance of television journalism in ousting the exclusive role of the news photographer. The other reason is that, of all areas of photographic practice, that of photojournalism has undergone the most radical change. This is particularly so in the realm of equipment. As little as thirty years ago, a crowd of press photographers would be an assorted group of raincoat-clad trilby-hatted men carrying clumsy cameras, to which would be attached equally bulky flash units. They would all wait patiently for the one moment when the important event would take place and the bulbs would ignite in unison during the moments of exposure. The cameras were sheet-film rangefinder models with individual single exposures that afforded no opportunity for a second attempt. The flash was produced by means of expendable bulbs – no second attempts here either. The nature of the discipline of press photography was dictated by the deadline; one, or possibly two, pictures were quite enough to satisfy the needs of the darkroom technicians whose sole requirement was to supply the blockmakers in time for the next day's first editions.

This did not mean that great photographic statements were less likely to be

For the American photographer Arthur H. Fellig (better known as Weegee) photojournalism was a way of life. He spent most of his formative years in a small New York apartment, flash bulbs at the ready on his trusty Speed Graphic, and roamed the city at night in his old car, covering everything from fires, to narcotics, rape, and murder. Yet this did not mean that his photographs were ever dull and predictable – on the contrary. He consistently produced remarkable imagery from his simple technique. This was surely because, above all, he knew what it was like to be on the downtrodden side of life, and therefore naturally responded in a compassionate way to life's tragedies. In this photograph of two women arriving at the Metropolitan Opera House, New York (left) there is a third figure grimacing at their self-indulgence. It is a poorly clad woman of lesser means who has come to watch and scowl. This is typical of Weegee's almost uncanny sense of the theatrical in life for, while the other photographers jostled in the foyer for the famous faces of the day, he was content to wait on the pavement outside, instinctively 'smelling' that there was a picture to be had. Too true: the Rolls Royce duly arrived, the socialites got out and made their way past him, and in a flash the picture was made. It is perfect and comes from an unerring instinct for the moment in time. Shot on a large sheet-film camera with expendable bulbs, the negatives have a superb pictorial quality that allows for an immaculate print, although this had never been the original intent.

made, but simply that the whole role of recording was entirely different. The press photographer predetermined the best viewpoint and the element of surprise was seldom a critical factor. Notable exceptions, like the photographs of the air disaster of the Hindenburg's arrival in New York or the moment of or aftermath of an assassination, were made possible merely because the photographer was quick-witted enough to record what happened.

The American photographer Weegee (Arthur Fellig) was just such a remarkable exponent of the large press camera and bulb flash. He used short-wave radio tuned into the Police waveband as his prime indicator of the events taking place and he was rapidly alerted to the burning tenement, the drugs raid, the arrival at the Opera House, the car crash, or the domestic beating. So successful was he in getting there ahead of the Police that he was nicknamed Weegee from the conviction that he must have gained foreknowledge from a Ouija board. 'I got no time for exposure meters and fancy things like that, I just set the distance and the aperture, move in close and shoot – just like that', he later declared. Yet his pictures had the extra dimension of compassion for many of the people that he photographed.

The role of the news or press photographer should not be underestimated in its contribution to the progress of the twentieth century. Not only did such photographers do a great deal to record the events of this era, but they also did much to influence them. Whereas Hitler had used the evocative role of the camera as a political weapon of propaganda in the theatrical staging of his rallies, within a decade the selfsame instrument was used to record the results of his ill-fated Third Reich at Buchenwald. By the 1960s the almost daily images from the battlefields of Vietnam had done much not only to inform American public opinion of the harsh realities, but also to ensure that the prosecution of the war should end. A similar role existed for the concerned photojournalist in recording the struggle for civil rights in the American South.

With the rise of television and the diminished role of the 'decisive moment', the picture essay is increasingly important. Picture editors today are frequently interested in more than just the single picture of an event and in quality newspapers the tendency is to move away from the obvious 'press shot' in favour of a more subtle and sensitive approach to picturemaking. It is therefore worth arriving well in advance of an event and spending some time not only seeking out vantage points but also looking at those small elements that give the clue to the uniqueness of the occasion. Details of the building, the landscape, the setting and the local colour can all add up to an enriching of the main photograph and, indeed, may even replace it.

The picture essay should be seen very much as an analogue to the written poem, with its images juxtaposed and interspersed, one offsetting the feeling evoked by another. Many opportunities exist in modern journalism for work that is not conditioned by 'instant' deadlines, and training the eye to see more than the obvious in any story is important to the successful photojournalist.

There will always be a need, of course, for the quick response to the editor's needs, but there are signs even now that the former role of the 35 mm camera in this respect is rapidly heading for change. Just as the past requirements of cinematographic news coverage have been overturned by the advent of electronic newsgathering, with its absence of processing and its immediate production of imagery, the conventional 35 mm SLR will also acquire a role in the process of instant picture-gathering. Already prototypes exist for electronic imaging devices that will attach to the rear of the camera. These will dispense with film altogether in favour of scanners that will encode the picture information on to recording disks. Once digitalized, it will be possible to send the information to a receiving unit in another town or even on another continent. On receipt, the picture will be reconstituted directly to a laser imaging device that will allow for control not unlike that currently used in the modern enlarging process. The only difference is that there will be no need for the image to be developed, fixed, and then printed.

Left: This portrait of a child in China comes from a major essay by the French photographer Marc Riboud at a time when there was great lack of understanding and mistrust in the West for the way of life in the Chinese Communist system. Much had been written about an unsympathetic and austere way of life, wholly without soul and purpose. As a result of photographs such as these, a more balanced perspective was arrived at. In China, nothing is more cherished or valued than a child and that surely is reflected in this sensitive image.

Right: When, in 1968, the Russian tanks rolled into the capital of his native country, the Czech photographer Josef Koudelka produced a profoundly moving account of a political system trampling down an alternative voice. The raised arm and the watch (below) give an uncanny insight into the way in which the streets were empty at the very time when they should have been packed – all around, the aura of menace persists and serves as an ominous warning. Also, from the same series, a young patriot offers his chest as a target for a confused Russian tank commander (top).

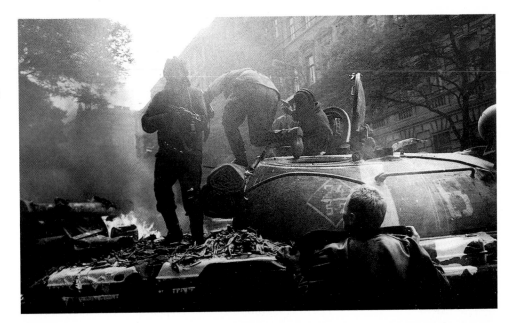

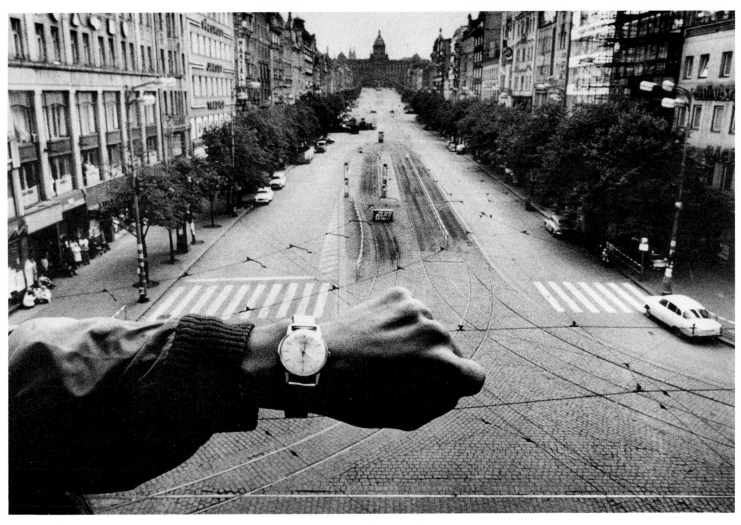

EQUIPMENT AND APPROACHES

Without doubt, the greatest change in photojournalism that has taken place since the end of the Second World War has been in the move towards the use of ever smaller cameras. Modern miniature cameras have allowed the photographer to close in much nearer to the subject matter than ever before. Press cameras, in the form of the old sheet-film versions of the

1940s, made no appearance in Vietnam, but the 35 mm SLR certainly did. The average press reporter there may well have had anything up to four camera bodies around his neck, each with a lens of different focal length. The cameras' speed of operation and internal metering, and the ability to interchange cameras without the need to remove lenses meant that there was no delay at all in getting straight into the action and danger at hand. No thoughts were given to the concept of 'art' either – it was necessary only to distil the reality in the shortest time, with the most succinct and expressive image content, and to get the pictures back to the newsdesk with the least possible delay.

Without doubt, the 35 mm SLR is the camera system best suited to the needs of the modern photojournalist, for it is the most readily adaptable format for any contingency that may arise. Its size alone makes it best for this role, and its range of specialist interchangeable lenses makes it uniquely suitable. Furthermore, the sophistication of current camera design is moving in favour of the photojournalist for additional accessories such as motordrives are now likely to be built-in. It is essential to have at least two camera bodies at hand, and, under pressure of time and circumstance, to use these to minimize the need for changing lenses. So two zoom lenses covering two different focal-length ranges

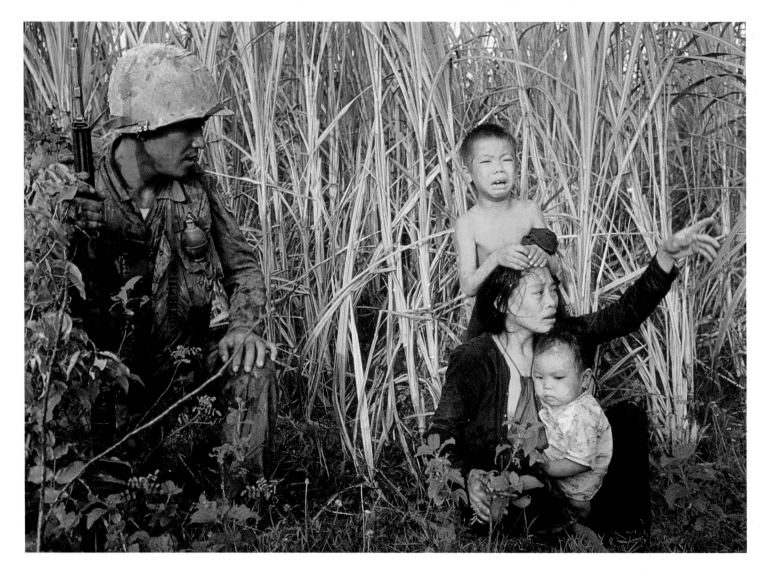

Left: Images such as this one by Tim Page burned deep into the subconscious of viewers and ultimately played an important part in rendering the whole Vietnam scenario unacceptable. The use of colour was an important factor in shaping perceptions, for it showed unequivocally the realities of war.

Right: Although a great deal of Don McCullin's output deals with the horrors of war and man's inhumanity to man, this is by no means his only pre-occupation. He is also committed to recording the lives of people who are living on the borders of, or manifestly below, what is commonly known as the poverty line. Yet his photographs are neither voyeuristic nor patronizing but derive from a feeling that it is an essential part of the photographer's role to record life as it is.

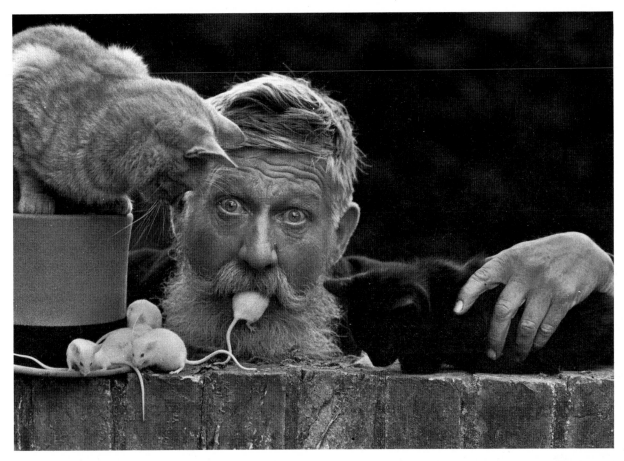

would form the ideal basis for most reporting on location. A small portable electronic flash unit, preferably fired from the hot-shoe position just above the pentaprism, greatly assists not only in illuminating dark areas but also in filling in harsh available light in difficult locations and when time for exposure reading is simply out of the question. The sensor in modern flash units helps to retain some of the stored energy in the unit when working with pre-selected aperture settings; this means that the recycling time is considerably reduced, which is a significant help when you are working quickly with a motorized film advance.

Often the photojournalist simply has no influence over the course of events. Pre-planning is therefore an essential ingredient to the skill of the photographer. Part of this planning is to tailor the equipment to the requirements of the work at hand. If, for example, the assignment is to be carried out under circumstances when it is essential to remain unobtrusive and at a discreet distance, then the use of a rangefinder camera with a quiet shutter would probably be appropriate – the average SLR is noisy by comparison; additionally, a small tripod would be essential. It is also useful to establish the best vantage point in advance and 'stake out' the position for the best working conditions. A small collapsible tripod is particularly valuable, coupled to a universal camera mounting bush that enables you to improvise supports from nearby walls or flat surfaces. It is often thought that the only way to work in subdued light is by uprating the effective speed of the film. However, there is an alternative which is well worth considering: a great deal can be achieved by using a small tripod in conjunction with shutter speeds of 1/15th sec or even 1/8th, provided that you fire the shutter by means of a cable release.

With lenses that are longer than medium telephoto good camera support is vital, particularly bearing in mind the limited positions from which you may be forced to work. The role of the photojournalist requires an essentially flexible technique and it simply may not be possible to alter the lighting or change your viewing position. Often it will be necessary to improvise and that is when you will appreciate the critical importance of the camera support. Apart from standard tripods and 'minipods', it is worthwhile carrying some small clamping devices that will allow you to hold the camera firm when you are working in confined areas. There are also gadgets for both supporting the telephoto lens and simultaneously using a cable release. These are usually made in the form of a small pistol grip that screws onto the lens, and are fitted with a trigger release that activates the shutter by means of the cable release.

THE PHOTO-DOCUMENT

There is another facet to the role of photojournalism that goes beyond the mere provision of pictures as support material to newspaper stories. This branch of photography has made a significant contribution to the understanding of many of the major social issues of this century – the photographic document. The single most obvious difference between working on the photojournalistic assignment and the photographic document lies in the question of the amount of time allotted to its completion – a documentary project is never subject to the same type of deadline requirement as its journalistic counterpart. The document, by its nature, often requires a long period of research, assem-

blage and evaluation, and is not necessarily directed towards the issues of the moment. Instead, it is the long-term execution of a personal essay that may, nevertheless, have major implications and benefits for its chosen subjects.

The essence of the photographic document rests in the intention of the photographer to say something important in such a way that the viewer will understand the statement. It refers particularly to that universally held desire to try to improve the lot of others. There is nothing new in this concept for, as early as the turn of this century, Sir Benjamin Stone was compiling his own record of the traditional events of the English calendar and coupling it to records of local craftsmen and landmarks. He did this for no better reason than that he was unable to purchase such pictures in any other form. A similar document exists in France, created by Jacques-Henri Larti-

gue, who, from the age of ten, had nurtured his fascination for photography by recording elements of family life, Parisian pavement life and fashion, and the development of the new flying machines of the aviation age. Born in 1894 and thus slightly older than the century itself, Lartigue had a comfortable middle-class upbringing that allowed his photographic obsession to be given full rein. The results of his long life's work afford us a unique and lasting insight into the development of the domestic life of middle-class France in this century.

Neither Stone nor Lartigue was centrally concerned with altering things so much as merely recording them. They are not to be seen in the same context as Lewis Hine or Jacob Riis, who worked in the United States at the turn of the century. In their case there was no argument – both men had been deeply concerned at the

Left and right: The role of the document can cover as widely diverse aspects of experience as a specialist subject on the one hand or domestic life on the other. In the former (left), this evocative photograph of the dying embers of the day on a snow-covered mountain range admirably shows the qualities that so captivate the climber – the colour, the moment in time, the splendour of the view, the rising moon. The waning light beautifully renders the form of the ridge.
Lartigue devoted a great deal of his working life to documenting the everyday pleasures of domestic life and exemplified the expression 'joie de vivre'. In this photograph (right), his cousin Simone careers down a slope, happily indifferent to the display of her underwear as she hastily applies the handbrake of her dangerous-looking cart.

plight of exploited working families. They were particularly concerned with the use of child labour under the poor working conditions of the time, and in many ways they were the forerunners of the great photographers of social documentation who worked during the Roosevelt Administration of the 1930s. For Roosevelt, the time was ripe for change. But the necessary power to support his arguments rested with the potential of the camera and for this reason he dispatched a group of photographers under the Farm Security Administration programme to go south to the dust bowl of Hale County, Alabama, with the simple request to 'tell it like it is'. Roosevelt remained convinced that the urban dwellers of the North had not the least idea of what was going on in their own country. From that group of idealists sprang the seed-corn of American documentary photography – Walker Evans, Dorothea Lange, Russell Lee, Arthur Rothstein, and Ben Shahn.

The gap between Lartigue and Walker Evans may be significant, but the work of both men points the way ahead from which all users of the camera may benefit. Both photographers make us realize that we are all part of a common heritage and have an important part to play. We live in an environment, and meet people for whom we care greatly; we share their lives, we have families, homes, traditions and ethnic identities and all of these issues are central to the concerns of the documentary practitioner. This type of photography is one of the richest sources of genuine enlightenment that owning a camera can afford. Within us all is a story waiting to be told – it only needs placing on film for it to have value and meaning to others as well. Consider carefully those values that are most important to you and direct your camera towards conveying them to others.

PLANNING

The photographic document, like any other form of document, can come in various guises and can deal with many aspects of human endeavour. We all, at some time or another, have been involved in the process of taking photographs. That alone means that to a greater or lesser degree we have been involved in the making of a document. This is because photography has a unique potential for the recording of passing time, of culling information and setting it down as a lasting record for later generations to value. Above all, photography is a wonderful recording process. When considering the potential of the document, it is well to remember that it is the one area of photographic practice where the 'amateur' can justifiably be said to be at an advantage – valuable documents do not necessarily stem from paid assignments. Indeed, the important thing is that the work is done essentially 'for the love of it'.

So, in planning a documentary essay, the essential criterion that you need for its success is the fact that, above all, you actually love the subject and relish the prospect of long days recording it. The subject itself can cover many areas – it may involve landscape, history, architecture, and patterns of living. But all of the great documentary essays that remain for us to savour have the special quality of informing us of a particular way of life in transition. Therefore, it is worthwhile starting with your own interests, rather than copying those previously covered by other photographers. You should realize that you, as an individual, are unique and, therefore, that pictures reflecting your personal interests will have a uniqueness of their own.

Another joy of the long-term photo-essay is the fact that it will of necessity involve you in support research, through books, archives and newspapers, and also in dealing with people that you would not normally meet. This in itself is one of the prime motivators for the document, for there is little to better immersing yourself in a situation that is entirely new; this, in turn, will mean that the photographs must be based on your own experience. The greatest limitation that inexperienced photographers usually have is a lack of belief in their own ability. As a result they are prone to imitate other, often weaker, photographers. This is quite different from the intelligent use and influence of the great photographers – but it is essential to develop a style and interest of your own.

The equipment you will need for this type of work need not necessarily be complex. In fact, it is better to strip it down to the bare essentials of the type of camera system with which you feel most comfortable. Thus, if you are a user of a 35 mm camera system you should start with one body (although if at all possible, a second one is of great benefit), a standard or medium wide-angle lens (either a 50 mm or a 35 mm), a good wide-angle in the 24 mm or 28 mm range, and a longer lens such as a 90 mm or a 135 mm. If the photodocument involves a great deal of close-range copying, you could replace the standard lens with a 50 mm or 55 mm macro lens that will act as a standard or copying lens. You will also require a really good tripod and a cable-release, for one of the benefits of automatic camera reading is that, with a good support, you can work in very limited lighting conditions without recourse to complicated additional lighting. Additionally, you should have a small electronic flash unit for emergency situations that will not allow slow shutter speeds.

Any further equipment should be dictated by your immediate needs and particular interests. An extensive field trip involving a great deal of black and white landscape work, for example, will require a suitable range of filters. Subject matter can also influence your choice of format, although there are few photographic situations that are not admirably served by the 35 mm SLR.

Another essential requirement for the photographic document is the concept of juxtaposed images. All of the great documentary photographers employ this idea of placing one image against another, a portrait against a wall, or a landscape, or a historical detail. Additionally, it is a good idea, in time, to lay your work out as it would appear on a double-page spread in a book or magazine. This will help you set an objective for the completion of the project. It is also worth considering supporting the pictures with relevant text.

Some photographers positively welcome the proposition of working with a writer on a topic of mutual interest. The text can be in either poetry or prose. This coupling of the photographic image to the literary one is a very rewarding way to work. The American photographer of the Deep South, Clarence John Laughlin, has spent a great deal of his life documenting the 'spirit' of the South by a series of haunting images that owe their basis to literary texts. Laughlin himself spent a great deal of his output on poetic writing. Similarly, Walker Evans, in his great work of the 1930s in the Dustbowl, worked side-by-side with the writer James Agee in the production of his masterful essays, which were eventually published in book form as *Let Us Now Praise Famous Men*. In Britain, the landscape photographer Fay Godwin has coupled her images to the poetry of Ted Hughes. She also records British writers in her photographic portraits.

Above all, it is vital to embark upon a project that is dear to you, and that will provide the basis for a long-term involvement or interest, whether for others less fortunate than yourself, for ethnic or cultural identity, history, landscape, architecture, or indeed any subject that fires your imagination. The inspiration could derive from other creative disciplines, such as writing or music, and that, in turn, may either be through classical references or from popular subcultures. All of these considerations may be said to derive from the basic concept of The Family of Man as originally drawn together by Edward Steichen – or from its counterpart The Family of Woman. It is a rich seam of enquiry that many have found to be one of the meaningful rewards of photography.

This photograph represents the final image of an overland document made in the United States, based entirely on the lyrics of Chuck Berry's song 'The Promised Land'. It begins in Norfolk, Virginia, and ends on the boardwalk at Venice Beach, California. To facilitate the project, which meant using Greyhound buses and trains, moving south to New Orleans and Houston and thence to 'The Promised Land', a small rangefinder camera was used, together with three interchangeable lenses, all packed into a small handcase for instant access. The essential needs were to have lightweight accessible equipment that would allow quick improvised picture-making. The unit was complemented by a small folding tripod that fitted into the base of the case. Integral light reading within the camera body, offering aperture priority, fulfilled the requirement for photography under all conditions, at night, on the road, in motels, and by pools. For this photograph, the lens was a 28 mm wide-angle, zone-focused to minimize confrontation with the subject, and stopped down to f16 for maximum depth.

THE PANHANDLE

There can surely be no finer illustration of the concept of the document than this one, which is very personal and has been beautifully executed by the photographer in question – Ken Griffiths' essay on the Texas Panhandle. Quite apart from what is to be seen in the pictures themselves, it is important to appreciate the motivation that exists for the pictures – ideas about what the last vestiges of the Old West are,

or were, and how they are being played out in the latter half of the twentieth century.

The images are assembled deliberately and with the full knowledge of the subjects. The posed pictures almost have a feeling of the American painters of the West or even of the equestrian paintings of Stubbs. There is also, of course, a great influence from the cinema. It is interesting to note though that Griffiths has not merely taken all the photographs in the same way, but has mixed portraits with details and with moving subjects. There is

no finer medium for the social document than photography, for it gives the image a meaningful sense of reality. In so doing, it records time in passing for posterity. Ken Griffiths continues the tradition of Walker Evans half a century later. Little has changed: the large negative and the committed approach to the subject, black and white film coupled to superbly controlled manual printing on traditional materials – all these add together to provide a document that will last and be valued for a long time to come. It is worthwhile for all

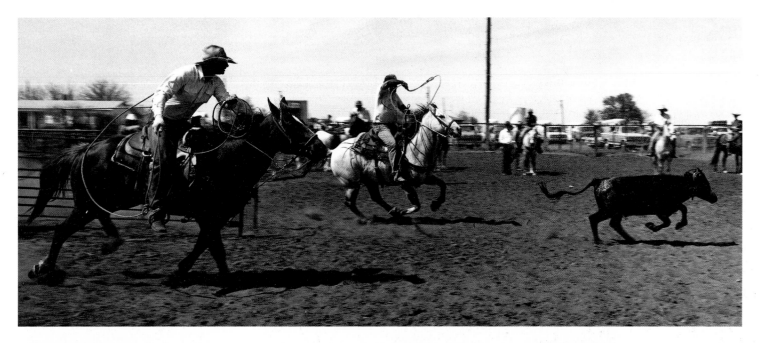

Both equipment and materials often have an influence on not only the making of the images but also our perception of them. By using the large monochrome negative, taken on a view camera, the stillness of the bulky equipment instils a quality in the photographs not unlike those from the early settlers in the Old West. The equestrian figure (left) and the detail of the clothing (lower right) owe a great deal to this, and the influence of the cinema which, in turn, was influenced by the selfsame early photographers. On the other hand, the more fluid use of the wide-angle camera (top right) is a direct result of the potential of modern faster films in the medium format range – a quality quite unobtainable by the infinitely slower films of the last century.

photographers, at some time or another, to set aside the time specifically to undertake a project that is meaningful to them – not for financial gain, but for the sheer pleasure of producing a document that is wholly an affair of the heart. The essential quality that emanates from these photographs of Ken Griffiths' is the genuine sense of pleasure in their creation, and that is their greatest lesson.

What the photographer saw

Ken Griffiths is a professional photographer whose photo story 'The Panhandle' evolved from a fashion commercial for Guess Jeans. The project, including the shot for the advertisement, took 23 days to complete, over a period of 10 months, and was fitted in around Griffiths' other work.

Of the 150 shots he took for the project, sponsored by Guess, 62 were selected and published in book form. The images shown here were chosen as being representative of the whole in their depiction of a unique area and its way of life.

Griffiths accepted the offer to do the book because 'Wherever I looked I saw pictures . . . I just didn't have any choice. I was fascinated by the light, by the landscape and by the people.' When searching for subjects to photograph, Griffiths followed his nose. 'If I drove into a town and it looked interesting I'd stay there for a while.' Most of the photographs were taken in or around Clarendon, Shamrock, Claude and Turkey. They are immediate impressions – 'If you stayed there for six months and then shot, the pictures would

be completely different.' Consistent with this approach was Griffiths' decision not to delve too deeply into the history of the area. He did not want to be influenced into selecting subjects for the wrong reasons and taking pictures he would never use.

The project necessitated a change from Griffiths' usual way of working as he found himself looking at photography more as a recording medium. In place of the set-up shot was the idea of trying to capture the 'scent' of his subjects. Something happens to make a subject worthwhile as a photograph – it might be a change in the light or a mannerism. Griffiths knows what makes an image work, but his instinct is fed by observation. The woman in the ice-cream parlour, the gun-toting sheriff set against a stern evening sky, the people just sitting

Above: When using specialist cameras with unusual formats it is important to tap the full potential of the system. This photograph of two riders on a dusty trail does full justice to the aspect ratio of the 6 × 17 cm negative format, which offers a picture three times as wide as it is high. The riders are placed within the broad expanse of a sparse landscape, and the need for a horse is never in doubt.

Right: This close-up shows workers at the end of the day. We see the trappings of a convivial existence, of hard work and the clothes that go with it.

around their pick-up trucks – we are witnessing real life as these people experience it, camera or no.

Griffiths found that he quickly built up a rapport with the people he wanted to photograph. 'They're my sort of people. I understand what makes them tick. They are very proud of their way of life and they like their pace. I didn't ask them questions about themselves – I just took photographs. They accepted me, probably more than they'd have accepted someone from New York. I didn't try to push them around. I'm fairly easy to get on with and I

have an old camera that looks a bit quaint. I let them see Polaroids and made a point of sending them photographs whenever I could.'

When Griffiths had completed the bulk of the shooting for the book, he knew there were gaps and so he returned to the Panhandle for a further three days. Although only a couple of pictures were used from this last session, Griffiths regards them as very important. He feels that they injected excitement and movement, without which the book would have been 'a bit pedestrian'.

This awareness of the project as a total entity is relevant to other decisions Griffiths made for the book. The short story that prefaces the pictures sets the scene and, to Griffiths' mind, says everything that needs to be said about his subjects. There are no captions and the people are not identified – the pictures are allowed to speak for themselves.

Griffiths works mostly in colour and this project gave him an opportunity to experiment with black and white. Most of the photographs were taken on a Gandolfi whole plate camera and the rest on a Fujica

Left: Further images that evoke the feeling of comradeship and mutual self-help that life on the range encourages. The group portrait (far left) reveals the unique patterns of existence of life on the Panhandle – the clothes, the friendships and the traditions. In this instance, auxiliary off-camera flash has been used. Off-camera flash was also used in the picture of the local marshal (left). It is important with this technique to use the flash with restraint, allowing it to complement the feeling of the ambient light, without bleaching out the details. In this photograph, the details in the sky remain, together with those in the bodywork of the car.

Right: This shot of the local purveyor of cowboy boots, with the name tabs in place, shows that portraits are critical to any essay, particularly when dealing with specialist subjects in remote regions.

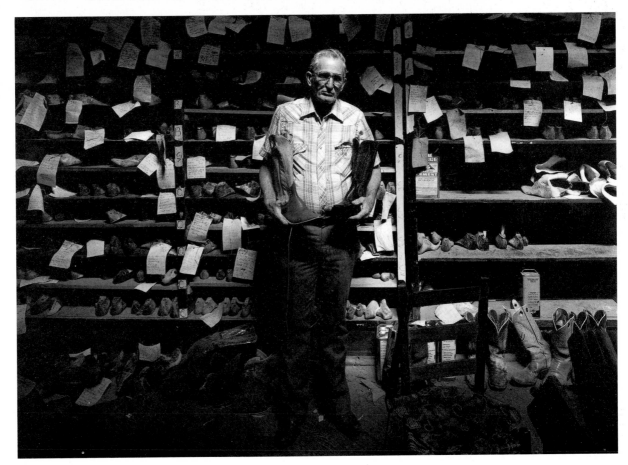

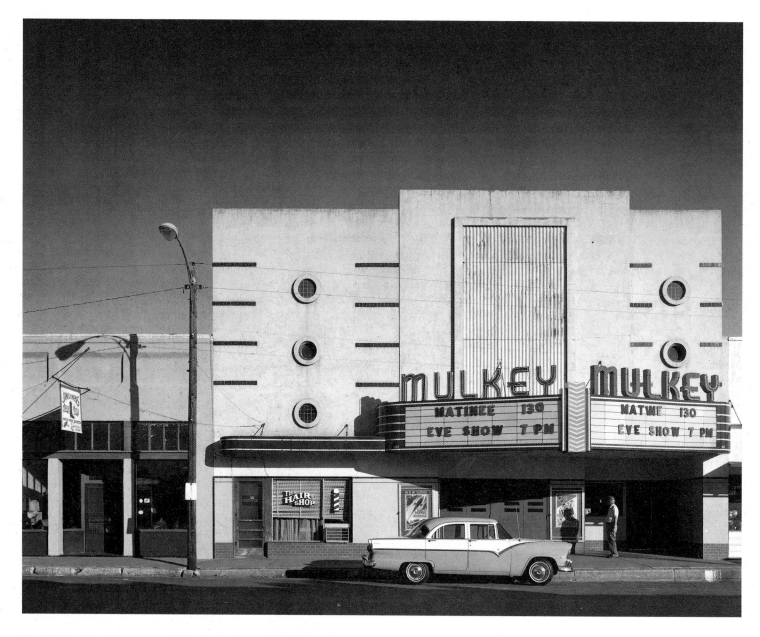

6 × 17 hand-held camera. The lenses he used were Schneider Super Angulon 90mm and 120mm, at f5.6 and f8, respectively, Schneider Symmar 210mm at f5.6, and Rodenstock 150mm at f5.6. The Kodak TriX film he used throughout was rated at either 200 or 100 ASA, as opposed to 400, because he wanted to flatten the film and lose the contrast. This film, particularly at 100 ASA, gave a dense negative which yielded more detail in the shadows and richer printing. 'You're really lucky with black and white. Modern-day films are so good that you don't have to worry about filters so much. I used a polarizing filter and red filters only when it was necessary to increase the density of shadows and the contrast. They also darken the sky – which I like – but you can do that yourself in the printing afterwards.'

The 'Panhandle' project has whet Griffiths' appetite for photo documentary type work. He would like to undertake something similar, but wholly on his terms. His instinct as a photographer is to follow through an idea and take a series of photographs. Once he finishes a commercial assignment he will invariably spend the available time shooting around for himself.

Were he ever to return to the Panhandle to do a story there, he would have to try a different approach, perhaps follow a rodeo or a cattle drive. 'It's a slice of my life and it's done.' And what does Griffiths feel comes through his 'Panhandle' pictures? 'I don't know whether a person can answer that. Other people might be able to say better than me. I take what I like.'

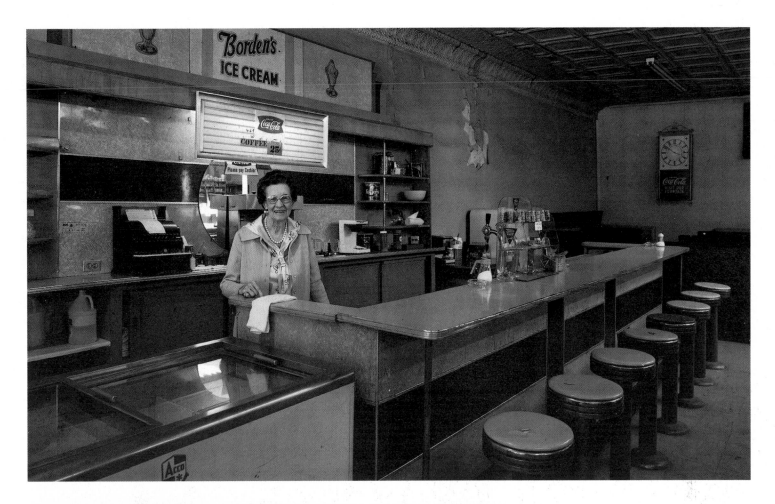

These images evoke a sense of the past, yet they are a living record of what the Texas Panhandle is today – in ten years or so, it may well have changed irreversibly. Within the images are all sorts of visual references that can be looked at time and again – the streets, the architecture, the cars, the diners, the interiors, the paintings on the walls. These details are infinitely more important as a document than any photograph of a statue or a government building. Like visual poems, they can be read again and again, small details of affection and experience that the photograph, above all, is supremely fitted to record. It is interesting to note how many photographers return to the themes of America that have given them pleasure over their lifetime – the concept of 'the last picture show', of dreams in darkened auditoriums, of cars, chrome and stetson hats, and of diners, the open road and that elusive 'spirit of freedom' which is so much at risk in our ever-conforming society.

FASHION

In the strictest sense, the role of the fashion photographer is to record clothes, and this would appear to be simple enough. But the fashion photograph has such a strong and particular niche that most fashion work goes far beyond simple recording. Photographing clothes in a dispassionate way is limited to an area known as catalogue photography. In this instance, expressive content is subordinated to the need for the clothes to appeal to as broad an audience as possible, without fear of offending, and the photographs are therefore taken as 'straight' as possible, with a co-ordinated look to the whole collection.

Fashion photography has gone much further than this, into areas such as theatre, fantasy, psychology, and sexuality that may well be extended into aspects of cinema narrative and surrealism en route. Similarly, the whole area of eroticism often has a natural part to play in the representation of clothes, because garments do more than merely keep the body warm – they extend into aspects of identity and personality. This is particularly so at the present time, since the politics of sexuality continually challenge the assumption that men and women should adhere to particular roles, and this is extended by added influences from popular culture that simply did not exist in earlier times. So the successful fashion photographer must do more than merely record the clothes and be in control of the mechanical devices for so doing, but should also be vitally aware of the social or psychological message that the image needs to convey.

For this reason alone the popular idea that the 'girl next door' can be a good fashion model is unlikely to be true, any more than she is likely to be a good film actress. The model must also be able to provide a personal contribution to the photographic session. Similarly, the photographer must be able to translate the clothing and the attitude of the designer into the photographs. This is particularly true when you are serving the needs of an

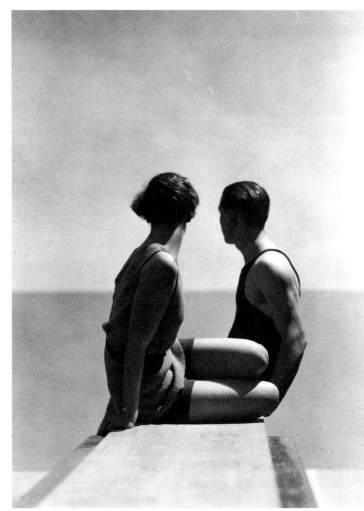

Left: The work of George Hoyningen-Huene (1900–68) owes not only a great deal to classicism but also to the leading movements of modern art and the avant-garde artists of his day; it owes a great deal also to Edward Steichen. Huene raised the level of fashion photography significantly during his working span for both *Harper's Bazaar* and *Vogue*, between the years 1925 and 1945. Additionally, he worked on both travel and portraiture. However, it is for his singular vision and application in the area of fashion that Huene will always be remembered, and his great contribution was to carry on after him to influence latter-day masters such as Irving Penn and Richard Avedon.

art director. In the professional sense, the fashion photographer seldom, if ever, works alone, but with a team of specialist contributors whose input is to ensure that no details are left to chance, whether in terms of make-up or set decoration.

The way you interpret the subject is therefore vital, and should be founded on the use of particular equipment and working methods. For this reason alone the fashion photographer seldom works in other areas of photography. There are notable exceptions, of course. Edward Steichen comes first to mind, and both Cecil Beaton and Irving Penn have worked in both fashion and portraiture. The doyen of American fashion photography, Richard Avedon, has extended his use of fashion techniques into social documentation by

means of his very personal approach to portraiture in his 'American West' series. Irving Penn also used aspects of his fashion technique in his major document 'Worlds in a Small Room' for American *Vogue* magazine. He took his collapsible photographic daylight studio to locations in Latin America, Africa, Europe and America. His method was profoundly simple – using daylight and a standard lens on a roll-film camera – but what shone through was the dignity and serenity of his subjects.

Underlying this kind of approach is a firm understanding and affection for what has gone before, in the pioneering days of the medium. It is simple, uncluttered and to the point, affording a classical beauty to the form that is particularly relevant to the fine fashion photograph.

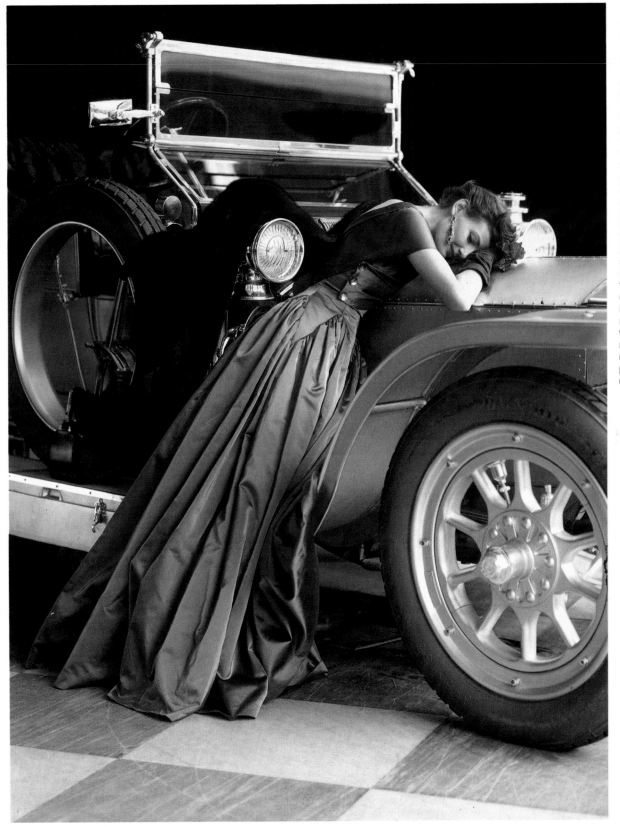

Left: Although an entirely different type of photographer from Hoyningen-Huene, it is clear that Norman Parkinson also owes a debt to the influence of Steichen in his larger format and more classical work. However, he has always had an interest in the use of movement, and this has led him to use a wide variety of techniques and formats in his output; his later work especially suggests the influence of Martin Munkacsi. In this example, taken in 1950 for English *Vogue*, Parkinson has used the large-format sheet film camera to record an image of his wife in a satin evening dress against a 1907 Rolls Royce. The use of colour is restrained and elegant, with the limited tonal range echoing the earlier days of the autochrome process. The lighting is daylight.

EQUIPMENT AND APPROACHES

If the success of a fashion photograph rests not only on the matter of the clothes themselves but also on interpretation and style, it follows that you must adapt your technique accordingly. A good fashion photographer must be fully aware of both market-place influences, of style and the concept of 'look', as well as being conscious of current thinking in photographic terms. It is absolutely essential that the fashion photograph is itself fashionable in some way, and the photographer must be fully aware of this and respond accordingly.

In the studio, electronic flash is without doubt the best form of lighting. It gives you great potential for arresting movement and flowing material, and also allows the studio and model to benefit from the low operating temperature of the lamps. The colour response of electronic flash is wholly predictable, and current metering technology allows very accurate control over the exposure, particularly when instant-picture film is used to preview the results and when medium- and large-format cameras are in use. With a miniature camera, motor-driven film transport is particularly useful. The relatively high through-put of exposures enables you to work freely and without encumbrance during the session. It is particularly worthwhile exploiting the potential of slave units on the flash equipment, for this means that you can trigger the main lighting without the need for physical linking by leads and sockets. By using a small flash unit in the hotshoe connector on the top of the camera and setting the autosensor to an aperture setting well below that in use on the lens, it is possible to ignite the main lights in synchronization with the shutter; this technique does not overexpose the frontal lighting from the camera position.

On location, it is important to select the

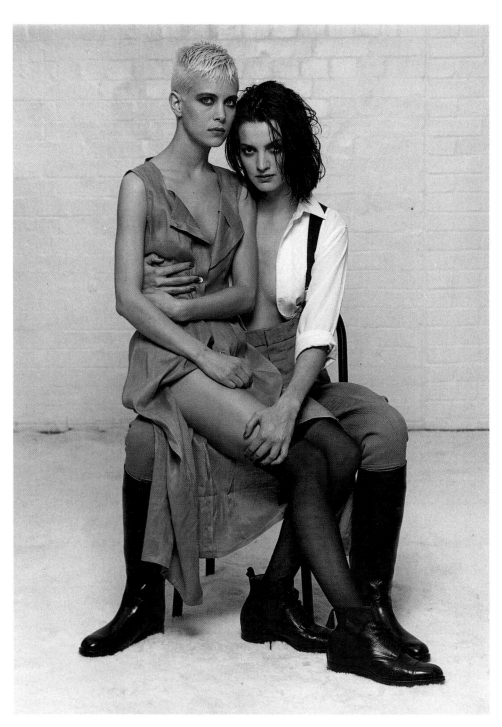

site carefully and to interpret and use that site well. Quite apart from showing the clothes, the photograph should also stimulate the viewers' interest and stop them flicking over the pages in a random manner. Therefore, a great deal of trouble must be taken on the question of style and

Above and opposite: There is no longer any such thing as a 'typical fashion photograph', for the best work in this area is conditioned by a variety of styles, approaches and interpretations. The challenging of social attitudes and assumed roles is also important. Women may be dressed in men's clothes or have boyish hair, with influences coming from popular culture and street fashion (above); or the inspiration may stem from

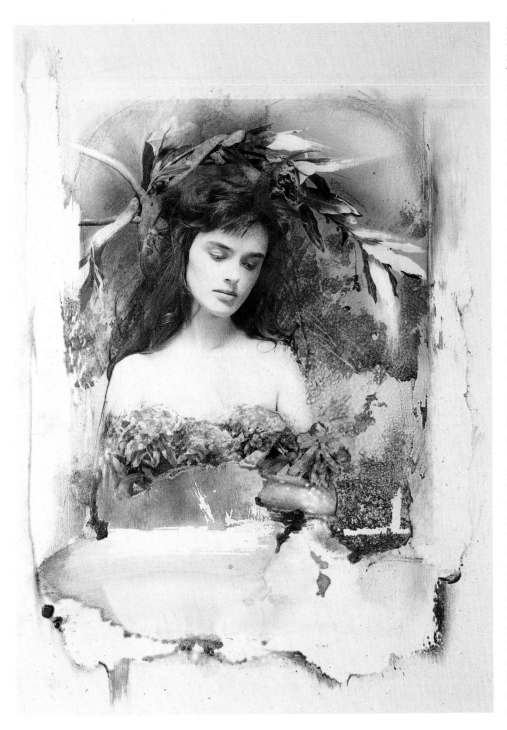

look. Often, fashion photographs owe their influence to the cinema narrative. Also, many photographers endeavour to show 'real' locations and 'real' people and adapt their technique to make their photographs look like press shots. Alternatively, techniques are employed to get wholly away from realism and into the area of romance and fantasy, with fast grainy colour films being used to mimic the visual quality of the turn of the century with soft pastel colours, low contrast and atmospheric use of colour. Yet another approach would be to employ colours that are influenced by popular street subcultures, video and television; recently this has been pursued by systematic and controlled use of wrong or unpredictable colour as part of the visual statement. To achieve this, the film is developed in negative colour chemistry and then reconstituted by means of an additional printing stage so that the colour is used in a way that had never been intended by the manufacturers when formulating the film. The colour that results is garish, brash and over-contrasty yet gives a particular stylized look.

However, it is well to realize that the role of fashion photography, as in fashion itself, often goes in cycles and that what was new today may well be somewhat imitative tomorrow. It is much better to work consistently from influences that are meaningful rather than merely follow a particular whim of popular culture at any given time. To this end, it is vital to be cognizant of the very best that has gone before and to remember that nothing, really, is actually new. Do not go to a location with nothing in mind. Pay a great deal of attention to matters of detail and background – things can be readily changed in due course, but start the session with a clear motif in mind.

Fashion photography is very akin to fashion itself and, although there are innumerable photographs taken in this area, there are few that are truly memorable. Like fashion, it requires that additional 'spark' to place it above the rest and this invariably comes from a simple idea well executed.

Victorian painting, the imagery of Lewis Carroll or Alma-Tadema, or the unique properties of the Daguerreotype – especially when hand-manipulated (opposite). It is particularly important that the successful fashion photographer should be well versed in popular culture and historical influences, especially within the history of photography itself. Fashion is more than merely a covering for the body – it is about image, style, period and content. The essential role of the photographer is to reflect this. Thus it is that although the concept of a particular fashion assignment may begin in the editorial office, the final product can be influenced through the lighting, the camera format and the approach, and can be finally realized through post-camera darkroom techniques. These can involve matters of contrast and hand-printing, and after-treatment of the image for a particular effect.

THE NATURAL WORLD

Although it is tempting to consider the natural world as part of the subject matter of landscape photography, the landscape photographer is not necessarily concerned with matters of the natural growth, ecology, and flora and fauna of the planet Earth, whereas the natural history pho-

tographer certainly is. Landscape photography may be concerned with quite different issues that are more related to society and history than merely the environment and, of course, the urban landscape owes nothing to the question of organic growth at all. Similarly, photography of the natural world extends from the horizon down to macrophotography in its examination and recording of growth. It therefore requires specialist techniques that have nothing to do with landscape as such.

Irresponsible pollution and inappropriate dumping of chemical waste have given many people the conviction that the natural resources of the Earth, if not handled more sympathetically, will deteriorate to a point at which life on this planet will be seriously threatened. There is currently a heightened awareness of the importance of ecological and environmental conservation and photography naturally has a vital role to play in this respect.

In the broadest sense, of course, there

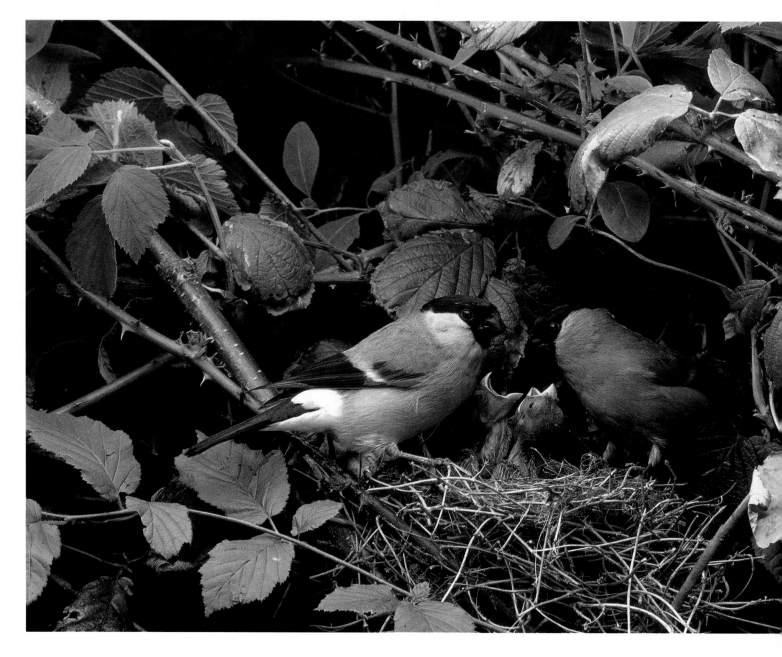

Below and right: It is critically important for the natural history photographer to do thorough preparatory work, for the best pictures do not happen by accident. For this photograph of bullfinches (below) the photographer has prefocused on the nesting site, almost certainly from a suitable hide, knowing that a moment such as this will occur. It is useful to augment available light with auxiliary flash – on a long wait the daylight can be uneven and irregular in both colour and intensity. No such problems exist in the open though, such as in this photograph of a resting dragonfly (right). Here the greatest problem is to focus on the elusive prey, but, again, flash can assist by allowing the use of a smaller aperture in conjunction with the daylight.

are parallels between landscape and the natural world, for both are subject to the passage of time, to the elements and to the waxing and waning of organic matter. Therefore, much is to be gained from the extensive use of natural light and the exploration of the quality of weather, season and atmosphere. Broad views of the landscape are not always essential for this. It may be better expressed by the careful use of close-up devices to record the dew on a web, or a flower, or the fungus on the side of a tree. However, your work will be more effective initially if your photography springs from a clear attitude to the environment and has a particular goal in sight, rather than from aimlessly wandering in pursuit of the pictorial and largely irrelevant detail that may casually spring to notice. Like other forms of photography, recording the natural world is best served by a precise personal viewpoint that is backed up by knowledge of the subject.

Essentially, the photographer of the natural world should acknowledge that the resources of the Earth are not haphazard and random but are wholly organized and interdependent, and that this kind of structured ecosystem is best recorded by

an approach that is similarly ordered and rationalized. It is far better to avoid obvious pictorialism in favour of rational thought, and to this end you naturally need to organize the equipment that will be appropriate. First and foremost, once you have abandoned the open panorama in favour of the closer viewpoint, it is critical to employ an additional source of illumination so that the appropriate modelling may be reproduced. This is best achieved with small electronic flash units that have portable independent power sources. Working within a wooded area, however, it is surprising just how low the lighting under such conditions can be. If you make colour photographs by lengthy time exposures, the colour of the ambient light will be unacceptably distorted. This is quite useless for serious work. An essential priority in nature photography is the accurate recording of local colour – distortion and imbalance are to be avoided at all costs. Further, the long exposures necessitated by the vegetation growing in darkly-lit areas of woodland involve the added risk of reciprocity failure on colour film, so it is essential to augment the lighting by flash whenever possible.

TECHNIQUES AND APPROACHES

Clearly, the close-up rendering of detail and form requires particular equipment and techniques. Much can be achieved by the use of a small flash unit connected to the camera by an extension cable and monitored by a remote sensor system. Couple this to a macro lens, and support the camera on a firm tripod, and you will have a good general-purpose set-up for close-up work. When selecting a tripod, it

is advisable to look for a model that will allow the centre column to be removed and reversed and also to be mounted at right-angles for direct vertical shooting to the ground from a pan-and-tilt head. Additionally, you should bear in mind that however good the tripod is, there is still the risk of movement from the plant or foliage itself, because of the wind. Again, flash is an extremely effective method of minimizing this problem. Particularly relevant is the fact that the colour temperature of flash is the same as that of open daylight, and therefore there is no risk of added colour shift when using it. The best way to use the flash is to position it to the side of the camera in roughly the same direction as the ambient daylight. Take care that the

flash is not too powerful, and match it to the available light.

When you are dealing with specialist subjects, such as insects and very small growth forms, it is necessary to employ the type of accessories normally used in medical photography. The leading camera manufacturers produce their own equipment for this type of work. It is usually in the form of a specialist close-up lens system to which are coupled two small flash units, one on each side of the lens barrel; there is an override control at the camera position. This allows for very precise and consistent control of the subject illumination and you can use such a device when hand-holding the camera for the recording of subjects such as but-

Left: Underwater photography needs specialist techniques, particularly where colour is concerned, for otherwise the subject will not be rendered correctly. The standard equipment is an underwater housing for the camera coupled to a special flash unit, as was the case in the example shown here.

Above: This wonderful series of images of an owl in flight has been achieved by means of high-speed multiple flash. Despite its sophistication, it proves the old adage that nothing is really new – it is very similar to the photographs of a flying duck taken by E.J. Marey in 1890.

terflies. One or the other, or both, of the flash heads may be used, according to the needs of the subject. A further device is the ringflash unit. This encompasses the entire end of the lens and may be reflected forward by means of a diffuser. The essential quality of this type of illumination is its overall evenness. Also, the close-working range is such that very small apertures may be used, so that the great problem of close-up work – shallow depth of field – is minimized.

Not all problems of nature photography are confined to questions of scale. Many spring from the fact that the subject itself may be extremely difficult to get near to. In these circumstances it is often necessary to devise strategies that will enable the subject to come to the camera, as opposed to the other way around. Clearly, the best method of achieving this is to build an unobtrusive tent-like hide in the subject's habitat, from which you can work unseen. This is particularly useful when a nesting site has been identified, for there will be a steady flow of visits from the adults when feeding the young. A suitable tripod and a small folding chair, together with a lens of around 300–400 mm, are essential tools for the job. A small flash unit may be useful at times when the light is weak, but never as a primary source, only as a fill-in. Another critical factor when considering the use of a particular site is that a long stay in the tent will involve a sizeable shift in the position of the sun – it is important not to work into the light when employing long-focus lenses.

However, other species require even more specialized equipment for their successful photography. Many animals are at their most active at night, and many birds are at their most beautiful in flight. Visual focusing at night is unpractical and much effort must be put into arranging the equipment so that it may be used remotely, often triggered by the creature itself as it passes the device. For this type of work, locating the nesting or roosting site is essential. You can then work out in daylight the position at which the lens must be pre-focused.

There is a great deal that can be done within the range of the well equipped photographer, especially if the camera allows for the addition of sophisticated peripheral devices with electronic coupling. A decade ago this would have been out of the question, but technology has advanced so rapidly that this is no longer exceptional.

By far the best method of capturing nocturnal life is by use of an infra-red triggering device not dissimilar from the systems commonly used in household security or in supermarket automatic door-opening systems. There are devices that you can purchase relatively cheaply and adapt for photographic use. They respond to the interruption of the infra-red beam and, when this is suitably directed at the entrance to the nesting site, the arrival of the subject will automatically trigger the system.

Flash photography is the only method of recording this type of work and, whenever possible, it is preferable to use more than one flash head to minimize the rather stark look of the on-camera flash position. More sophisticated use of extremely high-speed trigger devices that will successfully 'freeze' the wings of a bee in flight are, however, beyond the scope of all but the most dedicated specialists, since they require very short exposure times indeed, and, to achieve this, specialized knowledge beyond normal photographic applications is needed.

DOMESTIC AND ZOO ANIMALS

Animal photography need not take place in difficult conditions in the field. The everyday domestic situation can provide good opportunities for the photographer. Animals of all sorts – rabbits, guinea-pigs, snakes, pigeons, and, of course, cats and dogs – provide the casual photographer with hours of endless pleasure, especially when used as part of a picture-making device with children, interiors or land-scapes. They should not be dismissed as unworthy subject matter merely because so many photographs involving animals are dreary and bad. With a little imagina-tion, the exercise can be both worthwhile and interesting.

It is preferable, whenever possible, to use the animal as a catalyst for photo-graphing an additional element within the picture, rather than as the subject in its own right. Of course, an 'animal portrait' on its own is quite feasible but, frankly, leaves little for the imagination other than as a mere record of the particular species; this, in turn, is not likely to be particularly interesting to anyone other than the ani-mal's owner. It is far more worthwhile to use the animal as the basis for the record-ing of a small domestic scene or the display of affection between the animal and, say, a child. At all costs avoid a tendency to insult the dignity of the creature by placing it in unusual positions or attaching ac-cessories to it. Many people keep animals purely for their companionship and it is in this area of mutual happiness that you will be able to achieve the best photographs. Be patient, and watch and wait. Often the simplest approach is the best, and the only added refinement may come from the use of a small fill-in flash unit to supplement the available light and to arrest any move-ment that the animal may make during the exposure.

Photographing zoo animals may also be pleasurable and rewarding. Zoos where the animals are allowed some freedom to roam

are ideal, but any zoo is a rich source of interesting subject matter. In addition to the animals themselves, of course, there are also the people who have come to watch them. A day spent at a zoo is rarely a day wasted. The obvious and direct advantage that the zoo offers is that the animals are confined and at ease and therefore are fine subjects for the con-trolled close-up from the watching areas. The effect of the cage and bars can be minimized by employing a good tripod and a long lens, coupled to the use of a

wide lens aperture to give the shallowest depth of field. The effect of this is to throw the foreground bars out of focus and thus render them less noticeable. Wide-angle lenses are less useful for this type of work, as they tend to reduce the size of the subject in the confines of the cage when getting closer is physically impossible.

Wild-life parks offer a similar range of opportunities, but with several added ad-vantages. The animals are easily accessible, the park allows direct vantage points to the animals without the need for cages and

bars and, particularly, any photographic work may be carried out from the safety of a car. Again, long-focus lenses are preferable for this type of work and it is also useful if you have more than one camera body. In selecting lenses for a trip to a wildlife park, you should consider the potential of the zoom. If this is not available, try 'doubling up' in focal length from one lens to the next. In this way you can quickly exchange one degree of magnification with another for the pursuit of revealing details in a given situation. This technique is especially useful with a second camera body. When using the longer lenses, though, it is essential to remember that the longer the focal length the higher the shutter speed needed to eliminate camera shake. It follows therefore that with the longer lenses it is best to employ the fastest suitable film.

Animals offer enormous potential for photographs, as the lasting imagery of Muybridge, Marey, Lartigue, Elliot Erwitt and Gary Winogrand shows. The imagery can derive from pattern in monochrome, as in this image of a dalmatian (left) by Herbert List, or from the natural colour and delicate hues of the animal itself (top). Alternatively, action photography can yield rewarding results, as in this leap by a dolphin in an aquarium. In good light an exposure of 1/1,000 sec is easily obtainable. Also, there is a considerable increase in the numbers of open-air zoos and these are wonderful sources for subjects in the animal world. It is feasible to work with long lenses from a car in such a setting. Yet do not underestimate the enjoyment of recording domestic animals – they are undemanding and provide a source of infinite pleasure in picture-making.

Above: When recording images of animals in a domestic situation it is often preferable to locate the animal within a framework, rather than simply on its own. In this way, the animal takes on more character and relates to the human environment.

ANIMALS IN THE WILD

At one time, the animal safari was the preserve of the privileged few but, increasingly, the potential for this type of activity is becoming more available to a greater audience and is becoming an attractive feature of the tourist industry. Whereas in earlier times the members of wild-life expeditions brought back evidence of their experiences in the form of stuffed heads to adorn the mantlepiece, today the rifle has given way to the telephoto lens. The camera is an infinitely better instrument with which to savour the pleasures of foreign journeys, particularly when it is possible to locate the animals in their natural habitat and coloration. Elaborate equipment is not necessary, for usually the light is good and the expeditions are organized in a way that will allow easy access to, and visibility of, the animals.

Many of the basic requirements for general nature photography apply equally to the wild-life safari, for the important thing is to know where the animals are likely to appear. This is usually determined by feeding, the social structure of the pack, and the protection of the young. Hides may be used, but these are time-consuming and limiting; it is preferable to work from a vehicle if time is of the essence. Night-time photography is not advisable without specialized equipment and careful pre-planning – most domestic flash systems are simply not adequate. It is better to concentrate on those elements that can be handled with ease in the time available.

Long lenses are essential, as are firm and reliable supports, while the choice between the fixed focal length and the zoom lens is essentially one of personal preference. With a zoom, you can use the wider settings to record the animal in the context of its environment, before using a narrower setting to obtain the telling detail. The disadvantage of the zoom, however, is that it is not as 'fast' in terms of light transmissions as its fixed focal-length counterpart. If the available light is too low for hand-held shooting then remember the potential of the pan-and-tilt head on a tripod, so that the animal's movement may be followed by panning with it; the slow

Left and above: The photography of animals in their natural habitat almost invariably restricts the photographer to the use of long lenses. These are needed if the subject is timid and difficult to approach, and also if it is dangerous and temperamental. This is the case (left) with the pair of rhinos but not so with the chameleon (above). In both pictures, the use of the long lens affords selective depth of field, and rids the picture of cluttering detail.

shutter speed is often an advantage.

Another aspect of wild-life photography that is both rewarding and increasing in popularity is that of the somewhat specialized area of underwater photography. Unfortunately, the waters of much of northern Europe suffer from poor visibility and low temperature, but towards the equator and in parts of the United States, the Aegean and the Mediterranean there are rich sources of subject matter.

Obviously, the primary requirement is a waterproof camera system. There are two means of achieving this: a specially designated camera for underwater operation, or an underwater housing into which the camera can be placed. In the former case, the camera is appropriately designed for underwater use, in that its optical system is designed to cope with the refractive index of the water, while the latter is not. The choice revolves around cost, because the underwater camera is not mutually interchangeable with its surface counterpart, so that many photographers prefer to employ suitable housings and attachments to overcome the problem.

Another major difficulty is that of light transmission: as the depth increases the light dramatically falls off and it is necessary to employ an additional flash fitted to the housing. Although good photography can be achieved with relatively simple means, such as a snorkel and a small housing in modest shallows, the area of underwater photography is a specialist one. It must be stressed also that such activities should only be considered by people who are sufficiently capable underwater and that under no circumstances should such expeditions be attempted alone. Nevertheless, rambling in the shallows with a modest camera system can still be one of the most rewarding aspects of photography when on holiday. Particularly, the abundance of anenomes, coral and small fish close at hand can offer great potential for the study of colour and form by natural light.

PLANT LIFE

The photography of plant life is a rich and almost infinite source of inspiration. Plant life, like any other form of life, is not haphazard and random, but subject to particular patterns of structure and development. To express this adequately in photographic terms, you should look at the gradual development of the plant and try to photograph it in such a way that its full glory, in matters of colour, shape, form and pattern, are recorded at the best time. For this reason, it is useful to look at the plant in purely abstract terms.

Without doubt, the finest equipment for this type of work is the 35 mm SLR, for it alone offers you the full potential for close-up photography, without recourse to complex calculations of light fall-off that would normally be involved with other camera systems. Extreme close-up work also affords shallow depth of field, and whereas in most photography this can be a limitation it is an exciting adjunct to the photography of plants. Thrown out of focus, a head of brightly coloured petals assumes a delicate field of saturated values against which to place the detail. Often the mixture of two colours in proximity affords beautiful shades of hue and contrast that are otherwise unseen. Thus it is that the

Left and right: Many photographs involve natural form, the environment and an awareness of the beauty of organic matter. Edward Weston particularly, and more recently Elliot Porter, have been committed to these themes. Many of the problems are linked with scale and may range from the type of subject matter that can be covered by a standard lens (left) or a macro lens (top right) or even a specialist lens coupled to suitable close-up devices like focusing bellow and extension rings (lower right). When closing in on such subject matter it is advisable to take steps to minimize subject shake through wind, as the degree of magnification is considerable. A tripod is essential, but useless if the subject moves rapidly. As in the photography of animals in situ, it is often useful to boost the available light by means of a small flash unit, especially when shooting against the light, as this will help to cut down the contrast that can exist in outdoor lighting conditions.

skilful use of the camera can not only record the beauty of natural form but can even augment it.

A macro lens is ideal for this type of photography; it may be a 'standard' macro type within the range of 50 mm or 55 mm, or a 'short telephoto' type of around 100 mm. With both of these lenses it is possible to work from extreme close-range out to infinity, and so they are able to double as both specialist and general-purpose lenses, according to need. Macro lenses are formulated so that the normal limitations of close-up photography in matters of definition and flatness of field are minimized.

However, even macro lenses may not be sufficiently versatile to accommodate some close-up work. It is therefore necessary to supplement the primary lens with some additional means of extending its distance from the camera body. There are two basic methods of achieving this: the extension tube and the focusing bellows. A third method, the supplementary close-up lens, is useful but less satisfactory, since it depends on an additional lens element being screwed on to the front of the lens and this is optically less desirable. The extension tube method is useful in that it allows the 'spacing' of lens and body to be made in incremental steps, if all the sections of a particular set of tubes are brought into use. Such tubes have an added potential of coupling to the lens diaphragm so that its automatic aperture function is not impaired. On the other hand, extension bellows afford virtually continuous degrees of magnification through the lens, but suffer from an inability to allow a very short distance between the camera body and the lens. But they do allow very high degrees of magnification, and can also be used in the automatic mode.

The problem of difficult exposure monitoring is largely overcome with the modern SLR, for the metering system will readily accommodate the needs of such accessories. One other problem that does arise from the use of extra-close focusing is that of subject movement. As with extreme telephoto lenses, the image is considerably magnified at the film plane and is particularly vulnerable to the problems of camera shake. The use of windbreaks around the subject will help to solve this problem. Additionally, the use of auxiliary flash from a small unit close to the subject matter is an invaluable aid to overcoming the problem of subject shake.

The photography of plant life need not be restricted to close-ups, however, and much is to be gained from locating the flora in its natural growing conditions and environment. Bill Brandt has done this with his photograph of the seagull's eggs on the Isle of Skye, and present-day photographers who work in this vein include Eliot Porter and Stephen Shore, both of whom employ a large field camera. Andreas Feininger spent a great deal of his working life recording natural forms and patterns of growth.

SPORT

The photography of sport is a specialist area that requires so much dedication, knowledge and sheer expertise that its practitioners seldom venture into other areas of photography. The reasons are many and various, but not least is the fact that in order to work successfully in a sport one must know exactly what is going on. This extends not only to the progress of the action itself but also to the specialist knowledge of the equipment that will be required to record it successfully. We have all tried to photograph events such as school sports days and been disappointed at the results and this is largely because we have given insufficient thought to the question of approach.

Apart from one or two exceptions like bowls, sport, by its very nature, is involved with speed and you must adapt your technique to accommodate this. Essentially, there are two basic ways of dealing with a fast-moving subject – either by high shutter speeds or by moving the camera in unison with the flow of action. In both cases it is vitally important to anticipate the peak of the action and to ensure that the most expressive moment is captured in that fleeting split second. High shutter speeds generally need to be used in conjunction with fast films, and it is essential to pack spare reserves of very high speed film when photographing sport. The contemporary photographer is well served in this respect by the great strides that colour film has made over the past decade. It has improved greatly in terms of both definition and higher speed and in many respects colour film now outpaces the properties of black and white materials.

The question of high film speed is a vital one for the sports photographer in another respect, due to the need for shooting the subject matter from a considerable distance which, in turn, necessitates the use of long-focus lenses. Such lenses greatly increase the scale of the focused image within the camera and thus the tendency for camera-shake is correspondingly in-

creased. Therefore, high shutter speeds are essential not only to preserve the action in front of the camera but also to sharpen the image within the camera, and it is best to employ the fastest film available for the work at hand.

The alternative is to 'pan' with the subject, so that the camera moves in the same direction as the main action. With this technique the relative speed of the subject matter is considerably reduced and so is the tendency towards unsharp

Left: At its very best, sports photography often transcends the event itself. The photograph of the embracing athletes from the Los Angeles Olympics tells us not only that one of the women has won an important race, but that the whole moment is a mirror of what it means to be a woman, gifted, and black. It is an image of joy and pride. Note the detailed colour on the athlete's fingernails.

Right and below: Like the photograph on the left, these two were taken with a long lens, used at particular positions from which the action could be seen, either at the end of a race, or at a crucial place in a match (right), as the ball is struck from a difficult position, or from a critical viewpoint (below), as jockeys struggle for supremacy in the straight.

the recording of sport can encompass many varied and fascinating aspects of photography and that part of the pleasure is in the interpretation of the subject. Sport is performed by people, not robots, and with that goes all the emotion, heartache and elation that great events bring to the human spirit.

An alternative lens to the long-focus is, of course, the wide-angle, which should be coupled to a position of greater proximity and faster action. The quality of the wide-angle is that it not only affords a greater angle of view, but it also 'stretches' the visual perspective. Accordingly, very dramatic results may be obtained by working close to the subject and panning across the action, even when this is very fast, as in motor-racing. The shorter focal length coupled to the panning action greatly minimize shake but, even when some blur is inevitable, this does not necessarily mean that the photograph is unusable, quite the contrary – the expressive use of blur is an exciting reward of this type of picture.

images. Most panning is done with the camera hand-held, but you can also use a tripod coupled to a pan-and-tilt head. This enables the camera to operate in a lateral movement only and so minimizes the risk of vertical shake. If space around the shooting position is limited to any great extent, an extremely useful aid is a mono-pod, for this can readily be packed into a small bag and may be easily opened in small areas at crowded venues.

Above all, it is important to realize that

PLANNING

In sport, a great deal of emphasis is rightly placed on the need for anticipating the right moment of an expressive peak of movement or style. You must do a great deal of advance preparation to ensure that this is likely to happen. The first requirement is to liaise with the promoters or organizers of the event. Show why it is in their interests that you should cover this particular event. If you already have an arrangement for the publication of the pictures, so much the better. In making these initial overtures it is essential to realize two fundamental points. First, the organizers will be concerned with security and public safety: you simply cannot expect to place a tripod in a public walkway or exit. Secondly, promotional embargoes may mean that the promoters will want to know precisely for what purpose your photographs are to be taken. Do not turn up at the entrance, camera in hand, and request free access – plan well in advance, give as much information as you possibly can, and under no circumstances take advantage of any goodwill shown. Having gained access, it is extremely galling to realize that you have not packed a particular item of equipment. If it is at all possible, and the promoters are willing, it is very useful to go along beforehand and carry out some research into the position of the audience in relationship to the stage and lighting – which way will the sun set, at what time will the main event take place, and is it being televized? Small details are also important. If the event is a quiet one, with no background noise, then consider carefully the fact that your favourite camera system may be relatively noisy – especially if the mirror action in your 35 mm SLR is obtrusive. Try new methods of approach, even to the point of using a small compact with no mirror at all. The modern compact is an extremely useful alternative to the SLR, especially when used in conjunction with fast films in low light. If at all possible, avoid flash under such circumstances.

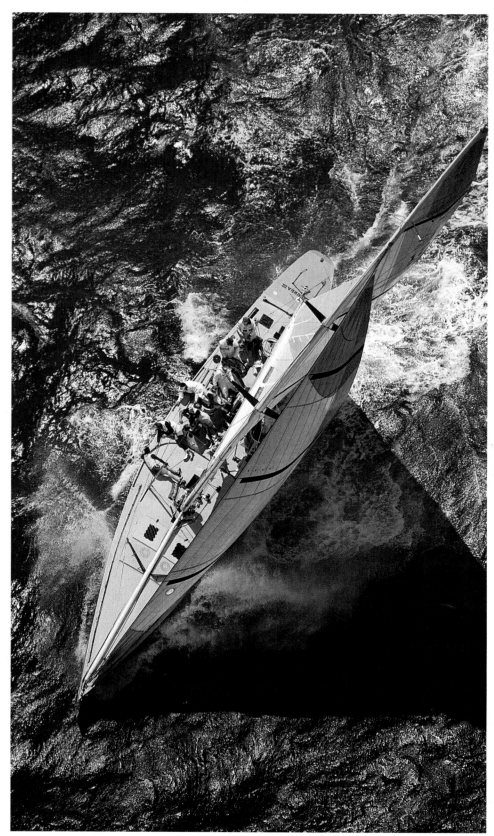

Left: A difficult photograph like this is quite impossible without planning. However, it is worth taking advantage of such a unique and stunning viewpoint, especially if you are working on an assignment with a particular publication in mind. Light aircraft or small helicopters are often for hire for short intervals and are an admirable way to obain that stunning image.

Right: A frightening moment like this cannot be planned for – just remember to be ready to shoot at any time. If you have two camera bodies, each with a different focal length lens, then so much the better.

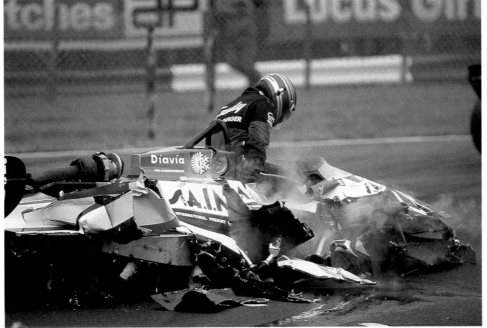

Above: Modern lenses are now so good that it is possible to close right in to small details of personal tension. Such lenses are costly and have limited applications, but it is worth looking into the possibility of hiring such equipment for the particular needs of the day. A good support is essential, of course. If a 'fast' (wide aperture) telephoto lens is not readily available, then compensate by using high-speed film.

SPECIAL TECHNIQUES

Sports photography, like fashion, has such a dominant role to play not only in terms of the daily newspapers but also in high-quality colour magazines that there is a continuous need for new and exciting ways to represent it. Moreover, television coverage at major sporting events is now so influential on our perception of sport that it is no longer enough merely to cover 'stock' situations in its photography. For this reason, therefore, it is essential to consider the opportunity of employing specialist equipment to give unique visual impressions. This type of equipment is, by its nature, expensive, but there is no reason why you should not hire it, particularly if a client is willing to support the venture with a commissioned series of photographs.

Although great sports photographs have been taken by the intelligent use of pre-planned electronic flash, such facilities are seldom granted now. This is almost certainly because of increased television coverage (and therefore an outlay of considerable sums of money, and thus priority) and also the fact that modern sport is usually linked to very heavy sponsorship deals. Therefore, the old concept of merely 'playing the game' has to take second place to one of 'win at all costs'. Competitors today are more likely to take a dim view of being bombarded by repeated flashes just as they are reaching the peak of their particular action. The other side of this argument, however, is that the frequency of television coverage also means that the amphitheatres and stadia are infinitely better and more evenly illuminated than before, so it is now much more feasible to cover events by available light. This being so, the careful selection of appropriate lenses is critical to successful coverage of an event.

Modern lens design has improved so much that long-focus solutions such as the mirror lens are much less in demand today. In these designs the compact length

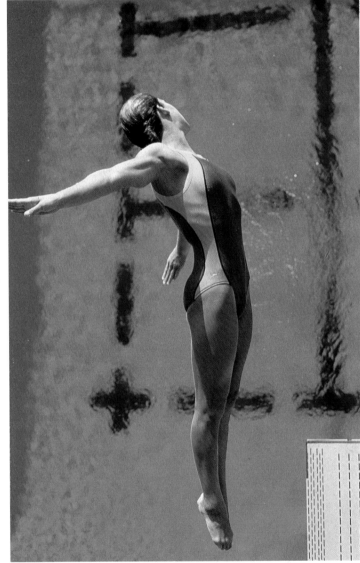

Left and right: Viewpoint is often critical in sports photography and an ideal viewpoint can be difficult to achieve. However, if the work is commissioned and there is a likelihood of publication, it is wise to hire specialist equipment for the job. Remote-control triggering systems, coupled to motorized bodies, have an unparalleled usefulness in making the memorable shot possible. Here, a swimmer (left) arcs briefly before plunging away from the camera and down to the pool below. Moments of intense concentration (top right) and speed (below right) are well served by extreme-focus telephoto lenses. In the case of the picture of Carl Lewis at the Los Angeles Olympics, the pleasure comes not only from the action but also from the colour – a factor that was so vivid at this particular Games. The long lens, coupled to the high action, has caused a slight blur in the background and the panning of the camera accentuates the athlete's beautiful action.

of the lens was arrived at by the use of an internal mirror system but this, in turn, meant that apertures were restricted to the f8 or f11 region – giving an image far too dark for serious consideration in sports. Instead, greater emphasis is placed on the combination of wide aperture and fast film index for the utmost convenience and portability. A 180 mm lens with an aperture of f2.8 is now wholly viable and, in special circumstances, a 250 mm f2 is available. Also, there is the added benefit of modern zoom lenses – and not merely for their obvious advantage of variable angles of view. Used on a firm support,

they afford unique imagery when 'zoomed' during the actual exposure. The final effect is one of visual 'rushing' towards the camera which can, if used sparingly, be spectacular.

In addition to the selection of suitable lenses, probably the most useful single piece of equipment is motorized film transport. Whereas in earlier days this was usually in the form of an additional attachment, the incorporation of microelectronic circuitry into the camera body assembly now makes its presence feasible as a built-in feature. Built-in or not, the motordrive enables you to make a greater number of

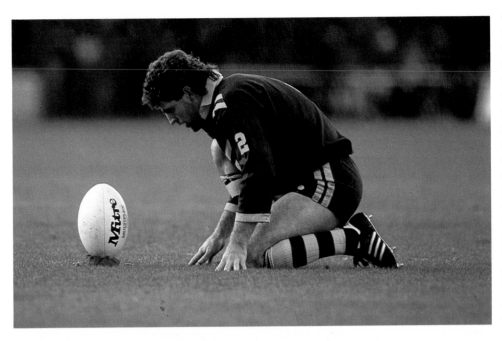

exposures over a given short period of time. In turn, this gives you a greater number of individual images to select from a particular sequence. Additionally, if you are using the top model of any particular camera range, it is often possible to replace the standard back with a bulk film magazine back that will provide up to 250 exposures at one loading. The drive itself will allow an exposure output in the region of five frames per second and therefore the bulk back is an important addition if prolonged exposures are planned at the trackside. Further sophistication may be introduced by means of remote control triggering devices, either by extended cable connectors or by wireless radio signals, but the use of such sophisticated accessories is best left to the experienced professional who possesses the requisite expertise.

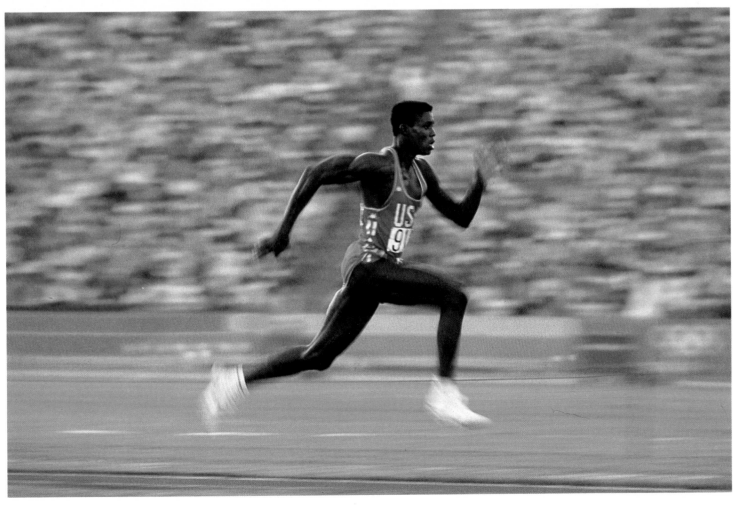

CAPTURING THE EVENT

Sport, like many other photographic subjects, covers a very wide variety of activities and calls upon the photographer to bring to it elements of picture-making that are not necessarily solely concerned with the progress of the event itself. Not only does sport involve athletic competition, it also brings together many different spectators and officials. It is thus as rich a source of subject matter off the field as on it. This makes it similar in character to events such as open air pop festivals, with their attendant fanatics, banners, paraphernalia and mystique. And just as it is often difficult to obtain photographic rights at a sporting event, this is now also likely to be difficult at a rock concert. Put simply, there is money to be made from such photography, and so there are restrictions on the extent to which it can take place.

However, this should not necessarily diminish the potential for the photographer. In many ways, the whole event is often more interesting than the actual performance. If entry to the playing area with a camera is refused, then take comfort in the fact that there are fascinating subjects all around you, together with exciting possibilities from the location of the venue itself. A cup final lasts only 90 minutes but the build-up and dispersal last all day. This is true of many large meetings and these need not only be within the fields of sport or popular music – they can involve such diverse interests as vintage cars, motorcycles, street performances, charity events, funfairs, and indeed any coming together of a large body of people. They all give you a captive subject, almost certainly in good spirits, which probably sees no threat in the potential use of the camera. Capitalize on this goodwill without causing offence, and you have a rich source of imagery.

Throughout the world and through the year there is a continuous procession of events that are based on moments of

Below: Wherever one goes throughout the world there are interesting and fascinating events taking place that are rich and fertile sources of pictures. Here an Australian life-saving team goes through its paces during its particular form of drill.

Right: A shadow almost becomes a tennis player's alter ego in this dramatic overhead shot, while a linesman looks on intently.

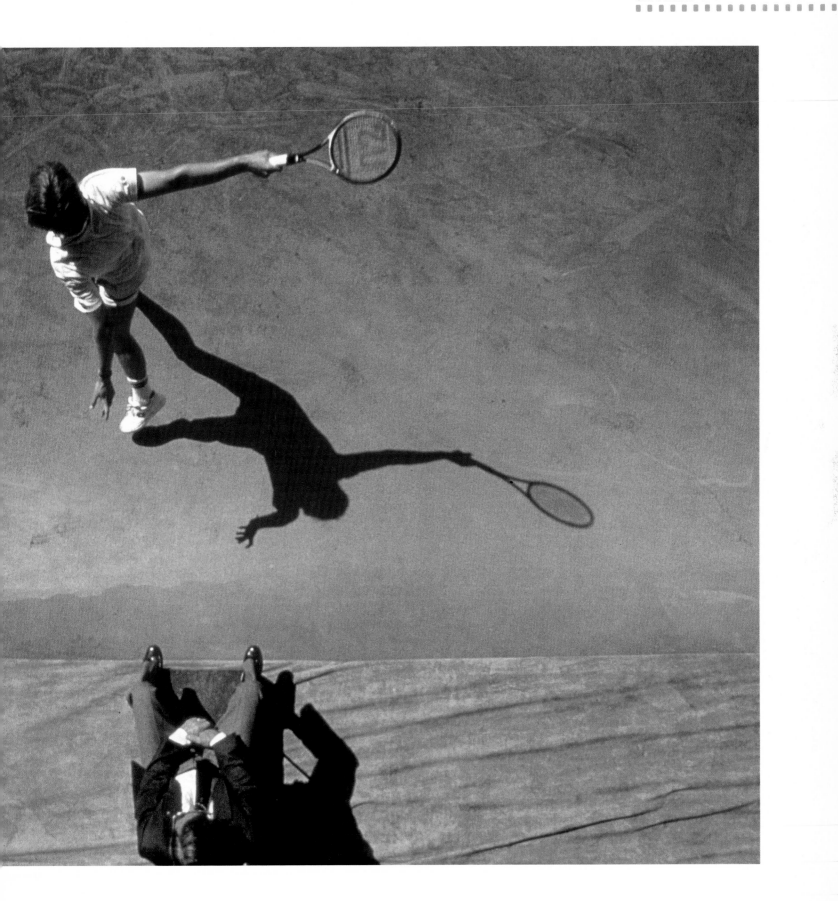

history that are often lost in time and yet which are unique to the region. The spring equinox and the midsummer solstice at Stonehenge, for example, the May Day dances, the summer fêtes and the various festivals based on the religious calendar, pilgrimages, horticultural shows – all can be seen throughout the year. Plan your trip well in advance, and realize that there is as much pleasure to be gained from the maypole on the village green as there is in many greater and more auspicious state occasions – this is the lifeblood of photography.

Within this congregation will be fine portraits and interesting characters aplenty. Take a viewpoint on the event and set about making a formal record of a unique occasion. Turn away from the stage and

Left and below: The range of subjects provided by an event is almost limitless. A pensive moment is caught (top left) at a carnival, away from the crowds, and is complemented by a restrained use of colour, while spectators at the Henley Regatta (lower left) wilt in the heat of an English summer by the River Thames. Contrast both of these quiet somnambulant photographs with the extraordinary image of celebrating football fans at The Kop – the terrace at Anfield, the home of Liverpool Football Club (below). The scene resembles something from a medieval battle or a Kurosawa film as the flares go off to greet the delight of the supporters at a high point in the game. Critically, the photograph is enriched by the dramatic use of colour, for this bathes the scene in an eerie glow. A memorable photograph of a memorable moment.

look back at the people who watch – who are they and why are they here? Accept the proposition that the camera in your hand is a unique instrument for the recording of life in its many forms and set about documenting the happening in your own terms. In this way the recording of an event can become something much more significant. It can take on the form of a social document – one that ultimately tells us a great deal more about how we live. Why is it that the people at a football match are so different from those at a rowing regatta; why do they dress differently and what is the symbolism in their dress? It would be a perfectly feasible project to work on a series of portraits of people *outside* venues as they queue to go in. This could show the relationship of

people to a particular form of music or sporting event, a religious revival meeting, a political debate or election address, or a village fête. It could even show how these values change from country to country.

Photography is used, of course, in crowd control, but this is a limited area of enquiry and not a primary function. The value of the photographic document is that it can be examined and interpreted long after the event and be a source of enlightenment in many ways. The massing of people for a cause or celebration has a great deal more to do with social conditions than with merely cheering on a particular team. It may be to do with regional pride, tradition, faith and aspiration. Photography is never far from the centre of any of these things.

PHOTOGRAPHIC GALLERY

'A great photograph is a full expression of what one feels about what is being photographed in the deepest sense and is, thereby, a true expression of what one feels about life in its entirety.'

ANSEL ADAMS

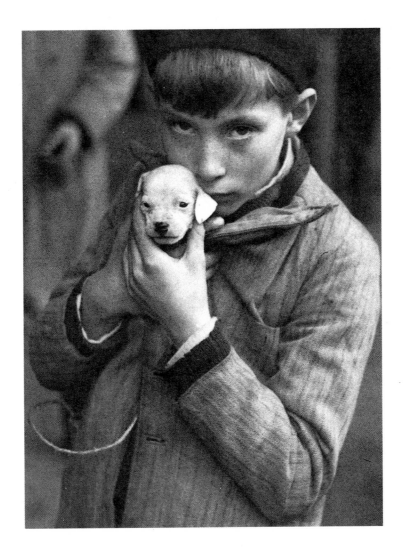

ANDRÉ KERTÉSZ
LE MARCHÉ AUX ANIMAUX, SAINT-MICHEL, PARIS
1927

PLUS ÇA CHANGE

In compiling a collection of photographs such as this there are immediate and obvious decisions to make – who, for example, is worthy of inclusion and whom should be excluded? Rather than base the selection on arbitrary notions of superiority, this compilation has been made much more along lines of visual comparability. The priority in this part of the book, therefore, is not so much to explain the history of photography as borne out by a selection of practitioners, but to examine matters of style, individual projects and pursuits that have shaped the progress of the medium. Other criteria are also considered, of course – especially the different techniques used and the properties of the materials involved. All these factors have influenced the choice of photographers represented in this section.

Most summaries of the history of photography are based upon the notion that one school of thought naturally flows into another, and that this thesis is best illustrated by presenting the images in a chronological sequence. But a wholly different approach may be used if we take the view that many of the attributes of photography are, in fact, timeless and that in many ways the medium has not changed greatly since its inception. Much of what fascinated Julia Margaret Cameron, or P.H. Emerson, or Edward Steichen, is equally fascinating to photographers today and it would be foolish to view the early development of the medium as irrelevant and outdated.

Accordingly, this selection of images does not rigidly follow the time-honoured chronological method and involves instead a comparative evaluation of visual styles across the years. In this way, certain undeniable truths emerge and, equally, other myths are rapidly dispelled. The idea that present-day photographic practice can only exist by virtue of the latest technology is surely open to question and is almost certainly flawed. The real joy of the process remains in the acts of seeing, of looking, and of becoming more aware of the medium's unique contribution to visual language.

What is so surprising about the early formulation of photographic systems and processes is that so many of them were jostling for a solution to similar problems within a few years of one another. The important advance, however, came with the introduction of the negative, for this meant that the original images could be produced in further editions and not restricted to a single copy as with the original French process. The negative may have lacked the latter's intrinsic iconography and beauty, but from that moment onwards the basis of the photographic process was forever changed. It is a principle that remains to this day.

There are many parallels between the achievements of the early pioneers with their cumbersome cameras and their modern-day equivalents. The intrinsic feeling of wonder that must have occurred to Daguerre on setting up his particular view of a Parisian boulevard in 1838–9 is surely mirrored by the extraordinary image made some 140 years later by Joel Sternfield in his photograph, taken on a large field camera, of a pumpkin stall in Virginia. The materials may well be new, for Sternfield is using modern colour negative material and meticulously printing to his own requirements, yet there are distinct similarities between the two images. In

Louis-Jacques Daguerre 'Parisian Boulevard' (1838-9)
This image of a suburb of Paris remains one of the most haunting in the history of the medium. It retains for us today Daguerre's wonder at what he saw before him. 'I have seized the light, I have arrested its flight.' Certainly, it is the first photograph of a human being for there, in the shadowy street, stands a man having his boots blacked. The image has been enlarged beyond the scale of the original deliberately so that it may be directly compared to the ensuing image (overleaf) taken some 140 years later.

one, a patient gentleman waits while his boots are blacked and, in so doing, becomes the first person to be represented in an urban landscape; in the other, a house burns under the gaze of the visiting fire brigade, while one of the crew sorts through the pumpkins of a nearby market stall. There is a timelessness that unites the two photographs.

The period that divides these two images is a source of perennial fascination. Photography is, after all, an extremely young medium and yet its contribution to twentieth-century art has been significant. At the outset, there was an undeniable tendency for the photograph merely to mimic the visual style of painting but this was probably as much to do with the limitations of the process as its potential. Early photographic systems were laboriously slow and so the element of time was an instrumental factor in the formulation of early still lifes and landscapes. The casual, almost snapshot, approach to picture-making did not really arrive much before the latter half of the nineteenth century, and yet it was this imagery, rather than the earlier and more pretentious photographs, that so fired the imaginations of Degas, Monet and Vuillard by its pictorial structure and language. This fascination for the photographic image held subsequent and equal sway with the Futurists, Dadaists and Surrealists, and even now, the imagery of a photographer like Eadweard Muybridge, working in 1895, may well surface in the works of contemporary painters. Francis Bacon, for example, has used the early exploration of movement in Muybridge's 'Wrestlers' as the basis for one of his paintings.

Nevertheless, the early pioneers of the medium, however well intentioned, were essentially gifted dilettanti seeking to emulate earlier concepts of painterly vision. Although photographers like Oscar Rejlander and Henry Peach Robinson were certainly breaking new ground with their use of multiple negative and assemblage techniques, their work still echoed the allegorical narratives of Victorian religious morality and the myths of ancient England,

the concept of the 'morality play' or the 'picture which told a story'. However, whereas this was often the basis for representing Romanticism through legend and fable, it also mirrored social attitudes of the time to life and death.

Robinson, without doubt a gifted artist in his own right, made meticulous studies in pencil and watercolour in advance, and his assemblages were carefully contrived. In his 'Fading Away' (1858) the figure of the dying girl was in fact exhibited separately in its own right at an earlier date, but the pose was originally set against a black background to facilitate combination printing. The assembled nature of Robinson's imagery affords us an enduring image of loss, mortality and the passing of time remembered.

This type of narrative storytelling is, in fact, still relevant today in the output of some modern workers, for it is the role of the photograph often to disturb and evoke memories of things past. It is interesting to compare Robinson's work to that of a contemporary photographer like Rosamond Wolff Purcell (1942–) who, through the process of assemblage, photomontage and semi-solarization, investigates the potential of the photograph to revisit past events. Working with the instant colour process, Rosamond Purcell creates an entirely different series of values in her work, being much more concerned with psychology, perception and mysticism. She employs various techniques in adjusting the image

Joel Sternfield 'McLean, Virginia' (1978)
There is a current movement in contemporary American photography away from small-format cameras and back to the basic concept of the field camera which had been so influential in the early years of the medium. However, this concept is being revisited through the modern colour negative film, measuring 10 × 8 in, and the contact print and through the work of photographers such as Joel Sternfield. His work often has within it an element of irony and no more so than in this view of a blazing house in Virginia, fronted by a small fruit stall from which a member of the firecrew selects a pumpkin. The large negative means that although such work is governed by the tripod, it is equally afforded unrivalled image quality. The negative allows for hand adjustment of the final print and the contact printing retains the supreme resolution of the original.

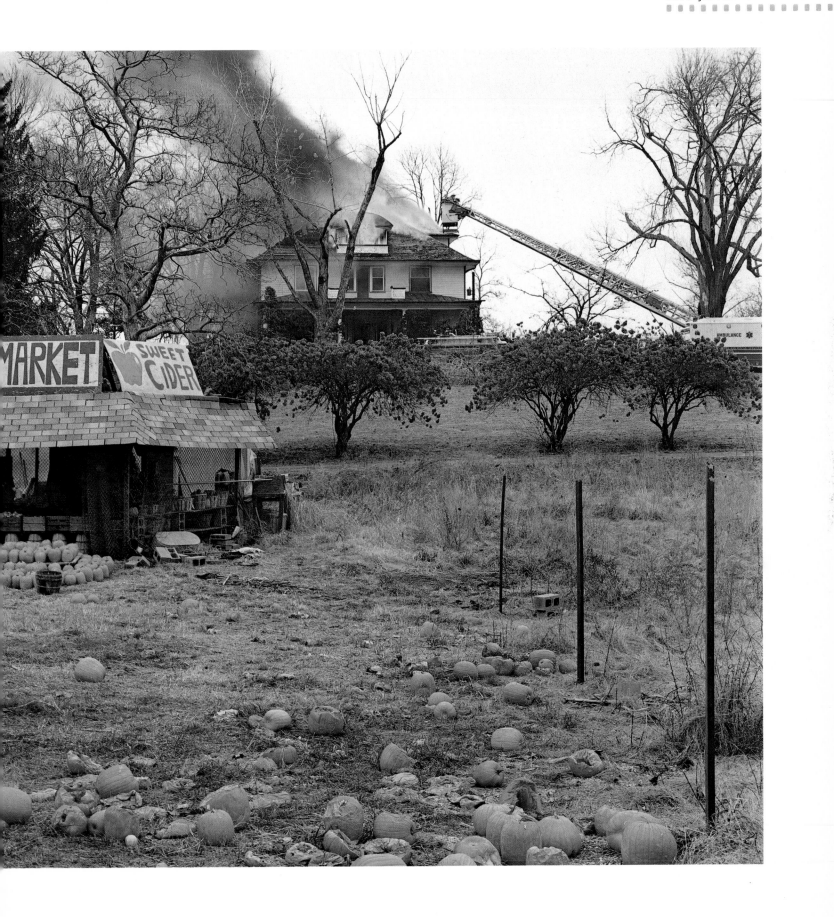

to suit her ends, and many of her images rely on a process of collage and recopying for the final statement. Their unsettling appearance echoes some of the earlier fascination of the Victorians for the potential of photographic ghost images and their obsessive ideas of virtue and the afterlife. This question of subjectivity and what the photograph appears to offer is at the heart of much contemporary work in colour. The Polaroid process with its particular colour rendering is the perfect medium for Rosamond Purcell's work. Its mellow quality is not unlike that of the earlier colour processes which so intrigued the Lumière brothers.

Above left: Henry Peach Robinson 'Fading Away' (1858)
Robinson sought to emulate aspects of classical composition by means of the photographic process. His pictures were often meticulously planned and executed using a series of specially posed models against a black background. These were then pieced together individually so that the assembled parts made up the whole narrative that he sought to express. In this image, five separate negatives were used.

Above: Rosamond Wolff Purcell 'The Other Woman' (1980)
Rosamond Wolff Purcell's haunting multiple imagery leaves a great deal for the imagination to ponder. She evokes this response by a variety of methods, of double exposure and subsequent recopying on Polaroid sheet film. Aspects of solarization are also employed. The direct access colour film has a particular characteristic that suggests the element of ongoing time.

VISIONARIES

It is the ability of the photograph, above all, to rise above the mere imitation of the aesthetic guidelines of the Renaissance and to provide a unique vision of the world that is its greatest contribution to the visual arts. In real terms, photography has not changed greatly over the years and, as we have seen, the earliest images still hold a striking similarity to some of the most recent ones. Those of Richard Avedon in his essay *The American West* (see p. 235) or Joel Meyerowitz, in *Cape Light* (see p. 241) contain many elements that directly echo the earlier days of the medium. In fact, it is often interesting to make a direct comparison across the years. If you compare the output of a photographer like the Englishman Frederick Evans (1853–1943) with his American namesake Walker Evans (1903–75) it is easy to see the remarkable similarity, with their use of the large monochrome image provided by the field camera. Frederick Evans made great strides in architectural work, and this is typified by his representation of Wells Cathedral and 'The Sea of Steps' (see pp. 119 and 120); Walker Evans produced memorable images of the interiors of poor sharecropper dwellings and vernacular buildings in the Deep South in the 1930s (see p. 229).

In the formative days of the history of photography in the nineteenth century there emerged certain individuals who were driven by the conviction that the new young medium would offer new insights to representation that were far more important than the slavish copying of classical techniques from Renaissance art. Two such individuals were Julia Margaret Cameron (1815–79) and P.H. Emerson (1856–1936). Julia Margaret Cameron is the perfect example of vision overriding technique, for it can be argued that her soft, somewhat fuzzy imagery was the result of limited technical ability. Yet her insight and her remarkable approach to portraiture allow her to rise above such criticism and remain one of its greatest

exponents. Indeed, she used a camera for only a relatively short period in her life, as a result of a gift of the instrument from her daughters – yet she avidly pursued its potential during her brief twelve-year involvement with photography. Her critics considered her work 'amateurish' in the extreme and reviled the manner in which she paid little heed to the aesthetic taste of her age. Instead, she doggedly worked at the all-obsessive medium and almost took pleasure in the limitations of its process. Her exposures, by angled window light, were sometimes as long as twenty minutes, and called for a sympathetic response from her subjects. Yet they mirrored an intense psychological portrait of the sitter, extremely powerful and naturalistic, to an extent that was to rivet the attention, long after her death, of Alfred Stieglitz. It was Stieglitz who championed her cause through the medium of his journal *Camera Work*, and he is largely responsible for the elevated position that she currently holds.

Looking at Julia Margaret Cameron's work now, it is almost perverse to compare it to the portraits of Richard Avedon or Irving Penn, and yet there are distinct similarities. The limitations of Avedon's large 10 × 8 in negative necessitate a long exposure, and the size of his camera means that the sitter is wholly conscious of the process of making the portrait. This can also be said for Irving Penn's series of portraits in his portable studio tent, with which he chose to document people from far and remote areas of the world using the simple expedients of a standard lens, a tripod and ambient northern daylight.

Peter Henry Emerson had quite definite opinions of the potential of the photographic medium in its own right and went to considerable ends in public lectures to denigrate the Pictorialist movement. His great contribution, apart from the quality of his photographic imagery, was his conviction that the photographer should avoid slavishly trying to emulate painting and, instead, should concentrate on discovering the camera's own disciplines and potential. He hated 'high-art' pretensions in photography and sought a new realism.

Above: Peter Henry Emerson 'Gathering Waterlilies' (1886) For P. H. Emerson, the concept of Victorian picture making, posed models and stilted narrative assemblages was anathema and he long championed the cause of the Naturalist aesthetic. For this he abandoned the idea of artifice and sought to show the 'real' things of life, without trickery and based on a notion of optical vision (sharp focus around the central image and the edges somewhat softer). This image, so remarkably like an Impressionist painting of the same era, was one of a whole series taken by Emerson on the Norfolk Broads in pursuit of his ideals. In many ways, Emerson's approach to the 'purity' of the image was to predestine the work of other great figures like Walker Evans.

Right: Julia Margaret Cameron 'Alice Liddell as Pomona' (1872)
It is remarkable to think that Julia Cameron did not take up the camera until she was 48 for her portraits remain some of the finest images in the history of photography. For many, the softness of focus and subject shake during the long exposures relegated her output to that of a talented amateur, and it was left to Stieglitz, after her death, to champion her work. Her great contribution was her willingness to create differing types of pictures, to allow softness of edge and form, and to experiment with different forms of lighting to create a feeling of character in her sitters.

MOVEMENTS IN TIME

For many, photography came to represent the New Vision of the Age, and for the next fifty years held a strong fascination for and influence on successive schools of painting and even sculpture. It is interesting, however, that some of the great practitioners were not artists at all, but physiologists, and in many ways this only emphasized the importance of the photographic image to creative thought in the early half of this century. There was a strong conviction that the marriage of science and art was an appropriate base for the new machine age and this was evidenced not only in fine art, with the Futurists, Dadaists and Surrealists, but also in the cinema.

Just such a pioneer was Etienne Jules Marey, who had met Muybridge in Paris in 1881, and whose fascination for the recording of time sequences and locomotion was to spawn not only a notable series of photographic sequences but also some remarkable camera systems. He perfected his own form of 'rifle-camera', with a revolving magazine of photographic plates, for the recording of birds in flight, and his later version of a camera, with its moving film transport for the even faster breakdown of action, was in effect the forerunner of the modern cinematographic camera.

In addition to the unique images of movement that the camera was to offer, it also fired the imagination of Degas and the Post Impressionists by its incidental and novel compositional devices. With the introduction of the first Kodak Brownie in 1888, photography left the confines of the studio and the scientific laboratory and made immediate inroads into the recording of everyday life, particularly the hustle and bustle of town life and its attendant street scenes. The camera's portability meant that it could be pointed down into the street and, in the process of the exposure itself, it could provide an image

in which the figures walked out of frame, sometimes in silhouette, or could be cut off by the frame itself. It could record parts of an action or sequence, and could invert the previously held rules of classical composition. The Renaissance had offered nothing to match this.

Such unique imagery within a new and expressive form of picture-making would require, ultimately, its own champion, someone who would suffer no prejudice against the new medium and passionately advocate its acceptance as a legitimate art form of the highest order. Just such a champion was Alfred Stieglitz (1864–1946). Stieglitz carved a unique niche for photography by proselytizing its cause to the new young avantgarde of European Art and, in the process, set up the dialogue between the traditions of European art and the new art of the Americas. He married Georgia O'Keeffe, an American painter of considerable stature, and was a formidable photographer in his own right. His natural longevity meant that his influence was to span both centuries at a particularly formative time and he, above all, was responsible for the posthumous interest in the work of Julia Margaret Cameron on the one hand and the introduction of the work of Edward Steichen on the other.

The influence of Stieglitz stemmed not only from what he did, but from the way in which he did it. The instrument through which he publicly advocated the importance of photography was the quarterly journal *Camera Work*, which he began to publish from his New York base in 1902, the same year in which he formed the Photo-Secession Group. His declared aim was to present, side by side, the best of photographic imagery, immaculately produced on the finest art paper, alongside the works of such luminaries as Picasso and Braque. In 1922 he wrote, 'My aim is increasingly to make my photographs look so much like photographs (rather than paintings etchings etc) that unless one has *eyes* and *sees* they won't be seen – and still everyone will never forget having once looked at them.' He personally supervised everything, from the selection of the paper

Edward Steichen 'Wind Fire, Thérèse Duncan on the Acropolis' (1921) Like many pioneering photographers, Steichen was fascinated by the particular qualities of the photograph that made it so different to the painted image; concepts of focus, light, exposure and movement were all equally absorbing to him. It was a fascination that was to last throughout Steichen's long and productive life. In this image the unique quality stems from the movement within a long exposure, allowing the moving tunic to delineate the form on one side of the figure and soften it on the other. The flowing material becomes a metaphor for flames.

to the overseeing of the printing process. It is interesting to note that while his first prize in photography had been awarded by no less a figure than P.H. Emerson, in 1888, the last two editions of his journal, in 1917, featured the work of Paul Strand. He coined the term 'Equivalents' when making his series of exposures of clouds in the 1920s and this was later to become part of the formative language of the Californian Group f64.

It can be argued that Stieglitz carried the baton for photography throughout his life, bolstered by the stimulus that a close association with painting in the early twentieth century, with its arguments, contradictions and triumphs, would bring. It is fitting that his disciples, Steichen, Strand and Weston, continued to carry that baton well into the second half of the twentieth century.

Edward Steichen (1879–1973) pursued a remarkably productive career through many facets of the photographic medium, encompassing aesthetic, commercial and wartime documentary work in the process. He developed an early affinity with painting, but it was the double edition of *Camera Work* in 1913 that saw his first rise to prominence as a photographer. From the outset, he was fascinated by all aspects of photographic vision, particularly with time, to record both movement and light over long exposures, and colour, by means of the newly marketed Autochrome process. In the 1920s he produced both original and highly successful fashion and portrait photographs and during World War Two he was director in charge of Combat Photography in the Pacific. From this base he directed two large photographic exhibitions at the Museum of Modern Art and was later to return for the production of his huge assemblage of world-wide photographs in *The Family of Man* in 1955.

Paul Strand (1890–1976) was to become one of the major figures of American photography. The paths through which his influence took shape are particularly interesting. Strand not only gained greatly from his liaison with Stieglitz but

Paul Strand 'T'ir A'Mhurain , South Uist, Hebrides' (1954) This exquisite landscape of the Western Isles of Scotland comes from one of the many essays that Strand made during his travels throughout the world. (T'ir A'Mhurain means 'the land of the bent grass'.) Strand always employed the direct confrontational approach in his portraits and the landscapes are reflective of the communities that he so admired and often sought to record. He was happiest when recording the small details of everyday life within rural communities, details that reflected a genuine honesty of purpose. Strand successfully published books on Egypt, New England, Ghana and the Hebrides.

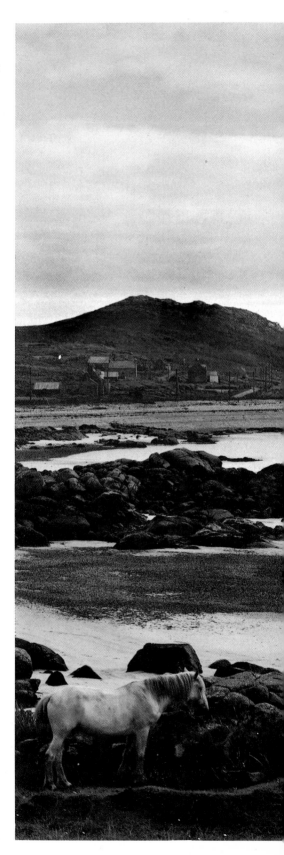

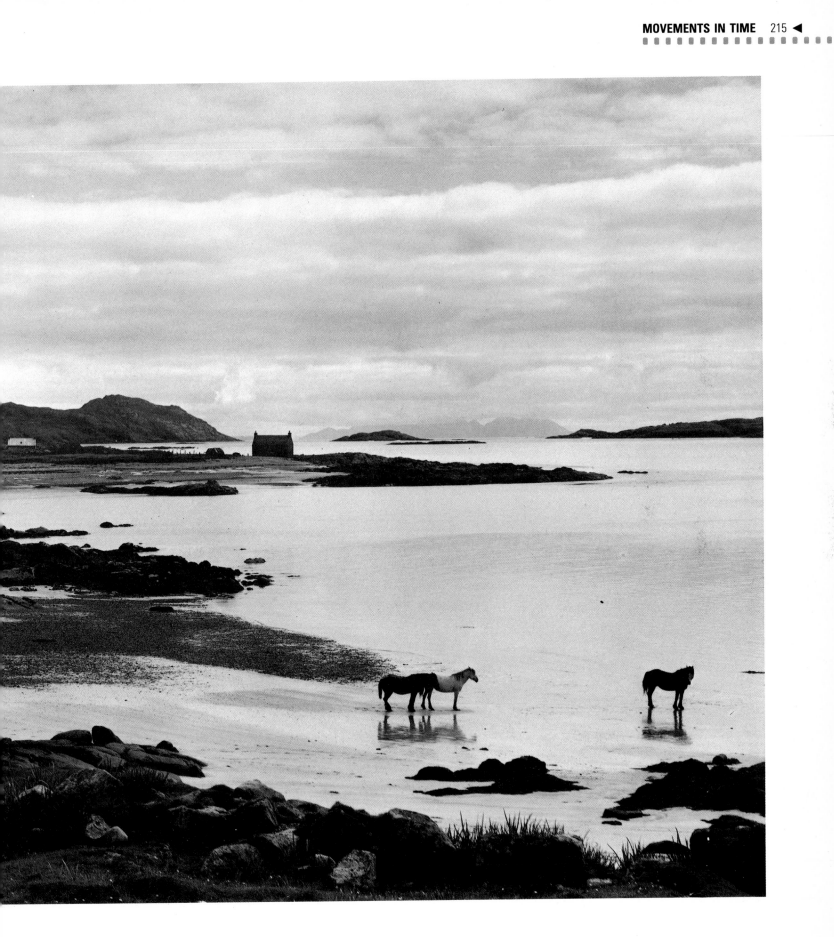

also travelled to the Soviet Union, where he met the film director Eisenstein; he also worked on the film *The Plough That Broke the Plains* in the 1930s. He not only took in influences from both painting and the cinema, but also from a musical association with both Virgil Thompson and Prokofiev (both of whom had written for films). Within this climate, photography was seen as a natural part of the expressive arts. A masterful printer, devoted to the purity of the photographic image with its richness of tonality and detail, Strand worked on several major documentations of various parts of the world, in Italy, Ghana, Egypt and the Outer Hebridean Islands of Scotland.

While Steichen and Strand had both been represented in *Camera Work*, it was not until 1922 that the young Edward Weston (1886–1958) first met Stieglitz – a meeting that was to change Weston's creative life. Stieglitz had always sought to establish an aesthetic that would put photography on a par with the other visual arts, and Weston held such comparable convictions. For Weston, as for P.H. Emerson, photography was best served when it was afforded its own singular vision and uniqueness, without tricks or manipulations, with a purity of vision and intent and with total attention to the mechanical means to achieve this end. The negative was not to be tampered with during the printing, and the lens was to be set at its finest point of focus, with its aperture at its smallest opening and the composition precisely ordered and arranged – nothing would be left to chance. It was this approach which was to give root to the term previsualization – which was to form such an important principle for the photographers of Group f64.

The title f64 sprang naturally from the smallest aperture of the lens, which afforded the greatest depth and overall definition within the photograph. To use this aperture meant a slow shutter speed and a tripod-based camera. With the large size of the negative, this in turn meant that the careful ordering of the pictorial contents in advance was crucial. This method

was the antithesis of the later way of working with the small format that was to become known as the principle of The Decisive Moment. This principle was expounded by the French photographer Henri Cartier-Bresson, with his unobtrusive use of the hand-held Leica from the 1930s onwards. He felt that by careful observation and patience there was a precise moment when the elements within the frame would come together in an expressive wholeness – not too early, not too late, but at *precisely* the right moment.

With Weston and his disciples, the objective was a new form of photographic purism that meant that the subject matter would be imbued with a unique vision of reality, be it a nude, a cabbage, a shell or a pepper. This obsession with the areas of value within the frame became the basis for what is now called the Zone System approach to the photograph, in which the range of tones is measured, exposed for and then developed, in such a way as to produce the most perfect negative possible.

This concern for the proliferation of a new kind of photographic purism is wholly admirable in many ways but fatally flawed in others, for a fundamental lesson was yet to be learned – in photography, as in painting, there is no one right way to produce a picture. To suggest that the f64 approach was the only approach was a heresy that would be put aside within the following decade by the advent of the hand-held miniature camera and the concept of the decisive moment. Nevertheless, the purist approach to the still life and landscape photograph remains a vital ingredient of one of the major schools of photographic thought and today there are definite signs of a revival in the use of the large-format camera. For this reason it is not incongruous to directly compare early examples of large-format photographs with their modern-day equivalents. The use of new and more sophisticated materials does not mean that the influence is lost. This has always been true for painters and is no less so for photographers – particularly those who are working within the realms of topographical landscape.

Edward Weston 'Cabbage Leaf' (1931)
A great deal of Edward Weston's output was directed towards the purity of photographic vision, of control and of ordering things technically so that the medium was totally at the direction of the artist. To this end he made exquisitely seen forms from natural objects and sought to emphasize their naturalism by the use of the camera's 'heightened sense of reality'. He endowed the most mundane subject matter – a shell, a pepper, a cabbage – with extraordinary beauty. He extended this concept also to his studies of the human form (see p. 143) and landscape.

EVOCATION WITHIN THE IMAGE

There is no doubt that the work of Weston and his followers continues to have a lasting influence. Indeed some of Weston's photographs bear a marked similarity to those of the reclusive and enigmatic French photographer, so beloved of the Surrealists, Eugène Atget (1857–1927). Atget was, without doubt, one of the most significant photographers of this century and yet he lived a life of penury and seclusion. He did not take up the camera until the age of forty, having failed both as a repertory actor and as a painter, and yet he amassed a body of work of the rapidly disappearing street architecture of Paris and the rural countryside of France, its parks and its gardens, that has more than stood the test of time. Indeed, he imbued his work with a quality of stillness and simplicity that at first sight may seem almost naïve and primitive and which nevertheless creates a haunting evocation of its period. It is an evocation that is at the heart of great photography – of time and experience, of an indefinable quality that simply cannot be expressed in words. It is not like painting in any way – it is unique, and affords the viewer a fascinating insight into an everyday situation. The tailor's dummies in the windows, the quiet cul-de-sacs of the great city, the deserted streets and boulevards of Paris, the ghost-like gardens of Versailles – each image has this same ethereal quality that is so difficult to define.

This type of fascination for the evocation within an image is a continuing theme in photography and is perfectly expressed in the work of E.H. Bellocq. Bellocq was such a reclusive figure that not much is known about his working life, save for the fact that it probably began around 1895 and lasted for the next three or four decades. A sad figure of local life, much as

Toulouse-Lautrec had been in Montmartre some two decades earlier, he worked in New Orleans and probably died around 1940. His output is best remembered as a series of portraits that he took of prostitutes in the Storyville district of New Orleans and which came to light in the drawer of a desk long after his death. What comes through in these photographs is a unique document of personal affection that raises them above the commonplace and mundane. The sitters are curiously receptive to the process of Bellocq's camera and it can only be surmised that this stems from a mutual respect that he shared with them. This feeling of haunting evocation is one that will appear again and again in various guises throughout the history of the photographic process.

It appears once more in the work of another photographer from New Orelans, whose parallel interest was poetry and the mysteries of the Old South, Clarence John Laughlin (1905–86). Laughlin made no apologies for the ambiguity in his work and for the fact that his original intent was to be a writer and he placed great importance on the influences he gained from Stieglitz, Strand, Weston, Man Ray and Atget. Laughlin wrote 'I did not start out as a photographer but, instead, as a writer. Whether for good or ill, this fact has inspired and coloured many of my concepts … through photography I have also tried to tie together and further my interests in painting, poetry, psychology and architecture. Whatever value my photography has it is ONLY because of these other interests.' This kind of almost spiritual approach to photography was also at the heart of the work of Minor White (1908–76), for whom the concept of meaning, metaphor and language was central to his creative output.

Laughlin's attachment to his native New Orleans, its people, its traditions and its history was in many ways similar to the love that Brassaï (Gyula Halász, 1899–) was to have for Paris. Brassaï devoted a great deal of his working output to the portrayal of the city and its people. He gained greatly from his early association

Eugène Atget 'Saint-Cloud'
(1915-19)
Atget was one of the great
figures of twentieth
century photography, yet
his work and output was
hardly recognized during
his lifetime and it was left
to two American
photographers to save his
glass plates from
destruction after his death.
Coming to photography
relatively late in life, he
remained reclusive and not
a great deal is known
about him. He decided
nevertheless to make an
enormous document of the
parks and gardens of
France, the streets of Paris
and the windows over-
looking the boulevards.
The results of his labour
are visual poems of
perennial beauty.

with another Hungarian ex-patriate, André Kertész. He recorded at length the low-life of the city after dark in a manner that, like Bellocq, had echoes of the painter Toulouse-Lautrec. Another photographer based in the French capital and for whom it was a major source of inspiration was Robert Doisneau (1912–), whose work was often reflective of the humorous and affectionate side of the human condition.

The ability to 'read' the image again and again in hindsight is essentially at the heart of the photographic process. Long after the death of W. Eugene Smith, it is still possible to look at his individual essays on matters of social concern, of the country doctor and Maude Callan the black midwife in the Deep South, or the dying child lovingly bathed in his Minamata series 12, and appreciate what he was trying to achieve. The concern for ecological preservation was heightened by the efforts of the likes of Smith (particularly through his documentation of mercury poisoning in the Japanese fishing community of Minamata), and we continue to be in his debt. Such concern was at the heart of the work of Roman Vishniac (1897–), but for quite different reasons. Vishniac, of Russian Jewish parentage, saw all too clearly in the early 1930s the storm clouds of oppression that were gathering in Europe. He was compelled to leave a legacy of the truth of what had happened, should he not survive. By careful use of a Leica hidden within his overcoat, he systematically documented the ghettos of Poland, Hungary and Czechoslovakia in the years leading up to 1939. Both Vishniac and his photographs survived, but not the subjects themselves, most of whom were to die within the next decade. Yet the unique quality of the photographs continues to inform and advise, and we are all the richer for that.

Another such talent was David Seymour (1911–56), whose career in many ways paralleled that of Eugene Smith. His work first came to prominence in the recording of the Spanish Civil War in 1936, and he was to produce major essays throughout World War Two. He formed, with Car-

tier-Bresson, the famous photojournalists' agency Magnum and, on the death of Robert Capa (1913–54) in Indochina, became its President. Sadly, he died in 1956 while covering the Suez Crisis in Egypt. The continuing tradition of concerned Central European photographers within the mainstream of photojournalism is further exemplified by the work of Josef Koudelka (1938–). Koudelka has devoted a major part of his output to the documentation of gypsy life throughout Europe, but has also recorded the Russian invasion of his native Czechoslovakia (see p. 163).

In addition to the output of Magnum after World War Two, there was a major source of British photojournalistic work to be seen in magazines such as *Picture Post* and *Illustrated*, both of which had been founded just before the outbreak of hostilities. These were to have a significant impact on the greater use of photoessays within popular journalism and, in addition to featuring Cartier-Bresson, Bill Brandt, Kurt Hutton and George Rodger, were largely responsible for the major output of Felix H. Mann and Bert Hardy.

Not all such documentation is so profoundly moving, however, and can in fact stem from the joy of life itself. Jacques-Henri Lartigue (1894–1986) devoted his life to the recording of just such happy days and has left as a legacy a diary of the entire progress of the twentieth century up until the time of his death (see p. 221). His critics complain that he was never really concerned with the serious side of life, preferring to ignore it for the pleasures of the breakfast table, the lawn and the countryside. Well-to-do, he was fascinated from an early age by both the fashions of the women who promenaded in the Bois de Boulogne and also the obsessive interest in the earlier part of the century for flying machines and automobiles. He also experimented for a time with the newly patented Lumière Autochrome colour process. His critics do him a grave injustice, for he had an unerring eye for the unique moment and interesting composition, and his work forms an outstanding document of its time.

Above left: E. H. Bellocq 'Plate 18 of Storyville Portraits' (1911)
There is a unique quality to the Storyville portraits of E. H. Bellocq. Found in a drawer after his death, the images reveal a touching series of portraits of people for whom the photographer obviously had high affection and regard. The sitters remain curiously compliant with his camera, and seem to acknowledge that his interest went far deeper than mere voyeurism. They are posed in their everyday rooms. Some of them are shy, some diffident but nonetheless willing to be represented within the group of women themselves.

Above: Jacques-Henri Lartigue 'Zissou in his Tyre-Boat' (1911)
Essentially a gifted amateur from a well-to-do French family, Lartigue spent his entire life documenting domestic pleasures throughout the century. From an early age he pursued his enthusiasm for all things mechanical and all things photographic – the early flying machines, the Le Mans rallies, the racing cars and the café society. Yet his naïve simplicity is deceptive – his photographs are vital documents of the progress of the twentieth century and continue to enthral to this day.

SURREALISM AND ITS INFLUENCES

There is often a distinct lineage of schools of thought across the photographic process. For example, major figures like Stieglitz were able to set in motion a whole series of interrelated figures in the development of photography that were to have a kind of knock-on effect from one generation to another. He illustrated *Camera Work* with the photographs of Julia Margaret Cameron, Strand and Steichen, who in turn knew Weston, whose imagery had many similarities to that of Atget, who knew Berenice Abbott and Man Ray, who worked with Moholy-Nagy and Bill Brandt, and so on. Photographers, like painters, are subject to mutual influence and respect, and it is essential to appreciate this when considering their respective outputs. Laughlin combined these elements of influence to evoke personal imagery of the Deep South, of mysterious figures within ruins, enigmas, unresolved and foreboding, visual essays of an era that has passed by, in a manner that was to influence later photographers, such as Jerry Uelsmann.

The question of influence, not only between photographers but also between photography and painting, is a two-way interaction. When photography was invented there had always been a tendency towards a self-conscious pursuit of painterly ideals – a kind of longing for intellectual respectability within the new young medium. By the early part of the twentieth century, the flow of influence was to reverse. The Surrealists had not been slow to realize the potential of Atget's imagery, nor the quality of Marey's motion analysis, and it is fascinating to compare Muybridge's moving figures with Duchamp's 'Nude Descending a Staircase', or Severini's 'Dancer at the Bal Tabarin'. Further, the influence was to cross back into photography when Gjon Mili produced his own

'Nude Descending a Staircase' by multiple flash in 1942.

The Surrealists were stripping bare the earlier concepts of 'Art' and for them the idea of a mechanical contrivance of the Machine Age was a perfect instrument to this end. Thus they enthusiastically explored the potential of photography as something that was entirely different from the pigment and palette of Classicism. They used collage, solarization, assemblage and negative values as a natural adjunct to their art. They had been sickened by war and the way in which they felt the world had been structured and sought to establish a new reality. Thus it was that artists had been made to move away from the classical concepts of easel painting, towards a new language of image making, preparing the stage for the advent of a new kind of truth – a desire to represent the world as it is. To this end, they would need new tools for the job.

The legacy of Surrealism is active today and there are photographers who have built upon the lessons first provided by its example and have sought to impart to the photographic process its own form of singular vision. In the work of Jerry Uelsmann (1934–), the basic physical properties of the photographic process and the interchange between positive and negative values on the surface of the printing paper lead him to improvise his final imagery solely through afterwork in the darkroom. Solarization, contact reversal, paper negatives, mirror imagery, slip register and 'bas-relief' techniques are all part of his expressive use of photographic language. Ralph Eugene Meatyard (1925–72) is a photographic Surrealist who employs more direct techniques within the framework of his locations, using disturbing elements within his subject matter as enigmatic pointers to their meaning.

There is growing interest among photographers in the potential of the arranged photograph in colour, but with a Surrealist influence. Many of these photographers work across the boundary between photography and art, such as Lukas Samaras and Sandy Skogland.

Left: Man Ray 'Solarized Portrait' (1931)
Man Ray was fascinated by the photographic medium's unique properties and he was constantly experimenting with aspects of collage, photogram and adjusted imagery. He did a great deal of work in the field of solarization, a technique wherein the image is half developed and then re-exposed and redeveloped again. He was committed to the idea of constantly challenging the accepted standards of what defined 'Art' and saw photography as a vital tool in this process.

Above: Jerry Uelsmann 'Ritual Ground' (1964)
The work of Jerry Uelsmann depends exclusively on the unique properties of the photographic process and the darkening of silver compounds by light. Therefore, it is wholly appropriate that he should use all forms of imagery to this end, double printing, paper negatives, sand-wiched negatives, double exposures in the printing frame and multiple printing. He is an alchemist of the darkroom, fashioning remarkable imagery from apparently simple originals.

DIFFERENT FORMATS: THE CHANGING EYE

Most of the photographers who have been considered and referred to so far in this section have had two things in common – they all worked in black and white for the major output of their work, and the bulk of their negatives were produced by the large-format camera. The resulting images afford a different kind of reality to those that have accrued in recent years from the dual influence of miniaturization in camera format and the proliferation of colour materials. That this should be so is obvious from the physical limitations and potentials of the differing camera systems. The large format is slow, laborious and obtrusive, and hardly the tool for impromptu picture-making; its greatest attribute is the image quality obtainable from the large negative. On the other hand, the availability of ever-smaller cameras that stemmed from the introduction of the Leica, has afforded a different kind of picture. A negative, no larger than an inch in height, may well suffer by comparison with the definition of its sheet-film counterpart, but the camera that produced it allowed a freedom of use that led to a new approach that has had a lasting and undeniable influence. No longer was the tripod essential, nor auxiliary lighting or extended exposure times – a new kind of freedom was at hand.

Although the story of the invention of the miniature camera goes back as far as the first Leica prototype, introduced in 1913 and marketed in 1924, the real watershed of small-format potential was to be gained from the use by Eric Salomon of the Ermanox camera. In fact, Fox Talbot had originally thought of the idea of producing cameras small enough to fit into the palm of one hand (and to which his wife had referred as his 'mousetraps') for his problem had been a need to concen-

Henri Cartier-Bresson
'Simione la Rotonde'
(1969)
Cartier-Bresson has
retained an unswerving
association with one form
of photographic approach
as the product of one form
of camera – The Decisive
Moment as portrayed by
the rangefinder Leica. It is
a relatively simple
philosophy based on the
conviction that, in any
given situation, there is
always one moment,
above all others, when the
elements of the design in
the viewfinder come to a
state of harmony and
refinement. This moment
can be neither hurried nor
delayed – it has to be
anticipated, seen, and then
precisely recorded, not too
early, not too late, but
precisely right. This has
been the basis for Cartier-
Bresson's output over the
years and extends also to
matters of the landscape
and the portrait. The
Decisive Moment is
heavily reliant on the quiet
shutter and the
unannounced presence of
the photographer – the
anonymous poacher of the
observed reality. This
deceptively simple, yet
beautifully seen, moment
in time readily expresses
Cartier-Bresson's delicate
sensitivity to his
organizational skills.

trate more light transmission by means of a shorter focal length. The Ermanox was really an extension of this concept, and gained greatly from the use of the first really serious 'fast' lens – an f2 coupled to a small body, in which diminutive glass plates were exposed. Although Salomon is always credited with pioneering the use of the Ermanox, Alfred Eisenstaedt recalls the time when he also used the camera and its small glass plates: 'I used to wear a waistcoat with my evening dress and so was able to have my unexposed plates in the left-hand pocket and my exposed plates in the right, and so never forgot which was which.' Whereas the first Box Brownie had been marketed with the slogan, 'You press the button – we do the rest', the descriptive text for the new little camera and its remarkable lens was 'What you see, you can photograph'. Salomon was to haunt the corridors of the League of Nations with his little candid camera, affording an insight beyond the pomp and circumstance of the formal openings and ceremonies – an array of anxious faces and earnest conversation as diplomats huddled over the coffee table to discuss the impending dangers for Europe in the 1930s.

But the real foundation of the miniature system was provided by the Leica which, with its addition of an integral long-base rangefinder system, had an immediate impact that has scarcely diminished to this day. Certainly, it has undergone many refinements, but in concept it remains the same – a small, quiet, hand-held camera of impeccable mechanical precision and durability that affords its user a particular kind of effortless recording of significant moments. The introduction of the classic Leica rangefinder in the mid-1930s spawned not only a new batch of photographers but, it can be argued, a whole new way of seeing. It was the f64 principle set on its head, with its lightness, small dimensions, first-class optics and its remarkably quiet shutter.

There were several contributory factors which led to the devoted following of the Leica, but probably the two most significant aspects were its simple optical view-finder system that supported its range-finder focusing and its lens, with a focal length that gave an angle of view roughly equivalent to that of the human eye. To appreciate fully the contribution of the Leica, one has only to look at the output of its users – Henri Cartier-Bresson, André Kertész, Alfred Eisenstaedt, Ben Shahn and many more in the era of photojournalism that was to lead up to World War Two and beyond. Henri Cartier-Bresson has spent all of his working photographic life with the Leica, producing the definitive body of work that fully displays the designing potential of the optical viewfinder. For Cartier-Bresson there was simply no other route to this particular way of working. For him the aim was to wait, and to remain still, observant and unnoticed until the precise moment presented itself. These visionary moments applied not only to picture essays but equally to portraits and landscapes. The purity of vision stemmed, no doubt, from his basic training as a painter and was crystallized through the viewing system of the Leica.

Of course, it is perfectly valid to argue that the type of camera is incidental and that, in any case, we cannot know whether Cartier-Bresson would have taken markedly different pictures had he used a roll-film camera or a technical one instead. Obsessional ideas about 'the perfect camera' are largely bogus and irrelevant, but it is certainly true that differing camera systems afford differing renditions of reality. To examine and justify this proposition fully it is necessary to look at the output of photographers who have worked across the divide of large- and small-format systems and consider whether the resulting work is appreciably different. The photographers who most readily lend themselves to such a comparison are Walker Evans (1903–75) and Bruce Davidson (1933–). Joel Meyerowitz (1938–) has also worked in both formats, but his output involves colour and is best discussed later in that context.

Walker Evans was a colossus of photography of the twentieth century. His prolific output has left a lasting impression on the power of the photograph to inform,

Alfred Eisenstaedt 'Skating Waiter at the Strand Hotel, St. Moritz' (c. 1930) Another great exponent of the Leica was Alfred Eisenstaedt, a major figure in photojournalism since the mid 1920s. However, his approach was not the same as Cartier-Bresson's, and Eisenstaedt preferred instead to shoot much more on the basis of pure instinct and professional expertise. Above all, through a long and distinguished career, Eisenstaedt perfected the role of the itinerant reporter, attending some of the great historical events and photographing their personalities throughout this troubled century, with subjects ranging from Goebbels and Mussolini to Marilyn Monroe. He has made more *Life* magazine covers than any other photographer, but readily admits that those early days are no longer with us. In this respect, his photograph of the 'Skating Waiter' is a metaphor for an age that is no more, an age of elegance, and of style – the likes of which will not be seen again.

instruct, advise and enlighten successive witnesses to his work. In many ways, his attitude to his work was not entirely different to that of P.H. Emerson for, like him, Evans was obsessed with a particular quality that is uniquely photographic. His credo was put thus: 'The real thing that I am talking about has purity and a certain severity, rigour, or simplicity, directness, clarity, and it is without artistic pretension in a self-conscious sense of the word.' Throughout a long and active photographic life, Evans never lost either this directness of vision or the ability to continually challenge the process at more than one level. Although he is largely thought of as a concerned documenter of the human condition, it would be a gross injustice to look on his work only in this way. He was not a 'portraitist' as such, although he made many memorable portraits, nor was he a 'photojournalist' in the true sense of the word, although he was passionately committed to the concept of telling a particular story in a particular way, nor was he a 'landscape photographer', although many of his pictures could be described as landscapes. He was able to move in and out of any of these demarcations with seemingly effortless ease. Yet he never lost his sense of purpose or vision, without recourse to false ideas about 'Art' and declared 'Good photography is unpretentious. One just does it.'

Without doubt, however, the major body of work for which he will always be remembered was that which was undertaken during his period with the Farm Security Administration Program of the Roosevelt period in the 1930s. At that time there was a massive area of deprivation and poverty in the Deep South that was desparately in need of help and financial assistance. The function of the FSA group of photographers (which included such luminaries as Ben Shahn, Dorothea Lange, Arthur Rothstein, Russell Lee, Carl Mydans and Evans himself, under the direction of Roy Stryker) was to document the hopes and aspirations, not to say the plight, of the people in the southern dustbowl. Evans responded mag-

nificently to the task, and brought new power to the ability of the photograph to communicate. He did this not necessarily by shouting at the audience but by providing a subtle, sensitive series of photographs with a directness of vision that was compelling: portraits, details of walls, of bedrooms, of shacks and shanty towns, of churches, sideboards, washbasins and tablecloths. It was photodocumentation par excellence.

In pursuing his ideals, Walker Evans had chosen to work with the writer James Agee, and they shared the life of the sharecroppers at a very basic and intimate level. Now, some fifty years on, it is still a source of fascination to see the way in which Evans worked, employing a 10×8 in sheet-film camera system or alternatively the newly introduced and fascinating Leica. With the sheet-film camera, Evans worked slowly and painstakingly, with Agee referring in his notes to 'the hooded figure grappling with his apparatus' and the family 'lined up as if in a firing squad'. With the Leica, he adopted a quite different approach, using the right-angle finder in the town square or after church to record the more casual and intimate asides in the flow of life. He had previously worked with the Leica in New York, but had long since desired to impose a greater meaning on his work and thus

Walker Evans 'Tuscaloosa' (1936)
One of the great socially concerned photographers of this century, Walker Evans is best known for his remarkable work in the Deep South during the 1930s. Most of this work was done on the large 10×8 in field camera. However, this was not the only way in which Evans worked, for he also used the Leica during his long and prolific working life. Without doubt his large format and largely unaltered imagery is among his most memorable, particularly the recording of vernacular architecture. Evans did not wish his work to be misunderstood and often complained 'You can call it what you want but for God's sake don't call it Art!' The team of photographers working under the leadership of Roy Stryker had been given a working brief from the Roosevelt Administration to record the daily life of sharecroppers in the South so that the industrialized North would have some form of knowledge of the problems and difficulties that abounded in the South at the time. Evans was one of the great figures to respond to this idealistic challenge.

headed South. The resultant photographs are not better with the Leica than with the sheet-film camera – they are simply different. For those aspiring photographers wishing to undertake long-term photographic documentation, whether using small or large format, there is no finer place to start than with the works of Walker Evans.

The second photographer to consider in the use of both formats within the same kind of output is Bruce Davidson. There is a common thread throughout Davidson's work that makes it particularly suitable for this type of comparison, for he has always been committed to the notion of social documentation in his work. Sometimes it appears in the form of people less fortunate than himself, (the circus dwarf, or the civil-rights protesters) or those who reject society (the Brooklyn gang or the subway muggers) but always there is a desire to communicate to others something about which he feels strongly. One of his first essays, *The Brooklyn Gang* (1959), dealt graphically with the problem of teenage gangs in New York and was undertaken on a small hand-held miniature camera; a decade later, he returned to the question of urban deprivation with a powerful photo-essay on ghetto life in the Spanish Harlem area of the city. In the second essay, however, he took a deliberate decision to change formats, and abandoned the anonymous and secretive character of the miniature for a large and cumbersome sheet-film camera. Not only was it a question of style that made him change, but also one of approach. He reasoned that if he was to gain the confidence and trust of the chosen subjects then he would have to be essentially honest about what he was doing – 'I just wanted to be part of the block, like the guy who cleans the windows, or fixes the plumbing, or the TV repair man, so that when they saw my large camera they would say, "Oh there he is again – how are you doin'?".' The result was that people addressed the camera in a different way; they had an appointment or an assignation, however informal and they knew that they were being photographed.

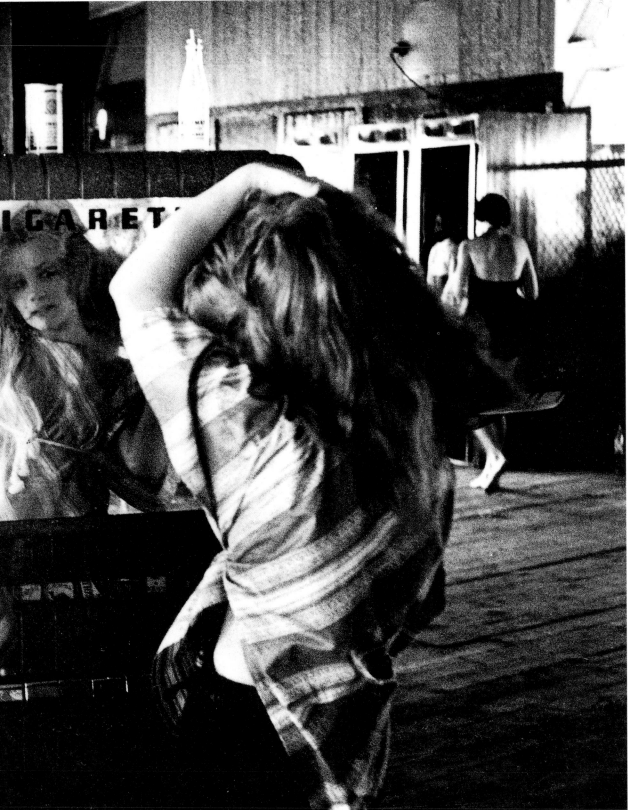

Bruce Davidson 'Teenage Gang, Coney Island' (1959) Like Walker Evans, Bruce Davidson was able to move freely between small format and large format cameras with apparent ease. His early essays were with the Leica and are typified by his work in the late 1950s with *The Brooklyn Gang*. The essay was made at the time when youth culture, teenage disenchantment, rock 'n' roll and urban gangs were making their mark. The small camera was a vital ingredient of Davidson's work, and afforded him unique opportunities as he gradually gained the confidence of the gang members. He was later to abandon the small format for a similar document in Harlem, where he felt that the size of a field camera would help him greatly to confront his subjects in a more honest and obvious way, and to this extent his convictions were justified.

FREE STYLES

As this examination of style and influence shows, in photography, as in any creative activity, there are no hard and fast rules. Any notion of what constitutes a 'typical' portrait or landscape photograph is in fact usually the basis for banality. Contrary to the convictions of many, the 'decisive moment' principle is not the sole way in which the miniature camera should be used and if further proof of this were needed, one would need to look no further than the work of Robert Frank (1924–). His most memorable and lasting document was created in the years 1955–6 when he journeyed across the American landscape in an old Volkswagen car, absorbing the ambience of a country in transition and assembling his project *The Americans*. Born in Switzerland, Frank looked at the American landscape with a kind of visionary perception that was to change not only the way in which American society would see itself, but also the manner in which the documentary photograph would be seen. Avoiding the pitfalls of merely imitating Cartier-Bresson's mastery of the organized and beautifully seen decisive moment, Frank chose instead to shoot in a random, almost haphazard manner, seemingly oblivious of any notion of beauty, poetry or lyricism. Yet the photographs when viewed as an assemblage of experience, one set against the other, without comment or explanation, often grainy, unsharp and seemingly careless in technique, afford a view of America that many social historians believe foretold the problems to come – the assassinations, the intrigues, the civil rights marches, the inequalities and contradictions that abounded in the social infrastructure. As the years pass, these photographs seem somehow to get better, yet, of course, they are exactly the same now as they were then. Instead, it is the viewer's perception that is getting better and that, after all, is what great photography is all about. Having first seen some of the Frank photographs, one looks at the world in a different way. And this is an undeniable effect of all that is great in the visual arts.

With this in mind, it is possible to give further thought to what a photograph tells us when we look at it. After all, a photograph is not a reality but an illusion – it is nothing more than the result of silver halides being darkened proportionately by the action of light. Yet we bring to our perception of a photograph quite particular responses, and those responses can simultaneously educate and inform us on the one hand or confound and mystify us on the other. The photograph, like any other form of visual language, has the ability to disconcert, to worry and to bemuse and with this in mind many photographers have directed their cameras at subject matter that might not otherwise have been seen as a particularly rich source of pictorialism in life or nature. One such photographer was Diane Arbus (1923–71). Her subjects were often those people in life who have not fitted in with the mainstream of existence, for one reason or another, either because their physical attributes are extraordinary, or because their lifestyle or sexual proclivities have banished them to the sidelines of life. To record transvestites, nudists, dwarfs, freaks, mentally disturbed individuals, enraged children, sobbing women, or vain charlatans she adopted an almost vicious confrontational style of portraiture. A standard lens, often coupled to a direct flash – with no scruples at all about 'artistry' – was the mainstay of her technique and yet her subjects, angst or not, seem to be almost willing her to take the photograph. Despite her unique talents, remarkable imagery and early self-inflicted death, there are still those who decry her work as exploitative and mean in concept, without regard for anyone other than herself. This is surely not so. Her work is so consistently honest in what it does that it is difficult to see it in any other light than that of compassion. She remains one of the most influential photographers of her time.

The question of employing a technique totally at odds with the Cartier-Bresson approach is something that many photo-

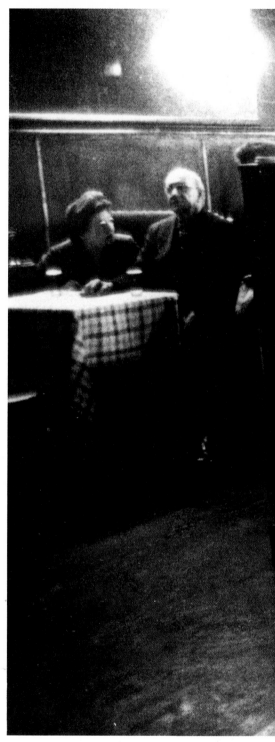

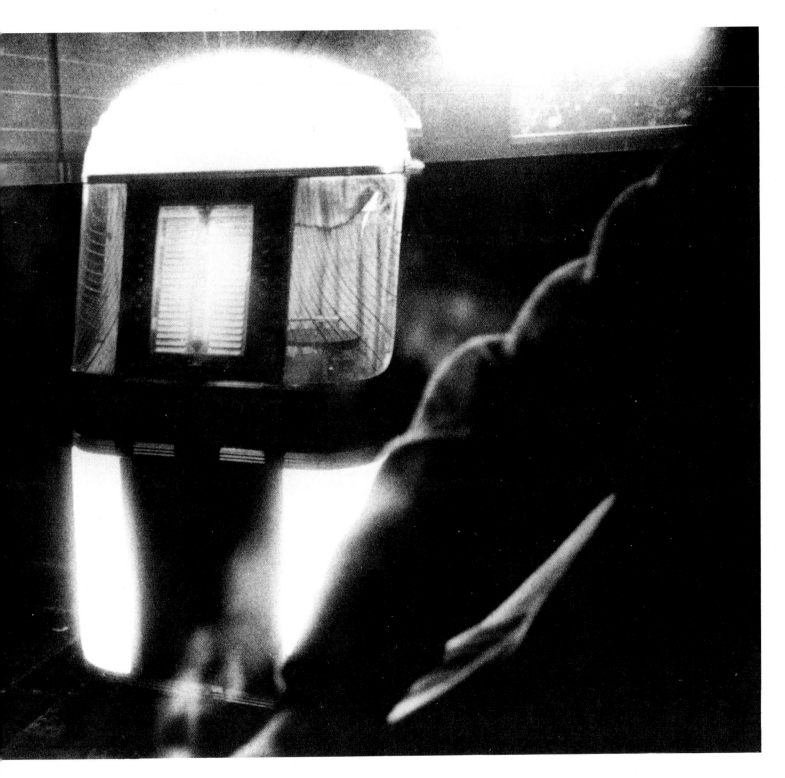

Robert Frank 'Bar, New York City' (1955–6) Frank's remarkable essay *The Americans* is perfectly represented here. In the gloom is a luminous jukebox, almost an alien presence, an automaton that rules all before it; in the shadows, two figures sit at a table, while a third brushes past the camera – menace pervades the scene. The image is not memorable in its technique, yet it is unforgettable. Having seen it once, we never look at a jukebox in quite the same way again.

graphers value and it is perfectly illustrated within the work of both Irving Penn (1917–) and Richard Avedon. Penn has invariably worked within quite particular limits, being one of the leading editorial photographers in the world. Nevertheless, he has always endeavoured to impart to his work more than mere commercial considerations and has striven for a kind of classical purity to his forms that is above 'tricks' and fanciful techniques. To this end he uses, as often as he can, natural daylight from a North window (so beloved of the painters of Naturalism), a tripod and a standard lens – no more, no less. His still-life photographs in colour display an extraordinary attention to the design elements and details within the picture.

In Richard Avedon's case, the same kind of almost ritualistic approach was adopted in his essay *In the American West*, shot entirely on a large 10 × 8 in field camera in black and white. In this series of photographs, he chose specifically to isolate each of the sitters in his project on the sundry characters who live in the American Mid West by photographing them against a simple white sheet placed against a backdrop, and illuminating them solely by daylight.

This rather austere mode of interpretation is not new, but it does point up the difference that approach, method, format and style can bring. In fact, August Sander (1876–1964) had used a very similar approach in his major documentation of the German people and the various social classes in the 1920s and 1930s. Yet still further differences in style can be seen when contrasting the work of both Penn and Avedon to that of Cindy Sherman. Although she is just as careful about content and detail, her work is wholly different. Instead, her attention is directed toward the control of elements within the picture so that they offer the viewer a form of challenge, or puzzle or visual pun. Most of her work is currently in colour but this has not always been so, depending on the feeling she is trying to evoke. She invariably uses herself as the model for her subject matter, but her pictures are as

much about the viewer as about herself.

In Sander's work the question of environment was often an important adjunct – but for very different reasons. It is in viewing these photographs from a period that included, at its beginning, the end of the Kaiser Wilhelm era and, at the end, the rise of the Nazi Stormtroopers of the Third Reich, that it is possible to see the changing face of German society. Indeed, the Nazis loathed Sander's work and banned it when they were struggling for

Richard Avedon, 'Portrait of Petra Alvarado, factory worker, El Paso, Texas, on her birthday' (1982) Without doubt one of the most influential figures in fashion photography, Avedon has lately been extending his output to the area of documentary through his incisive and particular style of portraiture. His most recent work in this regard has been to record the people of the American West. To this end he uses a large field camera, the 10 × 8 in Deardoff, to gain that absolute clarity of vision so essential to these later works. Having focused the large camera, he stands to its side, never taking his eyes from the subject until he is satisfied that the elements he seeks are in place. Yet it is not the mode of the quiet observer – it is the ritual of the large staring eye and the simple backcloth.

Cindy Sherman
'Unidentified Sitter' (1981)
The basis for Cindy Sherman's work is, quite literally, herself. She chooses to explore the concept of narrative by association within the images that she creates. Therefore, as the model is invariably herself, then it is within the eye of the beholder that the subject changes, or appears to change. In fact, the photographs are carefully constructed, even when apparently in the manner of snapshots. The question of monochrome or colour, the angle of lighting, the position of the figure in relationship to the viewpoint – all conspire to provide a mystery that the viewer feels compelled to solve, to locate, and to explain. The question of psychological association is also involved, the notion of colour affording a sense of menace, of fear, or lust or victimization. The photograph becomes the modern equivalent of the mask, offering many views of the wearer but never the self.

In this image, the implied message owes a great deal to the use of colour, and viewpoint. The figure appears to stare out of the frame to an unknown person – what is about to happen? Why is the figure perspiring? Is she in bed and who is the intruder? The peroxide blonde hair suggests an aspiring actress and has echoes of the death of Marilyn Monroe - or is this all in our own mind? There are no answers.

For Cindy Sherman, when editing out her pictures from a day's shooting, those that make her look like someone else are those that are for her the most successful. Like Cartier-Bresson, she values her anonymity, but for quite different reasons, and the search for her true identity is in fact a false search.

power in the early 1930s. What Sander's photographs did was to show the value of a long-term documentation of people, the shopkeepers, the clerks, the cooks, the soldiers of a particular era. His photographs were not merely portraits but a remarkable inventory of individual types within a particular period of history. Steichen had always valued the work of Sander, whose photographs were ultimately to have a lasting influence on Walker Evans, Diane Arbus and Robert Frank.

It is an interesting comparison to consider the output of a photographer like Sander with that of Yousuf Karsh (1908–). Although both are working within the same framework of operation, the formal portrait, there is in fact virtually no similarity in the resulting images. In the case of Karsh, there is no question of the impromptu behaviour of lesser mortals, for his output has been dictated to by the needs of the leaders of the twentieth century to have lasting images of themselves at the height of their power. The subjects are not paupers but princes, presidents and popes and to each is brought a sense of meticulous lighting and the grand theatrical gesture – but at no stage could their images ever be seen as anything in the way of a social document. They are more akin to the products of the court painters of the European royal families (see p. 128).

Nevertheless, other photographers chose to interpret the luminaries of our century in quite a different way. Like Karsh, Arnold Newman (1918–) has devoted a great deal of his life to the portrayal of famous people but, instead of the grand theatrical gesture, prefers to work much more subjectively. Often the design of the framework of the photograph, its layout and its viewpoint, are direct visual clues as to the personality of the sitter. His portrait of Stravinsky (see p. 126) sees the maestro framed beneath the raised lid of his piano, while his portrait of Piet Mondrian is formally arranged to echo the design elements of the painter's abstract work. On a different plane altogether, Cartier-Bresson works at precisely the opposite extreme to either Karsh or Newman, preferring in-

Left: August Sander 'SS Hauptsturmführer' (1937) Again, the portrait with the social context, for this is one of the portraits that Sander took in his major survey of the German people. A Nazi officer, shortly before the outbreak of World War Two, proudly displays himself to the gaze of Sander, confident of the victories to come. The contemplative gaze under the grinning skull of the SS helmet badge displays an unshakeable faith in the Third Reich but, seen now some 50 years later, foretell of the temporal nature of such convictions.

stead to wait, watch and 'poach' with the miniature camera without interference to the subject. Cartier-Bresson has also photographed the great artists and leaders of this century, but in a much more human way. When photographing the sculptor Giacometti – much of whose output was concerned with walking figures – Cartier-Bresson reflected this aspect of the artist's work. In the one instance, Giacometti is pictured preparing an exhibition, nervously adjusting the works and moving through the exposure as he carries a piece of sculpture; in the other, he is seen crossing a road in a Paris suburb, raincoat over head, as the rain patters around his feet. Even great men, it seems, can get their feet wet.

Left: Arnold Newman 'Alfried Krupp' (1963) The question of subjectivity is never far away in the work of great portraitists and the added dimension of colour extends this principle yet further. Not only can the expressive portrait rest on the face, but also on the surroundings. In this instance, Newman has used several devices for the portrayal of menace within his portrait of the German industrialist Krupp, whose name is forever linked to his involvement during World War Two in the proliferation of armaments through his massive steel plants. The lighting is low and angled to suggest the aura of evil genius; the stare, full frontal and uncompromising affords a genuine feeling of menace. The feeling of menace is further enhanced by the characteristic response of the colour film. Its variation to lights of differing colour temperature allows the rear part of the photograph to be recorded in a sinister greenish cast – quite typical of the rendering of colour by many industrial light sources – and this bathes the scene further in an unsympathetic glow. Thus it is that the masterful combination of several elements come together to make a formidable portrait.

THE MEDIUM OF COLOUR

In many ways, it seems remarkable that, in a review of twentieth century photography ranging from Niépce to Diane Arbus, there has so far been little mention of colour. How can this be so when so much of the imagery that we see today is in the media of colour photography, colour films, colour video and colour television – after all, do we not see in colour? And did photography not become universally popular at the very time when the Impressionists were obsessed by colour? Why, if this is so, has it taken so long for a meaningful aesthetic in colour photography to evolve?

To be sure, there has never been a shortage of interest in colour photography. The Lumière brothers, in addition to their pioneering work in the evolution of cinematography, had patented an additive colour process plate as early as 1904. This was marketed three years later as the Autochrome process. Indeed, the integration of colour theory into a form of photographic apparatus goes back even further to the split-beam camera of Du Hauron in 1862. His 'View of Angoulême' in France was actually made in 1877 – only five years after Monet had painted 'Sunrise, an impression', the title that was to give the Impressionist movement its name. And prior to this, many of the beautiful little Daguerreotypes of the day had been manipulated by hand-colouring.

With the marketing of the Autochrome process, Stieglitz lost no time in exploring the potential of this new medium in *Camera Work*, and the Steichen portraits of George Bernard Shaw and Lady Ian Hamilton, taken in 1907, were among the first, in the following year, to be published anywhere. The process continued to enthral photographers for the first quarter of the century, but its overriding limitation remained: its screen was coarse and somewhat unsatisfactory. It was not until 1935 that two scientists working for Eastman Kodak produced the world's first success-ful subtractive colour reversal film – in fact the film was to be the prototype for Kodachrome and its modern equivalent exists as one of the finest systems of colour photography currently in use.

The most serious obstacle to the establishment of colour on anything like the level of seriousness that had attended the arrival of the black and white systems was the feeling that, above all, one had to 'put up with' the results that the systems provided. André Kertész, when asked why he had not responded to the challenge of colour, replied that he had 'always felt that the colour was not as he had seen it, but as some anonymous scientist had thought he had seen it'. Photographers like Paul Outerbridge (1896–1958), however, remained fascinated by the potential of the medium, particularly when used as a print process. To this end he used an early system of carbro colour printing for his meticulous imagery. Outerbridge was extremely interested in the psychological quality of the photographic image, its metaphor and its meaning, and thus was naturally attracted to the added potential of controlled colour in his work. It is also interesting that Outerbridge had not only met Stieglitz and Steichen in his formative years and discussed the use of colour as a print medium, but had also travelled to Paris and met Man Ray. Again, influence and cross-influence were the inspiration of many of the important users of the medium in its seminal days.

The argument against the proliferation of colour, with its inherent limitations, could be illustrated perfectly by the comparative work carried out in the 1930s by the Farm Security Administration Program. Russell Lee, together with other members of the team, did take quite a great deal of colour material concurrently with black and white (and it should be pointed out that both Walker Evans and Edward Weston worked in colour in later life for both commercial and aesthetic reasons); but this work suffers badly in comparison to FSA photographers' monochrome output and this is almost certainly due to two fundamental reasons. Firstly,

Paul Outerbridge jnr 'Nude with Mask and Hat' (c. 1936)
Although greatly influenced by the modernist movements in fine art, and painting a great deal himself, Outerbridge nevertheless made significant contributions to the art of photography. A sophisticated and intuitive designer, with great reserves of skill and determination, he was also very interested in the psychology of the photographic image. It was wholly appropriate that he should extend this interest into the dual areas of colour and sexuality. To be sure, he incurred much displeasure from some people who mistrusted his motives, but this judgement was unjust. His work was never crude and his early use of colour quite remarkable. The images often had undertones of Freudian psychology within their subject matter, together with aspects of tactile contrasts and fear. He remains a unique figure and has greatly influenced many contemporary workers in matters of photographic language.

colour does not necessarily add to a picture if it can operate equally well, if not better, in black and white; and secondly, expressive photography gains greatly from the controlling hand of an enlightened printer, whereas in colour reversal this vital constituant is missing.

To support and justify this viewpoint, it is appropriate to examine some major figures of contemporary photography whose output is wholly reliant on colour. Joel Meyerowitz is particularly interesting because he has worked not only in 35 mm reversal, using a Leica loaded with Kodachrome, but also on a cumbersome 10 × 8 in view camera loaded with sheet colour negative material. With the same photographer working on two entirely differing systems, therefore, one can gain greatly from a closer look at the images that each system has produced. With the Leica, Meyerowitz came heavily under the spell of Henri Cartier-Bresson, his idol and mentor, and in his prefaces he writes lyrically of the days when they ambled the streets of New York together, wrapped in the fascination of observing and recording life 'on the move'. The images so gathered have a curious, almost wry juxtaposition of elements, with contradictions and enigmas within the rectangular frame. It is the philosophy of the decisive moment reworked within the framework of colour – a step that Cartier-Bresson never saw reason to take.

In 1976, however, Meyerowitz abandoned the use of the miniature camera for his colour essays in favour of a large, somewhat unwieldy, view camera that was designed to accommodate 10 × 8 in sheet film. This was to be a step so manifestly different to anything that he had done before that he had to rethink his whole working method. The lens required to subtend a standard on such a camera image is 360 mm in focal length; its aperture, when used by Meyerowitz, was stopped down beyond the limits of the f64 school to an effective setting of f96. This meant that Meyerowitz was essentially revisiting the picture-making potential of a century earlier, but through the colour

material of the twentieth century. In the process he wanted to examine the particular characteristics of colour materials when subjected to varying degrees of colour response and differing times of day. In fact, not only was he revisiting the principles of photography of the late nineteenth century but also, in his subject matter, re-examining those aspects of representation that had so fascinated Claude Monet.

Two other photographers working within the limitations that so attracted Meyerowitz are Joel Sternfield (1944–) and Stephen Shore (1947–), both of whom work with 10 × 8 in colour negative film. Both photographers have worked across the body of the American landscape to produce major documents of topographical scenes. It is almost ironic that Sternfield, in producing his eight-year-long project *American Prospects* should adopt the technique of the Volkswagen odyssey not unlike that employed by Robert Frank some thirty years earlier. Yet the work could not be more unlike Frank's. In place of the quixotic and random nature of Frank's imagery are the distilled visions of the American experience subtended through the large eye of the view camera. But there is more to Sternfield's work than merely relying on a large negative to instil quality into the physical imagery of the photograph. The pictures have within them a sense of purpose and place, often portraying moments of irony. A plumpish man watches the roll-out of the prototype space shuttle, an exhausted elephant lies in a road and is quenched by the hose of a fire tender. Such images have that bitter-sweet quality which so typifies Sternfield's singular vision (see p. 207).

This concept of irony often surfaces in the work of American topographical photographers and in the case of John Pfahl (1939–) the irony is part of the process by which he 'adjusts' his subject matter. Again, Pfahl uses the view camera and the colour negative, and in the process of his work seeks to subvert the expected, either in terms of inverse viewing and perspective, or by accentuating or altering formal links within the subject before him. Essen-

Joel Meyerowitz 'Porch, Provincetown' (1977) Meyerowitz is one of an increasing band of contemporary American workers who have gone back to the roots of the photographic medium by reverting to a large 10 × 8 in field camera for his current output. Like Avedon, he also uses the large wooden Deardoff and the bulky tripod, and makes no effort to work within the framework of The Decisive Moment. Indeed, the lens that Meyerowitz uses goes down even further than the classicism of the f64 school pioneers, for his working stop is f96. What this means is that his imagery is conditioned by very long time exposures which, in colour work, can have disconcerting side effects. However, to counter the problems of reciprocity in colour, he uses the ultimate control of the colour negative for his output, and one that is especially formulated for exposures beyond ten seconds. Any unwelcome shift can then be corrected in the printing. In conditions such as those that prevail in this picture, taken at dusk, this seemingly difficult way of working admirably displays its advantage for, as the exposure is building up within the camera, a bolt of lightning from a distant storm carves its trajectory onto the film. Normally a split-second decision, in this instance it is part of the way of working.

tially, this is the product of a fine art principle, with *trompe l'oeil* playing an essential part. As photography is always linked to an assumptive idea of 'truth' then it becomes an interesting challenge to alter this notion of truth by careful use of the viewing screen. The view camera offers a particular kind of potential for the designing photographer and for this reason alone it is the most often used camera for controlled studio still life work – or indeed for any subject for which it is vital that the viewing screen shows *exactly* what is being photographed. In the work of John Pfahl, the critical alignment of edge, line, pattern and perspective is essential for success and Pfahl uses instant Polaroid film to give a

final check on the picture design. Again, after exposure, critical control is employed for the final presentation of the conceptual image by skilful use of the colour darkroom for printing.

There is a recurring theme within the work of some workers in colour that has reference points in illusion, charade and theatricality on the one hand and definite links with major art movements – like the Surrealists – on the other. Influences stem too from the cinema and the history of photography. Many of these elements are found in the work of Bernard Faucon who, in his elaborate scenarios and fictional narratives, constructs a sort of dream world.

John Pfahl 'Triangle, Bermuda' (1975)
One of the great assets of the field camera is its ability to afford the photographer a large and very precise rendition of the final constituents of the photograph and it is for this reason that many workers in the studio refuse to abandon its cumbersome disadvantages. In a similar manner, Pfahl prefers the organizing ability of the camera for his exquisitely crafted *trompe l'oeil* imagery. Carefully selecting his viewpoint and matching elements of the composition with his own interference with the subject matter, he produces wry and imaginative visual paradoxes. Here the two lengths of rope appear to end at the rock, and form his own particular version of the Bermuda Triangle.

Bernard Faucon 'Carnaval' (1978)
The elaborate scenarios contained within Faucon's work are usually populated by his collection of mannequins, with the possible exception of one living person. Faucon then orchestrates these imaginary characters into imaginary scenes, dreamlike and surreal. He spends days working on the theme but, once the photograph has been taken, rapidly disassembles them again, leaving only the latent image on the film. Both Faucon and Paul Outerbridge employ an old method of colour printing known as the Fresson process, which was an early form of trichromatic carbro printing, and this gives a very particular quality to the colour reproduction and granularity.

The large-format colour negative is not the only route to serious colour photography. The colour negative is rarely employed in magazine work and then only if it is essential to control the final image. This is because reversal film is far better from the point of view of reproduction and if there is no need for manual adjustment of the image then it is pointless to use a system that is, by its nature, inferior. A war photographer like Larry Burrows (1926–71), for example, sought to bring back colour photographs that were essentially *real* and in no way 'artistic' or aesthetic in the accepted sense of the word. The Vietnam War, above all others, was ultimately ended by the uncompromising reality of the front-line combat photographers like Burrows and Tim Page (see p. 165). The colour added to the sense of outrage, for here, unlike a black and white image, blood was no longer to be confused with mud – it was red and horrific and all too true. Yet not all photographers of that particular era worked solely in colour. Don McCullin (1935–), whose searing essays in Biafra, Vietnam, the Lebanon and the drought-ravaged areas of the Equator did much to arouse public consciousness of these tragedies, almost exclusively preferred black and white. For such photographers, the choice remains: for the image that is not to be tampered with, the obvious film would be colour reversal, while if the photographer prefers control over the expressive tonality of the subject matter, the monochrome image prevails.

Increasingly, there is now a tendency with serious colour photographers to adopt a larger format – at least the medium roll-film format, but preferably that of the sheet-film view camera – coupled to negative film and hand-adjusted printing. This is because colour, for so long in the doldrums as far as 'serious' photography was concerned, is increasingly looked upon as a natural alternative to black and white. The almost tyrannical situation, wherein photographers in colour felt obliged to work in reversal material to suit the needs of the reproduction process, is now, happily, past. Such strictures have never been placed on black and white photographers, who have always valued the recourse to personal intervention at the printing stage. It is only appropriate that devotees of colour should now have similar benefits.

However, not all contemporary users of the colour process are reverting to an idea that colour, to serve its purpose fully, must either be wholly descriptive in the literal sense or else the basis for personal experimentation and adjustment. Some photographers, like Jan Staller (1952–), work in wholly non-manipulated colour but in the twilight zone when the daylight gives way to the night. Colour film responds quite differently to varying sources of light and colour emissions and, unlike the human eye, does not adjust its perception accordingly. In practical terms this means that, as each light source has its own characteristic colour and hue, the admixture of differing balances affords a singular beauty that is particular to colour photographic materials. If, additionally, the work is produced on colour negative materials then a second influence is brought to bear – the printing process itself. When colour printing, you cannot change one colour without affecting another. So, if the sodium street lamp bathes the road with a reddish-yellow tint you might try to minimize this by introducing its complementary (cyan) into the print. However, in so doing, the neutralizing of the reddish-yellow road may well mean that the sky goes blue, and so on. It is a very particular by-product of colour materials and is a fascinating basis for investigation, particularly if the added advantage of colour printing is also at hand. It is the basis for much of Meyerowitz's work and that of Arthur Ollman (1948–), and particularly of those photographers who are interested in the urban, as opposed to the rural, landscape.

Many contemporary photographers working with colour systems are particularly interested in the specific potential that colour allows over its monochrome counterpart. They are often motivated not only by the physical difference of the sensitivity of the material and its response

Jan Staller 'Curtains, New York City' (1982)
There is a considerable increase in the use of urban landscape in contemporary work. Jan Staller is particularly interested in that curious twilight world of the city, when the dying daylight gives way to the warmth and sometimes eccentric colour of the street lighting. Employing a medium-format camera with rollfilm colour negative, he allows the disparate nature of the differing light sources to afford him very particular responses on the subsequent colour print. Thus it is that ugly areas of concrete and asphalt take on a mysterious glow, almost like some aspect of a surreal theatrical underworld.

to available light, but also to the manner in which the viewer responds in turn to colour itself. The major advances in the Polaroid system mean that this material now provides a real basis for expressive use.

One photographer who works in Polaroid instant colour is Marie Cosindas (1925–). Like Rosamond Wolff Purcell (see p. 209) she uses its unique colour properties in her delicate and sensitive portraits. To this end, she has produced meticulously ordered 10 × 8 in still-life compositions, but it is particularly in the field of portraiture that she has reached a personal style. From her earliest days as a photographer she has consistently enquired into the particular nature of the Polaroid instant colour system and its ability to produce a very subtle tonal and chromatic range that is like no other. She has developed, over a long period of experimentation and usage, an instinctive knowledge of its potential and uses this greatly to her advantage. Her pictures assume an almost uncanny timelessness and have a quality that seems to persist from the earliest examples of hand-coloured Daguerreotypes.

The increased use of the considered and controlled image in colour has lead to a renaissance of the use of still life, and two particularly skilful exponents of this are Jan Groover (1943–) and Olivia Parker (1941–). Jan Groover, a graduate of fine art, has moved away from her earlier work with the small-format camera in favour of the 5 × 4 in view camera and colour negative materials. She works in a particularly intimate and personal way, arranging and adjusting the ephemera of the domestic scene (see p. 159). Jelly moulds, lemon squeezers and stainless steel bowls interact with the organic natural forms of mushrooms, peaches and pears. They are icons of personal experience, almost like visual poems of contemplation. At first sight, Olivia Parker works in a similar way, but in fact this is not so. Her subject matter may be similar, but her approach is to revert to the concept of previsualization that shaped the thoughts of Edward Weston a half century earlier. However, her previsualization extends to the method

and materials she has chosen, for, instead of working with either the reversal or negative systems of colour photography, she chooses to use Polaroid instant colour. This surprising choice means that all of her thinking and potential for alteration takes place in advance of the exposure, in the mind and through the camera's viewing system. Further, the nature of instant colour film means that she is unable to make additional prints. She usually works in limited editions of five or nine images, so that on completing her exposures and moving the position of the tripod, the images are rendered unique.

Creative use of colour has been at the centre of aesthetic considerations since the time of the Impressionists, and there is every sign that this will not abate. On one hand, the beautiful historical systems like the early Autochromes that so beguiled the Lumière brothers and Lartigue, instil an image with a sense of a particular time, in much the same way as the early orthochromatic films of the turn of the century did to the monochrome photograph. Currently, a new age is about to dawn – the age of electric colour, wherein the image will not be suspended in three separate layers of the visible spectrum on a film support, but will be encoded on to a small cassette resembling a miniature disk rather like those currently in use in computers. The major difference will be, though, that questions of subjective preference will be able to be dialled in on a Visual Display Unit (VDU) before committing it to paper. Colour photographs will no longer be as subject to material deficiency as previously and will be stored permanently for years to come. Similarly, what you can put into a storage system, you can equally take out, alter, adjust, modify and select from, and the immediacy of electric colour is a tantalizing prospect indeed. Time delay in processing is not involved and the image can be subject to continual viewing under modification. However, it will not dispense with the need for the photographic artist to have the final say about the precise nature of the image produced.

Olivia Parker 'Untitled'
(1979)
Olivia Parker
works with Polaroid colour,
although mainly in the
area of still life. Her
camera is the large
10 × 8 in studio model
with the ground glass
screen and her imagery
derives essentially from a
contemplative approach.
The elements within the
frame are often elements
of mystery, of death, of
time, of affection and of
mortality and she goes to
endless trouble to render
the image precisely to her
needs. She explores
photographic language and
the human psyche through
her work and combines
also literary associations
with some of the
iconography. The fact that
she works in instant colour
materials means that, once
the tripod is moved, the
picture is gone forever.

THE LASTING IMAGE

In any kind of overview and summary of various visual styles of photography there are inevitably major omissions and gaps and one has to accept the shortcomings of the relatively limited amount of space set aside for this. What is important to realize is that the medium of photography is open to an enormous range of visual working methods, and that these may stem from an equally wide range of causes – from matters of technical enquiry through to a concerned commitment to improving life on this planet.

In photography there are no absolutes or certainties, and it is always worth considering a different approach. Do not settle for the concept that there is only one way, and always be prepared to employ another solution if it is required.

There is a wonderful story about Ansel Adams (1902–84) and the taking of his landscape icon 'Moonrise Hernandez, New Mexico'. This one image has probably sold more copies than any other image in the history of the medium. A disciple of Edward Weston, Adams had spent his entire life working within the philosophy of the ordered image, of previsualization and total control. It is true, of course, that he used smaller cameras (even 35 mm from time to time), but essentially his output was geared to absolute order and control. In the case of the Hernandez moonrise, Adams came across the scene almost by chance in his car and realized at once that, although the situation was undeniably memorable, it was changing so fast in atmosphere, light and mood that there was simply no prospect of getting it on to film by his normal process of careful evaluation. In fact, if he was to use a tripod, there would not even be time to take an exposure reading. Fortunately, however, a lifetime of experience told Adams what the exposure would have to be if the details of the face of the full moon were to record on the film. Accordingly,

the image was shot entirely by hunch, on the spur of the moment; the instinctive reaction, supported by unerring experience, was the vital factor. The resulting image, devoid of the Zone System, was to become his most memorable.

There are two morals to this particular story: firstly, if all else fails, be prepared to take a chance and work by instinctive hunch; secondly, whenever possible support such a hunch with a lifetime's experience. Meet these two requirements and the picture is as likely to be memorable as not. As a photographer you are well on the way. Until that situation arrives, however, spend as much time as you can on supporting a meaningful working technique by educating your eyes to see. Add to this an acquaintance with the best of what has gone before and apply it to your own particular philosophy and circumstance. It takes time, but the experience is nothing if not worthwhile.

But, above all, it is critically important to realize that *you* are unique. Your experiences, your values, your aspirations are like no one else's and are individual to you. Build on this reality and make statements with the camera which reflect your vision of the world you see around you. Merely to imitate poor popularist work should be avoided at all costs, for that is not what photography is about. Photography offers a genuine means of self-expression, even for the relatively inexperienced photographer. The approach is all. So, value your individualism and distil it for others to share.

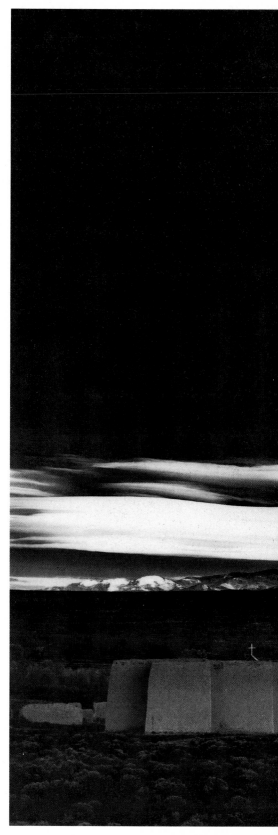

Ansel Adams 'Moonrise, Hernandez, New Mexico, 1941.'
This image is possibly the most well-known in the history of the medium, for it captures so many of the elements that have attracted photographers over the years: the infinite detail, the quality of light, the transcending of observed colour into monochrome abstract equivalents. Yet, for all that, it would be wrong merely to dismiss the major part of Adams' output as superficial and over-romantic. Adams was originally trained as a musician and often likened the photographic process to the notes on a musical score. His roots ran deep, back to the formative days of the Edward Weston purism. Popularity in photographic styles may wax and wane over the years, but almost certainly this image will remain one of the enduring icons of twentieth century photography.

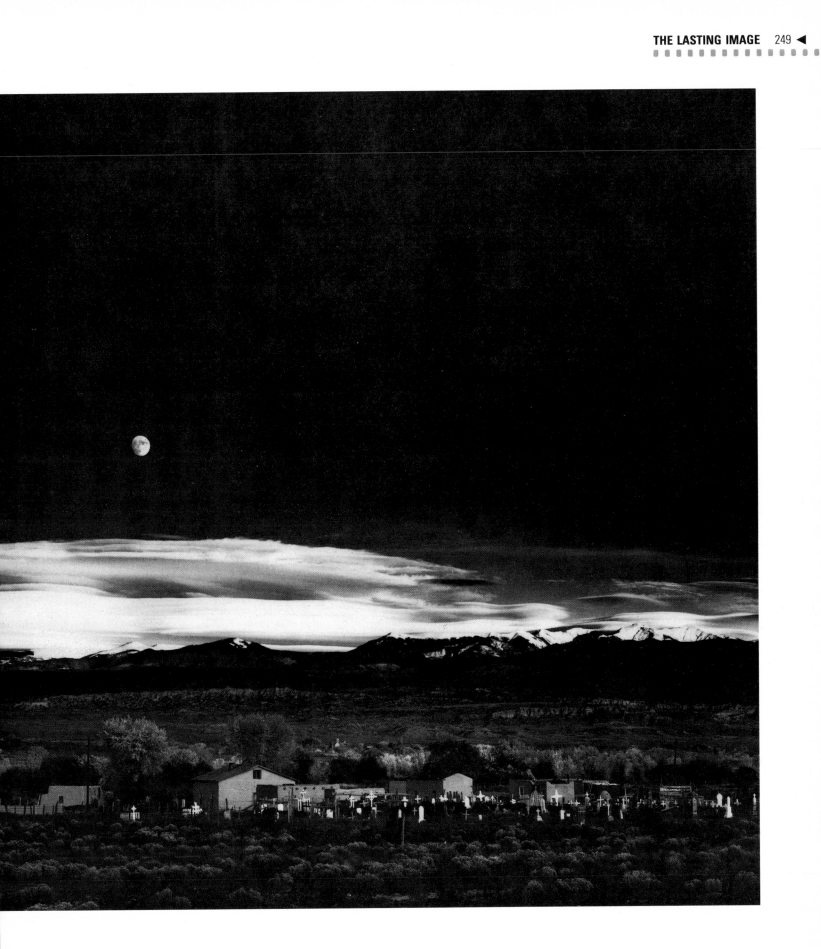

GLOSSARY

Aeriel perspective The illusion of distance and space by the action of haze, atmosphere, dust and UV light – as opposed to the rendering of depth by lines and vanishing points.

Anamorphic lens Lens with particular optical properties, which compresses a wide-angle field on to a standard image size by vertical distortion; the image is reconstituted on projection with a lens of similar properties into the original angle of view, from the same standard frame. Used particularly in cinematography.

Angle of view Angle of acceptance of a particular scene, when viewed through a particular lens. This varies with the focal length of the lens and its relationship to the format.

Aperture Variable opening that controls the amount of light that is able to pass through the lens. Almost universally of the diaphragm type today, it also affects the amount of depth of focus. It is calibrated in f numbers; the higher the number the smaller the opening.

Aperture priority Exposure control system in which the preferred lens stop is pre-selected manually and the shutter speeds are automatically adjusted and set by the camera's metering system, according to the intensity of the light.

ASA Arithmetically progressive system of speed ratings for films based on the American Standard (instead of the European DIN), now being replaced by the ISO system.

Aspect ratio Relationship, in either prints or negatives, of the two governing size factors in the rectangle, which determines the picture format. The higher the ratio the higher or wider the negative or print format.

Autofocus System of automatic electronic focus control within the camera body or the lens itself that obviates the need for visual focusing.

Autochrome Early system of commercial colour photography patented by the Lumière brothers in France in 1904. It was a random-dot screen that formed its colour by additive colour synthesis. It survived until the formulation of subtractive systems (Kodachrome) in the early 1930s.

Backlighting Illumination by a primary source of light which is at the rear of the predominant subject. This requires careful monitoring to establish correct exposure.

Barn doors Devices that are attached to the side of studio lamps to control the degree of light by variable angle – they swing into the light path rather like large doors and are useful for minimizing unwanted 'spill'.

Bellows Accordion-like device for allowing the front lens to be moved continuously for focusing and alignment.

Bracketing The practice of making additional exposures of a particular subject by means of increased or decreased values in relationship to the reading given by the meter – usually in half and one-stop increments up or down.

Camera obscura Early image-forming device used by artists to assist in pictorial organization. Originally a room, it was later confined to a box shape.

Catadioptric lens Lens configuration that allows an extremely long focal length to be compressed into a small lens size by the expedient of internal reflection and mirror surfaces. The design does not allow for a variable aperture. Also known as mirror lens.

Characteristic curve Graph produced by plotting the relationship of density to the increase of exposure. It is related to the properties of a specific developer, processing time and temperature. A low angle indicates less contrast whilst a steeper angle allows more – the tangent is expressed numerically as the Gamma.

Charge coupled device (CCD) Electronically sensitive surface that is used in automatic focusing (AF) systems for comparative evaluation of two differing areas of sharpness.

Chromatic aberration Lens fault, relating to inconsistent performance across all three primary colour values, red, green and blue. Produces colour fringing if uncorrected and thus a soft image.

Cibachrome Colour print system patented by Ciba-Geigy for the production of positive colour prints from colour transparencies without the need for a negative interstage.

Cold cathode light source Enlarger light source with low-temperature working characteristics for monochrome printing. It is softer in contrast than conventional sources and is unsuitable for colour applications due to its incorrect colour temperature.

Colour reversal film Colour system in which the values are reversed chemically to produce direct colour positives for projection without the need for a negative. Produces projection positives.

Colour negative film Colour system that is based upon the classic photographic principle that the greater the exposure the darker the negative – conforms to the same basic principles as those governing monochrome negative materials. Produces colour prints.

Colour temperature Classification of colour characteristics by degrees Kelvin and expressed as the temperature required to heat a black body to emit a particular hue. Daylight (and electronic flash) are expressed as 5,500k, tungsten as 3,200–3,400k.

Coupled rangefinder System of focusing in which a rangefinder is coupled to the focusing of the lens by a suitable cam, and when the images superimpose the lens is in focus.

Covering power Lenses form their image in a circle, which is greater than the image format. The covering power of a lens is the extent to which it offers a usable image. This may be critical if the rear film plane is to be moved – as in the technical camera. Failure of the lens to offer full coverage will result in fall-off, or vignetting.

Darkslide Standard method of holding sheet film for use in a field, or view camera, consisting of a double-sided sheath with a removable slide that allows the film to be exposed, once it has been inserted into the light path.

Deep-tank processing Processing method based on a large tank of chemicals in a darkened laboratory. The film is held in spools or a rack, and this method is particularly suitable for either sheet-film processing or bulk processing. The chemistry is monitored and replenished after use.

Density In the simplest sense, density refers to the opacity of the developed silver deposit of a film and its ability to block off transmitted light.

Depth of field The limits of acceptable definition from the nearest to furthest point at any setting of the focus scale.

Diaphragm shutter Internal shutter assembly operating on the principle of the diaphragm, opening and closing from the centre to the edge and back again. Its most important characteristic is its ability to work with electronic flash at all speeds.

DIN The European standard for mechanical calibration used most frequently in photography as a rating for film speed. Now replaced by the dual ISO system.

Dodging Selective control of the amount of light reaching the photographic paper during enlargement by holding a shaped card, or the hand, in the light path.

DX System of encoding information in black and silver rectangles on the film cassette and which allows electronic sensors in the film chamber to automatically set the film speed and length into the camera's display.

Emulsion Light-sensitive silver compounds that are coated on to a film or paper support.

Exposure compensation Deliberate adjustment of the indicated exposure to allow for subject anomaly such as backlighting, excessive contrast, or over-dominant local colour, or likely adjustment by the developer.

Exposure latitude Extent to which a film can be subjected to extremes of exposure and yet still produce an acceptable image – often referred to as a range of f stops.

Exposure value (EV) Additional information or reading from an exposure meter relating directly to the amount of light being read used in conjunction with suitably calibrated lenses. The value offered is set on the lens and, when coupled, allows the interchange of shutter and aperture without affecting the resultant exposure.

Field camera 'Classic' large format camera design, often in wood, that folds down into its own body. Light and transportable, it is literally for use in the field.

Film plane The position that the film occupies in the light path and to which the lens is focused. It is usually marked externally on the camera housing with a small white line.

Flash synchronization The precise moment when the shutter is fully open and the flash ignites in unison.

Focal length Distance between the centre of the lens and its focused point or sharp image, at infinity setting. The longer the focal length the greater the image magnification.

Focal-plane shutter The most commonly used shutter system in miniature cameras, involving a variable moving blind in advance of the film (or focal) plane.

Focus The precise point at which the light is converged by a lens to form a sharp image, or the action of aligning the

converging rays to render a sharp image.

Focus lock Device to retain the point of focus selected by an automatic system when subsequently moving the camera on to new subject matter or an alternative view.

Focusing screen Ground-glass, or similar screen, that allows critical examination of the focused image in the same plane as the film, either by mirror or by replacement.

Fogging Unwanted deterioration of an image by light or chemical contamination.

Grain Pattern structure of the image-forming silver halides when processed. This affects the resolving power of film. It is coarser in fast films, finer in slow.

Guide number Lesser-used standard for rating flash output in relationship to given film speed. It is the product of Distance (ft or cm) × Aperture (f number).

Hotshoe Popular term for the direct connector for flash on the camera housing to allow chordless synchronization.

Hyperfocal distance The nearest point at which a lens affords a sharp image when focused at infinity – most useful for setting the lens to obtain maximum depth from nearest point to infinity, as opposed to setting on infinity.

Incident light reading Method of reading exposure by means of a diffusing cell, pointed away from the subject and at the camera thus measuring the amount of light falling on the subject rather than that reflected from it.

Infrared Radiation emitted by warm or hot bodies, outside the range of visible light. Cameras focus IR at a slightly different plane and often lenses are marked with a small R or red dot to help compensation.

Infrared film Film especially made for the detection of infrared sources. Monochrome types require a red or 'black' filter to be used. Colour films have false sensitivity, need a yellow filter, and render green objects blue, red objects green and natural vegetation pink.

Inverse square law Basic law of light that governs output by the formula that, as the distance from the source increases, so its power diminishes by reciprocal of the square of that factor; 2 times the e.g. distance affords a quarter of the light, 3 times a ninth, etc.

Iris diaphragm Variable light-controlling device within a lens, not unlike the iris in the human eye, and calibrated in f stops.

ISO Current standard (International Standards Organization) index for film-speed ratings with dual replacement of both ASA and DIN systems – although this value continues to be expressed in both former values.

LCD Liquid Crystal Display. Commonly used for information readout from camera circuitry, with switchable options across various modes.

LED Light Emitting Diode. Small light source that signals position of operation in viewfinder (shutter speeds etc) or basic functions (battery check, self timer etc).

Line film High-contrast orthochromatic film, designed for copying (especially suited to line drawings etc), with similar characteristics to printing paper.

Lith film Ultra-high-contrast film for lithographic applications and no intermediate tones when developed in appropriate two-part Lith developer.

Macro lens Close-up lens with special correction for work at close range. Can also be used in standard applications.

Microprism Small interference patterns on focusing screens that aid image evaluation – they 'break up' when unsharp and disappear when sharp.

Mirror lens See CATADIOPTRIC lens.

Modelling light Auxiliary light to assist in the use of electronic flash. It acts as a substitute of the flash head for visual evaluation.

Monorail camera Studio standard camera that achieves focus by moving the lens and film panels on a rail or bar.

ND Neutral Density. Usually refers to filters that hold back the light by a known amount (in f stop values) as an alternative to the aperture. ND filters can be used to allow a wide stop and slow shutter speed in high levels of light.

Normal lens Lens with a focal length that is equal to the diagonal of the image format. Also called a standard lens.

One-shot chemistry Photographic solutions that are used once then thrown away, as opposed to being replenished or adjusted by time in subsequent use.

Orthochromatic Limited sensitivity to the colours of the visible spectrum, being very sensitive to the blue end and insensitive to the orange/red bands – able to be used in red safelighting for visual development.

Panchromatic Sensitive to all colours.

Panning Pivoting the camera along a horizontal path to follow a moving subject and thus minimize the differential movement between it and the camera.

Parallax Differential between the viewing lens and the taking lens on the non-SLR camera.

Pentaprism Optical device that converts the image reflected from mirror in an SLR to an upright, non-reversed one in the viewfinder. Standard on SLR, but is often interchangeable with alternative types of viewers.

Photogram Image produced by the direct assemblage of varying artefacts, modulators or negatives on the printing paper, when exposing to light.

Polarization The selective holding back of wavelengths of light by means of a suitable filter, which is rotated while its effect is viewed. Minimizes reflections and darkens sky in colour materials – most effective if the angle of incidence of the light is between 45° and 90°.

'Pushing' Slang for increasing effective film speed by appropriate adjustments in processing.

Rangefinder Coincident system of establishing distance by two separate images coming together, usually coupled to the lens focus mount or viewing system, but not necessarily.

Reciprocity failure When the time-honoured formula that states that Exposure is the consistent product of Intensity × Time no longer holds true, and compensation is necessary at either very short, or particularly, very long exposure times.

Reflected light reading The primary method of reading light reflected from the subject to the camera.

Rollfilm Medium-format film for consecutive exposures, supplied on a spool and backed with paper.

Self timer Time delay, usually built in to the camera's shutter circuitry, to allow a short interval before exposure.

Shutter priority Exposure system that allows manual selection of the shutter speed, while the camera adjusts the lens aperture automatically.

Silver halides Light-sensitive compounds of silver and other constituents that become the coating of the film.

Single lens reflex Camera with reflex mirror system that allows the photographer to view the taking lens.

Slave unit A small auxiliary device for remote triggering of flash, usually sensitive to another flash or an infra-red wavelength. It obviates the need for a chord connection.

Spot reading Reading taken from a small area of a given scene when monitoring light levels.

Standard lens See NORMAL LENS.

Synchrosunlight balancing the effect of sunlight or ambient light by an equal amount of, or slightly less, light from a flash unit during the same exposure.

Telephoto lens Lens with focal length in excess of the diagonal of the image format – affording magnified imagery.

Thyristor Monitoring device within small portable flash units that enables the circuitry to automatically control the output by its sensing device.

Tungsten lighting Studio lamps emitting a colour temperature of 3,200k and appropriate for use with artificial-light colour film.

Ultraviolet Wavelengths of light slightly outside the visible spectrum. Although unseen, they influence colour film when photographing distant views, especially over water.

Viewing screen Ground-glass surface on to which the image is focused.

Wide-angle lens Lens with focal length less than diameter of the image area – affording greater angle of view.

Zone focusing Non-visual method of focusing by reading off distance settings from the lens barrel and selecting a suitable aperture to create the necessary depth of field.

Zoom lens Lens with continuously variable focal lengths built into its formation – offering varying degrees of magnification and selection from the same viewpoint.

INDEX

Page numbers in *italic* refer to the illustrations

ACKNOWLEDGEMENTS

The publishers would like to thank the following for their permission to reproduce the photographs in this book:

Ace Photo Agency/Karl Ammann 36 top, 48–9 **Action Plus** 57 bottom, 64, 193 bottom **Allsport** 24 left and right, 25 left and right, 26–7, 33 right, 52–3, 65 top, 192, 193 top, 195 top and bottom, 196, 197 top and bottom, 198–9, 200 bottom, 201 **The Ansel Adams Publishing Rights Trust, Trustees of (Carmel). All Rights Reserved** 105, 110–11, 248–9 **Aperture Foundation, Inc., Copyright © 1962. Paul Strand Archive, Millerton New York,** 214–15 **Ardea London/Ron and Valerie Taylor** 184 **Richard Avedon Inc., Copyright © 1985. All Rights Reserved** 234 **David Bailey** 180 **Bayerisches Nationalmuseum, Munich** 204–5 **Arthur Bell Distillers** 159 top **Estate of Bill Brandt, Copyright. Courtesy of Noya Brandt** 125, 146, 150 **Bronica** 21 top right **Camera Press** 129 left **Canon** 16–7 **Castelli Graphics, New York** 147 **Center for Creative Photography, Copyright © 1981, Arizona Board of Regents** 142–3, 144, 216–7 **John Cleare/Mountain Camera** 166 **Colorific!, Life Magazine © Time Inc** 227 **Life Magazine © 1955 Time Inc** 11 **The Conde Nast Publications Inc., Copyright © 1930 (renewed 1958). Courtesy Vogue** 178 **Julia Davey** 111 below **Kevin Davies** 130 left and right, 131 **Mary Evans Picture Library** 12 bottom, 13 bottom **Bernard Faucon** 243 **Fox Photos** 133 top **The J Paul Getty Museum, Malibu** 236 **Ken Griffiths/G'Day Pictures Ltd** 41 bottom right, 106, 111 centre right, 132, 134 bottom, 135, 139, 154–5, 170, 171 top and bottom, 172–3, 173 bottom, 174–5, 175 top and bottom right, 176, 177 top and bottom **Hag** 71, 97, 151 left **Hamiltons Photographers Gallery, London** 179 **Robert Harding Picture Library** 47 bottom, 121 top, 191 bottom **Hasselblad (UK) Ltd** 21 top left **John Heseltine** 61, 107 bottom, 111 above right, 115 bottom, 116, 119 bottom **The John Hillelson Agency** 167, 136, 221 right, 224–5 **Tommy Hindley** 133 bottom **David Hiscock** 181 **B.E.C. Howarth Loomes** 12 top **Peter Hunter** 15 top left **The Keystone Collection** 58–9 **Alfred Lammer** 55 **Leica** 14 **The Library of Congress, Washington DC** 228–9 **Lichfield** 18 **Robin McCartney** 129 right **Donald McCullin** 165 **Nadia Mackenzie** 115 top, 117 top **Alex McNeil** 124 top **Magnum** 128, 134 top, 163 top and bottom, 230–1 **Yoke Matze** 141 top **The Metropolitan Museum of Art, Warner Communications Inc. Purchase Fund, 1977,** 239 **Duane Michals** 256 **Metro Pictures, New York** 235 **Joel Meyerowitz** 103, 241 **Robert Miller Gallery, New York/Jan Groover** 158 **Robert Mapplethorpe** 149, 159 bottom **Bruce Weber** 145, 148 **The Ministry of Culture, France** 2, 203 **Musee National d'Art Moderne, Centre Georges Pompidou, Paris** 151 right **Museen Der Stadt Koln, Cologne/Rheinisches Bildarchiv** 222–3 **Museum of Modern Art, New York, Gift of the Photographer, with the permission of Joanna T Steichen** 153, 213 **Anonymous Gift** 160–1 **The Abbot-Levy Collection. Partial Gift of Shirley C Burden** 218–19 **NHPA/Anthony Bannister** 189 **G J Cambridge** 190 **Stephen Dalton** 54 top, 65 bottom, 182–3, 185 **Nigel Dennis** 188 **Douglas Dickens** 187 bottom left **Ian Griffiths** 191 bottom **John Shaw** 183 right **David Woodfall** 191 top **Adrian Neville** 137 **New Orleans Museum of Art (Museum Purchase: Dr Ralph Fabacker and Women's Volunteer Funds)** 220–1 **Arnold Newman** 126–7, 237 **Nikon (UK) Ltd** 15 bottom **Octopus Publishing Group/Martin Brigdale** 69 bottom **Carol Sharpe** 69 top **Charlie Stebbings** 68–9 **Pace/MacGill Gallery, New York** 206–7, 232–3 **Tim Page** 164 **Olivia Parker** 247 **The Parr Joyce Partnership/Christopher Joyce** 26 bottom, 27 bottom, 54 bottom **Will Curwen** 40 bottom, 46–7 **Keith Bernstein** 57 top **Den Reader** 107 top **Pentax** 19 top, 20 top and bottom **John Pfahl** 242 **Stuart Pitkin** 141 bottom **Bill Philip** 157 **Susanna Price** 117 bottom, 187 top **P.P.S. Galerie F.C. Gundlach, Hamburg** 186 **Rosamond W Purcell** 209 right **Nick Rains** 53 top, 194 **Rapho, Paris** 140 **Rex Features/Sipa Press** 200 top **Marc Riboud** 162 **David Rowley** 36 bottom, 37, 42, 51 top left, 118–9, 187 bottom right **The Royal Photographic Society, Bath,** 119 top, 120, 208–9, 210–11, 211 right, 223 **The Rumsey Collection** 13 top **San Francisco Museum of Modern Art, SFMMA Purchase, Gerda Dorfner Memorial Fund** 152 **Alex Saunderson** 40–1 **The Science Museum, London** 15 top right **Science Photo Library/David Parker** 124 bottom **Sinar** 21 bottom **Sotheby's, London** 138 **Jan Staller** 245 **Tony Stone Worldwide** 32–3 **The Telegraph Colour Library/C Lim** 123 **G P Risen** 122 **Tessa Traeger** 155 right, 156 **V.A.G. (UK) Ltd** 30–1 **Zefa Picture Library** 198 left All other photographs are reproduced with the permission of the author. The Duane Michals print and text on the following page and the Joel Meyerowitz prints on 103 and 241 were applied by 'Solutions'. The Bill Brandt prints, pages 125, 146, 150 were supplied and retouched by Tony Avery and Rod Wynne-Powell of 'Solutions'. The Hag print, page 151 left, was retouched by Terry Lawler. Int. Partnership/IFF supplied the David Hiscock photograph. In addition the publishers would like to thank Pam Roberts at The Royal Photographic Society, Bath and Hildegard Mohoney at The Photographers' Gallery, London for all their help and assistance.

THERE ARE THINGS HERE NOT SEEN IN THIS PHOTOGRAPH

My shirt was wet with persperation. The beer tasted good but left me unsatisfied and I was still thirsty. One drunk was talking loudly with another drunk about Nixon. I watched a roach walk slowly along the leg of a bar stool. Glen Campbell began to sing a song called "Southern Nights". I felt a pressure in my bladder and needed to go to the men's room. A derelict began to walk toward me to ask for money. It was time for me to leave.